A publication of ArtsEngaged, a division of Outfitters4, Inc.
635 West Fourth Street, Ste. 201; Winston-Salem, NC 27101
www.artsengaged.com

BUILDING
COMMUNITIES,
NOT AUDIENCES
THE FUTURE OF THE ARTS IN THE UNITED STATES

Written and Edited by
Doug Borwick

Contributors:

Barbara Schaffer Bacon
Sandra Bernhard
Susan Badger Booth
Tom Borrup
Ben Cameron
William Cleveland
Lyz Crane

David Dombrosky
Maryo Gard Ewell
Tom Finkelpearl
Pam Korza
Denise Kulawik
Helen Lessick
Stephanie Moore
Dorothy Gunther Pugh

Diane Ragsdale
Noel Raymond
Preranna Reddy
Naila Rosario
Sebastian Ruth
Russell Willis Taylor
James Undercofler
Roseann Weiss

ArtsEngaged
Winston-Salem, North Carolina

TABLE OF CONTENTS

FOREWORDS

Rocco Landesman, *Chairman*
National Endowment for the Arts

I met with Doug Borwick almost a year ago now to talk about his Engaging Matters blog, as well as this book. In our conversation, I was particularly struck by Doug's formulation of the arts as "campfire": the sites, objects, and activities that gather and connect us communally around a shared experience.

At the National Endowment for the Arts, I talk a lot about "creative placemaking" – the ways in which communities are using the arts to help shape their social, physical, and economic characters. As Doug would agree, there are two chief prerequisites for creative placemaking to succeed: a strong and deep commitment to the art itself; and cultural organizations with porous walls. Cultural organizations should be like living cells with permeable membranes that exist to organize and protect the art, but that let the art out into the community, and let the community into the art.

Over the past three years, I have spoken about the Streb Lab for Action Mechanics, Elizabeth Streb's artistic home in Williamsburg, Brooklyn. Elizabeth talks about arts organizations that still use the traditional model of churches to organize themselves as places to come at proscribed times of the week to observe and receive a set text and set of experiences. The best arts organizations – and the best churches, I should add – have eschewed that model entirely. Elizabeth, in fact, now talks about borrowing the model of a 7-Eleven: a place that is always open and that can meet a huge array of your needs.

Whether you want to think of them as cells, campfires, or 7-Elevens, I have seen arts organizations all across this country that have inextricably woven themselves into the fabric of their societies: the Trey McIntyre Project is using its NEA Our Town grant to be on the road less and become even more part of their community in Boise, Idaho. In Louisiana, the Shreveport Regional Arts Council is using NEA support to re-conceive and reopen an abandoned fire station as an arts building that will anchor a new town commons. And, inspired by the NEA's Blue Star Museums initiative, the Mississippi Museum of Art is offering free admission to all military families in and around Jackson all year long to help integrate the military and civilian communities that often exist side-by-side with little or no interaction.

One of my favorite images for this notion of art and community in constant exchange is a production that The Foundry Theatre did in 2009 called "The Provenance of Beauty: A South Bronx Travelogue." This piece was a performed on a bus that traveled through the South Bronx, literally (and figuratively) bringing some audience members to parts of the community they had never before visited, while simultaneously showing other audience members the blocks of the city they call home through the eyes of a poet.

I think the days of the arts in ivory towers are behind us; the very best arts organizations are like this bus: navigating and connecting communities with artists as tourguides. Not only can the arts build communities, I think we must.

Robert L. Lynch, *President and CEO* Americans for the Arts

"... We are engaged in a serious search for a formula that balances the surging democratization of the arts with the inescapable autocracy of the arts."
– Dr. Joseph Golden, *Olympus on Main Street*

In this seminal 1980 text, Joe Golden who was an early mentor of mine details a successful community-based process he led to envision and build a performing art center in Syracuse, NY that would stand, not as a temple for the worship of art, but as a center for community and for arts participation. As executive director of the Cultural Resources Council of Syracuse and Onondaga County, NY and throughout his career, Joe called the question about art and community. It is one that Doug Borwick and the many voices he has assembled renew in **Building Communities, Not Audiences**. Then as now, it is an important conversation.

It is important because art is important. Art conveys important messages, contains important information, and offers ways to think differently. Art has value to people *and* to communities. As stewards of a community's cultural assets, we have a responsibility to put that value to maximum use.

"It is difficult to get the news from poems, yet men die miserably every day for lack of what is found there."
– William Carlos Williams "Asphodel, That Greeny Flower"

Art is important to humans and to community survival as William Carlos Williams so eloquently illustrated in his 1955 poem. When elected officials, business and community leaders call for solutions to issues of public safety, transportation,

jobs, and education, they are calling for poems. They are inviting arts and culture to the table with other sectors to define and address civic problems; to inspire, challenge, imagine, and build new civic futures; to boost image and identity; to drive revitalization, social bonding, and economic growth.

When audiences seek more forms of arts participation, they are calling for poems. They are seeking arts experiences that enrich, connect, expand, reflect, and engage them. They desire to tap the creativity within themselves. They are creators and curators of their own arts experiences and they are calling to be co-creators of the experiences that we offer.

Today, every boundary around arts and culture in America is morphing and expanding. For community-based organizations and those in rural communities, community and civic engagement is a core value, engrained in their operations. More recently, cultural institutions in every discipline, led by their national service organizations, are experimenting with and establishing civic practices that align mission and public value. Not all will be successful. New skills and knowledge are required.

But, deep engagement with community is among the five key characteristics described in the 2012 report, Bright Spots, a study of cultural groups in the Pacific Northwest that are successfully adapting to their changing circumstances without exceptional resources. Commissioned by the Paul G. Allen Family Foundation, the study defined deep engagement as "operating in and of their communities, and they possess a deep understanding of their interconnectedness with others and their role as civic leaders."

In **Building Communities, Not Audiences:** *The Future of the Arts in the United States*, Doug Borwick calls for substantive rather than superficial efforts, authentic and systemic changes. The writings of theorists, historians, and practitioners he has drawn together offer seasoned insights and fresh perspectives, tested strategies and new technologies that explore many dimensions of community engagement.

"The public demand [for cultural services] is likely to increase –
not only for the services, but also to be heard, taught, and involved
in determining the cultural destiny of our communities."
-- Dr. Joseph Golden, *Olympus on Main Street*

Dr. Golden was correct. This book advances an important conversation that is as timely as it is evergreen. The challenge is not whether to build communities or audiences but how to build communities and audiences together.

PREFACE

I come to this discussion and to this work as a product of the arts establishment in the United States. My early arts experiences were in children's choirs in church, private piano and trumpet lessons, and, later, public school arts-music and theatre-in the Midwest of the 1960's. This led me to pursue a career in music and, as I am continually telling workshop attendees, colleagues, friends, and strangers on the street, I am as over-educated as a musician can be. I have a Ph.D. in composition from the Eastman School of Music. I do not say that with any sense of pride or superiority. To be honest, as may become clear later, my feeling is at least somewhat to the contrary. My reason for laying that particular card on the table is to head off any argument that I do not understand the arts.

It was my observation of the transformative power of the arts, first for me personally and later at the community level, that kept me (and keeps me) in the field. As an extremely shy eighth grader, I volunteered when the junior high band director asked who wanted to come at 7:00 a.m. to play in a stage band. (You may know of them as lab bands or dance bands in the Big Band tradition.) The result was a five year public school career in such bands, summer music camps, show choirs, and lead roles in high school (and later college) theatrical productions. And, though it is a truism that should probably go without saying, my work today as a public speaker and workshop presenter would have been unthinkable without those experiences.

In the summer of 1976 I was part of the production team for an event commemorating the U.S. Bicentennial in Waco, Texas, a city of about 125,000 at the time. It was a Texas scale event with nearly 30,000 in attendance (about 25% of the city's population) in a football stadium viewing a thousand performers on twelve stages. The person sitting next to me was on the headphones to cue the Air Force jets in their flyover. What I learned about production was invaluable to my career as an arts administration educator. More pertinent to the topic of this book, however, was the discovery I made about that event's impact on the community. For months afterward, the common currency of most casual conversations in Waco began with "Were you there?" and proceeded to analysis, critique, and celebration of that extraordinary experience. This was an arts event that influenced an entire city. That such a thing is possible is a lesson I have never forgotten.

These experiences led me to a twenty-seven year career as an arts administration educator. My position as an academic rather than a front-line administrator has afforded me the distance and time to observe things about the field that may not be readily apparent to those in the throes of day-to-day management of arts institutions. Most particularly, my metaphorical distance from ground zero at the beginning of the "culture wars" allowed me to process some important points. (My geographical distance was nearly nil since I live in Winston-Salem, NC, home of the Southeastern Center for Contemporary Art–SECCA–famous in that early moment for the show that included Andres Serrano's "Piss Christ.")

In spite of my clear personal awareness of the power of the arts to transform individual lives and communities, I observed that no politician paid any price for attacking the arts and that no politician gained any significant support for coming to the defense of the arts. What that demonstrated to me was that the bulk of the electorate had no strong connection with the arts.

This awareness provided me a new lens through which to view other well-known "truths" about the arts in the U.S. The decline in arts education in the public schools, the lack of respect for the arts, and the dearth of public funding (and the vulnerability of the public funding that exists) for the arts, to name just three, all derive from the same root. In the main, the person on the street does not believe that the arts are in any significant way valuable for them.

Given my experience-based belief in the importance of the arts, this was not just troubling. It forced me to reconsider many of my basic assumptions about the relationship between the arts and the communities in which they exist. In grossly over-simplified terms, the core constituency for any particular "high art" form has been identified as in the range of 5% of the total population, and the traditional demographic make-up of that 5% was (and is) a declining subset of the U.S. population. The status quo began to appear unsustainable. In addition, given the resources invested in the established arts infrastructure, I was led to question the morality of "settling" for such a small percentage of the population benefitting from the investment, especially since those benefits are so profound.

This was the beginning of the intellectual pilgrimage that has led to this book. My conviction is that change, transformative and potentially painful, is both inevitable and necessary if today's established arts organizations are to continue serving the cultural needs of the U.S. for the next century. If change such as is envisioned here is not undertaken, a new arts delivery system will evolve. Many believe the latter to be

inevitable. It is my hope that the discussion prompted by this book will help create a path linking the current arts establishment and the arts infrastructure of the future.

WHAT FOLLOWS

Part I of this book introduces basic concepts and sets out issues that need to be addressed in support of community engagement work in the world of the arts. Part II presents engagement theory and tools from the perspective of field experts. (The tools it presents-in some cases, modes of thinking would be more accurate-are ones that can be profitably employed in community engagement work.) Part III contains case studies showing that community engagement is not only a viable option but is one that holds much promise for success for arts organizations. Part IV, taking the preceding material as a foundation, advocates for substantive engagement as the path to sustainability for the arts,

INTRODUCTION

PERHAPS THE GLASS IS HALF EMPTY

The arts will always exist. As long as human beings live in community and individuals consider their own relationship with each other and with the world that supports them, our species will express itself through the arts. It is far less clear that the not-for-profit organizations serving as the principal arts infrastructure today will survive through the next several generations.

Established arts organizations have, as a result of their evolution, support structures, and programming assumptions, been cut off from the lifeblood that is the evolving culture of the United States. There is a real danger that they stand upon gradually melting icebergs drifting further and further from solid ground. The fundamental cause of this drifting is a lack of direct, meaningful connection between those organizations and the communities in which they exist. This lack is for the most part not the result of conscious choices but of the history of the evolution of art in Western culture and of the arts delivery systems that support it.

The economic, social, and political environments out of which the infrastructure for Western "high arts" grew have changed. Today's major arts institutions, products of that legacy, no longer benefit from relatively inexpensive labor, a nominally homogeneous culture, or a polity *openly* managed by an elite class. The changes that have created stress on arts organizations to this point will only accelerate in the next fifty years.

Expenses are rising precipitously and competition for major donors is increasing; as a result, the survival of established arts organizations hinges on their ability to engage effectively with a far broader segment of the population than has been true to date. Most communities in Western society have made (relatively speaking) huge investments in support systems (*e.g.*, facilities, organizational structures, and artist training) for these organizations; a sense of justice demands greater attention be paid to developing relationships with subsets of the population that are largely uninvolved in their work.

The means for addressing these issues is to connect more substantively with the communities in which arts organizations do their work, a process referred to here as community engagement. Meaningful engagement is rooted in mutually beneficial

relationships. In established arts organizations, the task of fostering community engagement is made difficult by the fact that there is, among their principal constituencies, little awareness of the issue or of means to address it. For the most part and with notable (and noteworthy) exceptions, artists have not been trained in this area; current audiences/patrons/board members participate because they are pleased with the status quo; arts administration professionals have been trained to manage the established order; and the unengaged (both individual citizens and public officials) consider these institutions to be irrelevant. There is little opportunity to gain purchase to alter the system.

BUT THE GLASS IS ALSO HALF FULL

In spite of the intimations of danger (if not doom) presented above (and in more detail later), there is also a way of viewing this need for transformation, in the words of a colleague, as a "Happy, happy; joy, joy" option. Most people involved in the arts want to reach people with their art. They want a better world for all and they want everyone to experience the inspiration and uplift that, as they see it, the arts can best provide. The process of community engagement outlined in this book is a path if not to that utopian future then at least to one in which their contributions to society are far more fully recognized, utilized, and valued.

Community engagement demands honest commitment; unengaged groups are quick to spot insincere or limited overtures. It demands unfamiliar skill sets; practitioners need training in dealing with and organizing diverse communities as well as in awareness and appreciation of non-Western or non-traditional art forms. And it demands time; relationship building is a long, on-going process. This is especially true in circumstances where subsets of the population, based on historic slights or institutional ignorance, have come to *mis*trust established arts organizations.

The purposes of this book are 1) to identify those factors that serve to isolate established arts organizations; 2) to point out the trends that loom as imminent threats to the long-term viability of the artistic status quo; 3) to present principles and mechanisms whereby arts organizations can significantly extend their reach into the community, supporting enhanced sustainability; and 4) to stimulate debate on these issues in an effort to encourage changes that will enable arts organizations to be vital cultural resources for their communities far into the future.

TERMINOLOGY

Every field has its peculiar (practitioners would often prefer to say "specialized")

terminology. The field under discussion here is particularly iconoclastic in terminology. Since this is not primarily an academic treatise on the field but an introduction to its concepts to those "on the outside," there will not be a full airing of the arguments about terminology. At the same time, since this book uses terms that could have a variety of meanings, the definitions of those terms as intended here are given below.

Arts-Centered Project: Community arts activity in which a work of art is utilized to address a community need (*e.g.*, a production of *West Side Story* through which issues of immigration are examined). Arts-based projects are often developed by established arts organizations taking an existing work and using it as the centerpiece of a community arts project. Alternatively, the organization can commission (or an individual artist can create) a work that in itself may not be primarily "about" an issue but in the context of its presentation can address it.

Community Arts: Arts-based projects/programming intentionally designed to address community issues

Community-Based Arts: Arts-based projects undertaken on a grassroots level, whether by artists or community members, that grow out of concerns or issues identified from within the community

Community-Focused Arts: Arts-based projects undertaken, often by established arts organizations, that address issues or meet needs of the community or of some identified subset of the community

Community Engagement: A process whereby institutions enter into mutually beneficial relationships with other organizations, informal community groups, or individuals. In the context of this book, this normally implies arts organizations developing relationships outside of the arts community.

Issue-Driven Project: Community arts activity in which a community issue is addressed through an arts experience (*e.g.*, issues of crime highlighted by art placed at crime scenes). The art in issue-based projects grows out of an issue, either in newly created work or in the re-production/presentation of existing issue-based work.

The Arts/ Community Divide

HISTORICAL BACKGROUND: HOW DID WE GET HERE?
The Arts as a Reflection of Culture

All art is culturally specific. This is not to say that great works of art cannot speak across widely disparate cultures, but the further removed the viewer/listener's culture is from the culture of an art work's creator, the more difficulty the former will have in appreciating the art. And in some cases the chasm may well not be bridgeable.

Those seeking to refute this sometimes cite music as their example. Since it is not bound to story or image in the way most other arts are, there is an assumption that it transcends cultural boundaries. The bromide that "Music is the universal language" is poppycock. Music *is* universal. Its vocabulary, grammar, and syntax are not. Music from unfamiliar cultures is . . . unfamiliar. Students in World Music courses come to understand this early on. Two stories, however apocryphal, illustrate the point. One is of the master musician from the subcontinent of India invited to an orchestral concert in London. When asked which part he liked best, he replied, "The first." His hosts asked if he meant the first movement of the first piece and he responded, "No, the part before that." The musician was referring, of course, to the orchestra's warm-up and tuning that bear some similarity to the *alap* of a classical Indian raga. The second is the story of the early 20th-century Native American musician invited to an opera in Washington, DC whose post-performance comment was, "It was interesting. But why did they keep singing the same song over and over again?" [Source: Titon, Jeff Todd. *Worlds of Music.* Third Edition. NY: Schirmer Books. 1996]

All art is an expression of its culture. The history of much artistic expression worldwide is participatory, inclusive, and community-based. These facets are a reflection of the cultures from which the art springs. As will be shown, the artistic expression with which much of this book is concerned-that of Europe, often more specifically Western Europe-places a barrier between artist and perceiver, tends to be exclusive, and focuses on the individual more than the community. These all reflect the society from which they derive, but they are also seeds of the problem being addressed here.

EVOLUTION OF ART AND ARTS SUPPORT

The origins of the arts appear to lie in expression of things important to the community. This expression might have involved everyone as active makers of the art or individuals who "gave voice" metaphorically (and sometimes literally) to that which was being expressed. However, in the latter case, the artist was primarily a conduit for the sense of the people and the "audience" was actually participating in the process rather than passively observing.

As most societies evolved, increasing prosperity led to specialization in all fields. This is true of the arts as it is for all other types of endeavor. The work of creative artists is then supported by the society as a whole or by wealthy individuals. Typically, however, when the latter happens, the patron's self-aggrandizement takes the form of placing himself or herself in a favorable light *in the context of the community.* The *griots* (and in music, the *jali*) of West Africa place the glory of their patrons in the long line of the community's history.

Concentrations of money and power initially contributed to and then fostered even greater specialization. The way this played out for the arts in the West, art was removed from its role enhancing community cohesion; instead it contributed to and emphasized divisions. Unlike farmers, plumbers, and merchants–other specialists–the product the artist created (*e.g.,* the portrait or musical composition) was not a product that everyone used. The wealthy could get *better* produce, plumbing, or merchandise, but everyone needed and had some access to each category. The wealthy were the sole beneficiaries of the entire category of "art product," at least with respect to "high arts." Skillfully executed art became a supporter of the social and economic structures that patronized it. Less technically proficient art, the only kind then available to the broader community, was left to "the masses."

In Europe, during the Middle Ages such a shift of the focus of cultural expression took place. In the Western Church, priests served as intermediaries between God and the people. This gave the Church great power and, along with it, much wealth. The arts became both intercessory and instructional–tools of the Church. The arts supported by the resources of the Church were no longer inclusive, community-based, and participatory. They became an exclusive, performer-based, observer experience.

As the Church gradually lost power and influence, its role as supporter of the arts shifted to political rulers. Kings, dukes, and counts took the patron role from popes, bishops, and priests. At the same time, the Western focus on the individual, beginning with the Renaissance, shifted the emphasis of arts patronage from promoting the Church to celebrating the lives of individuals. Skilled performers became even more

separate from the bulk of the population. Congregations and, later, audiences/viewers–invited guests of the patrons–were, for the most part, recipients of rather than participants in this art. The passive audience was born.

ARTS DELIVERY SYSTEMS

In these "arts delivery systems"–the processes by which the arts are funded and presented–patrons supported the creation *and* presentation of the arts. In nineteenth-century Europe, the rise of the middle class (or, more accurately, a lower upper class) led to the development of a system of ticket and gallery sales for the generation of additional revenue. This response to changing social and economic realities had an impact upon the arts created and presented. However, the patronage system continued to be a dominant part of the creative process. Patron subsidies remained essential.

In the Twentieth Century, in most of Europe the patronage system by the wealthy, powerful individual (whether monarch, noble, or merchant) was taken up by the state, albeit a more democratic state than had been true in the past. This was a relatively easy transition since patronage by a king or queen did, on the surface, look like state patronage. (This is true despite that fact that royal patronage is actually patronage by an individual using state resources, whereas contemporary state support is a collective enterprise.)

A similar transition, but one more appropriate for its political and economic history, was made in the U.S. First, the presentation function was taken up by what evolved into the not-for-profit corporation. (It is worth noting that, in general, corporations have a tendency to be far more conservative than individual patrons.) Second, financial support was taken on by members of the upper class and by corporations (as surrogates for the upper class). A critical difference in the two systems is that a large measure of the art supported in Europe was home-grown, a situation very nearly reversed in this country. As a result, a somewhat broader base of political support for the arts exists in Europe than in the U. S.

In the U. S., the arts maintained a relatively stable, if quiet, niche in society until the 1950's. Interest and activity in the arts then grew until the mid-1960's, at which point an explosion in arts attendance occurred. After 15 years of booming growth from 1965-1980, attendance at professional performing arts events reached a plateau. A very readable analysis of the causes of both the boom and the plateau can be found in a book entitled *Waiting in the Wings* by Bradley Morison and Julie Dalgliesh. To summarize briefly, many factors contributed to the boom, but a thriving economy (at least through the first part of the period) and the explosion in higher education

precipitated by the GI Bill were prominent factors. However, the principal influence was the role of the National Endowment for the Arts in decentralizing arts activities in this country and encouraging the expansion of arts opportunities into previously unserved areas. During this period, the U.S. went from having 6 state and 50 local arts agencies (like arts councils) to 50 state and over 2000 local arts agencies. Professional theatre companies increased from 40 to 140, opera companies with budgets over $100,000 increased from 35 to 109, the number of museums increased by 28%, and the number of dance companies increased at least fivefold.

Morison and Dalgleish observe that by the 1980's, through decentralization, the market had been "maxed out." Converts had not really been won. Those who were predisposed to be interested in the arts had simply gotten onto the bandwagon because the wagon had gotten to where they lived. Most arts organizations had anticipated that the growth curve of the 1960's and 1970's would continue. They were caught short when it plateaued.

REFLECTIVE ART/VISCERAL ART

To continue the analysis, it is helpful to understand the nature of the arts experiences discussed here. The terms "high art" and "popular art," while familiar to many people, are imprecise and have value-laden connotations that are not helpful. A pair of "new" terms reflective and visceral art–can aid understanding at the same time acknowledging the merits to be found in all artistic expression.

The principal characteristic distinguishing reflective and visceral art is aesthetic focus. By this is meant the relative emphasis placed upon depth of content as opposed to immediacy of impact. Works emphasizing depth of content challenge the mind and spirit and offer rich rewards for repeat exposure to them. Works emphasizing immediacy of impact are designed to have a profound and immediate effect upon the perceiver. These two foci are not mutually exclusive. Great works of art attend to both of them.

Beyond this, reflective works often have as one motivation an attempt to educate or edify and require effort to be appreciated. Works that are primarily visceral in character attempt to entertain and are characterized by ease and accessibility. These categories are not hard and fast nor are they, like aesthetic focus, mutually exclusive. However, understanding this makes it clearer why what is known as "popular" (or visceral) art can survive what economists call the market test and why reflective art should not be expected to do so. (A chart outlining the basic idea is given on the next page.)

	REFLECTIVE ART	VISCERAL ART
AESTHETIC FOCUS	Depth of Content	Immediacy of Impact
MOTIVATION	Educate/Edify	Entertain
PERCEIVER INVOLVEMENT	Requires Effort	Easy/Accessible

The not-for-profit arts establishment in the U.S. is concerned almost exclusively with reflective art. Such art demonstrates what economists call market failure (inability to support itself in the marketplace) and political scientists term political failure (it lacks sufficient electoral support to provide full, or even substantial, funding through government). Nevertheless, reflective art has been deemed to be valuable and so it is supported through the mechanism of the not-for-profit corporation. This is the same mechanism developed to support other valued enterprises such as social services, private education, and issue/policy advocacy to name a few.

OLD WINE/NEW SKINS

The arts supported by established presenting organizations are primarily reflective art created in Europe in the eighteenth- and nineteenth-centuries or art that is a direct outgrowth of that epoch. They are rooted in a cultural language that is increasingly foreign in the twenty-first century U.S. This makes such artistic expression remote for many people; it requires considerable effort on the part of the perceiver to understand a cultural "language" that would have been commonplace to those from that place and period. It can be difficult for those without a solid background in European culture of several centuries ago (who now make up the vast majority of our population) to benefit from what the arts of that culture have to offer. The result is arts and arts institutions that stand removed from a considerable portion of their communities.

The social, political, and economic conditions out of which that art and its "delivery systems" grew no longer exist. As contemporary conditions become further and further removed from those that gave rise to these arts and their institutional structures, the less viable those structures become.

Socio-political Conditions

The cultures that gave birth to the arts with which this chapter is primarily concerned were monarchies with elaborate aristocracies. The arts were produced for and supported by them. As long as this system remained in place, there was little concern about the arts relationship with "the people." When Europe moved to

constitutional monarchies and democracies, much of the status quo from earlier eras was maintained in a plutocracy of the social elite.

The situation was different in the United States. Some of the original settlers of this continent were antagonistic to the arts, and later immigrants–the poor, the tired, the huddled masses–were clearly not from socio-economic groups that were arts patrons. This is but one reason that there is not a long history of public support of the arts in our country.

There was never a monarchy here; however, from the beginning, the notion of class has played a significant role in our society. (The Constitution granted the vote only to white, male property owners and prevented direct election of U.S. Senators.) The disparity in wealth between rich and poor (among free whites), while significant, was not until the arrival of the Gilded Age near the end of the Nineteenth Century the chasm here that it was in Europe. It is no coincidence that the establishment of many of the United States' flagship arts institutions dates from the second half of the Nineteenth Century.

The layering of plutocracy on a democratic political system is a circumstance with which many in this country are uncomfortable and would prefer to ignore. The rights movements of the 1950's and 1960's brought the awareness of social inequities to public consciousness in a way that the labor movements of the first half of the twentieth century had done with economic inequities. One result has been an increasing concern with accountability and equity in matters of public policy. This has begun to have an impact on public discourse about the arts (and is one of the things that some in the arts community still do not understand) and the demand for equity will only increase. The Occupy movement of 2011, while not focused on the arts, suggests a rising tide moving in this direction. A system supporting (or that is seen to be supporting) arts for the well-to-do will be completely untenable in the near future.

Demographics

Established arts organizations in the U.S. are overwhelmingly concerned with the presentation of arts that were far closer to the vernacular cultural language of eighteenth- and nineteenth-century Europe than to the U.S. today. (Even then, it was not the vernacular of the "person on the street" but of the upper class. Nonetheless, it would have been more readily recognizable by Europeans then than by U.S. citizens now.) This is not a criticism of that art, merely a statement of fact. Even for U.S. citizens of European heritage, the culture out of which those arts grew is several centuries and thousands of miles removed from their daily experience.

At the same time, as virtually every periodical is pointing out regularly, the U.S. is quickly becoming less European in the cultural background of its citizens. There is some disagreement about the exact date at which the percentage of whites of European descent in the U.S. will dip below 50%, but there is no doubt that it is coming soon.

Taken together, these facts indicate that an industry based primarily or even largely on the heritage of a foreign culture will soon face serious survival issues, even if the issues of expense and funding were not becoming increasingly troubling.

Economics
Productivity Lag

The arts industry is among the most labor intensive of all categories of enterprise. There is little way to improve the economic "productivity" of a symphony orchestra beyond a certain point. There are fixed amounts of time required for rehearsal and performance. Baumol and Bowen's classic assessment that "It will always take four musicians to play a string quartet." is an acknowledgement that there are inherent limits to promoting efficiency in the arts. (However, Broadway musicians' strikes against the increased use of sampled and synthesized music to accompany musicals suggests that even this old truism is in danger of falling victim to technology.)

Almost all other industries mitigate the effects of inflation through mechanization and computerization to improve the efficiency of personnel or to reduce the number of employees required. The arts' inability to take full advantage of this option results in what economists call productivity lag. This results in a "double whammy" for the arts since not only do the arts feel the effect of inflation that all experience, productivity lag renders them increasingly more expensive relative to most other "commodities."

This is particularly true for large performing ensembles, especially symphony orchestras. The simplest way to think about this is to understand that when the orchestra developed, labor was *far* less expensive relative to the cost of everything else than is the case today. The economic environment that spawned the medium of the orchestra no longer exists. If the orchestra, as a medium of artistic expression, were not a given fact of life now, today's economic situation would never have allowed it to evolve. The economic pressures represented by inflation and productivity lag will do nothing but create an increasingly hostile environment for this institution that developed in a completely different economic circumstance.

What is true of the orchestra is true of all arts activity to varying degrees.

Funding: Competition

As noted earlier, the reflective arts, because they are inherently less "salable" than the visceral arts, always have and always will require some form of subsidy. The 1960's to the 1980's saw a huge increase in the number of arts organizations in the U.S. The last twenty years have seen a 50% increase in the total number of not-for-profit corporations in this country. (*All* not-for-profits are labor intensive, so the issue of productivity lag with respect to the arts applies to the entire sector as well.) At the same time, economic reality accompanied by a political/philosophical shift in government has resulted in significant cutbacks in public money to support any not-for-profit activity. Each not-for-profit requires funding. They are all competing for a finite pool of charitable giving dollars.

Funding: Corporations

The demands of the market and the vagaries of the economy have forced corporations to re-evaluate long-standing patterns of corporate giving. There is more concern with observable results, especially with respect to corporate employees and product sales. In the arts, this led to the emphasis on corporate sponsorships and in the broader not-for-profit world on cause-related marketing.

Funding: Patronage

Skyrocketing costs and the competition for funding have affected the nature of private patronage as well. In the period of initial arts patronage in the U.S., due to extreme concentrations of wealth and low labor costs, it was possible for a single patron to fully fund an arts activity. The Boston Symphony, founded in 1881, was for decades supported by a single patron, Henry Lee Higginson. Such a situation is simply unimaginable today.

In addition, much is being written about the changing face of patronage. While extreme concentrations of wealth have re-emerged over the last thirty years, compared to the mid-Twentieth Century, the attitude regarding charitable giving of those with money has shifted. Among those with inherited wealth, the 1980's loosened the hold of *noblesse oblige* that had characterized earlier generations, making charitable giving less a foregone conclusion than had been the case. Among the newly wealthy, there is a great demand for accountability for and tangible results from their contributions. Especially among high tech entrepreneurs, there is also a greater desire for a personal connection to the cause being supported than had been true in earlier eras.

The proliferation of not-for-profit organizations requiring funding has far outpaced the expansion of the multi-millionaire pool. Inevitably, a smaller percentage of not-for-profits will be able to find deep-pocketed individual donors than has been the case in the past. This will lead to increasing pressure to expand the donor base. The math for the future of individual giving is that one million dollars can come from a single gift or from 40,000 gifts of $25. And a shift to the 40,000 gifts model will require organizations to be deeply engaged in their communities.

RATIONALE/IMPERATIVE FOR CHANGE
The Peril of the Status Quo

The arts and the systems that supported them in Western Europe were, in general, not expressions of communities but of individuals with money and power. It is these arts that form the bulk of "high arts" presented in the U.S. even today.

This background is essential for understanding the "state of the arts" in the U.S. in the Twenty-first Century. Ours is a society that does not freely support the work of established not-for-profit arts organizations. There is no museum so important to a broad range of attendees that it can keep its doors open solely through admission fees. There is no symphony so wildly popular in its community that it is fully-funded by city government. There is no dance company so meaningful to its donors that they provide it with all resources necessary to maintain its operations each year. Indeed, these three scenarios are so far-fetched that even entertaining them seems ludicrous. Yet an examination of the reasons we understand them to be preposterous can provide significant insight into the state of established arts organizations in the U.S. today and provide some sobering glimpses into the future.

In a capitalist democracy, the long-term viability of any enterprise is only assured if it can fully support itself through earned revenue or if 50% plus one of the voting population is passionately committed to it. There is an intuitive awareness that neither are true of our established cultural institutions.

Paradigmatic shifts in socio-political, demographic, and economic systems have taken place since the structures that support European-based arts activity emerged. These shifts have de-coupled established arts organizations from the general public and present a practical rationale for changing the focus of those organizations. The long-term viability of the established arts world appears to depend on increasing the breadth of reflective arts experience offered and expanding the base of the public being served by those experiences.

In addition to the practical argument, there is a moral one as well. U.S. society has invested a huge quantity of resources in the infrastructure supporting Eurocentric arts. The physical facilities that arts centers represent, the human resources that arts education has produced, the person-power represented by untold hours of volunteer service has provided, and the annual financial investment in arts organizations

represent a nearly incalculable investment in the support of culture. Why should the benefits of this resource be, practically speaking, available only to a small percentage of the body politic? If there is a way to utilize this investment in the service of the whole population (or even a much expanded portion of it), it seems very nearly criminal not to do so.

Any industry that demands growth of its consumer base for survival at a time when it is faced with what appears to be a saturated market must undergo fundamental re-evaluation of itself. The arts are not a product delivery industry. They are a personal relationship industry. Those whose heart and soul is their art must remember what it is that drew them to the profession. It had something to do with the effect that the arts had upon them as individuals and the connections it allowed them to make with others. If a means must be found to grow in order to survive, that growth can only take place by re-imagining what it is artists and arts organizations can do and for whom they do it. The personnel of the arts industry need to engage not an undifferentiated "audience" but a collection of individuals in community with them.

The traditional approach to marketing holds that, for example, a Beethoven Sonata is an *a priori* good, regardless of the background or interests of the public to be reached. While on first consideration that may seem true, it should be remembered that for sixteenth-century Catholics, Palestrina was an *a priori* good. Today, however, an industry is not built around his work. Times and tastes change. There is a fundamental question to be addressed. Which is more important, that particular Beethoven Sonata or, on the other hand, the role which reflective music should play in society? If it is the latter, not only should marketing approaches be re-examined; the understanding of the product presented should be re-considered as well. The focus on tickets or body count rather than the people who are the potential market has led the industry away from creative thinking about how to expand its conception of that market.

COMMUNITY ENGAGEMENT AS A PRACTICAL TOOL

There are numerous reasons, both moral and practical, for pursuit of a community-focused arts agenda, both for arts organizations and for communities. The practical reasons fall in the categories of systemic (meaning of value to large systems: the "arts world" or "the community") and organizational. While some of these reasons may be obvious, it should be helpful to articulate them here.

Systemic
Community Development Strategy

For city development officials, an arts community actively involved in community-focused art projects can be a vital resource. In on-going efforts to support economic development and improve educational opportunities, community/arts partnerships have much to offer. This will be discussed in much greater detail later. In addition, a city where the arts and business or education communities are in regular dialogue has the option of drawing on this relationship capital to address opportunities immediately as they arise. This can provide a competitive advantage in corporate recruitment, decrease lag time in infrastructure development or project implementation, and significantly improve the turnaround time on efforts to address issues in the public schools.

Community Building Strategy

Similarly, an arts community thoroughly integrated into the life of a city can significantly enhance the quality of life. Again, this will be discussed in much greater detail below; but where community-focused arts projects designed to improve the lives of a city's citizens are well implemented, the social fabric of that city will be significantly healthier than would otherwise be the case. And, when difficult social issues arise, there are communication structures in place to address them.

Public Policy Strategy

Members of the arts community can frequently be heard asking sympathetic public officials or opinion leaders for language and arguments that would encourage elected officials to support the initiation or expansion of public funding of the arts. These questions spring from an unquestioned shared conviction within the arts community that such funding is justified. An interesting response to the question would be that the solution is not in tricks of language or more persuasive arguments but in an obvious and undeniable record of arts organizations' community engagement leading directly to healthier, happier, more equitable, and prosperous places to live. The results of such a record would be an electorate that would demand public support of the arts (both in funding and in broader policy). The fact that that is not the case speaks volumes.

Where the arts are visibly involved in improving people's lives on a broad basis, there is real potential for the creation of political capital that will support greater public funding and arts-friendly policy initiatives. Where the arts are seen as making a vital contribution to the entire community, the atmosphere of public acceptance will aid in all elements of public sector relationships with the arts.

Sectoral "Brand" Enhancement in Hard-to-Reach Populations

While directly related to all the other headings in this section, particular mention needs to be made of the importance of community engagement activities in reaching the middle class and better-off suburban/exurban populations. For reasons addressed at length in many other parts of this book, these groups are generally not predisposed to be supportive of the reflective arts. The tools discussed here by which the arts can address concerns of importance to all people represent a powerful means of rallying an "apathetic suburbia" and a "disaffected middle class" to the value of the arts. As will be discussed later, the improvement of public education (as one particularly good example) by means of arts engagement is a common ground on which support for the arts can be built.

Organizational
Development Strategy: Public Relations, Marketing, Funding

For the individual arts organization, a community engagement agenda is inevitably a development strategy. From a purely public relations point of view, an organization visibly involved in improving the life of the community will be seen in a positive light in direct proportion to the good seen and understood by the public. That might bear public policy fruit for the specific organization; but more typically, it sets the stage for marketing and funding benefits. The arts organization that is presenting community-focused arts programming is already attracting a broader range of people than is typical. In addition, people who see an arts organization as a valued member of the community will be more likely to consider patronizing its offerings, much the same way that relatives of student performers are more likely to attend a high school theatre production than are strangers. The sense of personal relationship or perceived direct value is a powerful motive for participation. Similarly, when an arts organization is viewed as making significant contributions to the well-being of the community, there is a far broader spectrum of potential donors than is typical. Visibility is the first element of fundraising; a clear understanding of the direct benefit of the work to the donor and community is the clincher.

Dorothy Gunther Pugh, in her article on Ballet Memphis points out how they have taken advantage of this as an opportunity to define a unique market niche. There are ballet companies in many small and mid-size cities, companies that have a tendency to be somewhat uniform in repertoire, reputation, and relationship with their communities. Ballet Memphis's community engagement agenda permits it to

form deep bonds within the city and to position itself as unusual if not unique in the pantheon of ballet companies on the national scene.

CHAPTER THREE

OBSTACLES TO CHANGE

If the handwriting on the wall is writ so large, why is there not a massive effort underway—in every arts genre—to transform established arts organizations? To some in the arts community, the status quo of the arts is so ingrained that the notion of broad-based impact is seen as preposterous. The systemic obstacles to significant change in thought about this are substantial.

ARTISTS

Artists, by and large, are trained in their craft, a craft rooted in the arts of Europe, and are not encouraged to think about the relationship of the artistic enterprise with those who are not predisposed to be interested in the art in which they are trained. (There is some evidence of change in this respect in the training of individual artists, but it is to date, neither broad nor systemic in the industry.) As a result, many of them cannot be leading forces for change because they are unaware of the need for change, of examples of what that change might look like, or of the processes by which to make such change occur.

Most artists contend that "The arts are for everyone." is a self-evident truth, a centerpiece of their worldview. However, deep down, a not insignificant number of arts professionals have serious doubts about whether what they do is *really* for Bobbie Sue or NASCAR Bubba. Their in-jokes about the "unwashed" attest to the mindset. This is often buried so deeply that they cannot even admit to themselves it is true. Nevertheless, their ambivalence about whether "high art" can really be appreciated by the masses is readily apparent to those masses. Clearly, if there is among artists even an unconscious sense that the arts are not for everyone, they will not be pressing for change.

And there is a particular artistic legacy that further stands in the way of change. In the Nineteenth Century there emerged in the West the idea of the heroic artist, aloof and disconnected from the concerns of common humanity, answerable to no one but himself. (In the Nineteenth Century it was almost universally *himself*.) This development, a culmination of the specialization of labor transformation discussed earlier in this book, stood the historical relationship between artist and community on its head. Now, instead of being an interpreter of and voice for the community, the

artist became an outsider forging new paths without concern as to who (if anyone) would follow. The artistic merits of this shift are open to lively debate. But the impact on social sustainability (and therefore political and economic viability), as has been discussed here, has been negative. From the point of view of fostering lively, artistically vibrant communities, this has led to a cultural cul de sac.

ARTS SUPPORTERS

Those who support established arts organizations do so, by and large, out of a love for what that organization presents and how it improves their lives. They like things as they are. Change might provide them with less of what they value, and so they have little interest in change. For some arts supporters, the "high arts" reputation as an activity of the elite is a prime attraction. Thus, significantly broadening the base of support for "their" organization would not be an attractive prospect.

ARTS ORGANIZATIONS
Survivalism

Not-for-profit arts organizations are, like nearly all institutions, conservative. There is much invested in the status quo. A frequently heard response to questions about expanding the artistic vision to be more inclusive is that it is barely possible to do what is being done now; there is no way to do anything else. This assumes two things–1) that all the things being done now need to continue being done, and 2) that there are not additional resources that might become available if significant shifts in focus and programming were made. Narrowly focused on institutional survival, there is not a history or habit of arts organizations viewing themselves as members of the community, members with a responsibility to partner with others to improve people's lives. This is particularly unfortunate because community engagement, when properly understood, can be a critical element of long-term survival and can help fulfill the artistic mission.

Governance and Management

All not-for-profit corporations are run, on the policy level, by Boards of Directors. These are made up of community members, but seldom experts in the field, who have an interest in the work of the organization. If artists are not trained in the need for and means to expand the reach of the arts, these volunteers can certainly be excused for having no such awareness.

31

Not-for-profit arts organizations, taken together, are by now an established industry, with a mature national infrastructure. Each arts discipline has its own service organization. These national bodies have a substantial vested interest in the status quo which has made it difficult for them to press for a radical (or even significant) change of focus. However, as will be discussed in this book's conclusion, during the last few years this has been changing.

Similarly, training grounds for arts administrators, whether in higher education or professional training workshops sponsored by arts service organizations, are measured on the success with which they place graduates in positions with arts organizations. This means education/training programs teach to what those organizations want. If training for engagement is not sought, there has been no structural incentive to provide it. Fortunately, here also, change is afoot.

Programming

Arts institutions exist to present art, and established arts organizations, supported by their artists and patrons, present the art that they unconsciously identify as being art. One of the most contentious issues in shifting to a community engagement focus is a perceived threat to the artistic canon. It is feared that engaging with the community might entail shifts in programming away from the core work of the artistic discipline as understood by those involved. It will, but the shift is primarily one of subtle emphasis rather than seismic disruption. It further serves to address unexamined cultural myopia and open up exciting new aesthetic possibilities. (To consider the quality question, see "Quality *and* Community" below.) Arguments for dealing with and processes for managing this concern are covered more fully under Principles of Effective Engagement.

Marketing

The traditional approach to marketing as practiced by arts organizations is the source of this book's title–*Building Communities, Not Audiences*. That approach is one this author calls product oriented. In other words, decision-making is rooted in allegiance to the art, an allegiance greater than any other concern. The demonstration of this is the role of the marketer in arts organizations. In general, the artistic director makes programming choices and presents them to the marketer with instructions to "sell" it to the public. The resulting "If we present it, they will come" approach precludes creative (and non-traditional) programming that might be welcoming to a broader portion of the community while maintaining faithfulness to the mission.

Indeed, the focus is so fixed on responsibility to the art presented that relatively little attention is paid to the interests or needs of the "audience–either traditional or non-traditional. The notion of any parallel responsibility to the community in anything other than a generic sense is often not a routine part of organizational thought.

Traditional Outreach: "For" not "With"

The good news is that most artists and arts organization personnel, when they focus on the topic, are interested in connecting with their communities. Unfortunately, a frequently heard response to suggestions for increasing engagement is "We already do that." *For the record, the number of established not-for-profit arts organizations that are actively engaged in on-going substantive partnerships with members of their communities outside of the arts is tiny.* Most outreach that is undertaken is done "for" the community, assuming that the arts organization understands what art the community needs. To be effective, successful engagement must be done "with" the community, based on reciprocal, mutually beneficial relationships with the organizations or communities being served. Indeed, the very word "outreach" implies an unequal relationship: the "outreacher" is central and those "reached" are peripheral and in need of service.

This is probably as good a place as any to address the idea that arts organizations' offering fundraisers for community groups is community engagement. It is not, at least not as that term is understood here. Fundraisers where some or all ticket or other proceeds are given to a worthy cause are laudable but do little or nothing to develop effective inter-organizational relationships. There is generally no community issue being addressed in such circumstances (although the publicity around the fundraising may slightly heighten community awareness of the cause being supported) and there is generally no substantive engagement or mutuality that develops between the participating organizations. On the contrary, these projects can establish the beneficiary as a dependent. (Exceptions to this exist when the fundraisers grow out of a relationship between the two organizations and include programming and community dialogue about the cause being supported, but such examples are comparatively rare.) Fundraisers are mostly a marketing tool for the arts organization. More tickets are sold as a result of public awareness that proceeds will benefit a good cause. This is cause-related marketing, a worthwhile undertaking, to be sure, but not community engagement to any significant degree.

33

Assumption of "The Given": Resource Limitations and Exhaustion

One of the most common responses from arts organizations to presentations about the importance of community engagement is the truism that every program and management option that can be done is *already* being done simply to keep the doors open. There is no way to do "one more thing." Later, in the chapter Principles for Effective Engagement, the opportunity cost of existing work in the light of the benefits of community engagement will be discussed. The essential point is whether all the things being done are more important to the health and vitality of the organization than working with the community to identify and address its needs.

QUALITY *AND* COMMUNITY

Any discussion of community-focused arts activity sooner or later gets around to the quality vs. inclusiveness argument. The assumption that this is an either/or proposition is damaging to the discussion and to the potential for engagement. High quality work is possible in any cultural expression, context, genre, or medium. The issues are at least three-fold. Who decides what "quality" is, what do we mean by quality, and does the work have realistic access to the resources required to produce estimable art?

For some, there is a fear that if efforts are made to provide arts experiences that appeal to those outside the traditional audience, that effort is pandering–grossly appealing to a lower common denominator. But who gets to decide what "quality" means? Some guardians of artistic purity operate with an unconscious assumption that the reflective artistic expression of Europe is superior to that of other cultures. Fortunately, this argument does not hold up well in the light of direct analysis. It is only the most conservative of cultural critics who persist in this line of reasoning when confronted with the position's implications.

For others, the quality question can reflect an unconscious discomfort with the unfamiliar. Experts in (or knowledgeable supporters of) an established genre of art, when faced with "foreign" art forms, media, and traditions find their expertise (or understanding) called in to question. The result is that they sometimes circle the wagons around the work they know.

The concept of reflective arts is beneficial in that it provides an opportunity to acknowledge a broad range of experiences that feed the soul. The merits of these experiences are not culturally specific. They can be and are rooted in the fabric of every human society. When a work of art–even a manifestly great work of art–does not speak

to a person or group of people, its excellence is not relevant to them. More to the point, excellence is inherent in the best artistic expression of *every* culture.

The notion of what *is* quality is one that gets insufficient consideration. For instance, the arts infrastructure supporting the European cultural tradition today is heavily weighted toward "spectator art." In other words, the quest for excellence (sometimes understood as technical expertise) is so pervasive that most people have been reduced to arts observers. Excellence is important; quality is important. However, participation in the creation and presentation of art is also important. Could not the participatory potential of an art form come to be understood as one criterion (and yes, only one) for quality? An aesthetic that dismisses the value of hands-on artistic expression in one that runs the risk of spiraling toward irrelevance.

Carrying the critique further, Arlene Goldbard provides, in her book *New Creative Community*, a through-the-looking-glass view of the argument. The pursuit of technical excellence can be seen as a means of making art artificial. This artificiality is off-putting to those not part of the cognoscenti, making the art, arguably, *less* valuable as an aesthetic experience. The phenomenon of castrati in 17th- and 18th-century opera demonstrates a telling extreme in the relationship between technique and artificiality. To make the same argument in a different way, home-made or handmade can be seen as providing a richer, more authentic result.

Goldbard also points out that it is the inequitable distribution of resources supporting cultural products, rather than any inherent difference with respect to technique, that is the source of at least some observed deficiencies in quality. How can any artistic expression compete on sheer technical excellence given the resources that have been devoted to the reflective arts of European origin over the last several centuries?

Finally, Goldbard's observation about the value of creating art rooted in everyday life experiences speaks not only to her concern about social justice but to a powerful means of community engagement, a significant path to relevance, and a richly renewable source of artistic inspiration. "[T]o demonstrate that the lives and stories of ordinary people can be the basis for skillfully executed and powerful art works makes a strongly positive social statement." (Goldbard, 55) Again, why can real meaning in people's lives not be *a* criterion for excellence?

Other criticisms of increased attention given to community-focused art include complaints of "income redistribution," threats to political stability (since such art often raises issues that question the political, social, or economic status quo), and undermining the artistic canon. The first argument is, of course, a concern that this

focus will take money away from established arts organizations. The assumption is that established organizations will not be participating in such work and that no new sources of funds (such as donors interested in work that is finally of interest to them) will be created by it. The other two criticisms could be reframed with relatively extreme responses to their basic content. The second could be viewed as one in opposition to democratic principles: "Why should the non-elite have access to artistic expression of their concerns or interests?" And the third could be diminished by the observation that there are broader human truths to be explored and that the Western canon represents a relatively narrow slice of human expression.

As a last practical note, community engagement work is a complex skill. It takes an understanding of principles as well as a good deal of practice to attain excellence in engagement. Artists with great technical skill in their art form who enter the engagement arena without sufficient preparation are going to have mixed results. That is not engagement's fault.

There are legitimate arguments to be made about the quality issue in the area of community-focused arts, though as shown above, they are often not as simple as they appear upon first consideration. Nevertheless, the arts delivery system in the U.S. today represents a *de facto* arts policy inordinately privileging Eurocentric arts. It is a policy that systematically (even if not purposely) excludes much of our population from access to the benefits provided by reflective artistic expression derived from a cultural language with which they are familiar. Providing them with that is not pandering nor is it an inevitable path to inferior artistic product.

The Road to Community Engagement

THE ROAD TO COMMUNITY ENGAGEMENT

Change in the arts is as inevitable as sunrise. Societies, cultures evolve and the arts which spring from them do as well. The question is whether today's institutions that are heavily invested in the arts of the past are capable of similar change, adapting to transformation of the environment and making meaningful connections with their communities.

This would not be an issue were it not for a peculiar and almost entirely subliminal understanding of mission on the part of many arts institutions. For some, there is an unconscious assumption that the primary (if not sole) responsibility of arts organizations is to the art rather than to the community. When consulting with organizations, the one question this author poses as central to the mission is, "How are the lives of members of the community made better by the work that you do?" It is a question that strikes some as odd; others assume it is satisfactorily answered by their organization's role in lending prestige to the community. The latter group is wrong. The question means what tangible (or *direct* intangible) benefit does the work of the organization provide each and every citizen of their community.

On the practical side, almost all of the income problems (lack of government money, lack of private donations, lack of corporate support, lack of ticket revenue) faced by arts organizations would be solved overnight if every person in a community had a conscious awareness of how their life was made better as a result of the programming offered by the museum, the theater company, or the dance troupe. That is not the case *not* because of poor marketing or public relations but because of an inward and myopic focus on the part of many arts organizations. Few established arts organizations are making the development of vital, mutually-beneficial relationships with the broad base of their communities central to their mission.

Theory and Process of Engagement

A CONCEPTUAL FRAMEWORK FOR COMMUNITY ENGAGEMENT

Fortunately, many members of the arts community care deeply about not only their art but about the well-being of the members of their community. Unfortunately, their passions are so firmly held they believe that they are already doing all that needs to be done or that a simple tweaking of their activities will accomplish what is being suggested here.

That is not the case. For many in the broad population of our country, the reputation of not-for-profit arts institutions is elitist, insular, out-of-touch, and irrelevant. Insofar as those institutions have not made community involvement a core element of their mission, they are not wrong. Nothing short of a radical transformation of the way arts institutions relate to their communities will suffice to convince the person on the street that established arts organizations matter in their lives.

The Los Angeles Poverty Department is a theater company of, by, and for the homeless. Homeless men and women write scripts telling their stories and perform them in the community. The experience imparts value to their lives in a way that society has not done otherwise and allows those of us who normally avoid them to gain insight into the causes and experience of being homeless.

For many in the arts community, merely hearing the description of LAPD is transformative. It is a venue for reflective arts that values a population never considered a "target audience," and it is an example of the arts having a direct social relevance. LAPD is not necessarily an example to be emulated. It is rather the demonstration of a radically transformed way of thinking about the relationship between the arts and the community that can break a conceptual logjam about the arts.

The first step in the process of creating a more responsive arts organization is arriving at internal consensus that the organization *should* be an active participant in the life of the community. This is *the* fundamental issue being addressed here. Some believe the prime responsibility of the arts organization is to the art genre or style or even specific works. For them such a shift in focus would be anathema. But, based on the material already presented, if arts organizations are to remain viable through this century such a shift must take place.

After agreement is reached on this issue, there are a myriad of options available through which arts organizations can become and be seen as vital partners in healthy communities. No organization need (nor can) undertake them all. Ideally a community's arts organizations would come together, discuss the many options, and undertake, individually and collectively, to address as many of them as possible.

CATEGORIES OF COMMUNITY INVOLVEMENT

The remainder of this chapter is divided into two broad categories of community engagement work. The most obvious is arts-based programming, programming that is built around or uses the arts discipline of the organization. The subcategories–economic development, education, and community building–present selected modes through which arts institutions can make a positive impact upon communities. "Economic Development and the Arts" by Tom Borrup and Stephanie Moore introduces the ways the arts can participate in economic development. It sets out a framework for understanding the broad range of options through which cultural activities can be a significant force in enhancing the economic well-being of communities. "The Arts and Education" and "Community Building and the Arts" serve a similar role for their respective topics. These are not exhaustive and are meant only to stimulate thinking about new (or enhanced) roles for arts organizations. The second category reflects an interesting approach supported by the Ford Foundation's Shifting Sands Initiative. The premise of that program was that arts organizations could engage with their communities simply by being "good neighbors," providing space or expertise to a neighborhood or city as needed, in ways not directly related to the arts the organization existed to present. This category is headed below as "The Arts as Community Citizen."

THE INTRINSIC/INSTRUMENTAL DEBATE

Before presenting them, however, it may be worthwhile to address an on-going debate in the arts community. The RAND Corporations' 2005 report, *Gifts of the Muse*, contained a critique of the way that the arts had begun to be "sold" to the public, particularly to funders. It discouraged focus on "instrumental" benefits (like economic development and improved test scores for students) as opposed to "intrinsic" benefits (like pleasure and "expression of communal meaning.") The principal difference between the RAND report and the analysis contained here is that *Gifts* takes arts organizations' current activities and orientation toward communities as a given and discusses the most productive ways to "make the case" for arts support. The concern here is in advocating for a transformation of those activities and that orientation. This

is not about the most effective means of marketing the arts to the community; it is about the most effective way of *being* in the community.

ARTS-BASED

ECONOMIC DEVELOPMENT AND THE ARTS
by Tom Borrup and Stephanie Moore

INTRODUCTION

Economic development is not limited to work in the for-profit sector; it also includes the not-for-profit and public sectors. The arts play a vital role in maintaining economies and revitalizing cities around the world. This article focuses on eight major strategies for sustainable development that illustrate how arts and cultural organizations can boost economic vitality.

All of these strategies are part of the economic development discussion. However, two listed below are typically left out and must be part of the dialogue. Both Strategy 2: Create and Enhance Identity and Strategy 3: Build Capacity/Social Capital are important when a community is working towards sustainable revitalization. These components of the economic development ecosystem focus on fostering an environment supportive of getting the work done. When a community-based project draws on the unique identity and the networks already present it becomes a part of the community. The sense of place and essential partnerships that come from these strategies can promote a diverse economy that is supported by all citizens. In short, people have to feel part of a collective identity and be able to work together for a local economy to succeed.

For each of the eight strategies, one case study is offered to illustrate methods used in the United States. The communities featured vary in size, demographics, economic status, and geographic region and represent a wide range of projects. It is important that these examples not be seen as models to be replicated. Each locale should employ strategies that match the community's unique assets, capacity, size, and needs.

Viewing these projects through only one strategy is limiting, it does not show the full impact on each community. All of the case studies affected their communities in multiple ways, building both economic and social capital. In illustrating the eight strategies we'll look at one specific impact and indicate other significant outcomes, where appropriate.

Figure 1, Economic and Social Capital Development Strategies, outlines the eight strategies and the examples that illustrate them. The variety of methods and tools used

and the diversity of communities profiled was intentional. The goal of this chapter is to help you understand ways to think about how arts initiatives make an impact on a community and to show that wherever you are, you can develop, plan, and implement an economic development strategy for your community.

FIGURE 1. ECONOMIC AND SOCIAL CAPITAL DEVELOPMENT STRATEGIES

1 **Create Jobs:** *Nurture artists and small cultural organizations as businesses and microenterprises to increase employment*
Greenpoint Manufacturing and Design Center, New York, NY

2 **Create and Enhance Identity:** *Develop civic pride and responsibility through good "place-making" and community-centered arts practices*
HandMade in America, Asheville, NC

3 **Build Capacity/Social Capital:** *Strengthen connections between neighbors, cultural organizations, and businesses through collective cultural experience*
Swamp Gravy, Colquitt, GA

4 **Stimulate Trade and Tourism:** *Create the right conditions for, and engage in, cultural tourism to bring new resources to the community*
Boyne Apetit, Boyne City, MI

5 **Attract Investment:** *Support artists and artist live/work spaces as anchors around which to build local economies*
Artist Live/Work Space in the Downtown Arts District, Pawtucket, RI

6 **Diversify Economy:** *Focus or cluster arts organizations as retail anchors and activity generators to attract and support other enterprises*
Massachusetts Museum of Contemporary Arts, North Adams, MA

7 **Enhance Value:** *Leverage the proximity of cultural amenities and the artists' touch to improve property and increase its value*
Paducah Artist Relocation Program, Paducah, KY

8 **Retain Wealth:** *Support local artists and business owners to keep dollars in the community*
BUY ART Program, Providence, RI

1 2 3 4 5 6 7 8
CREATE JOBS

The arts and culture sector has rarely been thought of as a major economic sector

in the US. However, this sector contains a large amount of a community's workforce: the arts and culture sector employs 5.7 million full-time equivalent positions. Individual artists and nonprofit cultural organizations should be recognized as small businesses that provide significant employment within communities. Small businesses employ more than half of private sector workers. They are more innovative than many larger firms. Small businesses are also faster growing than larger firms, creating over 60 percent of new jobs between 1993 and 2009 (Small Business Administration, 2011). Having a vibrant arts and culture district supports nearby business. Studies from Americans for the Arts show that the nonprofit arts industry generates $166.2 billion in annual economic activity (Americans for the Arts, 2007). This number only covers formal arts institutions, not individual artists or collectives. This economic impact is not only from ticket and art sales, but also from restaurant, hotel and small business purchases related to those expenses, i.e., a couple buys tickets to a show, hires a babysitter to watch their children, has dinner at a local restaurant before the show and drinks and dessert after the show.

Artists and small cultural groups are naturally micro-enterprises. The pure entrepreneurial spirit of artists in producing and marketing their own works makes them a large economic force within a community. Artists work either individually or within collectives to produce work and then market and sell that work either individually or through small businesses and nonprofits. There are various groups that work to ensure that artists and small businesses receive affordable, flexible workspace.

The case study that follows is one of many that create jobs by repurposing old buildings and providing stable and appropriate space for artists and creative entrepreneurs. The Greenpoint Manufacturing and Design Center in New York City has been rehabilitating manufacturing buildings for occupancy by small manufacturing enterprises, artisans, and artists.

NURTURING ARTIST ENTERPRISES
THE GREENPOINT MANUFACTURING AND DESIGN CENTER
NEW YORK CITY, NY
www.gmdconline.org

Setting

Greenpoint, and other areas of Brooklyn, contain enormous buildings that once housed "smokestack" industries. Many had become vacant or substandard work and living spaces. With older, noisy, and often polluting industries relocated away

from population centers, these buildings and neighborhoods were ready for a new life. GMDC started in the late 1980s to reclaim derelict factories and sustain newer industries and manufacturing in New York City. GMDC's buildings can be found in the North Brooklyn Industrial Business Zone (IBZ) and the East Williamsburg Empire Zone where the city offers tax credits, energy discounts, relocation, and other benefits to the manufacturing and industrial companies within the IBZ; the East Williamsburg properties are also eligible for state business incentives. Both of these locations ensure the stability of manufacturing businesses within mixed-use environments by protecting them from displacement and the increasingly volatile real estate market.

Organization Description

The Greenpoint Manufacturing and Design Center (GMDC), a nonprofit industrial development company based in New York City (NYC), rehabilitates abandoned manufacturing complexes for occupancy by artists, artisans, and small manufacturing enterprises. Since its formal incorporation in 1992, GMDC has renovated six buildings in North Brooklyn and currently owns and manages five of these properties representing over half a million square feet of studio and retail space. More than 500 people are employed by the 100-plus businesses that reside within these properties.

Current tenants include artists, woodworkers, fabric/cloth manufacturers, and interior designers.

Mission or Statement of Purpose

GMDC works to position itself through research, conference presentations, and other marketing efforts as a national model that can be replicated in other cities. They believe that keeping light manufacturing and artisans in American cities is essential to the sustainability of creative, mixed-use neighborhoods. They are committed to helping small business owners develop and flourish their creative passions in NYC.

Goals and Strategies

The GMDC creates and sustains working manufacturing sectors in urban neighborhoods in NYC by rehabilitating buildings, planning mixed-use communities, and working with small business owners on various other projects. Their primary roles are to:
- Lease studio and retail space to small businesses in rehabilitated warehouse buildings
- Work closely with small businesses as a financial intermediary

45

- Advocate for innovative coalitions and collaborations among diverse stakeholders
- Lobby for policy and the allocation of resources to ensure a positive environment for light manufacturing
- Act as a model for urban manufacturing by offering assistance to other communities interested in creating a mixed-use environment and presenting work through publications and presentations nation-wide

GMDC allows small business owners to focus on their creative endeavors and on building collaborations by acquiring, renovating, and developing a mixed-use community of affordable and flexible production space. They have been able to influence the use of abandoned "smokestack" properties and drive the need for mixed-use communities through their mixed funding system, engaging staff and stakeholders in the design and renovation of properties, and marketing these new production spaces to small creative enterprisers throughout NYC.

Assets Employed (The Greenpoint Manufacturing and Design Center, 2011)
- Presence of artists and small and mid-sized artisan businesses
- Vacant manufacturing buildings suitable for retail, light industry, and studio space
- City tax credits, energy discounts, relocation, and other benefits to the manufacturing and industrial companies within the North Brooklyn IBZ
- In East Williamsburg, state business incentives

Direct Outcomes (The Greenpoint Manufacturing and Design Center, 2011)
- GMDC has rehabilitated six North Brooklyn manufacturing buildings
- GMDC owns and manages five of these properties
- Space totaling more than a half million square feet
- Over 100 businesses reside in their properties
- More than 500 people are employed in these businesses
- Push a mixed-use agenda through funding, building design, and renovation at the city and state level
- Indirect and Potential Outcomes
- Development of a more socially connected commercial corridor
- Innovative business ideas used to create more jobs for cultural entrepreneurs
- Development of walkable mixed-use neighborhoods with jobs, residences, retail, and services

Summary

The Greenpoint Manufacturing and Design Center employed their assets to engage the entrepreneurial drive in the city. They built "ownership" for artists and small business owners. This case study illustrates the opportunity vacant warehouses offer artists and craftspeople within a city and how those mixed-use spaces are a key to creating jobs and diversifying the economy.

1 **2** 3 4 5 6 7 8
CREATE AND ENHANCE IDENTITY

Creating or enhancing a community's identity can be a great way to engage citizens in the life of their community as well as bring others into the community. This strategy builds on the idea that every community has its own unique identity hidden away that simply needs to be uncovered.

When a community comes together to find its identity they learn the importance of local customs, traditions, and organizations that are part of the status quo. Building community identity can lend an air of authenticity to objects that are produced there as well as creating "ownership" of the place. The assets can then be leveraged to attract new residents, visitors, and businesses.

Connecting local businesses and individuals can also help build clusters of activities, which can lead to historic districts, arts districts and main street neighborhoods. All of these clusters can then be used to promote the neighborhood or town as a destination for all.

The local customs and traditions include the heritage of the people within the community. This heritage not only comes from the stories, music, and customs passed down through generations, but also the culinary traditions of the community. The culinary arts are a growing part of the cultural sector where chefs are also known as artists. Specifically, food has been recognized as a form of both the visual and performing arts. Adria, Blumenthal, Keller, and McGee (2006) stated, "The act of eating engages all the senses as well as the mind. Preparing and serving food could therefore be the most complex and comprehensive of the performing arts." Just as other forms of art, the culinary arts are a critical part of many ethnic traditions and should be considered part of every community's cultural identity.

The following case study of Boyne Apetit outlines how a small Michigan town used their assets to create a unique identity combining their restaurant, farming, and outdoor recreation industries. Focusing on the long-standing local farming

community, Boyne Apetit, encourages residents and tourists to sample their unique fare at multiple restaurants and markets.

The following case study of Boyne Appétit outlines how a small Michigan town used their assets to create a unique identity combining their restaurant, farming, and outdoor recreation industries. Focusing on the long-standing local farming community, Boyne Appétit, encourages residents and tourists to sample their unique fare at multiple restaurants and markets.

ENHANCING LOCAL IDENTITY
BOYNE APPÉTIT
BOYNE CITY, MI
gov.boynecity.com

Setting

Boyne City is located at the southeastern end of Lake Charlevoix, a 20-mile-long lake extending from Lake Michigan in the northwest part of the State. About 60 miles north of Traverse City, and 70 miles south of Mackinaw City, Boyne City and its historic downtown is five miles off US Highway 131. Sitting back from the highways makes Boyne City a purposeful choice by travelers; not one found by passers-by. Boyne Mountain and Boyne Mountain Resort, a major ski, golf, and waterpark resort with year-round activities, can be found nearby. This resort is surrounded by extensive vacation home development that draws a steady stream of tourists to the area, of which only a few find their way to Boyne City.

Among other important characteristics of the area is a mixed economy of diverse products and services, founded and operated by local entrepreneurs, some of whom have extended their specialty markets nationally and internationally. As a result, a strong creative community, a flourishing restaurant scene, and a highly regarded farmers market are prevalent in Boyne City. These attributes provide a competitive advantage to the Boyne City Brand.

The Creative Food Experience, outlined in the Dreeszen & Associates report (2009), develops and connects Boyne City's strengths, creative assets, and identity to produce a unique brand. The culinary arts, including signature creative and handmade foods along with the marketing and production abilities in Boyne City, push the agenda of a unique culinary experience as a means to enhance the community's identity and economy.

Organization Description

The Boyne City Main Street Program and other community leaders initiated the Boyne Appétit project. It is a response to a Community Economic Development Plan completed in January 2011. This economic development plan included five major goals to diversify Boyne City's economy:

1) Position Boyne City as the 'go-to' place for unique and creative regional food experiences and 'take-home' food products.

2) Maintain and build on the vitality of the Historic Downtown and lakefront.

3) Create a favorable working environment for traditional and creative artists and performers, as well as craftmakers and food producers in all forms.

4) Promote the area's natural environment and outdoor recreation opportunities as a draw for visitors and as quality of life amenities for residents.

5) Improve communication, coordination, and effectiveness of local development efforts. (Dreeszen & Associates, 2009).

The Boyne City Main Street Program follows the national "Main Street Four-Point Approach" for revitalization developed by the National Trust for Historic Preservation. This approach focuses on four points of revitalization including design, economic restructuring, organization and cooperation of businesses, and promotion of unique attributes within a neighborhood. In Boyne City a volunteer-driven program centers on the preservation and economic development of the downtown area.

Mission or Statement of Purpose

Boyne City is known for its culinary offerings. Community members take pride in their wide-array of food related businesses and festivals. Innovative restaurants featuring wild and homegrown, prepared and packaged foods, the National Morel Mushroom Festival, and the annual Farmer's Market are part of the fabric of this community. The region around Boyne City is also full of specialty regional food producers and accessible outdoor spaces for people to enjoy the natural beauty of the area. The Boyne Appétit program is focused on making Boyne City the go-to culinary destination in Michigan where food, the outdoors, and the arts can all be enjoyed together.

Goals and Strategies

Positioning Boyne City as the 'go-to' place for unique and creative regional food experiences and 'take-home' food products takes the effort of many community

members and the collaboration of all food industry organizations. The strategies to reach goal include:

- Attract new and repeat visitors and enhance their experience through foods and a more complete creative/cultural experience by promoting local "celebrity" chefs, partnering live music and art with culinary experiences, and organizing food and culinary arts tours of the region
- Leverage marketing and event-producing talents to produce a showcase Expo for local and regional food industry organizations and personnel including specialty foods and products
- Support the continued growth of the Boyne City Farmer's Market into a year-round event and build stronger networks between farmers and chefs in the region
- Develop additional local specialty food products
- Create a test kitchen for culinary exploration through education about locally grown food products
 (Dreeszen & Associates, 2009).

Assets Employed (Dreeszen & Associates, 2009).
- Abundance of farm and food related businesses
- Natural environment including the Lake Charlevoix waterfront
- Multiple events coordinated by volunteers and a network of civic organizations resulting in various annual festivals, a farmers market, and weekly seasonal events including the National Morel Mushroom Festival
- Community residents who "step up" and have a positive attitude about contributing to the community
- The small town feel and sense of pride in the community, including a friendly ambience, spirit of cooperation, and progressive attitude where people and ideas matter
- Boyne Mountain Resort, the third largest resort network in North America, represents a massive marketing and promotional machine relative to local natural assets as well as visitor opportunities and accommodation

Direct Outcomes (Dreeszen & Associates, 2009).
- Attract tourists to the region for food and culinary arts related events and vacations
- Develop a sense of local pride around the culinary arts

- Build a stronger farmer's market structure to lengthen the selling season
- Generate new jobs and new income; support existing and spark the creation of new cultural related businesses
- Reinforce what people value about Boyne City, improve the quality of life and increase year-round residency
- Foster a healthy intergenerational environment; attract retirees, youth, and people of all ages
- Strengthen the civic fabric of the community; support education, cultural, and social life
- Build on the unique qualities of the community; promote its creative, historic, and natural assets
- Indirect and Potential Outcomes
- Build a larger tourism industry that promotes the unique blend of Boyne City assets
- Enhance Boyne City's reputation as a foodie haven
- Attract visitors from the Boyne Mountain Resort to enjoy the nearby town
- Grow environmentally friendly enterprises, activities, and practices; build bridges to the ecological/green future.

Summary

Boyne Appétit is a program that takes the culinary, creative, and recreational assets of Boyne City and uses them to strengthen local identity. This identity gives the community a unique place in the region and promotes their love for the culinary experience. By enhancing this identity, the Boyne Appétit program engages community members by allowing them to promote their hometown chefs and products at festivals and events. This engagement builds networks and partnerships that enhance Boyne City's economy and quality of life.

1 2 **3** 4 5 6 7 8

BUILD CAPACITY/SOCIAL CAPITAL

Engaging and connecting people through collective experiences is something the creative sector can easily accomplish. This strategy focuses on the positive impact collaboration can have within a community. Building social capital is necessary to get people working together across sectors, creating the synergy among businesses that leads to economic growth. Social capital is characterized as networks of trust and reciprocity and the benefits from these partnerships (Putnam 2000). Building a

network of local organizations creates a sense of belonging to the community and an opportunity for continued learning and growth. Partnerships also enable organizations to share knowledge that can improve their day-to-day operations, in turn allowing them to work more efficiently toward their goals.

When people from many different social and ethnic groups come together there is always an opportunity for mutual growth as well as a greater likelihood of innovation. Engaging various demographics in a collective project focused on their shared environment can build social networks that had never before been conceived. This collaborative experience can help people understand how important everyone's story is in their community's unique identity, giving all residents a sense of ownership of and pride in the community as well as more civic responsibility. Together, they can arrive at ideas and create activities and goods not imagined before.

In the small town of Colquitt, GA, Swamp Gravy encourages people to work together. This project has enabled artists, residents, and business owners to collaborate on new levels to create a community built on creativity and respect.

STRENGTHEN CONNECTIONS
SWAMP GRAVY
COLQUITT, GA
www.swampgravy.com

Setting

Colquitt, GA is a rural farming community in Miller County. The peanut industry, farming and processing, along with textile manufacturing stimulated the region's economy until the mid-1980s. As both of these industries faltered, the residents of Colquitt found themselves with lower than average incomes and a struggling downtown unable to support businesses.

In 1991, founder Joy Jinks met Richard Owen Geer in New York City and together they developed what would be known as community performance theater. Volunteers began collecting stories from the people of Colquitt, GA. Stories were passed on to Jo Carson who adapted some of them into the play while Karen Kimbrel wrote the song lyrics and Steve Hacker the music. Since its inception, the play has been performed in the Cotton Hall Theater, part of a cotton warehouse that was renovated in 1995 and also houses the Colquitt Miller Arts Council and a Storytelling Museum.

The Colquitt Miller Arts Council (CMAC) was founded as a grassroots initiative to foster and sustain the economic growth of the region. Including annual productions

of *Swamp Gravy*, a folklife play written and acted by local residents, the council has produced CDs of local music and published oral histories of local communities. They also offer scholarship assistance for attendance of programs and workshops to underserved populations throughout the community ensuring full community engagement.

CMAC offers many programs to the community and tourists, including Swamp Gravy, CMAC Youth Theater, The Storytelling Museum, Market on the Square, May-Haw, Grassroots Arts Program, Swamp Gravy Institute, New Life Learning Center, Millenium Mural Project, Global Mural Conference 2009.

Mission or Statement of Purpose

Swamp Gravy has always been recognized as a tool for cultural and economic revitalization. As director Richard Owen Geer began to work with the residents of Colquitt he realized the importance of this project to restore the cultural identity of the community. It also became a way for residents to engage in dialogue and art-making about the historical conflicts and issues that had separated them. *Swamp Gravy* has connected local citizens from diverse economic, social, and ethnic backgrounds in theater making and continues to teach acceptance and understanding through its multiple performances, storytelling workshops, and outreach programs.

Goals and Strategies

Swamp Gravy began as a vehicle for civic engagement as theater director Geer and other scholars trained Colquitt citizens to take and transcribe oral histories. The stories gathered by local residents became part of the final play giving it authority and allowing the play to express local knowledge. During this initial process the community disagreed with many of Geer's artistic preferences and outsider aesthetics. (Animating Democracy) As the project evolved, Geer took more direction from the actors and created a safe environment for community members to interact during rehearsal and performances. This project has deepened community pride in Colquitt and has now been replicated around the United States.

Assets Employed (Borrup, 2006)
- Oral histories of Colquitt, GA and Miller County residents
- The entrepreneurial spirit of community leaders and creative professionals
- Renovated abandoned warehouse space in Colquitt
- History of storytelling in the area

Direct Outcomes (Borrup, 2006; Lambe, 2008)
- Strengthened partnerships between businesses and the creative sector
- Generated revenue through diverse methods, including a larger tourism industry
- Engaged all Colquitt and Miller County residents in the writing, acting, and producing of a theatrical performance
- Educated residents and others of the history of Colquitt, GA as seen through residents eyes
- Since it began in 1993, Swamp Gravy has sold over 120,000 tickets and generated more than $4 million for Miller County
- The Miller County Arts Council has reinvested over $1 million into downtown revitalization efforts

Indirect and Potential Outcomes
- Build bridges between various demographic populations: intergenerational, economic class, social class, religious, and ethnic background
- Strengthen the identity of Colquitt, GA
- Promote equality among residents

Summary
Since Swamp Gravy began in 1991 it has strengthened the social capital of Colquitt, GA by creating collaborations throughout the community and engaging residents in the act of producing theater. This play has engaged diverse residents in dialogue about their community and the unique stories that built their town. Swamp Gravy is a community-based theater program that promotes storytelling, develops cultural understanding, and creates a safe space for education. As a method of building social capital, Swamp Gravy has proven that theater can cross boundaries and heal a city. The spillover of this new creative and collaborative energy has also left a significant mark on the physical and economic vitality of the community.

1 2 3 **4** 5 6 7 8
STIMULATE TRADE AND TOURISM
This strategy focuses on creating favorable conditions for and engaging in cultural tourism to bring new resources to the community. However, the side benefits of a tourism campaign can be just as important: building a unified identity and increasing

cross-sector and cross-business partnerships. This section presents some of the trends in the growing industry of cultural tourism.

The travel and tourism industry in the United States accounted for over $700 billion and directly funded 7.4 million jobs in 2009 (US Travel Association). This is one of the largest industries in the US today as 1 out of every 9 jobs depends on the travel industry.

When choosing a destination for leisure travel 16% of Americans find that a place with interesting culture is extremely important to them. Other important considerations included historic attributes (13.7%) and Museums (8.6%) (National Association of State Arts Agencies, 2009). The figures below are some of the answers from the 2009 State of the American Traveler Survey. American adults were asked where they traveled in the last 12 months:
- Visit an historical place or attraction **42.3%**
- Visit small towns/villages **41.2%**
- Sightseeing in rural areas **39.1%**
- Visit a state or local park **27.8%**
- Drive a designated scenic byway **24.9%**

Cultural tourism is effective when it emphasizes an authentic community identity. When the basis of the campaign is genuine heritage instead of superficial marketing, people will seek it out, and those individuals tend to have more respect for the community they are visiting. Another important side benefit of cultural tourism is the cross-sector collaborations. Combining assets from multiple organizations, i.e. social capital, stimulates ownership of the community. This cooperation tends to lead towards a sustainable tourism program.

Western North Carolina has done an excellent job of creating a bustling tourist economy over the past 20 years. Through the efforts of Handmade in America, a nonprofit organization founded in Asheville in 1993, Western NC has become the center of the handmade craft movement in the US.

CONNECTED BY CULTURE
HANDMADE IN AMERICA
ASHEVILLE, NC
www.handmadeinamerica.org

Setting

HandMade in America is based in Asheville, NC and works in twenty-three

counties throughout Western NC. Nestled in North Carolina's Blue Ridge Mountains, HandMade helps promote small towns throughout the region. Instead of simply passing through the mountains, visitors are encouraged to stop and enjoy the cultural offerings throughout Western North Carolina.

Organization Description

Handmade in America began in 1993 and got its start when it received a three-year organizational development grant from the Pew Partnership for Civic Change. A regional planning process including almost 400 citizens helped determine how HandMade could establish the region as the home of the handmade object in the US.

HandMade developed various programs to help ensure their mission including the Appalachian Women Entrepreneurs (AWE), a support program for Western North Carolina female small business owners; the Small Town Revitalization Program to help residents revitalize the physical and civic infrastructure within their community through asset-based planning and community-driven methods; Craft Across the Curriculum, a program that connects teachers and local artisans; the Craft Architecture and Design program for craftspeople who produce custom architectural designs and building contractors; and finally the HandMade Institute offers consulting services on arts and revitalization throughout the region.

Mission or Statement of Purpose

HandMade in America's mission is to ensure the growth of handmade economies in Western North Carolina. Through craft, cultural heritage, and other community assets they work to build a flourishing region focused on the unique cultural assets including the people and spirit of the community.

Goals and Strategies

Guiding Principles (As found in HandMade in America, 2011)

- The handmade object and the artists who create it: Craft is an integral part of economic development. The creation and appreciation of the handmade object is transformative to individuals and communities.
- Cultural heritage: Honoring arts, artists and cultural traditions in a region preserves and enriches community life.
- Sustainable development: The people in communities serve as the best resource to understand their challenges and opportunities and to seek and find solutions.

- Inclusion: It is vital, and all are welcome to participate.
- The regional approach: All communities come to the table with distinct assets and the opportunity to contribute and learn together across perceived boundaries.
- Partnerships: People, the communities and the region are best served by individuals and organizations working cooperatively.
- Innovation: Creativity is essential in finding and implementing workable solutions.

Assets Employed (Borrup, 2006; Davé, Evans, & Stoddard, 2008)
- Industry of craft artists working in studios, classrooms, and galleries throughout the Blue Ridge Mountains
- Some of the oldest, grandest mountains in the world
- Biodiversity hotspot
- Some of the most creative craft artists in the nation

Direct Outcomes (Borrup, 2006; Davé, et. al, 2008)
- An economic impact study conducted in 2008 revealed that craft-related activities had a total $206.5 million economic impact on the region
- Of the $500,000 gross sales from Western NC's 130 craft retail galleries, 62% of sales are to tourists
- Galleries offer works from over 90 local craftspeople
- Craft-related activities bring over 500,000 out of a total 21 million yearly visitors to the Blue Ridge National Heritage Area
- A clean and sustainable industry vibrant in the region
- A public education about the history and heritage of Western NC
- Enhanced learning for local primary and secondary school students

Indirect and Potential Outcomes
- Builds partnerships between local businesses to promote the regional identity
- Develops large-scale craft events that promote a diverse economy

Summary

HandMade in America exemplifies this strategy–Stimulate Trade and Tourism–through it's focus on promoting the craftspeople found in Western North Carolina. By marketing and promoting the unique craftspeople in the region, HandMade

encourages tourists to visit local studios and craft galleries throughout the Blue Ridge Mountains. This encouragement generates tourism revenue that stays in the region and that directly supports the artisans who are the tourism attraction.

1 2 3 4 **5** 6 7 8

ATTRACT INVESTMENT

Attracting investment to the community can be done through many incentive programs started by the city council, established arts organizations, businesses, or citizen-run organizations/associations. Programs can include business incentive programs, artist relocation programs, and historic and arts districts among others with both tangible and intangible results. The case study for this section demonstrates all of these types of programs and how they can be successfully run.

Working to attract businesses and artists to an area must also include a system to attract citizens to live in and around these areas. One way to ensure this is to create live/work spaces and to convert upper floors of retail spaces into condos or apartments, giving artists a place to live. This process is cyclical and includes continual marketing on both how attractive the area is for businesses and what unique opportunities there are for living within this area.

The following case study illustrates the connection between city engagement in the creative sector and attracting investment to a community that has recently deteriorated. Pawtucket, RI created incentives for artists and businesses to move back into the community, in turn creating a vibrant community that attracted other arts organizations and businesses to relocate to the area.

ARTIST LIVE/WORK SPACE IN THE DOWNTOWN ARTS DISTRICT
PAWTUCKET, RI
www.pawtucketri.com

Setting

Pawtucket is an industrial city founded in 1671 on the Blackstone River and the upper tidewaters of Narragansett Bay. The river powered the many mills that popped up during the industrial revolution which have closed as the economy shifted away from these industries. These buildings became prime space for the city to use in revitalization efforts.

Pawtucket began attracting artists because of this program and its affordability. Rental rates are extremely competitive including studios for about $5 per square foot

that would cost about $12 to $18 in Boston's South End. The location of the city also became an asset, encouraging artists to live within a quick drive to both Boston and Providence.

Organization Description

In 1998, at the request of local civic leaders, the Rhode Island state legislature created an arts district in Pawtucket, with no state sales tax on purchases of art if artists lived and worked in the space. Then a restaurant loan program was developed including loans to bring fire code compliance and creating zoning districts that included the mill overlay district to allow mixed use–live, work, retail. A citizens' board, along with city officials, oversaw these changes.

Abandoned mill buildings, totaling about 1.5 million square feet, have been renovated into live/work spaces for artists. There are now hundreds of local artists living in the historic district. Other mill buildings have been redeveloped into condos and market rental apartments for arts and non-arts professionals.

Along with creating artist live/work space Pawtucket has renovated space for arts education and arts presenting organizations. An important step in revitalizing the historic downtown has been the renovation of the 106-year-old Pawtucket Armory. The Pawtucket Armory Association (PAA) with the support of Mayor Doyle revitalized the armory structure into a regional performing arts center, Pawtucket Arts Exchange, which is now a vital part of the city's Arts & Entertainment district.

Mission or Statement of Purpose

Pawtucket civic and cultural leaders were attempting to revitalize downtown through the arts. Creating an arts district with financial incentives for artists and arts organizations as well as renovating the Pawtucket Armory into a performing arts center has encouraged other arts organizations and businesses to move into the historic downtown area.

Goals and Strategies

In creating a space where cultural events and artists thrive, Pawtucket undertook a series of strategies to attract investment to the area. The city:

- Developed an arts district that is exempt of state taxes on sales of original works
- Created a dedicated arts advocate position in the Office of Cultural Affairs

59

- Promoted the assets currently found in the city that were of interest to the creative class
- Used the vacant mill space to create live/work space for artists and small businesses

Assets Employed (Weiss, 2008)
- Abandoned mill buildings throughout the city
- Proximity to Boston and Providence
- Vacant gothic Pawtucket armory building
- Numerous civic and cultural leaders engaged in creative economy development
- Artists living in and around Pawtucket
- Flexibility in city codes for restaurants

Direct Outcomes (Weiss, 2008)
- 15-20 abandoned mill buildings have become artist's live-work spaces
- City codes have been changed to allow restaurants in the Downtown Arts District
- The Pawtucket School Department has opened the first statewide arts high school in the Pawtucket Armory
- The Sandra Feinstein Gamm Theatre and All Children's Theatre has relocated to Pawtucket
- Indirect and Potential Outcomes
- Reinvigorated community and civic pride
- Encouraged businesses and restaurants to move back into the city

Summary

In Pawtucket, city officials worked to revitalize the economy by encouraging artists and arts related businesses to relocate to the area. This project included offering state tax incentives to artists and changing the zoning codes for mill properties along the riverfront and in the downtown core. Through these changes artists and arts organizations have created a thriving cultural sector in Pawtucket.

1 2 3 4 5 **6** 7 8

DIVERSIFY ECONOMY

This strategy represents the creative sectors' use of the economic goal of diversification. With a wide variety of industry types in the local economy, a community

is more resistant to an economic downturn. To ensure diversity, it is most effective to tap existing assets in the community as the basis for a broader economic base.

Roberta Brandes Gratz, an urban and historic preservation activist and writer, has recorded many successful urban development projects that all hinged on the idea of "thinking small in a big way" (Borrup, p. 53). These projects, including Savannah's Victorian District and Seattle's Pioneer Square District, distributed the economic benefits throughout the community and also retained and built upon existing social connections and networks (Gratz, 1990). They were first and foremost about strengthening the community, not about the typical big-fix projects that focus on bringing in outside investors and large chain stores. This emphasis on community building first and economic development second yields more vigorous, sustainable economic results.

Cultural workers can begin diversifying the economy by building connections between sectors in their communities. The civic, business, and cultural sectors can come together to create interdependent economic networks. The following case study of the Massachusetts Museum of Contemporary Art shows how a cultural organization can advance a diversified economy. The opportunities offered through MASS MoCA's economic development programs allow local businesses to be part of the creative and innovative community within MoCA's mill complex.

BUILDING CROSS-SECTOR CONNECTIONS
MASSACHUSETTS MUSEUM OF CONTEMPORARY ART
NORTH ADAMS, MA
www.massmoca.org

Setting

MASS MoCA is located in a renovated mill complex in the downtown of North Adams, MA. The mill was built in 1860 for Arnold Printworks, which closed in 1942. Sprague Electric Company used the complex for many years, leaving it vacant for more than a decade before the opening of MASS MoCA.

In 1986, a year after the Sprague Electric Company vacated their warehouse in North Adams, leaders in the city were trying to come up with an innovative use for the building. They found this use when Mayor John Barrett III suggested it be given to the Williams College Museum of Art to exhibit large contemporary works of art. Joseph C. Thompson, from Williams College, led this mill complex through the multi-million dollar renovation process into what is now MASS MoCA. Two years later after

the Massachusetts legislature announced support for the project despite economic issues the community and private sector joined in the fundraising efforts raising $8 million to ensure its success. In 1999, after multiple feasibility studies and economic setbacks MASS MoCA opened its doors. Since then it has become a major factor in the revitalization of the North Adams economy and another important cultural amenity in the Berkshire region. Also located in the Berkshire region are the Jacobs Pillow Dance Center, and the Clark Art Institute, among others, that draw visitors from New York, New England and beyond.

Organization Description

MASS MoCA encourages dialogue between art making and display while working to create a welcoming space for residents and visitors to engage in the visual and performing arts. MASS MoCA also exposes participants to the creative process from rehearsals, fabrication, and development to the final performance or showing of a particular work of art. The mill complex, managed by MASS MoCA, includes high-quality performing arts spaces with professionally staffed facilities and stages for contemporary performance as well as large open studios and on-site fabrication staff to allow artists to create works that would otherwise be impossible to realize without the time, support, and space at MASS MoCA.

Mission or Statement of Purpose

"MASS MoCA seeks to catalyze and support the creation of new art, expose our visitors to bold visual and performing art in all stages of production, and re-invigorate the life of a region in socioeconomic need" (MASS MoCA, 2011).

MASS MoCA continuously works to leverage the arts as a catalyst for community revitalization. They understand that creating new markets and offering high-quality jobs allow them to achieve their mission and ensure a sustainable economy. "We at MASS MoCA are convinced that advancement of the arts, increased tourism and community participation, and regional economic redevelopment are mutually reinforcing and inextricably linked, and we act forcefully on that belief" (MASS MoCA, 2011). They are advocates of the idea that the arts help build community identity, social capital, and improve quality of life.

Goals and Strategies

MASS MoCA focuses on enhancing the economic and commercial development within North Adams. Through the development and leasing of retail, office, and

culinary space to local entrepreneurs on the mill complex, MASS MoCA works to diversify the local economy through creative small business ventures. These spaces help offset operating costs of the facility and stimulate the job market in the region. MASS MoCA also collaborates across the region to ensure a strong, creatively focused tourism campaign, improve the infrastructure for small business owners and retain residents.

Assets Employed (Borrup, 2006)
- Vacant warehouse building and adjacent properties
- 60,000 square feet of office and retail space for commercial tenants in the communications, high tech, and new media industries
- Vision and risk taking among local civic and business leaders
- Connection with the intellectual and financial resources of Williams College
- Proximity to cultural attractions and the natural beauty of the Berkshire Hills

Direct Outcomes (Borrup, 2006; Benjamin, Oehler, & Sheppard, 2006)
- Diversified the North Adams economy through creative use of space
- Created approximately 230 new jobs throughout the county
- Created $9.4 million in local growth in 2002 dollars
- Developed artist housing in former mill properties around MASS MoCA, attracting many new residents
- More than $14 million in new annual business spending
- Over 100,000 individuals visit MASS MoCA annually
- More than $11 million in capital investments in hotel properties
- Increased residential property value an estimated $14.3 million in 2003 dollars
- Reduced the percentage of households leaving North Adams as compared to the previous decade

Indirect and Potential Outcomes (Benjamin, Oehler, & Sheppard, 2006)
- Improved community and civic pride in North Adams
- Contributed to a quality of life that encouraged residents to stay
- Indirectly provides $2.2 million in federal and state business and personal tax revenues annually
- Reduced neighborhood turnover (gentrification) while boosting the economy

- The business sector has diversified significantly to meet the needs of the visitors to North Adams

Summary

MASS MoCA shows the spirit of a small community to create diverse economic opportunities. Using the large vacant warehouse space in North Adams, MASS MoCA provided space for business incubation, creative businesses, and created an environment to attract artists and creative entrepreneurs to this small town. North Adams has experienced revenue growth, increase in entrepreneurial spirit, and a considerable sense of community pride since the establishment of MASS MoCA and will continue to prosper as a result of the Museum's community engagement mission.

1 2 3 4 5 6 **7** 8

ENHANCE VALUE

This strategy focuses on improving housing and small business property by putting artists and the arts to work. Creative involvement in restoring and building new housing through the use of artists and other creative professionals can help stabilize a community and enhance the value of place.

Bringing unused properties back onto the market through artist relocation programs can be one way to encourage revitalization in any downturned area. Communities that embrace the work done by cultural workers in renovating and enhancing properties find that other citizens and businesses become interested in the surrounding spaces. They find that once this revitalization has started it can attract new artist homeowners who become invested community members.

In Paducah, Kentucky, civic, business, and creative leaders collaborated to renew the historic downtown district and enhance both the value of property and the quality of life in the community. With the help of a locally owned bank, artists had the opportunity to renovate historic buildings into mixed-use spaces that offered studio, retail, and residential space. This endeavor has been joined by the National Main Street Project which offers resources for the rejuvenation of historic downtowns that use assets currently available in the community.

REVITALIZE PROPERTY VALUES
PADUCAH RENAISSANCE ALLIANCE
PADUCAH, KY
www.paducahalliance.org

Setting

Paducah, KY is located at the junction of the Ohio and Tennessee rivers, an area frequented by riverboat cruises. The Mississippi Queen, Delta Queen, and others bring around 11,000 visitors to the area each year regularly through the Port of Paducah.

The Renaissance Area of Paducah includes the historic downtown, the LowerTown Arts District, and the riverfront development project. The Historic District in Paducah includes a downtown farmer's market, wall-to-wall floodwall murals which include images from historic events in Paducah, commemorative bricks, and an Art a la Cart program, which encourages artists to set up carts around downtown to demonstrate their craft. The downtown district includes many upper floor apartments and condos allowing residents to live within walking distance to shops, restaurants, and artist studios. The Renaissance Area has flourished because over 9,600 people have moved into renovated spaces within the historic district.

The LowerTown Arts District is full of renovated Victorian homes and storefronts that now offer creative space for artists. Many artists have established studios and galleries in this neighborhood, presenting a concentration of creative professionals that is rarely found elsewhere. Visitors to the area have the opportunity to watch artists create in their studios and the chance to browse galleries full of works by local and internationally known artists.

Organization Description

The Paducah Renaissance Alliance is part of the National Main Street Program. Their mission focuses on developing and enriching the Paducah Renaissance Area in the historic areas of Downtown Paducah, Kentucky:

- PRA partners with business owners, property owners and our great citizens through historic preservation and effective marketing.
- PRA maximizes the potential of our unique Renaissance District by focusing on business recruitment and retention.
- PRA believes that promotion of the Renaissance District, paired with the exciting Riverfront Development, will make Paducah a thriving, vibrant, and

attractive destination, benefiting the entire community. (Paducah Renaissance Alliance, 2011)

PRA is supported through a mixed funding system of charitable contributions and civic funding. Individuals, businesses, and organizations committed to making Paducah a thriving historic district provide support for all of PRA's programming. PRA coordinates multiple fundraising events throughout the year, which promote the beautification of the downtown area. These fundraisers include commemorative brick sales, hosting Old Market Days, and renting vending space at the Farmer's Market.

In the LowerTown Arts District an artist residency program creates a collaborative spirit and a true sense of community and brings in new local and international artists on a yearly basis. These artists continually breathe new life into the Paducah arts scene and offer visitors and residents alike a chance to engage in multiple arts making events.

Mission or Statement of Purpose

The work in Paducah continues to grow at the encouragement of local civic and creative leaders. Revitalizing the Renaissance Area began with Mark Barone, a painter and resident of LowerTown. He suggested offering the vacant historic buildings to artists for studio and gallery space to rejuvenate the area through cultural diversity. The city and the Paducah Bank supported his idea and the Renaissance Alliance has grown out of the work he started.

Goals and Strategies

The Paducah Renaissance Alliance uses the "Main Street Four-Point Approach" developed by the National Trust for Historic Preservation, including economic redevelopment, promotion of unique assets, design of accessible spaces, and organization of businesses.

- Economic restructuring strengthens a community's existing assets while diversifying the economy through new ventures. PRA offers business incentives to local business owners looking to move into the historic downtown.
- Promotion is used to encourage a positive image of the Renaissance Area and invites consumers and investors to live, work and play in the community.
- Design includes revitalizing the physical space in which the community lives and works. This embraces the assets already in the area and creates an inviting atmosphere through window displays, sidewalks, parking areas, and building improvements.

- The primary goal of the organization is to get the entire community to work towards one goal for effective revitalization. This includes getting the human and financial resources lined up and creating governing and standing committees to monitor the work. The PRA is how the Renaissance Area's continued work is organized and maintained.
(Paducah Renaissance Alliance, 2011).

Assets Employed (Paducah Renaissance Alliance, 2011)
- Walkable downtown area with adjacent historic residential area
- City leaders willing to take risks for economic development
- Desirable location on a river in a tourist zone for riverboat cruises
- City zoning and code flexibility allowing mixed use in historic buildings
- Artist relocation incentives including financial aid

Direct Outcomes (Borrup, 2006; Paducah Renaissance Alliance, 2011)
- Over seventy artists have moved to LowerTown since 2000
- Community branding has been reinforced by local and national level media and awards
- Abandoned properties have once again become part of the community
$1.2 million in city funds committed to infrastructure upgrades, including 144 historic-designed lights enhancing the gallery district
Awards from the Kentucky Governors Office, Kentucky Chapter of the American Planning Association, American Planning Association, Kentucky League of Cities, Kentucky Bankers Association, National Recreation and Parks Association, Bruner Foundation, and the National League of Cities

Indirect and Potential Outcomes (Paducah Renaissance Alliance, 2011)
- Growing momentum for sustainable economic development through incentives for businesses
- Increased civic involvement and pride
- The building of multiple large-scale arts centers and education facilities around the historic district

Summary
The Paducah Renaissance Alliance has engaged residents to take pride in their community by encouraging artists and businesses to settle into the historic

neighborhoods that were previously vacant. Many of the buildings that have been renovated are now inspirations to artists because of the great artistry used in originally creating them. Bringing vibrant businesses, economic activity, and a high quality of life to the neighborhood, the artists have become the major economic development leaders.

1 2 3 4 5 6 7 **8**

RETAIN WEALTH

Buy local has, in recent years, become a prominent movement in the U.S. There are many reasons for engaging in a buy local campaign. Figure 2, Keeping Dollars in the Community, shows nine essential reasons to buy local. (Portland)

Encouraging residents and tourists to buy locally grown or made products allows a community to keep their revenues–refreshing their economy. Ann Markusen (2006) has found that by buying locally-produced products, residents not only support local business owners, they also keep a larger amount of revenue in the community through wages and services. This is one of the quickest and most effective ways to contribute to community revitalization. When extended to the arts, buying local has other benefits. The growth of a distinctive local culture and arts scene is fostered. Developing appreciation of local creativity encourages artists, teachers, youth, and others to participate in growing their creativity. And, as economist Ann Markusen has reported, "Creative places nurture entrepreneurs." (Creative Placemaking 2010).

Many cities across the country have embraced buy local campaigns. In some cities this is a grassroots strategy and in others it is a political strategy with the municipal government setting up and structuring programs to nurture a buy local environment. One culturally specific program developed by a city government is the BUY ART campaign in Providence, RI.

FIGURE 2 - KEEPING DOLLARS IN THE COMMUNITY

- Keep money within your local economy
- Embrace the unique assets in your community
- Foster job creation by creating more local jobs for residents
- Local businesses are more connected with the natural environment in which they work. They usually collect a walkable distance from other local businesses creating a vibrant downtown core.

- Studies have shown that local businesses contribute twice as much of their revenue to the community and promote a sense of community pride in all they do.
- Small businesses conserve tax dollars by needing less public infrastructure and making more efficient use of city services.
- Local businesses offer diverse products that are closely connected to the community and not to national sales plans.
- The staff and managers of small businesses are often more passionate and excited about their products and have a greater interest in building personal relationships with clients.
- Entrepreneurs are the power behind local businesses. They offer innovation and growth in an economy that nurtures a community spirit of entrepreneurialism.

http://portlandbuylocal.org

BUY LOCAL
BUY ART
PROVIDENCE, RI
buyartprovidence.com

Setting

Providence is the capital of Rhode Island and a New England transportation and manufacturing center. In the early twentieth century the town faced abandonment, deterioration of physical space, and a dwindling of civic pride. In the 1990s, Providence uncovered the rivers and lined them with public spaces including promenades. Providence, known as "The Creative Capital," has developed an annual arts advocacy program focused on the purchase of cultural goods and services, BUY ART.

Organization Description

Mayor David N. Cicilline and the City of Providence Department of Art, Culture + Tourism created this program in collaboration with cultural spaces and artists across the city. The BUY ART campaign is a major marketing and advocacy program for Providence.

An annual contest for resident or studio-based Providence artists is run by the city's Department of Art, Culture + Tourism to adorn the "I Buy Art" buttons and marketing materials. This award showcases local artists and includes a small stipend

for them. About 13,000 buttons were created in 2009 to thank shoppers who buy works of art. This program promotes Providence-based artists and cultural venues by creating a visual receipt of arts purchases in the city. In addition to the purchase of art, studio classes, museum memberships, and performance tickets are included in the program. The BUY ART name and information must also be included in the promotional material for the organizations that participate.

Mission or Statement of Purpose

BUY ART focuses on building community pride in the Providence art sector. This program is city funded and free for all creative businesses in Providence. Providing "I Buy Art" buttons to all purchasers of art products in Providence creates a spirit of community among those engaged in the creative sector.

Goals and Strategies

The city is using this program to promote the purchase of locally made and/or produced creative products from the visual to performing arts. Over the past four years, individuals and communities across the US have noticed "I Buy Art" pins and publicity. Residents and visitors not only wear the buttons, but also give them as gifts showing their pride in buying local art products. Creating a visual and engaging way to thank purchasers of local art aided in the revenue growth in Providence.

Assets Employed (Buy Art Providence, 2011)
- Abundance of artists in the Providence area
- The hidden community of arts supporters and purchasers
- Innovative spirit to create a visual receipt for arts purchases

Direct Outcomes (Buy Art Providence, 2011)
- Reinvigorated interest in the purchase of local artists' work
- Awareness of the number of people who purchase artwork
- Renewed civic pride and cultural identity
- A city database of local art galleries, performing arts venues, and other creative organizations
- Indirect and Potential Outcomes
- Reinvestment in the larger community
- Restored support for the businesses in the capital city
- Emphasizes the value of creativity and artists in the community

Summary

In Providence the city has provided an opportunity to encourage residents and visitors to not only buy local, but also buy local art. This program encourages individuals to support local artists and artisans when they are considering buying gifts throughout the year, but especially during the holidays. Using the approach of offering a free button to all those who purchase art, the city promotes a positive image of a buy local campaign.

Conclusion

The arts have great potential for contributing to the economic health of communities. The examples cited here are not "best practice" models for replication elsewhere. They are illustrative of the potential that the arts have for participating in community improvement. In addition, these case studies do not provide a complete view of the challenges each community faced nor are they unique in their methods. They are intended to offer readers a view of community accomplishments and a context for the success of projects attempting to address economic development.

REFERENCES

Adria, F., Blumenthal, H., Keller, T., & McGee, H. (2006, December 9). Statement on the 'new cookery'. *The Observer*. Retrieved from http://www.guardian.co.uk/uk/2006/dec/10/foodanddrink. obsfoodmonthly

Americans for the Arts. (2007). *Arts & economic prosperity III*. Washington, DC: Americans for the Arts

Animating Democracy. (2011). *Swamp Gravy*. Retrieved on August 20, 2011 from http://ww3.artsusa.org/animatingdemocracy/labs/lab_044.asp.

Benjamin, B., Oehler, K, & Sheppard, S.C. (2006). *Culture and revitalization: The economic effects of MASS MoCA on its community*. North Adams: Center for Creative Community Development

Buy Art Providence. (2011). Webpage. Retrieved from http://buyartprovidence.org

Davé, D. S., Evans, M.R., & Stoddard, J.E. (2008). *The economic impact of the craft industry in western North Carolina*. Retrieved from http://craftcreativitydesign.org/home.php

Dreeszen & Associates. (2009, October 4). Boyne City Michigan Cultural Economic Development Plan. Retrieved from http://gov.boynecity.com/government.phtml?catid=33

Gratz, Roberta Brandes. (1990). *The living city: How urban residents are revitalizing America's neighborhoods*. New York: Touchstone

The Greenpoint Manufacturing and Design Center. (2011) History & About. Retrieved from http://www.gmdconline.org

Lambe, W., University of North Carolina at Chapel Hill., & North Carolina Rural Economic Development Center. (2008). *Small towns, big ideas: Case studies in small town community economic development*. Chapel Hill, N.C.: UNC School of Government.

Markusen, Ann. (2006). A Consumption Base Theory of Development: An Application to the Rural Cultural Economy. Retrieved from www.hhh.umn.edu/projects/prie/pdf/273ConsumptionDriven.pdf

MASS MoCA. (2011). History & About. Retrieved from www.massmoca.org

National Association of State Arts Agencies. (2009, March 9). State of the American Traveler. *NASAA Notes*. Retrieved from http://www.enewsbuilder.net/nasaanotes/e_article001366550. cfm?x=bdrJ70L,b7vjbfgn,w"

Paducah Renaissance Alliance. (2011). Retrieved from http://www.paducahalliance.org/about.php

Paducah Renaissance Alliance. (2011). Artist Relocation Program. Retrieved from http://www.paducahalliance.org/artist_relocation_program.php#articles

Portland, Maine Buy Local. (2011). *Top 10 reasons to buy local*. Retrieved from http://portlandbuylocal.org

Putnam, Robert D. (2000). *Bowling alone: The collapse and revival of american community*. New York: Touchstone

Small Business Administration. (2011). Frequently asked questions. Retrieved from http://www.sba.gov/advocacy

U.S. Travel Association. (2011). U.S. travel answer sheet. Retrieved from http://www.ustravel.org/

Weiss, H. (2008). *The ABCs of creating a customer friendly arts district*. Retrieved from http://www.pawtucketri.com/arts/plan/

THE ARTS AND EDUCATION
Based on an interview with
Sandra Ruppert, Director
Arts Education Partnership

A skilled workforce and good schools are essential for viable communities. Studies too numerous to mention document the power of the arts to improve the intellectual capacity of students, to aid in their understanding and retention of material in all disciplines, to enhance their problem-solving abilities, and to make them better, more productive citizens. The arts are uniquely suited to positively transform the educational system.

INTELLECTUAL/EDUCATIONAL ENHANCEMENT

The arts make children smarter. Students that play musical instruments, sing, draw, act, and dance do better on standardized tests than those who do not. The arts help students understand and remember what they learn. Who would have learned fractions without the benefit of drawings of pies? The arts are not a frill, yet why are they not more fully embraced in public school curricula? While this reads like (and is usually treated as) a rhetorical question, the answer to it has at least some of its root in the public's disinclination to believe the arts have transformational power. (For a fuller discussion, see "Public Value, Community Engagement, and Arts Policy.") This disinclination is one of the issues that community engagement is designed to address.

PERSONAL GROWTH AND SOCIAL DEVELOPMENT

Athletics have long been touted as laboratories for team-building skills. Unfortunately, not every child is athletically inclined. Far more students have potential

in collective performing arts disciplines–choirs, bands, orchestras, theater, and dance–where the lessons of teamwork, discipline, and the rewards of hard work are learned. Interesting studies have shown that participation in theater significantly enhances the capacity for empathy, a critical ability for healthy societies. Students with arts experience in school end up being more fully engaged in communities, committed to making things better to an extent not mirrored by their peers who did not participate in the arts.

Students with arts experience bring valuable tools to the workforce, regardless of the type of job they end up doing. The arts make students problem solvers. Artistic creativity–making something interesting, useful, or beautiful out of raw or discarded materials–aids in the process of solving seemingly intractable scientific or social problems. The ability to "think like an artist" is an advantage in confronting new situations. The entrepreneurial view that many artists bring to career building can be transmitted via arts education, bringing economic benefit to the community.

Rigorous standards for arts instruction have been developed, approved, and mandated on the federal and state levels. However, the benefits of the arts are realized over the long term and the skills are not included in testing. Therefore, despite their potential for positively transforming public education, they continue to be vastly under-utilized. In the face of standardized testing pressures, only a powerful groundswell of support from community leaders and parents can remedy the situation. Nationwide, grassroots efforts have gained some ground to develop alternative assessment models and alternative approaches to achieving the desired educational results.

Keys to learning include excitement about school and the belief that one is capable of learning. The arts foster both. Students who have found a niche, and thus identity and success, in one of the arts are far more able to benefit from the entire academic curriculum for having done so. In particular, young people who are excited about school because of activities they enjoy have far better attendance records and are far less likely to drop out than peers who are not engaged by their school experiences. Retention is such an important issue–both in impact and in public relations–that it is probably time to turn focus from studies about arts education and test scores to arts education and graduation rates.

ARTS AND EDUCATION AS A VEHICLE FOR COMMUNITY ENGAGEMENT

To get the issue out of the way at the beginning, the arts and education partnership literature has for years contained at least some criticism of private arts organizations

"bailing out" public school administrators who cannot (or choose not to) find the resources to fund arts programs. While in the abstract that may be a valid criticism, in this instance the outcome is more important than the process of getting there. It still and always takes a village to raise a child and education *is* the future of our society. Withholding tools to improve education on principle would be detrimental to our communities for no significant purpose; and on the practical level, it would further diminish the pool of future arts patrons, a prospect the arts community cannot afford.

Public school curricula have long been a bellwether of the esteem (or lack thereof) in which the arts are held in the U.S. Notwithstanding federal and state mandates, local school boards are particularly susceptible to the concerns of parents and other vocal citizens. The widely reported and lamented removal of substantive experiences in the arts from the schools is not merely a shortsighted response of school boards and administrators to budget constraints. It also illuminates a lack of passion about the topic on the part of the bulk of the general public. Lip service to the value of the arts in education clearly does not, in general, translate into broad-based advocacy for reinstating the arts as an essential element of school curricula. If passion about the subject were real and deeply felt, the policy results in the public schools would be readily apparent.

That said, arts and education partnerships provide a unique access point to a community, making them valuable mechanisms for engagement. The focus is on better-educated children rather than on the arts exclusively, so even those antagonistic toward the arts will seriously consider proposals when children benefit. If the case is made that the arts significantly improve students' lives and the truth of that is demonstrated over time, there is great potential for building good will, support, and political capital.

Successful examples of broad-based arts and education partnerships from around the country demonstrate the truth of this. Particularly good examples are Dallas's Big Thought program that marshals the resources of approximately 110 community partners (including the Dallas Museum of Art, the Dallas Opera, the Dallas Symphony, and the Dallas Theatre Center) in serving over 100,000 students in in-school, after school, and summer programs; and Cleveland's Art *is* Education program with 40 partners, including all of Cleveland's major arts organizations, in residency programs as well as Arts for Learning, a third-grade literacy skills curriculum.

Access Points and Gatekeepers

Notwithstanding the apathy toward the arts in schools cited above, the sensitivity

of school boards to local concerns makes arts and education collaborations particularly well suited to transforming curricula. Demonstrably successful programs will garner support among parents and concerned local residents, generating pressure on school boards to provide such opportunities to more students. Grassroots action, in some communities, can be effective in supporting educational change. The additional benefit of such work is that in raising awareness of the benefits of the arts for children the public will also be made somewhat more aware of the broader value of the arts to their communities.

School administrators, depending on the educational politics of a district, are sometimes far more able to effect change than might be imagined. Superintendents, when not subject to a domineering school board, often have broad discretion about approaches to education undertaken in their districts. In individual schools, principals, through budgetary and hiring authority, may have considerable autonomy in how their teachers teach and in what resources are brought to bear to further their students' education. Strong superintendents and visionary principals can be significant change agents supporting arts and education partnerships.

Necessary Skills for Partnerships

While this is not a "how to" primer for establishing arts and education partnerships, it is important to acknowledge that crafting effective arts-schools collaborations is not easy. As will be discussed later in the section on forming partnerships, successful ones require commitment to the process and the end result, the learning of basic skills, and time. Artists need to understand the particular constraints and concerns of educators. Teachers and administrators need to understand the potential for the arts to support the educational process. Each needs to learn the language of the other. And all need training in the process of building coalitions. Partnerships, especially those that cut across disparate disciplines, are difficult to form and maintain successfully.

Conclusion

The kinds of partnerships discussed here provide the arts world with an interesting and valuable community engagement opportunity. Wealthy communities self-fund their schools' arts programs. Urban center communities, with direct access to high-level arts organizations through simple geography, sometimes have better than expected access to arts education. It is often in the schools of the "missing middle"–middle class, suburban, or rural–where arts programs are most challenged. The populations those schools serve are particularly disaffected from the arts in general. Working with these

communities to improve their children's education can pay multiple dividends for arts organizations. It can raise visibility, engender good will, provide proof of the value of the arts for addressing pressing issues, and develop knowledgeable arts supporters for the future.

COMMUNITY BUILDING AND THE ARTS

Community building is an area of arts activity that is not widely recognized either by artists or by community leaders. However, the potential for creating better cities is probably greater in this area than in economic development or in educational reform, and it is certainly the area most closely related to the task of making the arts directly relevant to the lives of a community's citizens. [Author's Note: Some overviews of the arts' community potential use terms like social change, social justice, and advocacy along with healing and nurturing as headings for this category. However, for some people, the first three terms have negative connotations. In an effort to be more inclusive (and to cast the theoretical net somewhat more widely), I use the term "community building."]

Cities in the United States can be described as vast collections of strangers. On an individual level, alienation, isolation, fear, mistrust, and misunderstanding separate people; these have profound negative impacts. These factors are, of course, roots of crime; but on a neighborhood or community level they also serve as hindrances to people working together, to finding broad-based solutions to community problems. Community-focused arts projects can serve as rallying points for neighborhood revitalization and civic engagement. The arts can provide safe distance for considering conflicting views and comparatively non-threatening points of entry for gaining appreciation of unfamiliar cultures. By providing clear mechanisms for articulating community needs and identifying cultural assets, they can also provide for more responsive services and for more effective delivery of them. Artists trained in these possibilities can create and enhance "community," bring reconciliation to conflicts, raise public awareness of unmet human needs that damage the social fabric, and facilitate projects that improve the "on the street" quality of life in neighborhoods and communities.

ALTERING THE FACE AND HEART OF AMERICA:
THE GARD SYMPOSIUM

In September of 2010, the Wisconsin Arts Board and the Robert E. Gard-Wisconsin

Idea Foundation convened a gathering of community arts workers and experts in a variety of disciplines related to community well-being to discuss what "healthy community" means. The title of the conference was "Altering the Face and Heart of America: The Gard Symposium." The discussions of community health that took place there were designed as a springboard for consideration of how the arts might support that health. While this is far from the only framework in which to consider the question of community building, it is fairly comprehensive. (The essence of each presenter's ideas can be found at the Gard Foundation's website: http://gardfoundation.blogspot.com/)

Economic Health (Sustainability)

Symposium presenter Dr. Jerry Hembd (Director, Northern Center for Community & Economic Development, Department of Business & Economic Development, University of Wisconsin-Superior) pointed out that the meaning of economic health has been transformed over time from jobs growth to industrial recruitment to regional competitiveness. Today the focus is on sustainability. Awareness of the limits of growth have tempered earlier assumptions about endless expansion. Dr. Hembd identified sustainable scale, equitable distribution of resources, and efficient allocation of those resources as the paths to economic health. In outlining the keys to achieving these ends, he focused on:

- Leveraging local assets,
- Meeting human needs, and
- Fostering relationships (individual and inter-institutional).

The inter-connectedness of economic health is evident in those keys. Leveraging local assets is a means of employing the results of asset (or cultural) mapping, discussed later in this book. HandMade in America (cited above) is just one example of utilizing local assets for sustainable economic development. Meeting human needs is, of course, another way of describing a concern for all forms of community health, the subject of this section; and relationship-building is the function of fostering social capital about which more is said below. As has been (and will be) demonstrated, the arts have a significant role to play in all of these aspects of economic health.

Physical Health

Dr. Stephanie Robert, (Neighborhood Health Specialist, School of Social Work, University of Wisconsin-Madison), defined health as "not just the absence of disease, but the presence of social, physical, psychological, and spiritual well-being." She

identified "a healthy community [as] one that provides an economic, social, and physical environment that allows individuals and families the opportunity to achieve their optimal physical health and well-being." The tasks for communities seeking to promote health in their citizens, according to Dr. Robert, are "1) identifying aspects of neighborhoods that are barriers to optimal health and finding ways to remove those barriers–either through policy or community action, and 2) identifying aspects of community that can promote health, even in the face of adversity." Specifically with respect to the role of the arts in these efforts, she said that the arts can help people: Recognize and name barriers to community health

- Effectively communicate those barriers to the community and to policy makers
- Support collective action to improve community health
- Celebrate and strengthen what works

Political Health

Barbara Lawton, Lieutenant Governor of Wisconsin at the time, defined a politically healthy community as one where "[a]ll citizens have the possibility of thriving–the ability to feed, clothe, house, educate, and nurture [their] family, and have that extra personal or social capital that allows [them] to make a contribution to [their] community as well." In such a community, "[l]eaders

- Champion a diverse culture;
- Develop the security of mutual respect by focusing the public agenda on a clear vision for the common good; and
- Encourage inquisitiveness, creativity, and self-reliance among community members."

The arts are a means of first resort in supporting the understanding and appreciation of cultures. They can serve as good modes to support the development of a community's agenda for improvement (highlighting positive options and illuminating circumstances in need of change). And they clearly support the ends of inquisitiveness, creativity, and self-reliance.

Spiritual Health

For Rabbi Jonathan Biatch (Temple Beth El, Madison, Wisconsin) "creating a communal sense of accountability to a higher cause–the notion that each member of society is accountable to an entity greater than him or herself" is the core of a

spiritually healthy community. He presented the following four elements as the indicators of such health:

- There must be a belief that one is responsible-through one's actions-to others.
- There must be an acceptance of the reality that one's actions will have an effect on others, both in positive and negative ways.
- There must be a common presumption that there will be a negative consequence if one does not bear in mind, and act in accordance with, the first two understandings.
- Individuals must feel a true sense of remorse if they commit a misstep and a true dedication toward the reconciling or repair of any relationship that breaks down.

According to Rabbi Biatch, the indicators of a spiritually healthy community are:

- A sense of positive intention (assumption of good will)
- Respect for all people
- Encouragement for each individual citizen to search for his or her individual spiritual path
 A continuous search for discovering the best ways of educating one community group about another
- Promotion of acceptance across all lines of difference
- Local media present issues objectively
- Community-wide dialogue about important (even controversial) issues is the norm, searching for, talking about, and promoting solutions to the problems examined
- Training of future leaders with the same vision of a spiritually healthy community

Several of these are directly related to the formation of trusting relationships, the core of social capital. Self-reflection on spiritual matters is often facilitated via the arts-poetry, visual arts, even participation in music and dance. The role of the arts in being able to provide a safe frame for discussion of difficult issues is an important element of their applicability to community building.

As observed above, this framework is not the only way to understand either healthy communities or community building. It does provide, however, a good beginning that has the advantage of being fairly comprehensive. It is the intent of the Gard Foundation, over time, to facilitate ever stronger connections between the arts

and other segments of the community in an effort to support healthier lives for all. [Disclosure: After the Symposium discussed here, I was asked, and agreed, to serve on the Gard Foundation Board of Directors.]

Social Health

While not a product of the Gard Symposium, the following are other elements (or differently articulated elements) that are also important to a community's health, loosely organized here under the category of social health.

COMMUNITY IMPROVEMENT

Advocacy (Awareness, Knowledge, Dialogue, Action)

In any community, there are needs for change, issues that should be addressed to make a more livable environment. The fact that disagreement may exist about what constitutes "improvement" does not negate this fact. Whatever the cause, the arts can provide a means for addressing it.

The presentation of issues in art raises the visibility of those issues. It is hard to outdo street theater, for instance, as a way to get people's attention. In addition, the arts excel at gathering people together. To be viewed, performing arts events must have audiences at a particular place for a specified length of time. Such "captive audiences" can then participate in dialogue and discussion. Works of visual art can serve as means of "marking" particular locations, making them gathering points for addressing an issue or simply place-based continual reminders of it.

Rendering an issue in a work of art provides a frame so it can be seen from the perspective of someone deeply affected by it. Misunderstanding or the lack of understanding of an issue is often the result of the fact that outsiders cannot see things the way those directly impacted do. The artistic frame can highlight an issue in ways that make it memorable, raising awareness and understanding; it also provides emotional distance that can provide the possibility of more reasoned dialogue than is sometimes the case when difficult issues are being addressed.

Celebrations and Rituals

Celebrations and rituals help foster collective identity, a commodity that is important to the social health of a community. When strangers see each other as part of a single "team," they are more likely to give each other the benefit of the doubt in moments of conflict and work together more productively when opportunities arise. Similarly, in times of grief or despair, rituals serve to bind people together, promoting

collective healing. It could very nearly go without saying that the arts-visual and performing-serve as the essential framework for virtually any celebration or ritual.

Social Capital: Creating/Enhancing Community

A community that takes pride in any enterprise with which it identifies is a community that has a contagious energy about it. This is, of course, one of the reasons for fierce competition for professional sports franchises. However, pro teams are not the only means of accomplishing this. Arts and cultural events and institutions that affect the lives of a whole community can do so as well.

More generally, much has been written about the lack of cohesion in U.S. cities today, Robert Putnam's *Bowling Alone* being a widely known example. Many problems that exist in contemporary society can be attributed to how little people know each other, how little opportunity they have for conversation. Garrison Keilor has said that no one does anything really wrong in a small town because too many people are watching. While it is a funny thing to say, there is much that is true in the observation.

The habit of neighborliness, insofar as it ever existed, has been lost. The very architecture of our dwellings in cities, towns, and suburbs reflects this. Where homes in the first half of the Twentieth Century had front porches where people could greet their neighbors walking by, today's homes have back decks, fenced off from the community. These homes have in a real sense "turned their backs on the neighbors."

Some in the South blame air conditioning; others blame busy, over-scheduled lives. But the end result is that people do not know people the way they once did. People who know one another look out for each other; people who don't do not. That is what is meant by the African expression, "It takes a village to raise a child." The value of social capital goes even deeper than mutual support. Studies have shown economic benefit, both to individuals and communities, in increased concentrations of social capital. The more people anyone knows, the more access they have to employment, housing, health care, and retail purchase possibilities (to name but a handful). This understanding of social capital is the theoretical basis for the truism, "It's all in who you know." The arts can provide opportunity for opening up conversation, for getting to know people one might not otherwise.

In addition, the social capital that can be generated by arts activities can be invaluable in opening dialogue between segments of a community separated by cultural barriers. Ethnic cultural festivals are but one example. However, the potential for enhancing understanding can be even greater than "cultural exposure" when activities that promote working together are supported.

81

INDIVIDUALS AND SPECIAL POPULATIONS
(E.G., YOUTH, SENIORS, SPECIAL NEEDS)
Reconciliation: Healing Wounds

Where divisions exist, sometimes the only way to initiate healing is through arts activities. As mentioned above, the emotional distance provided by art can facilitate those on different sides of an issue for the first time recognizing the pain of "the other."

In 2004, the Sawtooth Center for Visual Design in Winston-Salem, NC mounted an exhibition, "A Thousand Words: Photographs by Vietnam Veterans," of photography by Vietnam veterans documenting their experience. After the opening reception, one veteran said it was the first time he had ever been thanked for what he did. This exhibition subsequently went on tour across the United States.

Empowerment: Giving Voice to the Voiceless

Having one's own life experiences lent value through inclusion in works of art–visual, performing, or literary–can be a tool in breaking the cycle of despair that prevents individuals from improving their lot. In addition, community awareness of social problems through raised visibility is the first step in solving situations that tear away at the social fabric. In California, the Los Angeles Poverty Department mentioned earlier is a theater project that helps the larger city better understand and respond to the reality of homelessness. In Washington, DC, a group of renters worked with El Barrio Street Theater to give voice to their demands for adequate housing after repeated unsuccessful attempts to get absentee landlords to address substandard conditions in their units.

The role of the arts in community building is little understood inside or outside the world of the arts. Certainly, to be participants, artists and arts institutions need to broaden their role in the community and, in some cases, their understanding of their role. However, such efforts are costly in both time and money. Expansion of this sort requires considerable investment. Much of the community-building potential of the arts lies in work with segments of the population without any previous connection to the arts. In addition, many of those who could be most powerfully affected are without financial resources. There is therefore no natural constituency of backers for this work. For our nation to take advantage of this potential of the arts, significant support from new as well as long-time arts supporters would be necessary.

THE ARTS AS COMMUNITY CITIZEN

In contrast to arts programming, there is an option for community engagement that is rooted simply in community citizenship. As pointed out earlier, arts organizations can also engage with their communities through neighborliness not directly related to the art they present. Clearly, this will not be a centerpiece of their work, but when it can be pursued simply, it can be a powerful means of connecting.

THE ARTS AS COMMUNITY CITIZEN: THE VALUE OF BEING A GOOD NEIGHBOR
by Lyz Crane

As arts organizations seek to build community, they must also consider their role as community members–a relationship that can have great rewards even while requiring proactive dedication of resources.

COMMUNITY–NOT JUST A EUPHEMISM

Of all the words in an arts practitioner's toolbox, *community* is one of the most potentially hazardous due to its fluid nature. Institutions will often use the word *community* to help distinguish between one thing and another–community arts vs. fine arts, the community vs. people with special knowledge or interests, community outreach vs. audience cultivation, community programs vs. flagship programs, and on and on. In all of these senses, *community* generates a connotation of generalization, the masses, the Others. Worse, as arts funding priorities increasingly incorporate 'community impact' as a key measure, the term *community* has become a euphemism for the non-traditional arts audience, whether in terms of class, race, ethnicity, or age.

These types of distinctions are misleading at best and polarizing at worst. The truth is that there is no such thing as 'the institution' and 'the community.' All institutions and organizations are a part of both THE community and indeed MANY communities. Just as many arts organizations are beginning to understand that there is great power in breaking down the barriers between audience and performer or presenter, there is now a great opportunity to begin breaking down the barrier between *organization* and *community.*

For this particular topic, the community of interest is primarily spatial in nature. This means it is not just youth, low-income families, immigrants, older adults, digitally connected, or any of the other hundreds of ways to identify a particular audience/

83

subgroup. Spatial communities consist of many players, who generally fall into four broad categories:

- Residents, and in many cases, visitors
- Local civic or social organizations
- Local businesses
- Community investors (elected officials, funders, developers, etc)

Engaging with surrounding communities means engaging with all of these players in one way or another.

ARTS ORGANIZATIONS IN COMMUNITIES

Arts and cultural organizations are a part of the fabric of our communities. They exist in a place, serve an audience that comes from somewhere, are made up of individuals with their own history and networks, and influence the way we think about the world around us. As generators of economic and social activity, they are beneficial to their surrounding neighborhoods, cities, and regions. Much like we can evaluate an individual's worth and economic productivity as a part of a larger community, we can evaluate an institution's worth and activity. However, where it is normal to expect that citizens of a community contribute some of their time and energy to neighborhood associations, local politics, and interest groups, we do not always share similar expectations of arts organizations.

Some arts organizations are naturally embedded in their surrounding communities. Others exist in a place but do not seem of that place. In either case, there is a persuasive argument for better integration and involvement not just in the cultural life of the community, but in the wider community picture and trajectory. This argument is based in mutual benefit and a shared vision of the future. By recognizing the potential value that active civic engagement can engender, arts organizations can find themselves better positioned to advance both their own interests and those of society at large.

How can arts organizations, filled with good intention but often focused inward, turn that focus outward and ultimately become Good Neighbors? How can they step outside their four walls and become not only a haven for creativity, but a steward of the values of democracy, inclusion, and upward mobility? Can arts organizations make community meetings, concern for housing, immigrant issues, and support for small businesses fit within their scope of operation?

Arts organizations have unique physical and mental 'space' within communities that allows them to play a valuable role in the evolution of their surroundings. Indeed,

arts organizations have critical physical, social, political, and creative capital that can be applied to community goals, often without altering their arts-based mission or diverting too many scarce resources.

This last note is fundamental for many arts organizations to understand. The tension between artistic excellence and community activities can be fierce. Yet, while the chosen focus of an arts organization can certainly enhance its engagement in surrounding communities, being a Good Neighbor is in many ways divorced from programming. Rather, the value of arts organizations often lies in that inherent capital:

1) **Physical Capital:** Arts organizations have space. Whether renting or owning property, they tend to be fixtures in constantly shifting communities. This permanence represents an important consistency of leadership and resource base that is both neutral in politics and positive in intent. Furthermore, arts organizations have a diverse array of options for how to engage the physical space outside of their four walls in ways that bring people together in shared experiences. They are stewards of vibrancy and placemakers.

2) **Social Capital:** Arts organizations can nourish and enrich, as the rest of this book shows over and over again. The arts are also often critical components of both individual and communal identity. Some of the most important soft skills that can be used to enrich community processes are comfort and sensitivity with cultural translation, perspectives that embrace complexity, and an ability to listen to and amplify critical messages. Arts organizations also have staff and board members with diverse interests, skills, and connections to valuable social networks. These tools, in concert with access to diverse audiences, allow arts organizations to serve as bridges and connectors between different kinds of leadership and local nodes of activity.

3) **Political Capital:** Arts organizations can reach high and wide to draw new stakeholders and resources into communities. Many arts organizations have valuable connections to local and national funders, some sort of relationship or buy-in by local politicians, a bevy of resources in their board members, and a strong basis for negotiation with local developers as a 'quality of life' asset. All of these networks are involved in the community change process, and arts organizations have opportunities to bring these assets into their communities and link them with the local, informal community leadership. Arts organizations are also connected to other local, state, and national professional associations and communication outlets that can shine a spotlight on successful community endeavors.

4) **Creative Capital:** Finally, arts organizations often have hard skills, such as graphic design, communications, vendor management, and event planning that can contribute to community development efforts. They are experienced in programming, planning, and producing. In combination with values that enhance imagination, critical thinking, and innovation, there is virtually nothing that arts organizations could not do, given the time and resources, to enact successful projects. Unfortunately for many communities, arts organizations have a tendency to reserve this capital in service of the organization, with broad claims that the time and financial resources do not allow for substantial sharing. The management of artistic production is indeed time- and money-consuming. However, the benefits of sharing can be astounding. When organizations reconsider their resource allocation to focus on both arts AND community, they can receive in return even more in-kind resources and value from all sorts of other civic organizations and community members.

As arts organizations take a stake in the future of their neighborhood, their neighborhood will take a stake in the future of them and this means more people through the doors, more volunteers, and more attention. This raised profile does not just increase audiences, but can draw praise and support from funders, policymakers, and the business community. When community investors are making decisions in a neighborhood about development that may affect an organization's ability to function, the organization may actually be approached as a community leader and asked for opinions or involvement, rather than having to beg for a seat at the table or be placed at the metaphorical 'kids table' of important civic affairs.

Additionally, ongoing engagement with the community can strengthen the direction of programming, identify new curatorial avenues, and sharpen communication and marketing strategies–all of which can ultimately advance many arts-based missions.

CULTURE SHAPES COMMUNITY: THE SHIFTING SANDS INITIATIVE

One specific type of community that arts have perhaps the greatest potential to influence is that of the neighborhood undergoing rapid changes, such as immigration, gentrification, or natural crisis. These neighborhoods are particularly prone to growth-curbing tension between populations. Between 2003 and 2009, The Ford Foundation in partnership with Partners for Livable Communities asked a cadre of neighborhood-

based arts and cultural groups to apply their capital to turn neighborhood tensions into opportunities for meaningful interaction and social change.

To achieve this mission, organizations added elements of community organizing to their operations, included the neighborhood impact in their decision-making, created new partnerships with community groups, and radiated these changes through the organization from the most junior staff all the way up through board chairs. They faced many challenges and learned many lessons on this journey. For example:

- To be accepted, they had to listen to other stakeholder agendas and help facilitate common solutions, rather than try to impose their own idea of how things should be.

- It was imperative to build trust, which required a commitment to follow through on promises even when other organizational or programmatic issues threatened to get in the way.

- Since they often lack training in community development, the organizations could achieve much better and more efficient outcomes through partnering with more knowledgeable actors.

- Partnering required very clear, stated understandings of assets and interests to be able to achieve mutual benefit.

- Without support at every level of the organization (staff, leaders, board), the work would be under resourced and ineffective, losing many of the potential benefits.

Even despite steep learning curves and periodic missteps, many of the organizations were able to enact meaningful, lasting change on their surroundings without compromising any arts-based programming.

THE ARTS AT MARKS GARAGE – HONOLULU, HI

The ARTS at Marks Garage is the key community project of the Hawai'i Arts Alliance. Located in Honolulu on the seam between Chinatown and the downtown Financial District, the area immediately surrounding Marks Garage had been gathering momentum as an arts and cultural district. However, initially, despite having a community-based mission, the organization had little traffic and inspired fear in some that it would serve as an agent of gentrification.

The primary challenge the organization faced in the community was how to ensure that the businesses and residents already in the neighborhood 1) had a voice in the changes to their community; and 2) could benefit directly from those changes. This included ensuring that neighborhood businesses were able to tap into the new

arts and culture patrons and that neighborhood residents, many of whom came from surrounding public housing projects, were able to participate in the new arts and cultural offerings in the community.

To address these goals, The ARTS at Marks Garage developed a far-reaching strategy that included the creation of a community organizer position to work full-time on building bridges. This person worked on increasing awareness of the opportunities that the organization's art space could provide for dialogue with developers, civic leaders, artists, long-time residents, business, and other community service organizations. By incorporating the new interests with the older ones and helping to negotiate a new and fair process for the downtown/Chinatown re-identification, the ARTS responded quickly and creatively to their community change. For example, their "Bright Ideas Project" provided an opportunity for community groups to win up to $4000 mini-grants for community projects that would enhance both Chinatown and the emerging arts district. Winning ideas included the development of a night market during First Fridays, walking tours that would discuss development and the future of Chinatown, and the redevelopment of a local pedestrian mall to better connect tourists to local cultural heritage icons. Another example is their "Talk Any Kine Festival," where they partnered with local merchant associations and civic interests to give participants the opportunity to "speak out" and share their concerns and recommendations on issues such as Getting Around Chinatown, Homelessness, Affordable Rental Housing, Better Business Environment, and Safer Neighborhoods. Voting methods included using interpretive, artistic materials like finger painting and colored post-it notes to help attract people and transcend the language divide.

Today, The ARTS at Marks Garage, which began as a fledgling organization, is a central hub for arts and culture on the island. Their regular events attract thousands of patrons, and they continue to serve as a connector between new and old local businesses.

MACLA/MOVIMIENTO DE ARTE Y CULTURA LATINO AMERICANA – SAN JOSÉ, CA

The William/Reed Corridor in downtown San José used to be primarily composed of Victorian homes with white single-family occupancy. As the neighborhood evolved to include a burgeoning population of renting immigrants, MACLA's role in the neighborhood also grew and evolved. MACLA, which hired a community organizer much like the Arts at Marks Garage, participated in countless meetings with organizations in the community, community members, businesses, and school

organizations in order to better understand their changing neighborhood. Out of those meetings came a number of innovative programs.

To name a few: MACLA leveraged its design capacity to prepare and publish the William Street Business Directory in English, Spanish, and Vietnamese to help promote local businesses; assisted in the creation of a local park; advocated for the placement of neighborhood banners; and organized community walks to explore the neighborhood with residents. They also provide daycare, food, and translation targeted to immigrant populations for all South University Neighborhood meetings, and have effectively helped to build trust and partnership between the local homeowner and immigrant communities.

As a result, the organization now receives funding from diverse groups such as the San José Office of Economic Development, is regularly involved in local funder initiatives, and has become a national example of community engagement through the arts. They also report that more than 30,000 people participate in the 50 programs they produce each year.

ASHÉ CULTURAL ARTS CENTER – NEW ORLEANS, LA

Central City New Orleans, once a thriving area of strength for the African-American community, had begun losing a lot of steam even prior to 2005. Unfortunately, Hurricane Katrina left the neighborhood almost empty with little to no community services, gathering place, or leadership structure.

Prior to the storm, Ashé had already committed itself to rebuilding its surrounding community. After the storm, Ashé was one of the few organizations that kept its doors open. As a result, they offered their space as the 'kitchen table' of the community, holding both community meetings and cultural gatherings to help bring the remaining population together in a spirit of hope. They also served as a central contact point for former residents, at the time still far flung, to ensure that as the rebuilding began to be defined, their voices would be heard just as strong as those of the developers. Ashé has since proceeded to partner with local community organizations and funding agents to spearhead an initiative to develop empty property in their neighborhood. The goal of the group has been to turn the neighborhood into a cultural corridor that both conforms to the values of those living there and celebrates local heritage.

Ashé's work in New Orleans has leveraged millions of dollars as a critical component to post-Katrina revitalization. While their arts programming remains their main focus, the organization's central role in community building and identity has allowed it to flourish and become a regional leader and hub of activity.

QUEENS MUSEUM OF ART – QUEENS, NY

One of the central case studies in this book deals with the Queens Museum of Art and its community engagement efforts. Another Shifting Sands project, notably, they too hired a community organizer as a means of blazing trails into the community. This position, along with a strong commitment by both the upper levels of leadership and the various departments within the museum, has allowed the Museum to become a trusted partner with community organizations of all kinds in the delivery of social services, development of local community identity, and re-imagination of physical spaces around the community. Over time, the role of these public partnerships has redefined how the Museum sees its mission and how it plans for long-term sustainability in times of financial instability.

REFLECTIONS

Each of these organizations already had some commitment to community embedded in their mission and goals. However, each organization has raised their profile and value exponentially through engagement with their communities. In some instances, these activities overlapped with arts programming, but in many instances they were complementary or supplementary to what they were accomplishing as arts producers. These benefits are of course on top of the amazing community changes they inspired:

- providing new resources to the community
- bringing disparate forces together
- raising the profile and increasing the economic prospects of their neighborhood through their economic development strategies and the celebration of their unique cultural assets
- placemaking and beautifying their neighborhood by investing in its aesthetic value.

CONCLUDING THOUGHTS

Being a Good Neighbor is more than just watering the lawn and fixing the roof. Similarly, being a Good Neighbor as an arts organization is more than just pretty signage and marketing. It is taking an active and interested role in the changes surrounding the institution and sharing resources for mutual benefit. It is recognizing that arts organizations have valuable assets beyond their programming; they have human resources (staff, volunteers, board members), facilities, equipment, expertise, and more. Being a Good Neighbor is not viewing the community as an 'other,' but

as a fellowship of players with similar and overlapping interests, and, based on that view, choosing to apply the organization's assets in ways that lead to more vibrant communities, support mutual interests, and yield healthier arts organizations.

To reiterate, the point of presenting these examples is not to describe projects to emulate but to show the results when arts organizations engage in community-oriented thinking. There is no single "correct" project or program. The options are as varied and individual as the communities and organizations out of which they will come. At the same time, there are some basic truths that apply in attempting to broaden the role of the arts and the base of support for them.

PRINCIPLES FOR EFFECTIVE ENGAGEMENT

INTRODUCTION

The first and most important principle in developing a broader role for the arts in a community is, somewhat simplistically, arts organizations believing that they should have one. The habits of thought for many artists and the organizations with which they work, as has been discussed at length before, often do not lend themselves to this point of view. Until arts institutions develop a compelling vision of community involvement, no real change is possible.

Generally speaking, this epiphany can be generated in one of two ways. First, upon consideration of the possibilities (including the examples given here), the merits of an expanded vision speak for themselves and prompt people to act. Many who work in the arts care deeply about their communities and believe that what they do has much to offer (although they have, perhaps, not thought about the practical benefits of the arts for addressing social problems). For them, exposure to the possibilities is sufficient inspiration for change. Second, the social and economic pressures facing arts organizations provide a pragmatic impetus for re-evaluation of the role of arts institutions. Seeking to avoid irrelevancy presents a persuasive argument for the expansion of organizational vision. However, for the latter path to prove effective, the leap must quickly be made to the inherent merit of the idea; otherwise the community will see the new interest in collaboration for what it is, a self-interested effort to avoid collapse rather than an honest attempt to be a responsible community citizen.

Whatever prompts the vision, it must be rooted in a belief that the arts should be a partner in everything that is important to a community–the messy as well as the sublime. Every arts organization should consider how it can contribute to the economy and social health of the region in which it exists. There will likely not be ways for it to address every issue of importance, but there are many more than most imagine today.

Becoming "a player" in the community will not be easy for arts organizations. A history of disconnectedness from ordinary affairs (the legacy of elitism) will need to be overcome. Demonstrating a track record of credibility in partnerships takes time.

However, it begins with organizational humility in cooperative efforts and a true sense of mutuality in any undertaking. There will be, at first, an inevitable suspicion that the only motivation is to increase ticket sales or contributions.

PRINCIPLES
Values, Vision, Mission

The bedrock of any not-for-profit institution is its mission. When arts organizations undertake a transformation as suggested here, a fundamental re-evaluation of the mission must take place. The question posed earlier, "How are the lives of members of the community made better by the work that you do?" provides a solid basis for imagining a broad-based mission. (In *The Nonprofit Strategy Revolution*, David LaPiana defines not-for-profit mission as "the social good the organization intends to create.")

At the same time, mission is an outgrowth of what are often even more deeply held principles. Organizational values and vision must be also subjected to the test of community service. To assist not-for-profits in articulating their values, an important question to be raised is, "What is the organization's responsibility to and relationship with its community?" The notion of responsibility is at the heart of the matter. Every not-for-profit should be a servant of its community. Raising this truth to consciousness is an important element in ensuring its relevance. An intriguing exercise to develop a community-focused vision is, "Describe the community in which the organization operates as you would like to see it ten years from now. How has this organization contributed to that?" Once again, the focus is on the community and *then* on the organization's role in it.

Mainstreaming

Community engagement is not particularly successful as an add-on program. In that position there is little or no budgetary support nor is there institutional energy behind it. Its true power lies in mainstreaming. Equally important, the "Not one more thing" objection to undertaking this work is a powerful deterrent to engaging with the community. The simplest, most organic approach is also the most effective.

Opportunity Cost

Virtually all arts organizations are constantly doing all that can be done with the available resources. As a result, in adopting a community engagement focus, it is important to examine the opportunity cost–the work not being done because of that which is–of existing programs, projects, and processes. In *Good to Great*, Jim

93

Collins discusses the merits of creating a "Stop Doing" list. Everything organizations do utilizes human and financial resources. The good crowds out the better or the best. If better, more mission-fulfilling alternative work is imaginable, current activities–even long-standing or beloved programs–should be eliminated in order to pursue those alternatives. Additionally, to be effective, community engagement should be a new lens through which all of an organization's activities are viewed, not as something extra. It should be mainstreamed as the core work. In this way, programming, development, marketing, and advocacy can simply be re-visioned as aspects of the larger purpose of connecting with the community. Extant personnel can be (slightly) retrained and administrative functions can be marginally retooled.

Re-visioning all the work of the arts organization as a subset of service to the whole community permits adaptive re-use of existing infrastructure. Development functions of visibility (marketing) and resources (fundraising and sales) become modes of taking the interests of the community seriously. Advocacy efforts flow from providing the community with direct examples of how the work of the arts is directly beneficial to them.

Programming

Most significantly, it is programming that is the cornerstone of community engagement. Arts organizations that take the concerns and interests of the community seriously and that present culturally, aesthetically, and topically meaningful reflective work of the highest quality will, over time, be embraced by that community.

But this transition in thinking is the most difficult step on the road to community engagement. As was pointed out earlier, engaging with the community will (must), at least to some extent, affect programming. So two issues need to be addressed. First, how vital is community engagement? This book lays out the case for the critical importance of connecting with broad constituencies. If it is important, then the means of making those connections *must* be pursued.

For the second, the concept of "reflective art" is helpful. There is great work in all the arts from all cultures. Shifting from one culture's expression to another's does not require sacrificing excellence. It does necessitate giving up intimate familiarity. The trade-off/reward is education–about other cultures and other ways of viewing the world–and the aesthetic value of great work that would have otherwise been unknown.

Before leaving this topic, a related issue should be addressed. Populations that arts organizations are attempting to engage expect (and deserve) to see their cultural expression and point of view represented in the programming of those organizations.

In an effort to ensure this, they request representation on the boards. This is not simply a request that persons of a particular racial or cultural heritage be included. It is a request made with the assumption that such individuals will be advocates for the cultural and community interests of the underserved group. What is sought is an advocacy that yields a more culturally accommodating organization. However, individuals are individual. Skin color or upbringing does not automatically yield someone who represents a cultural identity. In fact, since arts board membership is often associated with class (derived from the assumption that board members will be substantial donors) and education, individuals selected for arts boards are often far more representative of the cultural status quo than of any historically underserved population group. This can lead to frustration and bitterness on all sides, especially arts organizations that believed they were doing what was asked. It is important that, in attempting to diversify their boards, arts organizations understand the goals of that diversification and work to ensure that their selections help achieve the desired results.

Collaboration

Community involvement as imagined here rests upon establishing inter-organizational relationships and, out of those relationships, developing programming; in short, collaboration. In some instances, this will mean work in areas where the organization has no reputation. It will begin *tabula rasa* to make contact and seek new opportunities. In others, it will be forced to overcome negative stereotypes about the arts or, worse, specific legacies of indifference or mistreatment. Needless to say, relationships are not formed quickly under any circumstances.

Self-Reflection/Readiness

While the details will be elaborated upon below, readiness on the part of all collaborators is an essential foundation for partnership. Funder mandates, community pressure, or a simple sense of obligation can be persuasive initial motivators. They are not, however, of themselves sufficient to sustain the difficult work of marshaling multiple organizations' resources to a common end. Mission-driven commitment to the project and experience in the process of cooperative enterprise are essential bases for success in such endeavors.

Evaluating Resources

An almost inevitable response to the notion of change is that arts organizations are stretched beyond their limits as it is and the addition of any other focus, especially

a labor- and time-intensive one, is out of the question. The real question, though, is, "What *is* the question?" If what has been presented here suggests that change is essential, not changing is unacceptable. That means the question is "How?"

The status quo for any not-for-profit arts organization is an extremely delicate balance of programming and support. The nature of such institutions is that everything that can be done will be done. Even subtle shifts can upset the equilibrium. A departure as significant as that suggested here *is* fraught with peril.

Re-imagining the nature of the relationship between the arts organization and the community can provide funding opportunities that did not exist before. Individuals, corporations, and foundations that are not particularly interested in arts funding can be much more interested in arts-based work that promises real social dividends. That has been the experience of the Oakland-East Bay Symphony and the Roadside Theater Company. While the competition is great for such dollars, there are more to be had than in strictly arts-oriented funding. (In addition, seeking an expanded role for the arts will have a direct affect on marketing, opening up new possibilities for ticket sales and attendance.)

The urgency for change suggested here demands a clear-eyed evaluation of whether all the programs currently being offered truly need to be offered. There is a possibility that a modest cut-back in programming could be undertaken, redirecting resources toward activities designed to open the organization more fully to the community. For instance, does the six-play theater season need to be six? Would five suffice if funds ear-marked for the sixth could be creatively applied to more directly building a better community?

Finally, an assessment of the organization's relationship-building assets should be undertaken. Consideration should be given to what relationships already exist between community members and groups and the organization's professional staff, volunteers, and board members. In addition, it should be determined what gifts for relationship development those people possess. A potentially invaluable resource is board members, committed to the concept of broadening the reach of the organization, acting as ambassadors to establish and nurture inter-organizational relationships.

Rocking the Boat

But there can be no denying that some loyal constituents will not be interested (at least at first) in embracing change. Their commitment to the organization is to its programming as it currently exists. Change, especially change that incorporates art from non-European cultures, may well turn them away. The only real antidote to this

reaction is a carefully reasoned and clearly presented rationale for the change. The case presented at length here, shortened and simplified, can prove compelling even to those most committed to the status quo. They need to understand it as a transition to the future of the art and, in particular, the organization. The work they love can and will be preserved, but to do so, the organization must expand its base of support and increase its relevance to the community.

Fortunately, just as the relationship building process must take time, the transition to a more community-oriented approach to programming can also be done gradually. In fact, too rapid a change might not be well-accepted by newcomers. The groundwork for lasting relationships is not quickly prepared.

Mutuality

The bedrock of any collaboration is that it is beneficial to all parties. It is important for both the arts community and the broader community to understand how partnerships can be helpful. Initially, the community benefits of this work may be somewhat more readily apparent, although for the most part, few people outside the arts have experience seeing the arts as a tool to aid community health and development.

"Process" and "Product"

Most arts and community engagement workers at some point make the case, in efforts to engage the community, for the process-especially process involving community participation-having importance along with the product. This idea needs some explanation because for many in the arts establishment, process is almost never seen as being of significant value. The only conversations that come close deal with chamber music ensembles (most often string quartets) where the importance of "feeling as one" and the process of achieving that-"practice, practice, practice"-are acknowledged as significant contributors . . . to the product.

For many artists formally trained in European traditions, it is only the product that matters. It is the product-the art itself-that trumps all, sometimes even the audience and *its* experience. This attitude is seldom spoken; indeed, it is so ingrained as to be infrequently even thought. To suggest that the artistic process could be more important than (or even as important as) the product is to some minds revolutionary. This is the central reason that a disconnect exists between the not-for-profit arts industry and substantive community engagement. Artists like to be valued, so something significant in the system must be standing in the way of them moving heaven and earth to connect

with people, large numbers of people. Elitism and its stepchildren, condescension and class divisions, are certainly barriers. But where a central premise of the arts is that it is the art that is most important and all else is secondary, there is a structural barrier of immense proportions between that art and the community in which it exists.

If process *is* important, some thing or things must have significance in addition to the art itself. The real need is to articulate what those things are. Fortunately, it is not a difficult list to construct and, with a little thought and encouragement, artists can fairly quickly get on the path to "Aha!" Healthier communities (*e.g.*, enhanced social capital–more and stronger relationships, greater cross-cultural understanding) and healthier individuals (*e.g.*, heightened sense of self-worth, enhanced self-esteem) are relatively easy to grasp as benefits of focusing on and valuing process in the arts. These are easy benefits to understand and easy to connect with the arts.

Another important issue is who is included. When community engagement workers discuss process, they are almost always referring to arts experiences in which participation is welcomed from outside the narrow circles of technically skilled artists. This, of course, raises the issue of quality; but since the case that quality and community are not mutually exclusive was made early in this book, it need not be repeated here. And, as will be shown later, inclusive processes can yield exceptional artistic results. (See especially, Liz Lerman's "Hallelujah" project, the Queens Museums of Art's *Launch Pad* projects and community-curated exhibitions, and HGOco's Home and Place partnerships.)

Product and process are not either/or choices. Indeed, the best community engagement work stunningly hits both bullseyes. It is not necessary or even desirable to make the product/process mix be 50/50. The goal, as a path to engagement, is simply to value process and elevate it to active consideration in the established arts world.

How Can Community Arts Projects Help the Community?

Community arts projects can serve several functions. They can assist in communication about issues, raising the visibility of community concerns. They can clarify an issue or provide it with focus by crystallizing it or by giving it context. They can serve to support calls for change by serving as a catalyst for community mobilization. And they can humanize an issue, putting a face on what may to some be an abstract problem.

Such projects can also be vehicles for action to address the causes of problems, as well as for supporting education, reducing recidivism, and promoting dialogue and

understanding in the face of community unrest. And, as has been demonstrated, arts activities can directly address economic development issues.

This is neither an exhaustive nor definitive list, but it does illustrate that there are practical benefits to the community to be had in community arts projects. In addition, this mode of thought does give some answer to the perennially provocative question, "Why should we support the arts when people are hungry?"

How Can Community Arts Work Help the Arts?

For some artists, as a result of the lack of exposure to examples of this work, the benefits to "the arts" of community arts projects are less clear. Nevertheless, those benefits are every bit as consequential as the community benefits. This work can significantly enhance the climate for the arts. Some projects, due to their hands-on nature, increase direct participation in the arts. Others, due to their visibility to new constituencies, increase the reach of the arts in the community. As has been mentioned before, arts projects that have a community orientation can gain access to funding sources-individual, foundation, corporate, and governmental that would otherwise not be available. They can enhance cultural and organizational vitality by opening up access to new communities. And they can, in general, improve the credibility of and community support for the arts.

Community-focused arts projects can also improve the lives of individual artists by opening new outlets for their work, expanding the palette of artistic options available to them, stimulating work in new genres, and facilitating their growth as artists by bringing them in contact with a broader range of people and cultures.

Again, this is not comprehensive overview of the merits of this work for the arts. It merely serves to highlight the fact that the arts stand to benefit from community arts projects in significant ways.

CHAPTER SIX

PREPARATION AND PROJECT DEVELOPMENT

THE PROCESS OF ENGAGEMENT

Successful collaboration for community-focused arts projects involves partnering between "unlikely suspects." There is little tradition of arts organizations developing on-going reciprocal relationships with non-arts entities. When a commitment is finally made to undertake the effort, participants can be anxious to "get working." This impatience ignores the fact that what is sought is a relationship. No two individuals become best friends instantaneously. Relationship building is a process that takes time. This is no less true for organizations than for individuals. Moreover, in this work there are often obstacles to relationship that must be overcome before the type of projects outlined here can be developed.

WARY STRANGERS

Engagement, as a prelude to collaboration, is, at its essence, built on the development of relationships. These may be between individuals, between an individual or individuals and a group or groups, or between groups. The engaging artist or arts organization will have skills in building relationships. Unfortunately, the arts and non-arts communities often approach each other with misgivings. They often can be described, at best, as wary strangers.

The Legacy of Privilege

One of the prime sources of this wariness is the often unspoken truth that the established arts industry, as a result of its history, has been a province of the elite. Howard Zinn, in *A People's History of the United States*, documents a nineteenth-century riot in New York City in which a mob attacked the Astor Place Opera House, shouting, "Burn the damn den of aristocracy." As discussed earlier, the financing mechanisms that developed to support the arts in this country have resulted in an arts infrastructure in which decisions are largely made by and for those with the money to support that structure. This has inevitably insulated the arts from the broad populace and served

to create a barrier between them and the arts. The result has been a combination of antagonism, mistrust, or indifference.

This separation has led each side of the divide to be isolated from the other. Often, the not-for-profit arts community does not fully see itself as a member of the larger 501(c)(3) community service world. And community members and organizations similarly see, when they think about it at all, the arts as an "other" that has (and can have) no direct relation to their work.

Reasons for wariness

Some in the arts world are concerned about potential negative impacts of community-focused arts. There is fear that, since the arts will be used in the service of other causes, the importance of artistic integrity will be minimized. Some fear being misunderstood. In addition, due to a lack of awareness of models of or experience with this work, there is simple apprehension of difference in considering collaborations with non-artists.

Community members and organizations similarly lack models and experience and are also apprehensive about the prospect of working with artists. Their apprehension is exacerbated by a fear that they will be faced with ridicule from the arts community for not "getting" the ideas an artist might propose. And, of course, there are circumstances where community members mistrust the arts community based upon negative experiences, often related to issues of class.

Neither side is fully blameless or fully culpable for this wariness. It is simply a reality that must be addressed directly in the process of developing a relationship and which will continue to be a background element of the relationship until new habits of mind are created by experience.

READINESS (SEPARATELY)

No collaborative process can be successful if the participants are not prepared to collaborate. In organizational collaborations, readiness is a factor not only of management capacity but also of the mindset of the participants, the preparation for cooperative effort, and the outcomes sought. For arts organizations, a special concern, first introduced in the early pages of this book, is the tendency to conflate marketing with community engagement. Coupled with this is a worrisome and too common assumption that the organization already knows all that it is necessary to know (or worse, that it does not need to know) about a community's needs and interests. The foundation of effective community engagement for arts organizations is a mindset that

the engagement will be a process in which the institution works *with* the community, not *for* it.

Beyond that, the following two lists outline basic premises that are essential qualities of partners in community-focused arts projects.

Artists/Arts Organizations

1) They view their product as something that has as its role to serve the people, not the other way around.

2) They emphasize grassroots arts activity that is based directly upon the experiences of the people who attend their performances.

3) They are seen, individually and collectively, as approachable members of their community.

4) They have genuine respect for the large majority of their audience who are uninitiated in the traditions and language of the arts.

5) They understand the potential that the arts have for improving the lives of the members of their community.

6) They have the humility to know that they do not know what is best for the communities with which they work. It is the *communities* that know.

Community Organizers/Organizations

1) They are committed to service and community betterment, not to themselves.

2) They know that the wisdom of the community comes from the bottom up, not from the top down.

3) They see themselves as peers and partners in the community with which they are working.

4) They have genuine respect for artists who will meet them as partners in community improvement work.

5) They understand the potential that the arts have for improving the lives of the members of their community.

6) They have the humility to know that they do not know how the arts might best accomplish the goals they have for their community. It is the *artists* that know.

Successful community-focused arts projects begin with participants operating from these basic positions.

DISCOVER WHAT YOU DON'T KNOW

After potential collaborators are individually prepared, there is a requisite step to be completed before the full work of relationship building can begin. Each

participant must discover what they do not know about their intended partner and about that partner's world. Simply raising this issue goes a long way toward addressing it. Acknowledging that the assumptions, experiences, and worldview of another are different from one's own forms the fundamental basis for pursuing the next step in the process. The arrogance of the alternative, consciously or unconsciously assuming that there is nothing to be known, will block the possibility of success in the projects undertaken.

BUILD A RELATIONSHIP/TRUST

At the risk of excessive repetition, relationship building is a difficult, time-consuming process, especially so in this context. In over-simplified terms, there are three steps:

1) Meet: This is the initial step. While it is perhaps not a literal first meeting of participants, this should present an opportunity to learn what is not known. Additionally, where there is "baggage" to be overcome, this is the time and opportunity to work it out.

2) Talk (Share Stories): Listen to and learn about the backgrounds and history of the organizations and individuals who will be participating. Discover what motivates each participant and what resources they bring to the potential project. In particular, note similarities in values and vision and pay attention to (and find ways to value) differences in perspective, experience, and motivation.

3) Work: Develop, implement and evaluate collaborative program(s). [See steps 6, 7, and 8 of the Eightfold Path.]

Another, substantially different, way of organizing thoughts on this subject is presented below: The Arts' Four Noble Truths and The Eightfold Path of Community Engagement.

[NOTE: As part of the initial set of posts on the blog Engaging Matters, I first playfully devised a riff on Buddhism's Four Noble Truths and the Eightfold Path. This did not grow out of any disrespect for Buddhist tradition, quite the contrary; it simply seemed like a good framework for highlighting the importance of engagement and the intentionality required in relationship building for this work. As the concept evolved, it became clear that there was unanticipated merit in the construction.

To give credit where it is due, the ideas out of which the Eightfold Path emerged came from Nello McDaniel and George Thorn's book *Learning Audiences.* In it they outline six disciplines to follow for successful relationship building, disciplines directly

applicable to building functional partnerships. Some of those six disciplines served as the basis of steps on the Eightfold Path.]

THE ARTS' FOUR NOBLE TRUTHS

1) Life in the arts as we know it today is suffering.
2) The origin of that suffering is insufficient attachment to community.
3) The cessation of suffering is attainable by engagement with the community.
4) Freedom from suffering is possible by practicing the Eightfold Path of Community Engagement.

Clearly, the first will bring a wry smile of recognition to the face of almost everyone who has spent even a day in the world of the arts. A life in the arts is rewarding, but this side is real. The second and third say in two sentences what the first 30,000 words of this book do, just far more succinctly. The Eightfold Path simply amplifies on the Meet/Talk/Work framework presented above.

THE EIGHTFOLD PATH OF COMMUNITY ENGAGEMENT

WISDOM

1) **Belief: know and trust that engagement is good for the arts and good for the community**
 No work in this field can be successful in the long term unless those involved truly believe it should be done. This cannot be entered into as "window dressing." It must be and seem real.

2) **Commitment: provide, ungrudgingly, the time and money that engagement requires**
 The early stages of relationship building should not immediately yield big projects. Be patient. Persevere.

RELATIONSHIP

3) **Fidelity: become a valued partner by listening/helping**
 Respect your partner. Establish dialogue. Listen. Be at the table willing to learn. Do small things together to build trust and avoid the ennui of "all talk." As in successful personal relationships, avoid hidden agendas; acknowledge the value of establishing a relationship for its own sake.

4) **Knowledge: learn what is important to the other**

As but two examples, discover what issues are important to the partner and in what things does the partner have a sense of pride?

5) **Insight: discover areas of mutual interest**

What arts activities touching on things important to the other are possible? Determining this can only be done after a relationship has been established. Only then is it possible to be aware of what might have meaning to those with whom no previous relationship has existed.

6) **Collaboration: develop and implement mutually beneficial project(s)**

Create and carry out an arts program or activity that is the contribution the organization can make to its community.

EVALUATION

7) **Assessment: gather feedback and performance data, determine successes and areas for improvement**

Articulate the values driving the process, review the outcomes sought, collate the results, consider resources used and results attained, celebrate accomplishments, identify elements to improve or abandon.

8) **Reformation: continually improve the quality of the relationship and of collaborative activities**

Make the changes suggested by assessment: build on successes, improve where needed.

Relationship is central to every aspect of engagement. Creating, maintaining, and improving interpersonal and inter-institutional relationships is the core of the work. While these two lists were originally conceived as a light-hearted way to present ideas about the relationship-building process, they have merit as tools for explanation.

It is human nature to want to rush each step on the path. The single most important warning here is that the time required *must* be taken. Programs offered to new constituencies that are not based on a real understanding of them will be at best unsuccessful or at worst serve as a source of resentment.

DEVELOP PROJECT(S)
Project Parameters
Arts-Centered or Issue-Driven Project

Once a topical idea has been selected for a community-focused arts project,

the project needs to be designed to maximize its potential impact. At the outset it is important to bear in mind the fundamental nature of the project so that "mission creep" does not occur. For instance, is the project going to be arts-centered or issue-driven? In other words, is it, at heart, a work of art being utilized to address a community need (*e.g.*, a production of *West Side Story* through which issues of immigration are examined) or is it a community issue being addressed through an arts experience (*e.g.*, issues of crime highlighted by art placed at crime scenes). Arts-centered projects are often developed by established arts organizations taking an existing work and using it as the centerpiece of a community arts project. Alternatively, an arts organization can commission (or an individual artist can create) a work that in itself may not be primarily "about" an issue but in the context of its presentation can address it. Issue-driven projects have the art grow out of an issue, either in newly created work or in the re-production/presentation of existing issue-based work.

Artist, Non-Artist, or Combined Creation

Further, what is the nature of the arts component? Does it focus on community members making art, artists making art, or some hybrid in which an artist or artists and community members work jointly or in parallel? While the answers to these questions (especially the second set) can evolve in the course of program design, it is helpful to resolve them up front to support clarity in the development process.

Program Design

There is no single best way to design a program or project. What follows is a description of one possible process. The Feedback section is taken from material presented by the staff of Animating Democracy at their Arts and Civic Engagement workshop. (Animating Democracy is a program of Americans for the Arts.)

Thoughts on the Nature of the Arts as
Related to Community Arts Projects

The different arts have vastly disparate characteristics. While generalizing leads directly to over-simplification, there may be some merit in quickly outlining differences that may have an impact on their merits for specific community arts projects.

The performing arts take place in time. Participants and observers, to experience them, need to be in a particular place at a particular time for a particular duration, unless, of course, they are recorded and presented at another time. Even then, however, the experience takes the length of time that it takes. They gather groups of people

(performers and audiences) together. In addition, live performing arts events are different each time they are presented, even if the basic "text" of the experience is the same. (No two live performances of a piece of music are ever identical.)

More specifically, theatre uses the vernacular language of its culture and is ideal for presenting and examining contemporary issues. Music and dance reflect deep cultural roots and are thus sometimes more understandable across cultures than theatre. Particularly when abstract (like instrumental music), they can be excellent vehicles for cross-cultural sharing and for developing an appreciation of differences. A further thought on music differentiates between vocal and instrumental as well as solo and ensemble. Vocal performance does not necessitate purchase of an instrument; ensemble performance is available to more people. For participatory projects, vocal ensembles provide the greatest access to the most individuals.

The visual arts are not as time-bound as the performing arts. Works have a form and presence for extended durations of time and are (usually) not dependent upon viewers being in place at a particular time. They have, thus, an advantage over dance, music, and theatre in extended presence. Representational art (with photography being a particularly accessible example) is an ideal way to illustrate conditions in need of change. Abstract art can express feelings about a subject in a particularly powerful way. Public visual art can be a place marker or serve the role of setting a particular location apart.

While not a genre, public art is available to all members of a community. Visual public art has a long history of celebrating or memorializing important people or events in a community. It can serve as a gathering point, a source of pride, or a means of helping a community bond around a common identity. Public art that is performance (from outdoor concerts to street theatre to flash mobs) can highlight issues, raise awareness, or provide a shared bonding experience for observers. By its relative infrequency it can be a particularly effective method of gaining public attention.

Preliminary Work

Begin by examining the basic parameters of the partnership in its current form. Consider whether any additional partners should be involved. Honestly evaluate whether any outstanding issues of organizational or individual trust need to be resolved or whether there is any history around the issue being addressed that needs to be more fully aired.

Prepare a preliminary description of the project. Determine whether all relevant organizational leadership is supportive of the idea. Ensure that the details of the project

are clear. In other words, write a description that can be immediately understood by someone not involved in the project.

Programming Principles

Arts activities must be culturally accessible for the populations the project seeks to reach, the formats and the venues accessible. Individuals not familiar with the arts need to be made comfortable with the physical environment as well as the social conventions of the arts event. In some cases this may suggest addressing or altering those conventions–"acceptable" dress, when to (and not to) applaud, etc. These principles do not mean "dumbing down" the experience; they simply mean recognizing that norms and experiences taken for granted in the arts world are not universal. In addition, traditional modes of marketing arts events are often not productive for community arts activities. Oftentimes it is necessary to go more directly to the people whose participation is being sought. The case study of the Pillsbury House Theatre gives good examples of what they call Gateway Experiences and Street Presence designed to welcome newcomers to their events.

In community arts work, it is important to remember that the arts event is never an end in itself. Stand-alone arts activities do not adequately support engagement because they do not allow opportunity for dialogue and relationship building. Successful community arts projects have a component of continuing opportunity for reflection. This can be as simple as holding post-performance discussions or as intensive as nurturing supper discussion groups, fostering advocacy committees, or hosting community forums on the topic of the project. When appropriate for the demographic being targeted, social media provide an opportunity for continued discussion of an issue. For this reason, it is not inappropriate to think of this work as Arts 2.0. Push-Pull relationships (information dissemination-feedback) are the ideal, just as in the case of what is referred to as Web 2.0. For the artists and arts organizations involved, this has the added benefit of building relationships with the participants.

Feedback

A helpful approach to program design is to convene a small committee of outsiders to give feedback on the potential project. This group can be presented the draft description of the project in advance of a face-to-face meeting to examine it for clarity. Then, in the meeting, one of the project designers can describe the core idea and get feedback about what the particularly valuable or striking elements of the idea are. The

project designer can then present questions s/he has about the idea and seek feedback from the group. The group should put "What if . . . ?" questions to the designer, emphasizing additions or alterations that could make it more effective or more exciting for participants. The project designer should explain the basic intent and ask further questions seeking advice on enhancing effectiveness. All meeting participants should examine the intended outcomes of the project, addressing in particular the questions, *"What are you toasting at the successful completion of the project? What positive change has occurred in the world as a result of this project?"* All should then consider what arts resources and what community resources are required to implement the project. Finally, the project designer should get feedback on the questions, "What do I not know that I don't know?" and "Who else should be involved?"

CHAPTER SEVEN

EVALUATION

Evaluation is often the last element of program development considered in the arts, if it is considered at all. Artists and their support systems are so aware of the intangible benefits of the arts that there is an intuitive sense that they are unmeasurable; and the task of presenting the arts is so resource-intensive that the thought of adding something to it, especially when it seems of dubious value, is viewed as a waste of resources.

The public's increasing demands for accountability are often cited as an explanation of the need for evaluation in arts projects. That is a valid argument. However, it is not the sole or, perhaps, most important one. Over the last two decades, research into the economic impact of the arts has been broad and strong enough that the positive messages have filtered (to a degree) into public consciousness. The research has yielded positive results in public policy. The criticism that economic impact has become the sole or primary justification for public support of the arts, especially in light of the fact that much of the research does not demonstrate why the arts are superior to, for instance, professional sports in economic impact, is valid. The truth is that economic impact is touted because we have documentation. Americans for the Arts' Animating Democracy program is a leader in a second wave of impact research, this time focusing on areas that may feel more comfortable to the arts community. The program's efforts in social impact research will over time do for the social value of the arts what economic impact research did for economic value.

The following chapter highlights Animating Democracy's work in evaluation. It provides an introduction (and links) to much good work on evaluation. It also makes the case for another powerful benefit of evaluation. The process of planning for evaluation, when part of the initial program development process, will inevitably improve the program in addition to positioning it to be effectively evaluated.

EVALUATING IMPACT/APPRECIATING EVALUATION
by Pam Korza and Barbara Schaffer Bacon

IMPROVING MUNICIPAL GOVERNMENT THROUGH ARTS-BASED ENGAGEMENT: A GOLDEN STORY ABOUT IMPACT

On a sunny July day in 2011 in downtown Portland, Maine, Mayor Nick Mavodones is poised before a brightly painted mural. He announces to the press and the community that Portland's Art At Work [http://www.artatworkproject.us/] program has been selected as a recipient of a $100,000 grant from the National Endowment for the Arts. The Our Town grant [http://www.nea.gov/grants/apply/OurTown/index.html] supports creative activity that fosters public/private partnerships that strengthen the social, economic, and physical characters of neighborhoods. The grant will extend the scope of Art At Work which seeks to improve municipal government through strategic arts projects with municipal employees, elected officials, and local artists.

Artist Marty Pottenger, who created Art At Work through her arts nonprofit, Terra Moto, Inc. [http://www.artatworkproject.us/terramoto/] and in partnership with the City of Portland, takes the podium next. From her perspective, having worked with Portland's city workers for four years, she underscores that, "The biggest asset any city has is its human capital. In our case, these are our Portland residents and our city workers. . . . And one of humanity's core elements and engines is creativity. I thought, what if people in local government could connect to this place of creativity in themselves when they're actually forming policy; when they're thinking of practical ways to keep things in a forward moving direction."

Assistant Chief of Police Mike Sauschuck, "not surprised" by this national recognition, steps up. He has personally been involved in the Police Poetry Project along with fellow police officers who worked with local artists to write poetry about their work and lives and to share them via an annual calendar and through public readings and dialogues. The aim of this project is to improve department morale and public perception of the police. "After four years, I couldn't be more impressed with the outcomes that we've had in the community, within our own hallways, and personally." Sauschuck also cites a recent play which police officers performed with immigrant youth. "Interaction with the community has certainly improved. This project has allowed the citizens to see police officers beyond the uniform as human beings with feelings and thoughts."

This paper was written for the book and online source, Building Communities, Not Audiences: The Future of the Arts in the United States, *edited by Doug Borwick and published by ArtsEngaged, 2012.*

Mayor Nick Mavodones acknowledges the power of art in what can be exhausting and even dangerous work that often goes unappreciated by the public. "Our city workers, the things they deal with on a day-to-day basis, they've been able to express through art. This project has been a bridge to the rest of the community."

Using visual art, performance, poetry, photography, video and audio, Art At Work has succeeded in fostering a culture of creativity that has directly involved over 60 city employees and 30 local artists. Employees in Police, Public Works, and Human Service departments have created 200 original artworks that have engaged over 25,000 people in the region and reached over a million through local and major media outlets. Their posters, photographs, prints and poems hang in galleries, city parking garages, lunchrooms, recycling centers, police stations, libraries, conference rooms and maintenance shops. The program has been nominated for a National League of Cities Best Practices award (2009) and selected by the Mayor to represent Portland in the NEA's Mayors' Initiative (2010).[1]

Finally, Anne Haskell, Maine House of Representatives, takes the stand. She testifies to the importance of telling stories to get to know each other–to reveal, "not only the stories of work but the stories of who we are as individuals." "The police calendar," she says "really helped to foster communications and connections that might not have been fostered absent the impact of that art."

This grant award, these testimonials by civic leaders, the numbers of Portlanders reached, and the effects on city workers of Art At Work are golden. They happen in the context of a city, like thousands of others, that are facing increasingly complex municipal challenges and diminishing resources. The arts-based civic engagement work in Portland, as the Art At Work website [http://www.artatworkproject.us/] confidently proclaims, has successfully demonstrated how "artmaking is a valuable, cost-effective and sustainable vehicle for strengthening cross-cultural understanding, enhancing communication, raising morale, and increasing understanding and cooperation between city agencies and the public."

To view the Our Town announcement press conference, see [http://www.youtube.com/watch?v=FCvmyR_ea1l&list=UULuUWi6Of3wyXMgnLHKLXFg&index=3&feature=plcp]

A CONTEXT FOR EVALUATION

As Portland's leaders and workers have discovered, art is a powerful force for illuminating civic experience. For over a decade, Animating Democracy[2] [http://www.animatingdemocracy.org] has been exploring this power by observing community-

based arts endeavors nationally, and more specifically, those with explicit civic or social goals. Art has a unique capacity to communicate beyond the limits of language, express difficult ideas through metaphor, and creates indelible images. The arts open hearts and minds. We have seen how artists and arts organizations are strong partners with civic organizations and other sectors, applying the power of both creative process and product to foster productive dialogue and engagement within and between groups. The arts inform and empower. They can broaden citizen voice and participation, give disenfranchised groups access to the civic realm who had not felt welcome, enhance public understanding of complex and often divisive issues, and motivate people to make change. The arts serve as catalysts, conveners, forums, and forms of civic engagement and social change.

While the potency of the arts as a contributor to civic and social change is widely observed, arts practitioners are increasingly asked to substantiate beyond anecdotal evidence how investments in arts based civic engagement lead to positive change in communities.

Funders experience greater pressure, too, to demonstrate the impact of their investments. Likewise, civic organizations, community organizers, and policy makers who have the power to include the arts in community efforts and to allocate resources need to be convinced that the arts add value to impact.

As arts organizations and artists try to meet this challenge, they are pressed to define what is meant by "civic" or "social" impact, whose standards to apply, what evidence to look for, and what to document and track. They wonder how to gauge hard-to-measure outcomes such as shifts in attitude or understanding and whether they can attribute civic outcomes to their community arts efforts, exclusive of other factors. Recognizing that some outcomes might not be felt until well after a project concludes, many ask what they realistically can do to track evidence of change over a longer term. With limited staff and financial resources to support the demands of serious evaluation, efforts are often constrained, even with the best of intentions.

Arts practitioners most often do program evaluation focusing largely on what worked and didn't about program design and implementation. Some have gained skill and/or partnered with researchers to demonstrate the economic effects of their work. Arts practitioners consistently find it more challenging to assess community level impact, particularly against the less tangible social or civic changes that have been defined. But, without more concrete evidence, the arts' full contribution can be undervalued if not missed entirely.

Despite the challenges, there are things that arts practitioners and their partners can do and choices they can make in focusing on evaluation, starting with defining clear and reasonable outcomes that the creative work is suited to achieve and determining what indicators or evidence of change to look for. This chapter focuses primarily on these fundamental aspects of evaluation. It is not a how-to guide but rather establishes why evaluation is important, useful, and doable!

Stories and resources referenced in this chapter come from Animating Democracy's Arts & Civic Engagement Impact Initiative. [http://animatingdemocracy.org/impact-initiative] The Impact Initiative works to advance understanding of and help make the case for the social efficacy of arts-based engagement work. Among its goals is to strengthen the capacity of practitioners to assess and describe social/civic outcomes. The two stories in this chapter emerged from the initiative's Field Lab which paired practitioners with evaluators to examine how to gauge and describe social change outcomes of their work. The initiative coalesces tools, frameworks, writings, and other resources on Animating Democracy's IMPACT web site [http://animatingdemocracy.org/home-impact] that have valuable application for community-based arts endeavors.

DIAGRAM 1: CONTINUUM OF IMPACT

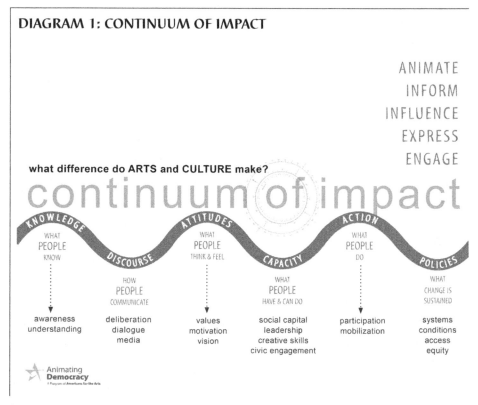

Several papers and resources are referenced that provide both practical and theory-based investigation of concepts introduced here.

CIVIC OUTCOMES FOR ART AT WORK

In Portland, artist Marty Pottenger wanted to know what changes in public perception of Portland Police occurred once the poetry calendars appeared across the city and the public had a chance to attend readings and dialogues with the police. She wanted to understand what, if any, shifts in morale took place within the Police Department that could be attributed to Art At Work as well as how government leaders would view the role of art in improving municipal government.

She knew that the program's civic outcomes would have to be measured and supported with evidence meaningful to key stakeholders-city government and department leaders, workers, and the public-if the program was to continue beyond Portland's three year commitment and with greater public dollar investment.

Pottenger therefore jumped at the chance to work with researcher and evaluation professional Christine Dwyer of RMC Research, based in Portsmouth, New Hampshire

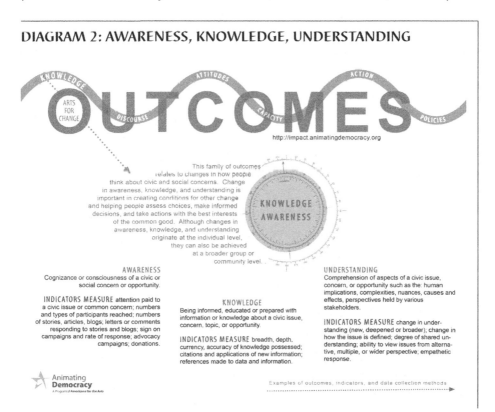

DIAGRAM 2: AWARENESS, KNOWLEDGE, UNDERSTANDING

OUTCOMES

KNOWLEDGE · ATTITUDES · ACTION · ARTS FOR CHANGE · DISCOURSE · CAPACITY · POLICIES

http://impact.animatingdemocracy.org

KNOWLEDGE AWARENESS

This family of outcomes relates to changes in how people think about civic and social concerns. Change in awareness, knowledge, and understanding is important in creating conditions for other change and helping people assess choices, make informed decisions, and take actions with the best interests of the common good. Although changes in awareness, knowledge, and understanding originate at the individual level, they can also be achieved at a broader group or community level.

AWARENESS
Cognizance or consciousness of a civic or social concern or opportunity.

INDICATORS MEASURE attention paid to a civic issue or common concern; numbers and types of participants reached; numbers of stories, articles, blogs; letters or comments responding to stories and blogs; sign on campaigns and rate of response; advocacy campaigns; donations.

KNOWLEDGE
Being informed, educated or prepared with information or knowledge about a civic issue, concern, topic, or opportunity.

INDICATORS MEASURE breadth, depth, currency, accuracy of knowledge possessed; citations and applications of new information; references made to data and information.

UNDERSTANDING
Comprehension of aspects of a civic issue, concern, or opportunity such as the: human implications, complexities, nuances, causes and effects, perspectives held by various stakeholders.

INDICATORS MEASURE change in understanding (new, deepened or broader); change in how the issue is defined; degree of shared understanding; ability to view issues from alternative, multiple, or wider perspective; empathetic response.

Animating Democracy
A Program of Americans for the Arts

Examples of outcomes, indicators, and data collection methods

as part of the Arts & Civic Engagement Impact Initiative [http://animatingdemocracy. org/impact-initiative] developed by Animating Democracy. Pottenger and Dwyer had the opportunity to team up in the initiative's Field Lab to explore together how to gauge and describe the social outcomes of Art At Work activities. They worked over a period of a year using an evaluation framework developed by Dwyer to systematically define outcomes and indicators for the Police Poetry Project. Their learning was documented in an Art At Work Evaluation Plan [http://animatingdemocracy.org/ resource/evaluation-plan-art-work-terra-moto-and-city-portland-me] so that others grappling with similar questions could gain insights and approaches from their collaborative inquiry.[3]

WHAT DO WE MEAN BY SOCIAL IMPACT? DEFINING OUTCOMES

In conventional program evaluation for a performance or artist residency, arts organizations might document the numbers of participants and audience members, assess how the program helped to meet organizational goals, such as education about art forms, or assess community members' experience of the art form in terms of joy and fostering interest in art. Artists, curators, and programmers are often interested in the success of the artistic product in terms of aesthetic investigation, advancing a genre or type of work within the field, or contributing to artistic methodology or practice. In community-based arts, where community members are engaged in informing and often creating the work, goals related to actually engaging in art, individual transformation for participants from that engagement, reaffirming cultural identity, and community-building often come into play.

Based on Animating Democracy's research, arts practitioners and their partners most commonly aspire to and achieve *social or civic outcomes* that fall into one or more these six "families":

- Enhanced awareness, knowledge of social or civic concerns;
- Improved public discourse around issues;
- Clarified values and confirmed or shifted attitudes;
- Increased capacity—skills, resources, status—to engage in civic concerns;
- Increased and more effective participation and action; and
- Improved systems and policies that ensure social justice.

Diagram 1 shows what difference arts and culture can make along a continuum of these kinds of social outcomes.

The wavy line suggests that these outcomes are not necessarily sequential within a project or across an arts organization's many efforts. Nor is there a hierarchy of

importance among these outcomes. Relationship building among fragmented and uninvolved residents may be the most critical need and desired outcome of a neighborhood arts project because it will help to build civic engagement capacity for a range of endeavors. In another context, policy change around an issue of environmental justice may be paramount.

With the help of evaluator Suzanne Callahan, Animating Democracy developed a set of definitions for each of the six outcome families above. Diagram 2 shows definitions related to the Knowledge and Awareness family. Such definitions can help to isolate and more clearly articulate the type of change(s) that is at the heart of a project or an organization's work.

For definitions of all six families of outcomes, see. [http://animatingdemocracy. org/social-impact-indicators/typical-social-and-civic-outcomes]

Because civic engagement and the creation of human, social, and community capital[4] are acknowledged as the place where the arts make perhaps their greatest contribution to social change, it is important to understand such effects in order to discover the best approaches to measurement and casemaking. These effects include: heightened awareness or deepened knowledge of civic/social issues; increased understanding of other perspectives; increased or more diverse participation; increased capacity for engagement and dialogue; new relationships built and/or existing relationships strengthened; and connections made that cross-institutional boundaries such as policy domains or sectors.

SHIFTING ATTITUDES THROUGH THE POWER OF THEATER: THE STORY OF LOW

The Hip Hop Mental Health Project (HHMHP) was an initiative of 1+1+1=ONE, a Brooklyn-based nonprofit founded and led by artist Rha Goddess [http://www. youtube.com/user/rhagoddess] that utilizes the methodology of Arts Based Civic Transformation to empower individuals and communities to affect positive social change. At the center of the HHMHP was a one-woman performance titled LOW, created and performed by Goddess. In it, she depicts the very human reality of mental illness in our culture by fusing monologue, movement, and music to tell the story of a vibrant young woman's all too common journey through the mental health system. Through the touring theater piece and structured post-performance dialogues, Goddess leads audiences to explore, and maybe confront, the mythology, stigma, fear, and confusion surrounding mental illness.[5]

Goddess was compelled to create HHMHP after the suicide of a close friend and mentor to many artists in the hip hop community. She observed that the hip hop community was largely silent about his struggle. Goddess's experience working with issues of urban violence and trauma pointed to a lack of safe outlets for young people of color who experience mental illness. She believed that hip hop performance could create a safe place to confront the issue. The Project was committed to engaging young urban and low-income communities of color as they are the most adversely affected by the disparities in mental health diagnosis, treatment, and care, as well as those who provide support to them.

Through the integration of performance and structured dialogues, the HHMHP works to impact public discourse and values. Goddess explicitly defined the outcomes she aimed to achieve as being to:

- educate about the signs and symptoms of mental illness and tools for recovery;
- decrease the social stigma of mental illness,;
- explore possible solutions to some of the life stressors that influence mental health;
- increase awareness of, and access to, mental health services and support; and
- influence public discourse about mental health.

As part of Animating Democracy's Arts & Civic Engagement Impact Initiative, Rha Goddess seized two opportunities to assess how performances of LOW and related dialogues might uncover, influence, and even change audiences' views on mental health and illness. Two complementary studies–one with City University of New York and the other with evaluator Suzanne Callahan, of Callahan Consulting for the Arts [http://www.forthearts.org/]–allowed comparison of research processes and results. The two studies also informed Goddess about how specifically the theater piece served to move, challenge, engage, and inform audiences.

For more on the evaluation processes related to the HHMHP, read "Moments of Transformation: Rha Goddess's LOW and Understanding Social Change." [http://animatingdemocracy.org/resource/moments-transformation-rha-goddess's-low-and-understanding-social-change]

OF WHAT VALUE IS EVALUATION? APPRECIATING EVALUATION

Leaders of Art At Work and the Hip Hop Mental Health Project appreciate the critical value of evaluation in their work.

Evaluation helps in understanding contribution to social change, that is, how arts-based programs are moving the needle to achieve intended social or civic outcomes. For example, mental health workers connected to the HHMHP observed and commented that the "treatment" of a provocative work of art coupled with dialogue works better than counseling in getting people to disclose their issues and pain related to mental illness. For Rha Goddess, this and other evidence of effects gained through her evaluation efforts would influence future bookings. It would help her respond to prospective community and mental health partners' questions about how and whether art contributes to changing attitudes about mental health.

> *"Having an in-depth evaluation design process and such a respected evaluator allowed partnering municipal government agencies and employees to see the project as a more serious, credible and useful activity."*
>
> **Marty Pottenger**
> **Art At Work**

Evaluation helps arts practitioners be accountable to their own organizations, partners, and public and private funders. In an ongoing way, the overarching goal of Art At Work "to improve municipal government" became a check point to beg the questions during implementation: How are we doing in relation to this goal? How are we getting at the things that matter to municipal department heads and city officials? The evaluation kept Pottenger focused on her "theory of change," that is, that the process of making art dramatically increases participants' ability to function as a team; understand other viewpoints; open lines of communications between the Police Department, the City, and the community; envision positive outcomes; and take inspired risks that lead to innovative solutions. Pottenger was able to integrate evaluation findings in her discussions with heads of Portland's Police, Public Works, and Human Services departments, as well as funders and participants, and to effectively frame the case for the program's continuation.

Evaluation helps improve civically engaged arts practice. Fundamentally, evaluation improves practice and programs in order to be most effective in achieving positive social change. It can help clarify capacity needs and issues, sharpen roles, and enhance

119

partnerships. Evaluation reveals the efficacy of implementation strategies and creative methodologies; for example, it gave Rha Goddess insight into how specific artistic choices created safe space, impacted audiences' emotional response to the performance and the issue, increased understanding of mental illness and homelessness in more nuanced ways, and fostered willingness to engage in dialogue, etc. It can help you know *how* art "tipped the needle" to effect certain change.

EVALUATION AND PLANNING: WORKING TOGETHER

"Similar to a complex construction job, the project lives inside my head differently every day from having incorporated an evaluation plan."

Marty Pottenger
Art At Work

Evaluation planning helps in planning the arts-based project or program. Imagining what the desired social change might look like can help make programmatic choices and establish priorities that are aligned with resources and what the art project is best suited to achieve. Planning *for evaluation* at the same time one plans for the program can help focus a program's intentions, identify who needs to be involved in evaluation, and evaluation approaches that will be most suitable and feasible.

The evaluation framework that Christine Dwyer and Pottenger created for Art At Work included:

- the major questions to be answered in an evaluation which relate to outcomes;
- the indicators of behavioral or attitudinal change that would be used to respond to the questions;
- potential data collection instruments and strategies that are appropriate for the indicators;
- notes about the target sample for a particular data collection strategy;
- timing of data collection; and,
- where relevant, any appropriate comparisons that might be made.

The framework was developed in consultation with key City partners. In the short-term, it guided evaluation of the Police Poetry Project, providing a comprehensive "menu" from which Pottenger and others could isolate the most important outcomes

and indicators to focus on in evaluation, given learning priorities and capacity. Over time, the framework would allow similar priorities and choices to be made. Also, by focusing data collecting over time, the framework could be used to further substantiate the case for the role of the arts in Portland's municipal systems and processes.

Linking evaluation planning to program planning has multiple benefits. It helps:

- clarify the purpose of evaluating thereby focusing program activities to meet that intent
- decide the evaluation approach to take
- anticipate kinds of data to collect
- determine whom you may need to enlist to conduct or assist with evaluation
- assess resources needed

For more on planning evaluation, including how to develop a theory of change and questions to focus evaluation, go to [http://animatingdemocracy.org/place-start/how-do-we-begin]

YOU *CAN* MEASURE SOCIAL CHANGE! INDICATORS ARE KEY

The push by many trustees, funders, civic leaders, and community partners to move beyond anecdotal evidence and to provide quantitative evidence makes the question of measuring social change not only challenging but often exasperating for arts practitioners. Some find it simply overwhelming because they lack evaluation expertise. Others ask: How do you measure such intangible results as "transformation," "community building," or "social justice?" They may resist the idea of applying empirical approaches that they believe are ill-suited to art and social change. Yet, others see usefulness and necessity in getting "more concrete." They want to know if they are meeting their aspirations and goals and why or why not. They want to be convincing to social service or movement building partners or funders and to compete effectively for resources. But even champions of evaluation know that it can be a demanding enterprise, often requiring the help of outside researchers or evaluators, and demanding time and money that are not often available.

While there is truth in all of this, almost any project that aspires to contribute to community, civic, or social change should be able to measure change at some level. Many evaluators and researchers proclaim, "if you can describe it, you can measure it." A key to this is in identifying *indicators*–measurable elements that signify that change has occurred. Indicators address the question: "If change occurred, how would we know? What would it look like?" Identifying *indicators* of change suggests what kind of data to collect.

121

Artist Rha Goddess and evaluator Suzanne Callahan looked at HHMHP's desired outcomes related to building knowledge and understanding as well as changing attitude and behavior. They defined indicators for which they could collect data. These indicators included:

- Emotional response–opening hearts and minds in a new way; fostering empathy
- Re-humanization–seeing beyond abstraction and statistics to the human side and implications of the issue
- Validation–validating experiences of or related to mental illness
- Reconnection to community–sharing experiences of mental illness with others
- Moments of insight–understanding deepened about causes of mental illness
- Interest in taking action–motivating even small actions
- Connections to information and services–seeking out information to become better informed, to pass on to others with mental illness

Each indicator served as a kind of yardstick, measuring the extent to which change is observed to have occurred. Data collection took place primarily through pre- and post-performance surveys administered to targeted audience members.

For more on these indicators, read Moments of Transformation: Rha Goddess's *LOW* and Understanding Social Change. [http://www.artsusa.org/animatingdemocracy/pdf/reading_room/rha_goddess.pdf]

Art At Work's evaluation plan included outcomes, indicators, and data collection methods as well as the timing of the evaluation effort. It also noted where there was possibility of comparing the data collected with other data to understand change. Diagram 3 plays out just one of the Police Poetry Project's outcomes. (See page____.)

Indicators can be used in a number of ways: a beginning point for developing survey or other instruments; the framework for content analysis of documents and records; a frame for guiding other types of documentation, *e.g.*, a film documentary; and a file structure for maintaining anecdotal information about the project. Marty Pottenger found the indicators for the Police Poetry Project helpful in all of these ways. She literally kept file folders on her desk tabbed with various indicators. Each time she heard an anecdote or learned about a piece of evidence supporting an indicator, she made note (documenting it) and slipped it into the folder. Her cumulative notes became a body of evidence. Having the forethought to video document the press conference described in our opening story (as well as other activities in Art At Work)

enabled her to create a highly compelling piece conveying evidence of impact on influential stakeholders in the project which will serve the programs casemaking into the future.

THE IMPORTANCE OF STORY: ELEVATING THE VALUE OF QUALITATIVE WITH QUANTITATIVE EVIDENCE

"One of the things people always ask in talk backs . . . is 'how was it for you?' But to have the audience experience is for me phenomenal. To have that depth and specificity is huge. This is a sample of what it is like to view LOW through the eyes of audience. It is a privilege to be able to do that."

Rha Goddess,
Hip Hop Mental Health Project

"No stories without numbers. No numbers without stories." This was the consensus of a group of funders as they discussed how to best understand and communicate the social effects of arts-based work. While anecdotes have sometimes been dismissed in favor of quantitative evidence, it is now generally agreed that qualitative data, narratives, and storytelling combined with quantitative data can strengthen social impact assessment.

The push for more "concrete evidence" suggests a desire for *quantitative* indicators that perhaps substantiate the scale of a project's impact, its reach, or the extent of social effects. Despite increasing demands for *metrics* (quantitative measures), there is conviction among evaluators and researchers, as well as arts practitioners, that *qualitative* data and evaluation methods provide important and relevant evidence of the social impact of arts-based work. Qualitative data are important, as ethnographer Maribel Alvarez states, "to measure what is meaningful to people and how they see themselves in relationship to the social dynamics that surround them," as well as to "yield data that will be deeper, more meaningful, more attentive to context, and substantially more complex and emotive."[6]Mark Stern and Susan Seifert of the Social Impact of the Arts Project at the University of Pennsylvania

[http://animatingdemocracy.org/organization/social-impact-arts-project] observed that qualitative methods are accessible to non-researchers and complementary to participatory evaluation, a democratic evaluation method well aligned to the values that inform arts-based social change work.[7]

The credibility of evaluation can indeed be strengthened when quantitative *and* qualitative methods and information are combined and corroborated. Partnerships between cultural agents and professional researchers and evaluators at universities, regional planning centers, and other entities can ensure needed expertise to collect and analyze quantitative data. Stories of the impact of socially engaged art, like the one told by Art At Work's Officer Sauschuck, are compelling and can speak as powerfully if not more powerfully than numbers. Beyond individual or random anecdotes, qualitative data can be methodically collected and analyzed to ensure a level of credibility.

EVALUATION IN ACTION: "WALK BEFORE YOU RUN"

Rha Goddess chose to focus on the effects of the performance of LOW and pre- and post-show dialogues about mental health issues. However, touring LOW across the country often involves collaborations with community-based mental health and arts presenting partners, empowerment-based training for community

DIAGRAM 3: INDICATORS — ART AT WORK POLICE POETRY PROJECT

Outcome	Behavioral/attitudinal indicators of change
Improved Community Relationship with Police Department	Community pride in professionalism of Portland Police Department
	Perception that police are fair/act fairly, especially on part of communities of color/immigrant communities
	Citizens are satisfied with level of community safety
	Police Department proactively recruit people of color for jobs
	People of color apply to Police Department for jobs (and are hired)
	Police force representative of community demographics in multiple ways—race, gender, sexual orientation, etc.

members, and participatory research to gather information that grounds and informs her performance and work in community in general. It was outside her capacity to evaluate the full "project" despite knowing these dimensions are critical to the impact of the Hip Hop Mental Health Project as a whole.

As a one-person operation, supported by interns, Art At Work chose to focus its first evaluation on the Police Poetry Project rather than the work being done in all three city departments. Pottenger was thereby able to ensure that she could support data collection related to city workers and leaders and the public, all of which were important to understanding the effect of the project against its defined goals. Despite this stated focus, the evaluation plan and coaching offered by a professional evaluator fostered a mode of evaluative thinking in Pottenger's day-to-day work. The evaluation questions were ever present as she shaped the project and interacted with participating local artists as well as city leaders. The evaluation reinforced the importance of less formal evaluation practices that she could easily manage, for example regular go-rounds with project participants and stakeholders asking for insights, highlights, and questions at the beginning, middle, and end of meetings.

Most community-based arts practitioners feel overwhelmed by what it might take to implement credible evaluation. Maria Rosario Jackson, researcher with the Urban

Instrument/ Method Sample	Timing Comparison
Interviews with community stakeholders	Ongoing
Records—editorial opinion; coverage post incidents	Ongoing; event-generated
Interviews with community stakeholders	Post initial launch and after completed project
Community survey (if part of City practice)	Comparison potential
Records	Ongoing/event-related
Records	Ongoing; pre/post project comparison
Records	Pre/post project comparison

A TOOL FOR DEFINING INDICATORS AND DATA COLLECTION STRATEGIES

Stakeholders often describe articulating indicators as the most challenging part of evaluation work. Animating Democracy's Outcomes families framework aims to facilitate this task. This framework provides numerous examples of creative strategies for each of the six outcome families-Knowledge, Discourse, Attitudes, Capacity, Action, and Policies-and the types of indicators that might be observed and related data collection methods.

Diagram 4 shows an excerpt from the framework. It extrapolates outcomes, indicators, and data collection for the Thousand Kites project [http://www.thousandkites.org] based at Appalshop in Whitesburg, KY.

DIAGRAM 4: THOUSAND KITES PROJECT INDICATORS

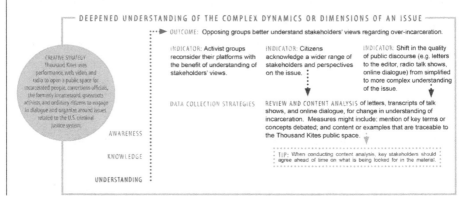

Institute, believes this is true because arts practitioners are driven by genuine passions and aspirations to make change and often set unrealistic expectations about what they can achieve through their arts-based efforts. Furthermore, they often feel compelled to assess *all* possible outcomes and to *prove* that an arts program "caused" a particular outcome. This is a tall order beyond the capacity of almost any organization, never mind under-resourced arts organizations and artists. Jackson and fellow evaluators and researchers who were part of Animating Democracy's Arts & Civic Engagement Impact Initiative agreed that arts practitioners (as well as funders and other stakeholders) need to recalibrate expectations about what change can be claimed in relation to arts and cultural endeavors as well as proving that an arts intervention "caused" a particular outcome.

> "I don't think any one effort in any arena can claim 100 percent causation. . . . My experience of large scale impact and change comes from the culmination of many localized efforts that are powerfully coordinated, networked, and leveraged over time. . . . I see it as a continuum [as opposed to] simply a before and after."
>
> Rha Goddess,
> Hip Hop Mental Health Project

Jackson underscores that community-based arts endeavors that aspire to social change should not make claims or take full responsibility for impacting social conditions over which they have no direct control. While it is important to aspire to a compelling long-term vision for social change, cultural organizations and artists need to see more realistically where they can *make a contribution* to change. By taking a more realistic stance, the possible appropriate focal points for evaluation come into relief.

Arts-based civic engagement initiatives should not expect to "prove" through quantitative analysis that an arts intervention "caused" a particular outcome. Jackson observes that the arts field, perhaps more so than any other policy area, is particularly concerned with establishing causality to confirm its value. The mere establishment of correlation with an intended outcome is enough in many fields to command attention and make a case about effects. The exception might be programs that are sustained over time (multiple years) and take place in relatively controlled environments (schools or similar settings).[8]

Read Maria Rosario Jackson's article, *Shifting Expectations: An Urban Planner's Reflections on Evaluation of Community-Based Arts.* [http://animatingdemocracy.org/resource/shifting-expectations-urban-planner's-reflections-evaluation-community-based-arts]

In a similar vein, The Metropolitan Group [http://www.metgroup.com], an agency that supports social change endeavors, advises to "walk before you run." It has outlined practical thoughts on making evaluation manageable in "Measuring What Matters" [http://www.metgroup.com/assets/690_measuringwhatmattersscree.pdf]

which offers framework that divides measures of change between those that measure *outputs* (what you create, such as collaborations, donations, news stories, community engagement activities) and those that measure *results*; the latter is often harder to do but more relevant to understanding social change.

Too often, arts organizations and their funders mistakenly expect that results of a singular evaluation can be generalized to broader assertions of impact. The Social Impact of the Arts Project at the University of Pennsylvania emphasizes that an aggregated body of research that looks across organizations, neighborhoods, regions, or the nation as a whole is required to move the field's case-making concerns forward. That said, evaluations of local initiatives and projects are important. They provide opportunity for reflection that can lead to improvement of practice and the recalibration of goals and expectations. When made available to the field, they also contribute to a larger body of knowledge about the work in question.[9]

Read Mark Stern and Susan Seifert's paper, Civic Engagement and the Arts: Issues of Conceptualization and Measurement. [http://animatingdemocracy.org/resource/civic-engagement-and-arts-issues-conceptualization-and-measurement]

CONCLUSION

For the arts' social impact to be recognized by civic leaders, policy makers, and funders as on par with prevailing economic and intrinsic arguments will require concerted efforts–partnerships between national organizations, funders, and research centers that might collect, aggregate, and analyze data. While the arts' economic impact has been well documented through empirical evidence and promoted locally and nationally, the social impact of the arts has received far less attention. There is yet a long way to go to broadly position the arts as valid and viable contributors to civic engagement and the achievement of social goals. The Social Impact of the Arts Project [http://www.sp2.upenn.edu/SIAP/siaphist.html] has played a leading role to research and document such impact and to coalesce efforts. The efforts, however, must start with practitioners and others committed to community-based arts and arts for change work. Animating Democracy and its Arts & Civic Engagement Impact Initiative invite your thoughts on this chapter and on the resources in the IMPACT web site [http://animatingdemocracy.org/home-impact]. Visit and comment and become part of the process.

FOOTNOTES

1) Art At Work web site, http://www.artatworkproject.us/

2) Animating Democracy, a program of Americans for the Arts, inspires, informs, promotes, and connects arts and culture as potent contributors to community, civic, and social change. It brings national visibility to arts for change work, builds knowledge about quality practice, and creates useful resources. By demonstrating the public value of creative work that contributes to social change and fostering synergy across arts and other fields and sectors, Animating Democracy works to make the arts an integral and effective part of solutions to the challenges of communities and toward ensuring a healthy democracy. http://www.animatingdemocracy.org.

3) Craig McGarvey describes *human, social,* and *community capital* as three interconnected and measurable outcomes of civic engagement work. Human capital is the development of individual potential with measures of acquired skills, knowledge, attitudes, and behaviors. Social capital is the development of networks of human and institutional relationships, with measures of depth, breadth, diversity, and durability. Community capital is the development of positive change in communities, with measures of problems solved or prevented, policies improved, systems and institutions made more accountable. (Civic Participation and the Promise of Democracy, 2004)

4) Callahan, Suzanne with Jane Jerardi and Caitlin Servilio and reflections by Rha Goddess. "Moments of Transformation: Rha Goddess's LOW and Understanding Social Change." Washington, D.C.: Animating Democracy/Americans for the Arts, 2009.

5) Alvarez, Maribel. "Two-Way Mirror: Ethnography as a Way to Assess Civic Impact of Arts-Based Engagement in Tucson, Arizona." Washington, D.C.: Animating Democracy/Americans for the Arts, 2009.

6) Stern, Mark J. and Susan C. Seifert." Civic Engagement and the Arts: Issues of Conceptualization and Measurement." Washington, D.C.: Animating Democracy/Americans for the Arts, 2009.

7) Jackson, Maria Rosario., "Shifting Expectations: An Urban Planner's Reflections on Evaluation of Community-Based Arts." [http://impact.animatingdemocracy.org/node/252] Washington, D.C.: Animating Democracy/Americans for the Arts, 2009.

8) Stern, Mark J. and Susan C. Seifert." Civic Engagement and the Arts: Issues of Conceptualization and Measurement." Washington, D.C.: Animating Democracy/Americans for the Arts, 2009.

9) Jenkins, Henry. *Confronting the Challenges of a Participatory Culture.* Cambridge, MA: MIT Press. 2009.

Tools for Engagement: Modes of thinking for Community Engagement

CHAPTER EIGHT

STRUCTURAL OPTIONS

THE 501(c)(3) ASSUMPTION

The not-for-profit corporation as codified in section 501(c)(3) of the Internal Revenue Service Code of 1954 has come to be the *de facto* standard for the structure of arts organizations in the United States. It is probably worthwhile to note that the code does not include any reference to the arts. It is through the arts' role in the area of education that the field is eligible for not-for-profit status.

The benefits of 501(c)(3) status are well known. Due to the incredible proliferation of not-for-profit corporations, many in the field would say excessively well known. Tax-free mission-related revenue, tax deductible contributions, eligibility for foundation and government grants, exemption from property tax (on property used for exempt purposes), and the potential eligibility for refunds of state sales tax on purchases represent a compelling set of incentives to pursue 501(c)(3) recognition.

Some people have a sense that existence as a tax-exempt corporation confers legitimacy to an arts enterprise. But for many, there is simply an unconscious assumption that arts organizations (in the established arts world) must be not-for-profit corporations. That is an assumption that should be seriously examined.

However, with 501(c)(3) status comes responsibility. Elizabeth Novick's Artsblog 19 May 2011 post, "What Is Your Community Benefit?" (http://blog.artsusa.org/2011/05/19/what-is-your-community-benefit/), makes the case. "The reason for the tax break for nonprofits is that nonprofits are meant to provide a 'community benefit.'" She amplifies the point, echoed here, that not-for-profit arts organizations have a structural responsibility to their communities. "If we want to stay under the nonprofit umbrella, then we need to get better at framing our work in those terms [service to our communities], and at doing work that has visible, tangible community benefit. And if that's not the goal, then we should seek other structures that suit our activities better."

Early in this book, the evolution of the arts patronage system into the U.S.'s not-for-profit arts corporation was mentioned. This has led both to the appearance and, in some cases, to the fact of arts institutions focused on the needs and interests of their wealthy patrons to the exclusion of others' interests, a situation that makes it difficult for those organizations to effectively engage with the population as a whole.

More to the point, however, the corporate structure required by the tax statutes (governance by a volunteer board of directors), the donor-based funding process, and the mandated income and management reporting requirements of the re-designed Form 990 are cumbersome. The structure is not well suited to rapid innovation or responsiveness to social and economic change.

What follows is an overview of structural options, including some within the 501(c)(3) model, that individuals and corporations interested in pursuing community arts work might wish to consider, either as stand-alone entities or as complements to other structures.

ORGANIZATIONAL MODELS IN THE ARTS AND CULTURE SECTOR
by James Undercofler

- Catherine, Andrew and Barb met in a modern dance class in college. They worked together on a piece, found that their work was interesting and compelling, so decided on graduation to form their own dance company. Their first action: form a 501(c)(3) not-for-profit corporation.
- Having interned in a city neighborhood organization during her undergraduate years, Nia, now living in an urban redevelopment area and studying for her master's degree, decides that her neighborhood would benefit from a street arts festival. She talks to the proprietors and citizens in the neighborhood and they are all very supportive and enthusiastic. Nia approaches a 501(c)(3) incubator so that she can accept donations and grants. Her festival is a success and the incubator, as prescribed, helps her to form her own 501(c)(3), not-for-profit corporation.
- Tracy and Katrina are active potters, both studying for their master's degrees in fine arts. They discover that there a number of potters in their area. In discussions with these new colleagues, and with the encouragement of mentors, the pair decide to create an organization that will provide studio space for ceramicists, offer classes to the public, and open a shop that will sell the work of selected artists. Their first thought is to form a 501(c)(3), not-for-profit, but they seek advice as to alternatives.

Question: Why was the first organizational thought in each of these three very real scenarios a 501(c)(3) not-for-profit organization?

Answer: The 501(c)(3) has become so synonymous with organizations in the arts that budding entrepreneurs believe it to be required, to be the only possibility.

And increasingly, especially since the "Great Recession" of 2008+ foundations and other key funders are posing the questions, "are there too many 501(c)(3)'s, is the rapid growth in numbers detrimental to the overall health of the arts and culture sector?"

There are alternatives. And some of these alternative organizational models can, in many instances, provide more effective structures than the 501(c)(3).

More interesting, however, is that budding arts entrepreneurs appear to select their organizational structure, the 501(c)(3), before they have analyzed more important core "business issues," such as need for capital and the construction of their net revenue. Only though analysis of these issues, and a deep look at just exactly they want to do (their missions), should a fitting organizational structure be chosen.

The purpose of the following is to present the reader with a series of organizational possibilities, each described and analyzed. As stated above, key funders now believe, for better or worse, that the 501(c)(3) is overused, or even outdated. And with the looming possibility of changes to the IRS tax code that may limit deductibility of charitable donations, it becomes a necessity to become familiar with alternate organizational models.

ASSESSMENT OF 501(c)(3) STRUCTURE

As a point of departure, let's begin with a deep look at the 501(c)(3), its pluses and minuses.

The pluses to the 501(c)(3) are well-known. Gifts from individuals are tax deductible, making the "ask" easier. In addition, most foundations, government agencies, and corporate philanthropic entities require that their gifts be given to a 501(c)(3). This particular element provides the most compelling factor in supporting the existence of the 501(c)(3). At the organizational level, purchases can be made free of sales tax

Before listing the negatives to the 501(c)(3), it should be noted that a large percentage of real and potential individual donors do not itemize deductions on their IRS Form 1040. They take the standard deduction. Fund-raising entities, such as (www.kickstarter.com), a "crowdsourcing" Internet site, successfully solicits gifts in small amounts (evidently from young people who have no concern with tax deductibility).

Perhaps the #1 negative of the 501(c)(3) is its governance and resulting administrative structure. Often heard is this question posed to budding arts

entrepreneurs, "do you want your boss to be someone who knows nothing about your art?" Call it board maintenance: it's a major cause of difficulties and failure within 501(c)(3) arts and culture organizations. The 501(c)(3) critically relies on volunteers to accomplish its goals, its mission. This can work, but only with extensive administrative inputs, and even then an ongoing challenge.

With expanding needs to raise contributed funds, plus extreme increased competition for them, 501(c)(3) arts and culture organizations have, by and large, increased the size of their boards and volunteer committees, but in doing so have increased their administrative costs. And these organizations are finding fewer and fewer volunteers who "know" the business and who "know" their role.

Added to this challenge is the very real emergence of proprietary philanthropy: donors who insist on controlling how their gifts are spent. While there are limits on just how "controlling" a donor can be, this philanthropic trend adds even more stress to an administration. It adds cost to General Operations, but does not alleviate this cost in the gift distribution.

A distinct insularity evolves within the 501(c)(3) organization. By definition it is an independent corporation. Additionally, in countless communities it may be the only opera company, the only museum, the only historical site, etc. The potential for insular thinking is enormous. It becomes very easy to dream extravagantly-and very much outside of an organization's means.

In addition to the potential to overestimate revenue, the pure cost of doing business independently adds an additional burden to organizations' expenses. The costs accrue primarily in support services and functions: business, human relations, technology, space rental and/or ownership, etc. One must question the resultant budgetary balance between expenditures directly related to making art and its delivery and the "cost of doing business."

Operating independently also can deter cooperative ventures that not only can lead to more efficient operations, but can also lead to cooperative artistic and community service efforts. A number of political and arts and culture leaders, especially those focused in arts policy, speak to the tragic cooperative opportunities lost because of the insularity of organizations within the sector.

STRATEGIC RESTRUCTURING
Mergers: Organizations that combine for common purposes, usually economic + artistic commonalities.

Some mergers eliminate one organization's incorporation, while others eliminate

both (or several) and form a new organization. There is considerable documented and undocumented experience with mergers of arts organizations. Common themes (or problems) persist in these experiences relating to giving up artistic and organizational identity, to problems of combining differing organizational cultures. The insularity of the 501(c)(3) referred to earlier generates highly individualized internal organizational cultures, which in turn make merging extremely challenging. That there are opportunities for similar organizations to merge in mid- to large-sized communities, both for economic and artistic delivery reasons, is unquestionable.

An example of a merger that this writer was closely involved with was the formation of Mercury Opera Rochester (New York) (www.mercuryoperarochester. org). In this case there were several entities, each with its own 501(c)(3) incorporation that came together to form a new organization, and in the process eliminated their own. Reestablishing live, locally produced opera in Rochester was the driving force that brought together the remains of the former opera company, its foundation, its guild, a new organization that had been formed by the former opera chorus, and the Eastman School of Music opera program.

There is excellent literature concerning the facilitation of mergers, the best-known by David La Piana (www.lapiana.org).

Shared Services

There are a number of examples of 501(c)(3) organizations that share services, and not only save on administrative expense, but gain in being able to afford a higher level of service. What is interesting about shared services is the discovery of which services are shared and what the concomitant challenges are for each shared function.

There appears to be a hierarchy of "challenge" for organizations as they share services. The following list moves from the least challenging to the most.

Technology support, both for administrative functions, as well as for development and marketing, such as sharing data mining functions in a program such as Tessitura.

Business-related functions: all but those related to specific organizational budgeting and investment management, which would not be shared, except in a merger.

Human Relations: from those most easily shared, such as employee benefits, job postings and staff development, to those more difficult, such as employee complaints, hiring and terminating procedures. As an organization crosses

into these last areas, real challenges arise, as internal culture issues come into play.

Education: few examples of shared services appear here, but a number of cooperative programming examples happen. To be a true shared service, personnel and other resources would need to be shared. There are independent arts education consultants, or contractors who teach and provide program planning services for a number of like organizations, but these also are not truly shared, in that two or more organizations do not cooperatively plan to employ a person to provide services.

Production Management: examples occur here when organizations share spaces, when they are co-tenants in a performing art facility, which in itself is usually a 501(c)(3).

Marketing: shared services include group buys and technical production elements, but rarely involve common planning, technical delivery or iconography.

Development: not shared, except at the data mining and technical levels.

Artistic: not shared, except occasional examples of cooperative artistic projects such as joint commissions.

Enormous opportunities exist within arts and culture communities of all sizes for sharing services to increase efficiency and free up resources to be directed toward organizations' missions. The line between non-threatening and intrusive is easily discerned in this shared services hierarchy. Organizations can learn where this line exists and move carefully toward it, and, with luck, over time find innovative techniques to move beyond it.

Where would an organization go if it decided it wanted to explore shared services? Three possibilities come to mind (as this would vary greatly depending on the local community): one, the local arts service organization; two, the organization's national or local discipline-specific organization; and three, the major private foundation funder in the local community. The last of these three will welcome the inquiry, as they are very likely concerned that too much of their money is being spent on unnecessary duplicative administrative services.

Pooled Services, Fiscal Sponsors

Pooled services are frequently offered by service organizations[1], some in local communities and some regionally. Services offered often range from fiscal sponsorships to health plans, insurance services, marketing in mega-sites, discounted travel services to group buying of objects and media. Membership in the service organization is a

general requirement, but the cost can offset the savings. This is especially the case in small to mid-sized organizations.

Fiscal sponsors are emerging as an important organizational option for small and mid-sized enterprises, especially those that are event-oriented. These organizations can receive contributed revenue on behalf of members, manage their finances, and provide other pooled services, such as liability and health insurance, among other options. The membership fee is generally very reasonable; and then, based on service usage, there are additional costs, often calculated as a percentage of budget or budget category.

In the recent past fiscal sponsors were often seen as incubators, e.g., they were used as a place to receive contributed revenue and manage books until a 501(c)(3) application was approved or until the 3-year waiting period to receive most foundation funds was fulfilled. There appears to be a recent change to this process in that fiscal sponsors are becoming more attractive by offering a broad menu of services, including professional development and discounted fees. And, with the broad arts and culture sector expressing its concern about the burgeoning number of 501(c)(3)'s, fledgling arts enterprises are deciding to remain in umbrella organizations. A prominent fiscal sponsor is Fractured Atlas (www.fracturedatlas.org). They offer a menu of services, as described above but also have taken a pro-active stance toward professional development.

It appears that there are substantial opportunities for expansion of pooled services in communities: not only expansion of what is currently being offered but also expansion into new areas not previously developed. Among these being explored are technical services (not the Geek Squad, but web site design, software selection and training, etc.), development services (grant research and construction), marketing (consultant input for design of targeted as well as season campaigns), and even general administration (shared CEO's). The creation of such entities might well address the "administrative cost" concern associated with the concerns regarding the 501(c)(3).

Arts Incubators (two very different types):

One type of incubator provides startup services to fledgling entities and assists them in becoming independent. In fact, in these types of incubators there is often a time limit toward independence. These incubators contribute to the proliferation of 501(c)(3)'s as the underlying concept is to incubate an organization until it can walk on its own. It is hoped that these reevaluate their missions and move to providing options for effective organization other than the 501(c)(3).

The more commonly understood idea of arts incubator relates to a space for artists where a menu of services, including classes in entrepreneurship and exhibition space, are offered. The incubator itself is a 501(c)(3) and seeks contributed revenue to support its operations. Revenue from municipalities is often part of the contributed revenue mix. Artists and arts organizations apply for membership and pay dues, receiving value in exchange. Frequently a particular artistic focus and/or organizational type are part of the review and acceptance for membership.

A superb description and discussion of the arts incubator model can be found in the blog, The Artful Manager by Andrew Taylor (http://www.artsjournal.com/artfulmanager/main/000226.php).

COOPERATIVES

A number of arts organizations call themselves co-ops. Some of these are true co-ops, but some are 501(c)(3) that have adopted certain aspects of true coops. A cooperative (co-op) is a business organization owned and operated by a group of individuals for their mutual benefit. The International Cooperative Alliance defines the cooperative as autonomous associations of persons united voluntarily to meet their common economic, social, and cultural needs and aspirations through jointly owned and democratically controlled enterprises.

Co-ops are businesses, subject to taxes. Owners can pass their taxation directly to their IRS Form 1040's as in LLC's. Arts co-ops appear to earn their income primarily by offering memberships and in return offer their members discounts, "deals," and in some cases, sharing of profits in limited percentages. Arts co-ops also earn income through sales of artistic work, of merchandise, classes open to the public and consultant services.

Cooperative Work Spaces

There has been a recent proliferation of more "benign" incubators, not directed specifically toward the arts, called "co-working spaces" within larger communities. These co-working spaces promote a variety of clients and then encourage interaction, through space configuration as well as through services and programs. They are highlighted often in regard to the "creative economy" as a place where emerging entrepreneurs can develop new ideas. There is some evidence that arts co-working spaces are being developed in a number of communities. Indy Hall (www.indyhall.org) is an excellent example of a co-working space.

HYBRIDS
Not-for-Profit/Commercial/Not-for Profit

There is nothing new about a museum operating a successful store, restaurant, or condo, or a performing arts facility or entity operating a catering space or parking garage, but what is newly emerging are 501(c)(3)'s exploring every possible option for commercial viability. In doing so, some are operating commercial entities as LLC's governed by the same personnel as the not-for-profit, while others are crafting partnerships and partnership arrangements. In these more innovative arrangements, contracts are written that "commercialize" that aspect of the not-for-profit's output, with a percentage return on profits. The not-for-profit assumes little risk in these contractual arrangements in that their responsibility is to provide artistic product. In general this "new" commercial activity is almost entirely Internet-based.

Commercial/Not-for-Profit hybrids represent an emerging area of organizational activity. Increasingly, commercial arts entities are creating parallel 501(c)(3)'s to foster their work in their communities. Just as in the former example where not-for-profits are creating commercial entities to enhance revenue, these commercial entities are creating 501(c)(3)'s to access contributed revenue and, in most cases, to provide education services to a specific population.

World Café Live in Philadelphia is an LLC that "has been built on a simple insight: that a place dedicated to showcasing live music should be a place that attracts and inspires live musicians. The result is a three-tiered music hall in which every detail has been designed to optimize the live performance experience, from sight lines, lighting and acoustics to green rooms, equipment access and concierge service." It leases its space from the University of Pennsylvania and sub-leases space to WXPN, a trendy FM radio station run out of Penn. It also often leases its stages to Drexel University and others. What makes WCL so interesting is its creation of LiveConnections.org (www. liveconnections.org). "Launched in 2008, LiveConnections.org creates innovative music education programs for children and special needs populations at Philadelphia's World Cafe Live. LiveConnections programs explore how music builds bridges and connects cultures. From Bach to beat-box, spoken word to salsa, LiveConnections seeks to spark both a love of music and learning that's hands-on, surprising, and alive." LiveConnections is a traditional 501(c)(3), but attached at the hip to World Café Live. It draws much of its content from WCL. It builds audiences for WCL. It provides a stream of contributed revenue that indirectly benefits elements of WCL. And, it rents space from WCL!

Unincorporated/Not-for-Profit

To be fully inclusive regarding organizational design, we must recognize the enormous number of unincorporated arts groups (some professional, some semi-professional), clubs and individual artists that work, perform, and teach in community and neighborhood centers, colleges, and universities. Some of the clubs form under IRS 501c7, which allows them tax free net revenues, but not tax deductibility on contributed revenue, while others simply operate by having members declare revenue on Section C of their 1040.

Additionally, one can find high numbers of incorporated 501(c)(3) organizations embedded within colleges and universities, and neighborhood or community centers. These entities generally operate under a contract or formal agreement regarding various shared administrative services such as branding, communications, and development (fund raising). In colleges and universities these entities are often the creation of a faculty member or senior administrator who may also serve as the artistic director. A good example of this latter arrangement can be found at Swarthmore College which "houses" Orchestra 2001 (http://www.orchestra2001.org).

L3C

The low-profit, limited liability company, or L3C, is a hybrid of a not-for-profit and for-profit organization. More specifically, it is a new type of limited liability company (LLC) designed to attract private investments and philanthropic capital in ventures designated to provide a social benefit. Unlike a standard LLC, the L3C has an explicit primary charitable mission and only a secondary profit concern. And unlike a charity, the L3C is free to distribute the profits, after taxes, to owners or investors.

A principal advantage of the L3C is its qualification to receive program-related investments (PRI's) from foundations. Program-related investments (PRIs) are investments made by foundations to support charitable activities consistent with their missions that involve the potential return of capital within an established time frame. PRIs include financing methods commonly associated with banks or other private investors, such as loans, loan guarantees, linked deposits, and even equity investments in charitable organizations or in commercial ventures for charitable purposes.

Just like LLC's, the L3C model allows for multiple investment tranches: investors at different classes (A, B, C levels). Each of these tranches assumes differing levels of risk. In theory, a foundation could assume the greatest percentage of risk or accept a smaller share of profits, thus providing individual investors with a certain level of cover.

As of this writing there are no known arts L3C's, but in discussion a number of ideas that could be effectively turned into L3C enterprises have emerged. Here are some examples:

Arts facilities development projects in "challenged" neighborhoods. In order to attract individual investors as well as foundation PRI's, these projects' business plans would need to demonstrate better-than-break-even results.

Theatrical productions that have the potential for commercial success but in being developed through an L3C direct a percentage of profits toward some aspect of social improvement.

Capital intensive endeavors that will serve the field and provide a modest return on investment but would have difficulty attracting private investment. One prominent fiscal sponsor/umbrella organization is developing an L3C to offer their now intermediary-offered liability insurance program.

Mission-relevant for-profit subsidiaries of 501(c)(3) organizations. Yes, these can and have been formed as LLC's, but profits are then subject to UBIT (unrelated business income tax). Profits coming from an L3C might be considered "related" enough to be exempt from UBIT.

The L3C may be a vehicle for attracting new resources to the field from private investors. The arts and culture sector is chronically under-capitalized and under-resourced. A foundation could make a targeted PRI in an L3C that could be leveraged to attract far greater funds from private investors who otherwise would be completely beyond its reach.

There are distinct advantages, and some disadvantages, to the L3C. Among the advantages not already stated are that owners (donors) have "skin in the game," in that they have a vested interest in the success of the entity. Of course, this could also be a disadvantage, as the investor could become overly involved in day-to-day decision making, a common problem in 501(c)(3)'s. L3C's have the potential of attracting investor/donors who would likely not be accessible to a 501(c)(3), in that the combination of a potential for investment return combined with a social goal may touch a wide swath of young business men and women who do not make donations to not-for-profits. And, the L3C eliminates the cumbersome governance structure associated with the 501(c)(3).

In the minus column is the converse of many of the advantages. There is no tax-deductibility and risk is assumed. As such there is potential for investment loss. Investment losses in an L3C would be considered passive losses, not deductible from

one's income taxes; however, one could offset taxes on gains from investments in other entities with passive losses from an L3C.

Oddly, there is the potential for profits to exceed expectations, raising questions about the incorporation itself. One of the missing pieces in L3C legislation is putting a number on what constitutes a "secondary profit concern." Yes, there is an underlying assumption that these entities will never yield much in the way of profits, but eventually there will be an L3C that breaks out of the pack and provides yields in excess of 10%.

The L3C is legal now in Illinois, Michigan, North Carolina, Utah, Vermont and Wyoming. It is on the docket in a number of other state legislatures, where it is likely to pass. What's perhaps most interesting about the L3C is that it's a manifestation of the blurring of lines between commercial and not-for-profit. To date, this model has been the domain of the social entrepreneur. Check out (www.moomilkco.com), Maine's Own Organic Milk Company. Their story illustrates an excellent example of how the L3C can be utilized to accomplish important ends.

COMMERCIAL MODELS
LLC

An LLC (limited liability company) is a flexible form of entity that blends elements of partnership and corporate structures. It is a legal form of company that provides limited liability to its owners in most U.S. jurisdictions. Interestingly, LLC's do not need to be organized for profit. The LLC is not a corporation and thus allows pass-through income taxation, meaning that owners report income and loss on their IRS Form 1040, Section C.

The principal advantages are the limit on liability (one's personal assets are protected, unless of course, fraud or gross negligence is involved), little paperwork (as opposed to a corporation, for-profit or not-for-profit), and pass-through taxation. Additionally, LLC's can be owned by a single proprietor or can be established as partnerships. In the latter case, taxation can flow to the partners according to their ownership share in the LLC.

Disadvantages are few, but notable may be the downside potential to there being so few requirements to governance and administrative structure. In other words, partners may form an LLC without detailing their relationship to the entity and to each other, thus causing problems down the line or on dissolution. Another notable downside is the increasing taxation of LLC's by jurisdictions. Some states and municipalities are now levying franchise taxes, capital values taxes, and business privilege taxes.

Additionally the District of Columbia now considers LLC's taxable entities, eliminating the flow-through tax advantage.

Internet-Based

These entities provide direct relationships between artist and participant using the Internet. This is a growing and important organizational design, an indicator of real change. In this type of organization, the artist offers services and products directly to the public. In most cases, the artist him/herself designs or asks a colleague to design the initial website. As the public is identified through web-based marketing devices, including social networking, the website becomes more vivid, and as sales increase, the artist generally hires subcontractors to manage the various necessary aspects of the "business." Some of these sites invite their participants to engage in the artistic process. They address an emerging trend in which participants increasingly ask to be included in the making of art rather than simply perceiving it.

A fascinating and successful example is found at (www.artistshare.net). Jazz artist Maria Schneider and others created this site as an interactive enterprise. At various price points, participants can join the creative process with a number of artists at any stage, from composition or orchestration through the production of the recording.

The emergence of these independent Internet-based sites is significant in that it touches on the public's desire to be directly involved in the artistic process (as documented in the NEA's Survey of Public Participation in the Arts). The summary of this report can be found at (www.arts.gov/research/research_brochures.php). And, while the "on the ground" arts community has generally dismissed these enterprises as marginal, a number of them are generating significant membership, participation, and revenue.

Sole Proprietorship

Most self-employed artists are sole proprietors. In other words, they file their taxes on IRS Form 1040, Section C. In Section C they itemize their income and expenses and pay self-employment tax on their net income. In not forming an LLC, their assets, personal and business-related, are subject to liability. However, in most cases, there would be little concern on this score.

B and S Corporations

One occasionally hears B, C, and S Corporations mentioned in discussion of innovative or alternative organizational models for the arts and culture sector. These

models do not seem to provide useful alternatives, although leaders in the sector should be aware of them.

The B Corporation is a certification offered by B Lab of Pennsylvania, designating a business as socially responsible. In addition to providing an independent assessment of a business's level of social responsibility, the certification process requires a business to rewrite its articles of incorporation to make it clear to investors that the business's managers are required to consider the interests of societal stakeholders such as employees, communities, and the environment.

An S Corporation, for income tax purposes, is a corporation that makes an election to be taxed under Subchapter S of Chapter 1 of the IRS Code. In general, S Corporations do not pay any federal income taxes, Instead, the corporation's income or losses are divided among and passed through to its shareholders. The shareholders must then report the income or loss on their own individual income tax returns. This concept is called single taxation; if the corporation is taxed as a C Corporation (most common LLC model), it will face double taxation, meaning both the corporation's profits and the shareholders' dividends will be taxed. Only one class of shares can be created in an S Corporation and the number of shareholders is limited to 100.

It's likely that the B Corporation has been included in general discussion because of its socially responsible character and mandate. It's unclear as to why the S Corporation model has been considered.

Let's now revisit the 3 anecdotes of our budding arts entrepreneurs (as presented at the beginning of this chapter). If they were familiar with alternative organizational models, would they have more wisely chosen something other than the 501(c)(3)?

- Catherine, Andrew and Barb would have eventually chosen to incorporate as a 501(c)(3). They did put the cart before the horse, however. They should have tested the feasibility of their enterprise by employing a fiscal sponsor for their early public presentations. As a modern dance company they would always need to rely heavily on contributed revenue, hence the fiscal sponsorship and the eventual 501(c)(3). They would not have interested investors for an L3C, as the potential to produce revenue in excess of expenditure would be impossible.
- Nia made the mistake of entering a "501(c)(3) incubator." She had heard that everyone must form a 501(c)(3) in order to seek tax-deductible donations. As it turned out, she produced the festival annually under the umbrella of

the neighborhood association's not-for-profit status as a quasi-city agency. She never proceeded to form her own 501(c)(3). Because the neighborhood association was deeply enamored with Nia's work, she operated with artistic and creative freedom. She did not have to educate and satisfy a board of directors in order to proceed with her work.

- Tracy and Katrina wisely sought advice before proceeding to form their 501(c)(3). In an analysis of their capital needs and net revenue, they decided to form a cooperative. Their earned revenue would come mainly from members, who would receive the benefit of utilizing the specialize facilities; from sales in their shop, from an annual juried show; and from teaching classes to the public. They did keep the door open to forming a 501(c)(3) in the future as they contemplated purchasing a facility.

As one can deduce from these anecdotes, multiple factors affect the choice of an organizational model. Perhaps the best advice at present is to know that there are multiple options, and to analyze one's professional and personal trajectory as well as capital needs and anticipated mix of net revenue before choosing one.

FOOTNOTE

1) Service organizations can include regional or community-based arts and culture alliances or councils, as well as discipline-specific ones, such as DanceUSA or the League of American Orchestras, among many others.

CHAPTER NINE

CULTURAL MAPPING
by Stephanie Moore and Tom Borrup

INTRODUCTION

Cultural mapping is not only a method for cataloguing the cultural assets of a community it is also a tool useful for community engagement and collaboration. For the purposes of this chapter, cultural mapping is understood to be the process of identifying and stating, in a written or visual inventory, all cultural assets within a specific geographic area. This includes the gathering of tangible and intangible assets from the community including but not limited to cultural organizations, artists, and stories. Cultural mapping provides an understanding of culture, history, and a community's unique identity that should be used at the beginning of any community development or planning project to create a list of potential partners, community resources, and tools needed for successful implementation. Input is sought from the community to guide the development of a plan to create a map of community networks and assets.

As a major part of municipal cultural planning, cultural mapping has grown out of research since the mid- to late-1980s in cultural planning from Canada, Australia, the United States, and various western European countries. The *Community Planning Handbook* by Colin Mercer in 1995 helped broaden the understanding of cultural resources. The Creative City Network of Canada, created in 1997 to support the community of municipal cultural workers throughout Canada, has since created three toolkits (Cultural Planning, Cultural Mapping, and Public Art) that have become invaluable for cultural workers throughout the world. UNESCO (United Nations Educational, Scientific, and Cultural Organization) officially recognizes cultural mapping as a vital tool for preserving the cultural assets of the world and offers multiple resources for identifying both tangible and intangible assets. Information about cultural mapping and cultural planning will continue to grow as more municipal and federal governments recognize its potential for building and strengthening communities.

This chapter focuses on cultural mapping as a stand-alone strategy for building strong communities and increasing community engagement. Without acknowledging

the importance of mapping as a specific community development tool, cultural workers will generate disconnected lists. Without understanding how the assets build connections between the people within the community, the maps themselves are useless to the individuals who created the map.

John P. Kretzmann and John L. McKnight (1996) have demonstrated that emphasis placed on non-native assets, those assets not directly based in the community, makes it difficult to build a positive community identity. For cultural mapping to build and foster a strong and sustainable community with empowered local leaders, it must include the individual and organizational capacities from within the local community.

DEFINITIONS

Cultural mapping allows individuals to discover and identify multiple as well as shared stories of their community. The following are definitions necessary for understanding cultural mapping:

Cultural mapping is the process of identifying and stating, in a written or visual inventory, all cultural assets within a specific geographic region.

Culture includes the arts, heritage, beliefs and environments that make up our individual identities.

Assets are the facilities, organizations, people, ideas, customs, and relationships that contribute to a way of life in a specific place.

Community refers to a group of people within a specific geographic area, *i.e.* cities, neighborhoods, states, or regions.

Cultural mapping is an important process that can build a network utilizing assets found in a community. It allows a community to discover the resources that contribute to the unique environment and qualities of that place. Cultural assets are therefore best recognized by members of the entire region and cannot be fully gathered by just one individual or organization no matter how thorough the effort. Mapping can be carried out in a number of ways but should always focus on community and collaboration. The process itself of getting people together to share resources and stories–and the working relationships that can result–have equal or greater value than the map or inventory of assets that might be generated.

Part I introduces a theoretical background that must drive the outcomes of all community-oriented mapping projects. To provide an example of the mapping process, a single model along with its ability to engage citizens is presented in Part II and within the online companion to this book (www.artsengaged.com/bcna); this is by no means the only way to undertake mapping.

PART I – THEORETICAL BACKGROUND: COMMUNITY ENGAGEMENT

Engaging a community in a cultural mapping process promotes both diversity and equality, builds community identity, and supports cultural sustainability while producing a usable list of the community's cultural assets. Each of these five outcomes can be used to understand the importance of mapping as a practice and can help inform how the map will be used within a community. Collecting information about the community and encouraging full participation while working towards a common goal is the essence of cultural mapping.

The Planning Process

Throughout the entire process it is important to maintain an environment that has several characteristics that may sometimes be challenging to balance. It is that balancing act that is the art form of the planner:

1) It is about creating, nurturing, and mending relationships. Planners may or may not be part of a community in which they work, and while they need to build trust, it is in the relationships across members of the community that are formed in the planning process that have long term value.

2) It is about learning. It should not be assumed that any participants come into the process with fixed positions. The planners, as well as all participants who learn together are more likely to arrive at more creative and more sustainable visions and solutions.

3) It is about addressing tough issues. Conflict should not be avoided but should be welcomed and embraced. Conflicting ideas provide opportunities for learning.

4) It should be about fun. Humor itself can be a great tool for fostering dialogue and learning. The joy of coming together to share, meet new people, explore, even debate should be emphasized and utilized. People will not want ever to engage in planning again if the process is tedious, consistently contentious, or without moments of levity.

Diversity

Around the world, communities are increasingly more diverse as individuals move for better opportunities, to be closer to family, or for new experiences. Cultural diversity as a major concern for all communities has been repeatedly addressed by UNESCO and was the subject of the Universal Declaration on Cultural Diversity in 2001. Accessing the value of diversity requires a tolerant and understanding world

148

in which every culture has a place. This is a pre-requisite for understanding the roles and value of all cultural assets within a community. The literature on community cultural development and cultural planning focuses on the importance of creating open dialogue throughout the community (Congdon, 2008; Dreeszen, 1998; Goldbard, 2004). Through this dialogue all forms of culture can be addressed and planned for according to the unique identity of the community.

Diversity not only includes ethnic or racial differences, but also differences of economic class, sexual orientation, age, and religion (Congdon, 2008). When engaging in community development it is imperative to have key leaders from diverse backgrounds involved in the project. By including diverse perspectives, the cultural map will include assets that have previously been overlooked by large cultural institutions. Everyone has their own perspective on the community and they should be given the opportunity to share their stories without prejudice.

Equality

Promoting equality where diverse cultural and social perspectives are prominent can be difficult in any community. However, creating a welcoming space is necessary for honest open dialogue to occur. The mapping process itself should mirror these values. It is important to remember that no one's ideas are any better or worse than another's. Freire (1974) asserts that dialogue is the only true means of communication. He states that a horizontal relationship between individuals, one that is built on mutual trust and respect, is the only way for meaningful dialogue to occur. The opposite of this relationship, known as anti-dialogue or a vertical relationship, contributes to hierarchical statements of opinions without active listening. Listening is an essential and often overlooked skill in cultural mapping.

Equality must also address the importance of accessibility for the entire community and not only the creation of a level playing field for communication. This is especially critical in the design of cultural facilities. Grodach (2010) holds that cultural spaces can and should function as public spaces and must be designed to accommodate everyone-not just the standard audience. This necessitates creating a space for underrepresented groups to be visible in the wider community and including a diverse array of programming to reach multiple segments of the population in those spaces.

Another method for encouraging equality in cultural spaces is to follow universal design standards when designing and implementing a building. A well-designed space can help create an environment that is welcoming and encourages dialogue among

participants. Universal design is a "design approach that assumes that the range of human ability is ordinary, not special" (Ostroff, 2001). Universal design standards are continually growing as the definition of accessibility evolves to include a wider range of people regardless of age, ability, gender, economic status, education, and more. This focus on accessibility ensures that all segments of the community have the opportunity to feel truly connected to the place in which they live.

Sustainability

Both economic and cultural sustainability can be addressed through the cultural mapping process. Hawkes (2001), a leading scholar on cultural sustainability, has written extensively on the interconnectedness of the four pillars of sustainability: cultural, economic, social, and environmental. He designates cultural sustainability as vital to the health of every community and affirms that if a society's culture fails then so will everything else. To ensure cultural sustainability within a community it is necessary to celebrate the diverse cultural assets and create an environment in which they are respected and able to thrive

One way to build a framework for cultural sustainability is to encourage a shared sense of ownership in the collective culture. Community members must have a chance to be part of community decision making and planning. Without this opportunity, individuals will continue to become more disengaged with society and not understand the importance of sustaining that way of life (Hawkes, 2001). Acknowledging both the shared values and the diversity within the community leads to the creation of a community's unique identity. When individuals are part of this process they gain a sense of ownership in their community. This sense of ownership then becomes an important value that is passed down through generations, encouraging a future built on this shared cultural foundation.

Community Identity/Place

Pride in one's community is an important outcome of building community identity or a sense of place. This pride encourages civic action among citizens and encourages service to the community. However, people have become increasingly disconnected from their immediate surroundings as they connect on a more global scale via new technology (Baeker & Cardinal, 2001; Evans, 2001). Placemaking or building community identity within a geographic region is a known outcome of any cultural mapping project. Developing a map that includes the unique qualities of a community, both tangible and intangible assets, can build a network of stories that

not only connect the individuals who told them, but also attract new residents and visitors to the area.

Creative capital is a concept that has been encouraging cultural development and planning across the United States. Quality of place is an essential piece of creative capital and is promoted by the creation of a unique community identity. Evans (2001) mentions that cities are now looking towards culture to recreate their identities and become a part of the creative city race. Cultural mapping can help strengthen this endeavor by creating a document that can be used to promote the community and attract new residents.

A strong community identity can also be an integral part of a cultural tourism campaign. Cultural tourism has become an important branch of the tourism industry. Thorne (2008) states that cultural tourists spend more time and money during a vacation than other tourists because they want to become immersed in the community they are visiting. They want a more complete experience, to be a part of the community, explore the diverse cultural offerings, and are more likely to develop an indelible connection to the area. Therefore, creating a cultural map can bolster a cultural tourism campaign and create pride and ownership of the community by its members.

Conclusion

Developing a list of community cultural assets is the principal goal of every cultural mapping project, however community engagement and collaboration must be used to reach that goal if the map is to be useful. Identifying both the tangible and intangible assets is necessary to complete a comprehensive map. Borrup (2006), Creative City Network of Canada (2009), and Kretzmann & McKnight (1996) all verify that the practice of creating a map from only tangible assets will ultimately miss much of the individuality of the area. Listening to the stories of the community and engaging in an open dialogue with current residents will help develop a map that truly represents the community and acknowledges the importance of the past on the current state of the cultural sector. Listening and dialogue also build stronger community connections which enhance its capacity to address a variety of challenges.

PART II – OVERVIEW OF THE CULTURAL MAPPING PROCESS

Part I established the theoretical background that could inform creation and implementation of a cultural mapping project. This section will summarize the ways a cultural mapping project can engage the community. It was mentioned previously

that cultural mapping can be a stand-alone endeavor or it could be the beginning of a cultural planning–or any city planning–process. Either way, it is important to engage the entire community and allow residents to offer feedback at every step. This makes certain everyone has ownership of the finished product and is a part of its successful implementation: building community pride and identity.

There are five major elements of a cultural map: Planning, Mapping Design, Community Support & Insight, Creating the Map, and Finalizing the Map. In each of these five steps community engagement should be a priority in order to build and foster a strong community. What follows are examples of ways that community engagement can be emphasized throughout each step as well as the benefit of those steps to the community. For a detailed model of a cultural mapping process that emphasizes community engagement please see http://www.artsengaged.com/bcna.

Step I: Planning

The cultural mapping process should begin with an internal capacity and community networks assessment before opening the project to the entire community. An internal audit is necessary to ensure that all ideas, resources, and current partnerships are organized. This serves as a good foundation for the community engagement work that will follow.

The establishment of goals, objectives, and parameters for developing a cultural map is essential; however, it is critical to include the entire community in doing so. Beginning the planning process with a town hall meeting allows community members the opportunity to be involved from the start. Asking for assistance in this also enables the community to build a sense of ownership in the project. This creates the opportunity for the cultural map to strengthen community identity and sense of place.

During the planning process it is essential to gather all available resources–human, technological, communication, fiscal–before beginning the public phase of the project. It is important to identify established partnerships when developing a list of resources. Many times a collaborating organization may have vital technological or human resources to donate to the process. The community also holds an abundance of human resources. Encouraging community members to be a part of a steering committee, task force, or to volunteer individually to distribute communication and surveys will enhance the sense of ownership in the resulting map. Also, without enthusiastic collaborators and community input, it is impossible to engage others in positive community development.

Step II: Mapping Design

Cultural maps can take multiple shapes. They can be, for example, a written inventory, a searchable database, a Geographic Information Systems (GIS) map, or a hand-drawn map. The design chosen for the cultural map not only depends upon the technology and funding available, but also on the community environment. Understanding how the community would engage with the map is a necessary question to ask during this step of the process. If the majority of the community has a lack of online resources it would not make sense to create a GIS map that only a few could access. On the other hand, if a GIS map is an important component for connecting across local and regional barriers, it should not be neglected.

Creating a database system and deciding on collection methods are necessary parts of Step II. As mentioned earlier, assets can be both tangible and intangible, making a clear organizational system necessary. This is critical in order to be able to find and sort the information once the project is complete. Setting categories for information is a great opportunity to include the wider community. For example, instead of making an executive decision to include only performing arts, visual arts, historical sites, and stories, the community can help identify categories that are important to them and uniquely define each of these terms so that terminology is used consistently throughout the mapping process.

Collecting data takes a great deal of time and human resources. Capitalizing on the use of community volunteers to engage in data collection can build strong foundations for the final cultural map. There are multiple ways to collect information–survey, recording, one-on-one interviews, focus groups–methods that are easily used by the community. Some valuable means to engage the community in this process include having middle and high school students take oral histories throughout the community; hosting a booth at a local festival or farmer's market to gather cultural information; or hosting focus groups throughout the neighborhood. These methods collect information at the grassroots level, can open dialogue among diverse demographics, and can build a diverse dataset representative of the entire community.

Step III: Community Support and Insight

This step includes ways to announce the project to the community, getting them excited to participate, and hosting focus groups and meetings. Creating trust in and a sense of transparency about the project are essential for a fully inclusive cultural map. Encouraging participation and support for this project can come from announcing the

cultural map as a way to find the unique identity of the community or to learn more about its under-recognized cultural assets.

The data collection methods agreed on in the previous step will be put to use here and should be fun and inviting for everyone. This step should be the most community focused of all. Listening to the community is the purpose of this step. It will be clear how engaging the collection process is once results start being entered into the database. Since everyone has a different view of the community, the level of engagement should be evident based on the responses received. If the community is only providing the standard cultural pillars in the community then it will be necessary to ensure the data collection materials are clear and the survey questions are open-ended. Truly listening to the heartbeat of the community will create an inclusive cultural map.

Step IV: Creating the Map

Completing the cultural map takes great attention to detail and a firm grasp of the parameters of the project. The map design from Step II will guide the creation of the map. Creating the actual map will involve a small group of individuals, but must include regular check-ins with the wider community. After asking for community support during data collection, it is crucial to keep the community involved throughout the implementation process. This way both the tangible and intangible assets can be correctly categorized and plotted. Transparency at this time also serves to build trust between the organization leading the mapping and the community, enhancing the likelihood of broad support for whatever projects result from the mapping.

Step V: Finalizing the Map

After completing final edits based upon the community review, the map is ready to be made public. This step should be designed to gain enthusiastic participation by a wide range of community members. Collaborators and, most importantly, the community as a whole should be thanked for their help in creating the map. This can be done as a launch party, as part of another community event, or as a press conference. What is important is that the entire community learns about and has access to the finished product. During this final step the community should have the opportunity to engage with the map and see how they helped shape it. This step should not be the end of community engagement but should be the door that opens up new partnerships and collaborations throughout the community.

Conclusion

Cultural mapping is a tool for building community that can then be used for advocacy and cultural planning, as well as economic and community development. The process of engaging citizens in the creation of their unique cultural identity, by finding the assets already existing in the community, promotes community empowerment, sustainability, diversity, and equality and strengthens their sense of civic pride.

Part I above described the theoretical background for understanding the many positive effects of cultural mapping as long as community engagement is a vital part of the project. Working on a cultural map can enhance the current partnerships in the community and build new collaborations by revealing the common identity among all community members. It outlined common definitions of diversity, equality, sustainability, and community identity/sense of place. As essential pieces of the planning process, cultural mapping is one of many tools that can be used to build and foster a strong community.

Part II focused on how each step of the cultural mapping process can engage the community and the benefits that result from that engagement. Inclusive planning and implementation of the cultural map can ensure that community identity and sense of place is strengthened. These inclusive methods also create a map that is diverse in its definitions of resources and types of resources plotted and provide an equal opportunity for all cultural assets in the community to be a part of the final map.

Cultural mapping promotes the idea that a community has a shared identity which is strengthened by its diversity. Creating a space for open and honest dialogue about cultural assets is difficult but should be the driving force behind cultural mapping. As mentioned throughout this chapter, without respect for all segments of the community on the part of the "mappers" and the community's trust of the process, the resulting map will be incomplete. Significantly, cultural mapping does not end when a map is created. Community engagement is not something that will, without effort, continue to be a part of the community once the map is complete. Once the community has engaged in this collaborative project it is important to build on the partnerships created. It must be continually fostered through collaborative and innovative projects that benefit the larger community. The mapping process provides the cultural community a means of beginning community engagement; it should not be the end of it.

REFERENCES

Baeker, G., & Cardinal, D. (2001). *Beyond garrets and silos: Bringing communities together through cultural planning?* Ontario, CA: Municipal Cultural Planning Project

Borrup, T. (2006). *The creative community builder's handbook: How to transform communities using local assets, art, and culture.* Saint Paul, MN: Fieldstone Alliance.

Congdon, K. (2008). In D. Blandy & G. Carpenter (Ed.), *Arts and cultural programming: A leisure perspective* (pp. 65-78). Champaign, IL: Human Kinetics.

Creative City Network of Canada (Organization). (2009). *Cultural mapping toolkit: A partnership between 2010 legacies now and creative city network of Canada.* Vancouver, B.C., Canada: Author.

Dreeszen, C., Bulick, B., & Americans for the Arts (Organization). (1998). *Community cultural planning: A guidebook for community leaders.* Washington, D.C: Americans for the Arts

Evans, G. (2001). *Cultural planning, an urban renaissance?.* London: Routledge.

Freire, P. (1973). *Education for critical consciousness.* New York: Seabury Press.

Goldbard, A. (2006). *New creative community: The art of cultural development.* Oakland, CA: New Village Press.

Grodach, C. (January 01, 2010). Art spaces, public space, and the link to community development. *Community Development Journal, 45,* 4, 474-493.

Hawkes, J. (2001). *The fourth pillar of sustainability: Culture's essential role in public planning.* Melbourne, Vic: Cultural Development Network.

Kretzmann, J. P., & McKnight, J. (1996). *Mapping community capacity.* Evanston, IL: Center for Urban Affairs and Policy Research, Neighborhood Innovations Network, Northwestern University.

Ostroff E. (2001). *Universal design: The new paradigm.* In Ostroff, E. & Preiser, W.(Eds.). Universal design handbook. New York: McGraw Hill.

Thorne, S. (2008). *Place as product: A place-based approach to cultural tourism.* Mapping and Place Branding Municipal World.

UNESCO. (November 02, 2001). Universal Declaration on Cultural Diversity. Retrieved from http://portal.unesco.org/en/ev.php-URL_ID=13179&URL_DO=DO_TOPIC&URL_SECTION=201.html

PUBLIC VALUE, COMMUNITY ENGAGEMENT, AND ARTS POLICY
based on an interview with
Jonathan Katz, CEO
National Assembly of State Arts Agencies

THE POLICY FRAMEWORK

There are elements of the public policy realm that are referred to as the "third rail," meaning that no politician can threaten them without fear of instantaneous political death. For the last half century, Social Security has been one such inviolable institution. In contrast, public support of the arts has been a "first rail," one that is among the easiest and first attacked in the political arena. The governor of Kansas recently made elimination of the state arts council a key political tactic. Whatever the final result of that choice, he clearly believed that there would be no serious negative fallout and that, on the contrary, political benefits would accrue from the action. Certainly, there was a considerable outcry against the governor's decision, but the fact remains that going in he and his advisers saw the move as a politically beneficial one.

To understand the context for this, it is helpful to review a policy analysis tool developed by Mark Moore at Harvard's John F. Kennedy School of Government. He frames a strategic triangle of public policy:

public value–"[transforming] existing social conditions in collectively desired directions;"

the authorizing environment–"Actors from whom authorization and resources are required to survive and be effective;" [This includes governmental units, interest groups, media, patrons, and the broad electorate.] and

operational capacity–internal "assets and capabilities plus [external ones] that . . . can [be influenced] to achieve the desired results."

[Moore, Mark H. and Moore, Gaylean Williams. "Creating Public Value through State Arts Agencies." Keynote Address to the National Assembly of State Arts Agencies Annual Conference, September 9.2005, Boise, ID.]

Arts delivery systems in the U.S. (as discussed elsewhere in this book) have reflected the separation between the arts community and the broad population found in those systems' European roots. As a result, the perceived public value of the arts (as viewed by the electorate) has been minimal. There is therefore little motivation in the authorizing environment (with the exception of existing patrons of the arts) to initiate or expand support for the arts; and the operational capacity of the arts community is largely limited to its internal resources, since it has little influence in the wider community.

Inside the arts world, there is a tendency to see the lack of political viability as a simple marketing problem: people are insufficiently aware of the public value of the arts; if communication strategies were more robust, the problem would be solved. There is, no doubt, a germ of truth in that assessment. However, the problem runs deeper. There is no conspiracy afoot to hide the arts' value from the populace. The simple truth is that in general, with significant and glorious exceptions, average citizens are aware of little direct personal benefit from the reflective arts.

ENHANCING POLICY ADVOCACY BY ENGAGEMENT

The cornerstone of vibrant support in the public policy arena is the fact and perception of public value. A supportive authorizing environment and expanded operational capacity flow from that. Therefore, the most effective means of developing and furthering policy initiatives favorable to the arts is for artists and arts organizations to assume a lead role in improving the lives of all members of the community. (This would have the additional benefit-as has been pointed out elsewhere in this book and is underscored in Moore's category of operational capacity-of supporting development and marketing efforts in the arts.)

The arts community must be involved in discussions of important matters beyond the arts. If the sector is not deeply embedded in core issues like food, water, energy, or security, it will be further marginalized as those concerns increasingly dominate public discourse. Such engagement will allow the arts to demonstrate a hitherto little understood power for social betterment. It will raise the sector's visibility both among opinion leaders and the general public; and it will eventually be established in the public consciousness as an important asset-for individuals and for the community- in achieving a brighter future. This will translate directly into a vastly improved "authorizing environment" for the arts.

Under the "organizational capacity" category of Moore's strategic triangle, the lack of ability to influence the use of external resources is particularly troublesome. As

one example, there are nearly countless studies of the practical benefits of the arts in broadly diverse areas of health, aging, public education, or the reduction of recidivism, to name only a very few. Yet neither professionals in the relevant disciplines nor the general public put sufficient stock in those studies to alter policy. This disinclination to believe is rooted in unexamined assumptions that the arts do not touch the lives of more than a select few. Work on producing greater public value will counter those assumptions, making belief in and action on the results of arts efficacy research more common.

TWO PRACTICAL STEPS

There are numerous practical steps that could be undertaken to transform the policy environment. This book presents many of them. Two unrelated approaches that would be useful are redirecting the focus of planning from an arts framework to a community one and staffing the engagement work that has been central to the discussion here.

Approaches to Planning

There is a habit of mind with respect to planning in the arts community that stands in the way of engagement. Arts-centered planning, in which an arts organization or the arts community analyzes its own needs and priorities, results in arts-centric solutions. It yields a focus on organizational needs when self-focused or on gap programming and the development of common services when flowing from the arts community. While unintentional, this approach enforces separation from the community at large. It is only much later in such processes, when cultural policy or community design are addressed, that points of intersection with those outside of the arts are considered.

An alternative planning model, focused on broad cultural planning in the context of the whole community, would far better facilitate engagement that enhances public value via the arts. Asset mapping (or cultural mapping when focused on the arts), a model for planning in the community development arena discussed in an earlier chapter, would provide an ideal opportunity for the arts to become deeply embedded in community improvement.

The *Animateur*

The form of deep engagement with the community that is necessary is so important that the arts world must staff it. The work is of the same level of importance as development and marketing. Just as every arts organization of any size provides itself

with human resources to run its fundraising and public relations efforts, all should equally hire personnel to direct the process of building and maintaining relationships with the community. The European notion of the *animateur*, a person responsible for connecting the community with the arts organization, is an example of such a position. (Elsewhere in this book, see the discussion of the Queens Museum of Art's community organizer.) This person can serve as a translator between the arts and the wider community, a relationship-builder in advance of any project development, and a process shepherd, navigating the somewhat fraught nature of establishing arts-community partnerships. These efforts are the essence of fostering an arts organization's public value.

CONCLUSION

The environment for arts policy today is difficult. Public budgets are imperiled by a weak economy. Politicians are both desperately and eagerly seeking ways to lower the cost of government. The relative dearth of political capital possessed by the arts community makes arts funding and other forms of public support easy first targets for cuts and for out-of-context ridicule, ridicule that erodes the good will of the electorate.

Public policy advocacy is rooted in both substance and messaging. As pointed out above, the answer is not simply better communication about what the arts are already doing. Marketing efforts must be supported by substantive work on the part of the arts world in claiming a place in solving community problems and enhancing community life. Widespread perception of public value, derived from substantive engagement in addressing community issues, is the best foundation available for a healthy arts policy environment.

CREATIVE ENTREPRENEURSHIP

Creative entrepreneurship is the application of principles of structural and systems transformation in the creative sector. It can be focused on enhancing revenue streams for individuals, organizations, or communities; but it can also be concerned with non-financial change: improving communities or individual lives. Since it is deeply concerned with the practical benefits of the work, often outside the world of the arts, it provides a unique vehicle for collaboration between the arts and the broader community.

CREATIVE ENTREPRENEURSHIP AS A TOOL FOR COMMUNITY ENGAGEMENT
by Susan Badger Booth

Creative Entrepreneurship is the practice of starting a business venture in one of the creative industries. Creative industries are defined broadly and by design include a diverse group of businesses often lumping together culinary arts, fine arts, architecture, film, literary arts, and crafts together in one large creative stew. Creative Entrepreneurs value their own creative and intellectual capital before any other ingredient necessary for a successful project. Creative Entrepreneurs embrace the process of discovery that in turn leads to successful innovations, and they care deeply about the broader community they live in and often seek out partnerships with both individuals and organizations as new projects emerge,

INTRODUCTION

Creative Entrepreneurs are not a new breed; in fact they were the founders of many of the nation's most successful regional cultural organizations. Now these established organizations are seen as the cultural bedrock in many of our communities. Increasingly, these institutions are tapping into the fresh innovative practices of a new generation of entrepreneurs. These wise organizations are leveraging the position of their well-known products and services with the original innovations a younger audience expects to see in creative organizations. This type of connection is a valuable way both to advance

organizational mission and to create environments where Creative Entrepreneurs will prosper.

Connecting Creative Entrepreneurs with community engagement projects in the arts happens naturally, often without any kind of strategic thought or planning because the entrepreneurial mindset understands that new projects trigger other endeavors opening doors to the next successful collaborative venture. Creative Entrepreneurs leverage their creative abilities to innovate, solve problems, and take on leadership roles that lead to new opportunities with potential for both social and financial rewards. These entrepreneurial values foster a drive to experiment and take risks, seeing failure as part of the process instead of an undesirable option at the end of a project. Cultural organizations provide access to creative resources and serve as a fertile environment for this creative process to occur.

Entrepreneurship has been a buzzword for decades. Countless business schools now offer degrees in entrepreneurship. Many of these programs began when entrepreneurial alumni returned to their universities concerned that existing programs were not teaching students the skills needed to start new business ventures. The Kauffman Foundation tracks entrepreneurship programs in higher education and notes that in 1970 only 16 business schools in the U.S. offered any entrepreneurship courses. Today, more than 2,000 colleges and universities have some kind of program in entrepreneurship[1].

Traditional business schools had been preparing students for managing and growing previously established businesses, not starting new enterprises. Entrepreneurship education focuses students on new venture creation. Where traditional business models neatly separate research and development activities from production, entrepreneurs tend to see the experimental process of innovation as their main course, moving fluidly between innovation and production. Serial entrepreneurs tend to have a long history of multiple start-up businesses or projects. It's easy to see how the Creative Entrepreneur could get swept up into this business practice and take advantage of the resources offered to this growing sector, since artists share an experimental mindset parallel to the entrepreneur.

Initially, entrepreneurs were seen as those willing to risk their own financial capital, and thus the definition precluded many creative entrepreneurs who could only leverage creative capital rather than financial. This restriction often created a barrier to access entrepreneurial startup funds for community engagement projects, but in recent years the definition of entrepreneurial practice has expanded to include social entrepreneurship. With the advent of social entrepreneurship, risking your own

creative capital was now valued equally as taking a financial risk. Often young Creative Entrepreneurs may not have funding to infuse into a new project, but now the value of creative and intellectual capital was seen on par with the ability to attract initial financial backing for startup projects.

Social Entrepreneurs are defined as change agents that recognize a social need and then apply entrepreneurial practices to address the need through creative innovations. Social Entrepreneurs often bypass government and business sectors and instead focus their work on changing broader systems, educating community members on the benefits of such a change, and then advocating for individuals in a community to make these changes. Social entrepreneurs see themselves as part of a broader community and accept the responsibility that goes with their role as community member. While business entrepreneurs have a history of measuring success through profit and business capitalization, social entrepreneurs also measure success through building social capital (addressing social needs). Social capital is defined as the network of relationships in a group of people or between organizations that can be utilized to build healthier communities. In time, successful ventures are rewarded with social and financial security. Like Social Entrepreneurs, Creative Entrepreneurs are more than resource users, they have a commitment to give back to their communities making them more appealing places to live and work.

CREATIVE ENTREPRENEURS WORKING WITHIN CULTURAL ORGANIZATIONS

With the onset of cultural mapping, as discussed in Tom Borrup and Stephanie Moore's chapter, it has become easier to group these Creative Entrepreneurs (for-profit) with Cultural Organizations (not-for-profit) so as to measure the broader impact of this larger more inclusive Creative Sector of the economy. Where for decades not-for-profit leaders have carefully avoided any unrelated business income, now these same organizations fluidly spin off secondary businesses with the freedom to address organizational mission in new and innovative ways. Watching the line between these two sectors blur offers us a view into this entrepreneurial mindset in action.

The story of the Metropolitan Opera's development of Tessitura[2], an integrated set of information management systems for arts organizations, illustrates just such an entrepreneurial spinoff from a not-for-profit cultural organization. Projects like this are sometimes referred to as "intrepreneurship" when coming from an already established organization. Upon seeing a need for an integrated database system tailored to the

unique requirements of cultural organizations, the Metropolitan Opera invested $5,000,000 of their own capital into developing a system that would eventually be know as Tessitura.

Originally seen as an internal project that was designed only to meet the needs of the Met, it did not take long for other cultural organizations to see the program's unique features and ask for access to the Tessitura system. After seeing a market for their new product, in 2001 the Met created a separate spinoff for-profit business that would market and distribute this new information system. What was so interesting about the Tessitura system was the family of users it created, users who were all eager to swap stories and strategies about how best to use this new system. Instead of seeing this informal group of supporters as competition for servicing clients Tessitura embraced and nurtured these relationships.

With the strength in the family created around this information management system, Tessitura was able to make a case for receiving not-for-profit status that they were awarded in 2003. Describing itself as utilizing a business approach that benefits the user community, Tessitura operates on a unique open and collaborative model providing familiarity above that of for-profit software companies. Now Tessitura grows through the innovations created by their international user base, seeing value in promoting third party products and services as part of the expanding Tessitura kin. In this case, the community engagement outcome developed through this entrepreneurial mindset now services a global community of cultural organizations brought together through shared needs and innovations.

CREATIVE ENTREPRENEURS AND ECONOMIC DEVELOPMENT

Creative Entrepreneurs are critical players in the development of the Creative Sector as a whole. Again, using a large net to define what is included in the word "creative," regional planners appreciate the diversity and growth potential of this sector. *Berkshire Creative*[3], a not-for-profit organization in North Adams, Massachusetts is on the forefront of this shift in thought. *Berkshire Creative* leverages ties between cultural organizations, local artists, and creative business owners to nurture the local creative economy. *Berkshire Creative* was the brainchild of Laurie Norton, Director and CEO of the Norman Rockwell Museum, and Ellen Spear, President of the Hancock Shaker Village. These two cultural leaders found themselves sitting next to each other at a meeting discussing a countywide economic development plan. They quickly realized the only way for this plan to benefit their work would be to rally the creative sector and advocate for the impact their sector has on Berkshire County.

Within the next year a 45-member steering committee was convened; soon after, the *Berkshire Creative Economy Report* was commissioned and produced by Mt. Auburn & Associates. The report documented over 6,000 jobs produced by the creative sector in Berkshire County. The definition the report gave for the Creative Sector was significant, "enterprises and people involved in the production and distribution of goods and services in which the aesthetic, intellectual, and emotional engagement of the consumer gives the product value in the marketplace."[4] It was critical that the report included not-for-profit cultural organizations, creative businesses, and individual artists all as part of this growing economic sector and suggested value in encouraging these groups to develop creative connections around their work.

By the summer of 2007 *Berkshire Creative* had hired Helena Fruscio as a summer intern. Helena grew up in the region and would quickly become Director of the organization. Armed with a new degree in Ceramic Sculpture and Anthropology/Sociology, Helena began developing innovative engagement programs for the creative sector. These programs are already being seen as models for communities across the country.

With the Berkshire's striking natural backdrop and the region's 200-year creative tradition, being home to a vast number of artists and cultural organizations, *Berkshire Creative* wanted both to generate awareness of the size and value of the creative sector and to incubate new creative projects. In 2009, BC's Creative Challenge program began to connect Berkshire manufacturers and businesses to local designers, engineers, and creative workers, with the aim of stimulating innovative research and development for existing or new product lines. Creative Challenges have resulted in two new prospective product lines.

BeCreative BarCamps, another *Berkshire Creative* program, offers county creative entrepreneurs a platform to share creative ideas. This event was modeled after a similar idea bounce event in southern California's tech industry. *Berkshire Creative* defines a BarCamp as an ad-hoc gathering born from the desire for people to share and learn in an open participatory environment. The content is provided by participants via discussions, demonstrations, and interaction. BeCreative BarCamps offer presenters 15 minutes to share their ideas. Past sessions have included: *Top Ten Copyright Myths, Kickstarter & Crowdsource Funding Opportunities,* and *How to Turn Your Blog into a Book.*

When Helena Fruscio was asked in a 2010 *Createquity* interview to share her favorite inter-sector collaboration she picked an early *Berkshire Creative* inspired connection. For years two founding steering committee members, Bill Hines, Jr. of

Interprint Inc. and Ellen Spear of Hancock Shaker Village had worked less than a mile apart from each other with very little interaction. Through the relationship created by their committee work, Interprint (a leading decor printer and designer of laminate flooring) decided to take inspiration from their neighbor down the street and design a new line of flooring motivated by the simple design motifs of the Hancock Shaker Village, benefiting both organizations both socially and financially.

The Berkshire Creative model is allowing Berkshire County to enhance the appeal of their community to creative entrepreneurs by offering resources tailored to their unique interests and needs. They see themselves as a bridge from creative innovator to small manufacturing production, utilizing community assets to attract and develop new businesses, thus enhancing the economic health of their entire region.

CREATIVE ENTREPRENEURS IN THE URBAN CREATIVE SECTOR

Although less strategically organized than the Berkshire County program, Detroit, Michigan's Creative Entrepreneurs have had a measurable impact on the city's economic revitalization and social health. Stark contrasts can be seen between Detroit, a post-industrial urban city with an unemployment rate regularly hovering above 30%, and the affluent rural community of the Berkshire Mountains. But more interesting may be the similar impacts the Creative Entrepreneur is having in both regions of the country.

Detroit's Cultural District, the Cass Corridor, is rich in both cultural history and resurgence as renovated lofts and affordable housing are attracting young people back to urban living. Between the Motown era and the 21st century rebirth of indie bands such as *The White Stripes* and the *Electric Six*, the Cass Corridor was home to one of the largest concentrations of poverty and crime in the nation. But as the pendulum of economic recovery moves slowly, this neighborhood is now home again to a growing number of creative businesses. It is also significant that this neighborhood is home to the Detroit Symphony's Orchestra Hall, the College of Creative Studies, the Detroit Science Museum, the Detroit Institute of Art, MOCAD the Museum of Contemporary Art Detroit and the African American Museum.

Detroit's *Open City*[5] is a group of small business owners and wannabes that nurtures this growing creative business sector with monthly meetings at Cliff Bells, a local bar. The city's unemployment rate is so high new venture creation is often the only option for staying-or moving into-the city. Open City offers themed discussions for the creative entrepreneur such as: *Fitting In: Your Business Niche, Legal Fun with a Detroit Twist,* and *Business Writing Detroit Style.* Cass Corridor members of this support

group range from the Burton Theatre, an indie film house in a closed elementary school; the City Bird urban wares; Leopold Books independent book seller; Curl Up & Dye Hair Salon; and Good Girls Go to Paris Creperie. Although not always formally connected to the cultural organizations in their neighborhood, these businesses share a symbiotic relationship in enhancing a sense of place and engaging visitors to explore the corridor beyond trips to a museum exhibit or a symphony concert.

Resources are abundant for artists and entrepreneurs when real estate is cheap, as seen countless times in urban areas from SOHO in New York City to Islington in London. Creative pioneers inhabit deteriorated, and often abandoned, neighborhoods inexpensively, gaining access to large spaces where they can innovate and create community value. Detroit, like these other examples, boasts an amazing amount of affordable housing stock.

In 2009, local Detroiters Mitch and Gina Cope attracted international attention when they began inviting artists to join them in buying foreclosed properties in their North Detroit neighborhood. The couple scooped up a dilapidated home for only $1,900. The house had been completely stripped, including all its copper wiring and plumbing. This was not a problem for Mr. Cope, an architect who planned to keep the home off the grid adding solar and a wind turbine with hopes to energize his and other area homes.

The Copes turned this building into the "Power House" a neighborhood arts center, currently occupied by Dutch architect Guido Marsille. Marsille is working on renovating the home and exploring "the idea of public and private contradictions, asking the question, 'What can a house be, other than a private dwelling? Can it have a function as a catalyst in a street, neighborhood and wider area?'"[6] Since the Copes put out their call to artists, a number of "creatives" have moved into the neighborhood. One artist reported purchasing their new creative quarters for only $100. The Copes are one of 12 individual Detroit artists who received a $25,000 Fellowship in 2011 from the Kresge Foundation to offer time and resources to further develop their creative work. Kresge grants are empowering artists to access the fertile resources in Detroit and become part of this emerging creative sector.

Detroit Soup[7], similar to the Berkshire Creative's BarCamps, adds a micro-grants component to their idea-sharing event. Organized around a monthly dinner, attendees are asked to present their creative projects, produced within the Detroit city limits. Proposals are due the Friday before the Sunday dinner. Diners vote on their favorite creative venture, and one participant is awarded a $600 - $900 grant to support their project, funded out of the fees collected for the community meal. Enhanced

networking opportunities, like the dinner portion of Detroit Soup, are seen by many as equally important to attracting creative entrepreneurs to a community, as is offering potential funding for their projects. It is the process of creating forums for like-minded creative entrepreneurs to engage with each other that helps build and retain these networks of artists.

New on the Detroit horizon is the *Detroit Creative Corridor Center*[8] (DC3), a partnership between Business Leaders for Michigan and the College for Creative Studies. DC3 was formed as a mechanism to support the growth of Detroit's creative economy, similar to Berkshire Creative's mission, DC3 programs include Open City (now living under their umbrella), a 12 month Business Accelerator program that is hosting it's first cohort of 17 creative businesses, and Drinks X Design a monthly happy hour series bringing together Detroit's design community who share ideas and learn more about each other's work.

All of these programs are supporting an environment that offers a more attractive neighborhood for audiences to come and enjoy Detroit's longtime established cultural gems such as the Detroit Institute of Art (DIA) and the nationally recognized Detroit Symphony Orchestra (DSO). It is the servicing of this shared audience that supports both the renowned art museum and the new creperie directly across Woodward Boulevard. Young professionals who are moving into this neighborhood recognize the enhanced sense of place local entrepreneurs and institutions are supporting as part of this turn around story.

CREATIVE ENTREPRENEURS AS TEACHING ARTISTS

Growing numbers of communities are seeing value in inviting artists into their schools, classrooms, and afterschool programs. With funding for public education in jeopardy, arts programming is often the first to get cut. But many communities understand the importance of fostering the 21st century skills of innovation and creativity in their classrooms. Creative entrepreneurs are seen as experts at teaching these critical skills for the 21st century worker. As a result, artists not previously engaged in the education system, are finding this to be a new opportunity both to engage with their communities and to enhance their earned income.

Gallery 37[9] is the flagship program of the umbrella organization *After School Matters*, based in Chicago, Illinois. Gallery 37 is a job-training program that follows a system called the ladder of opportunity. Students apply for positions in pre-apprenticeship, apprenticeship, advanced apprenticeship, and finally professional internships. In each level students are paid to work with professional artists. Currently, areas of study

include drama, painting, flamenco dance, improvisational comedy, culinary arts, and skateboard design. The Gallery 37 Store completes the cycle of entrepreneurship as students sell their work in a professional gallery setting.

The Gallery 37 example offers a unique window into the creative entrepreneur as mentor to inner city youth. The role of the artist is elevated as the program frames the artistic discipline as a job-training program. By paying student apprentices for their time, the value of the creative work they are learning to master is enhanced.

Utilizing the motivations of for-profit fiscal sustainability and a not-for-profit's social mission, *Community Records L3C*[10] provides community-centered music programming and education. Located in Ypsilanti, Michigan, Community Records L3C organizes and trains musicians and music professionals to serve community needs. Currently, programs are designed as part of after school enhancement curricula and include songwriting, music composition and production, and self-expression in response to community topics. These workshops naturally bring musicians, youth service organizations, and cultural institutions together with interested community leaders.

Collaborative projects have brought a youth songwriting programming to the local Public Library and are often used to host concerts to raise awareness and funds around identified community issues. The L3C business structure maintains dual expectations that have propelled Community Records to create empowered students, sustained programming, and the efficient use of community musical assets. Community Records and Gallery 37 support artist employment through hiring local teaching artists. Both programs offer opportunities for youth to develop 21st century skills in applied learning environments and to engage directly with their public school districts.

CREATIVE ENTREPRENEURS AND LIVE/WORK PROJECTS

Moving west across the country, Ventura California is the backdrop for one of a growing number of live/work spaces for artists. These live/work projects address the pressing need for artists to find both flexible and affordable spaces to live, create, and display their work. Particular emphasis has been given to the need to address gentrification in these communities. Some projects take small industrial buildings and refurbish the interiors as large residential units usable as both living and studio spaces.

Other projects, such as *Working Artists Ventura*[11] *(WAV)* have taken advantage of building new structures on less expensive land in brownfield sites (abandoned commercial areas that may have environmental cleanup issues). Both types of developments use Low Income Housing Tax Credits and Historic Preservation

Housing Tax Credits to offset costs for these projects, in addition to private and public financing. Successful projects sometimes begin with the donation of a site by a local municipality. These projects may include additional components with adjacent retail space, common gallery and performance spaces, and units for sale in addition to low-income rental units.

WAV further engages with Ventura by offering a new environmentally friendly component with their building being described as fully sustainable, LEED certified. WAV boasts recycled building materials used throughout construction, car sharing for residents, water and energy conservation, and renewable solar power. Of the 69 units of affordable housing, 54 units are reserved for artists and their families. The balance of the units are set aside for homeless families and local eighteen year olds who have recently graduated out of the foster care system. In addition, 13 market rate condominiums (priced from $625,000 to $875,000) are perched on the penthouse level of the WAV complex, an area including a 500 square foot rooftop deck. Sales of these condominiums offset project costs for the affordable housing units.

Successful artists live/work projects are often developed in conjunction with larger cultural districts and organizations, offering opportunities for a mixed income community. These can allow individuals to build equity, making the projects more sustainable. WAV's extreme range from temporary housing for homeless families to high-end condominiums will be an interesting testing ground for whether the cool factor of living within an artist community will be enough to attract buyers for the high-end ocean view condominiums. Projects without access to ocean views may have a harder time offering such a broad income mix in one facility.

Some Live/Work Projects include additional resources for the Creative Entrepreneurs in residence such as small business incubators, business workshops, and community engagement programs encouraging collaborative work among residents. Developing these clusters of artists often leads to community engagement projects simply through a larger concentration of artists. These creative community citizens enhance their neighborhoods by sharing their creative work, engaging with students as teaching artists, and addressing community needs through their work. Other projects work more strategically with local cultural institutions in creating public art programs, expanding access to live performance, or developing community applied arts programming.

CONCLUSION

The growth of the not-for-profit cultural community in the 1960's and 1970's began with an eye toward entrepreneurship, but in many instances, as is common with any established organization, this resolve has faded. Often cultural organizations have forgotten both the risk and opportunity involved in the vulnerable practice of incubating creative projects. No longer is the not-for-profit cultural organization always concerned with addressing the interests and even needs of their communities; in fact, many have become risk adverse making safe programming choices rather than innovative ones.

Creative entrepreneurs have the potential to engage with these organizations and lead them back to their original entrepreneurial mindset. Certainly not a paradigm shift, but rather an evaluation and reassignment of the many assets found within our creative organizations and creative communities. Beyond the theory of Creative Entrepreneurship are the individual entrepreneurs putting this theory into practice. One-by-one their small actions have resulted in measurable and meaningful impact on our communities.

Connecting Creative Entrepreneurs and cultural organizations produces environments that are readily conducive to collaboration and will enhance our broader communities, making them more attractive places to work, live, and play. The shared value of creativity and the creative process offers a common ground on which these collaborations can be built. The infusion of new energy from creative entrepreneurs has been used to create open, and evolving, solutions to enhance our communities and neighborhoods.

The Creative Entrepreneurs highlighted here can be organized loosely around the following five community engagement outcomes. First, greater accessibility between artists and the broader community enables *the creation of new products and services*. This can be seen clearly in *Berkshire Creative's* programs that link artists with small manufacturing resources, already resulting in two new product lines as artists engage with the manufacturing industry. In Chicago we can see that hiring creative entrepreneurs as mentors through *Gallery37* programs has enabled generations of students to hone their 21st century skills in creativity and innovation, while at the same time learning the mechanics of a specific artistic discipline.

Second, *self-sustaining programs and partnerships are developed* through the application of business skills and training. Detroit's *Open City* support group grew out of this need. Creative entrepreneurs in Detroit saw the great potential for success, but also the challenges that they faced as they started their own creative businesses.

These early entrepreneurs understood that a network of successful businesses could support each other, so sharing lessons learned made great sense to the broader goal of revitalizing a neighborhood and even a city.

Third, there is an *increased ability to attract community interest*, through the appeal and organizing power of the arts. There is a reason that collaboration often needs face-to-face encounters to incubate. This was seen with the *Detroit Creative Corridor's* new *Design X Drinks* monthly networking event, where individuals from Detroit's design community were offered a chance to share ideas and learn about each other's work at an informal social event. Another example is offered by the residents of artists' live/work spaces, such as the WAV project, who see the value in living among like-minded creative individuals gaining inspiration through day-to-day encounters created by living in a shared community. These encounters are expanded to the broader community, when artists open their studios to the public or offer their knowledge to young people through educational opportunities.

Fourth, creative entrepreneurs *generate economic development that directly addresses community needs*. Creative entrepreneurs represent an important part of a growing small business sector in the U. S. In all the case studies discussed earlier in this chapter artists are tapping into local resources and hiring local talent in support of their businesses. Successful ventures cannot be developed without an understanding of community needs and interests, but creative entrepreneurs are unique in that their values tend toward a sophisticated appreciation for how their work will affect their neighborhoods.

Fifth, creative entrepreneurs *foster idea generation, which supports other local entrepreneurs and the sustainability of cultural organizations.* Innovative solutions to community needs are generated when engaged community members are appreciated and allowed to take action. This process of idea generation is often taken for granted, but when the power of innovative thought is harnessed and put to work strategically in our communities, change can be dramatic. This power can be seen in the rural and urban communities of both the Berkshire Mountains and the City of Detroit discussed previously.

These outcomes address both the social and financial interests of the Creative Entrepreneur as well as the needs of the communities they call home. The present situation is one where a majority of for-profit corporate CEO's express creativity as the number one leadership competency needed by a 21st Century workforce[12]. This is an environment where need is meeting opportunity, centered on community engagement. This, coincidentally, is a great atmosphere for Creative Entrepreneurs and

cultural organizations to test ideas, learn from failures, and discover the needs for potential new markets.

FOOTNOTES

1) The Growth and Advancement of Entrepreneurship in Higher Education; An Environmental Scan of College Initiatives. Kauffman Foundation. 2001
2) http://www.tessituranetwork.com/
3) http://berkshirecreative.org
4) Michael Kane. Berkshire Creative Economy Report. Mt. Auburn Associates. 2007
5) http://www.opencitydetroit.com/
6) Plockova, Joann. Power Meets the Arts in Detroit. Next American City. Web. June 24, 2011
7) http://detroitsoup.com/
8) http://www.detroitcreativecorridorcenter.com/
9) http://www.afterschoolmatters.org/
10) http://www.crl3c.org/fr_home.cfm
11) http://placeonline.us/projects/wav
12) Working Beyond Borders: Insights from the Global Chief Human Resource Officer Study. IBM Institute for Business Value and IBM Strategy & Transformation. 2010

SOCIAL MEDIA (ART 2.0)

The time when influential individuals or established organizations could simply present data, information, or Truth without being subject to question is long since gone. The upheaval of the 1960's through the Watergate scandal permanently voided the social contract in which institutions and authority figures were given the benefit of the doubt. The advent of technologically-mediated means of individual citizen participation in nearly all aspects of life has provided people the ability to voice their questions if not their mistrust.

The social media platforms that define Web 2.0 (the Internet-based sharing of ideas, opinions, and information) have transformed all means of communication. They have also given rise to new ways of creating and/or defining community.

These facts are important to the world of the arts, especially arts institutions. Like every contemporary institution, they are subject to concerns on the part of the public about their trustworthiness–even value. Habits of interaction must evolve. The "authority-based" role that arts organizations have held (or assumed) is increasingly anachronistic.

The following article reflects on the nature of the transformation that is occurring in social relationships, on some elements of its impact on arts institutions, and on the potential benefits of those changes for arts organizations. Indeed, it suggests that social media may prove to be a force pushing arts institutions toward deeper engagement with and, through that engagement, greater support from those communities.

PARTICIPATORY CULTURE AND THE ARTS
by Doug Borwick and David Dombrosky

The rise of social media over the past decade has revolutionized our capacity to digitally communicate with one another both individually and collectively. What was once a unidirectional relationship in which arts organizations broadcasted messages to audiences via websites, email, and online advertising has now evolved into a multidirectional relationship wherein arts organizations and audiences engage each other in a series of multimedia conversations. With this new capacity for engagement,

how are arts organizations harnessing social media to build deeper relationships with their audiences?

THE RISE OF PARTICIPATORY CULTURE

The advancement of online technology over the past decade has produced a highly participatory environment wherein individuals no longer simply consume culture; they actively produce and contribute to culture. Of course, people were independently creating and distributing cultural material prior to the Internet: authors self-published with vanity presses, bands independently produced their CDs, guerilla filmmakers sent documentaries to customers via videotape as ordered. So what changed?

Access to Media Production Tools

As broadband infrastructure grew exponentially within the United States and abroad, many media production software companies shifted away from providing software via CD-ROM to creating web-based software-as-a-service, which was often far more affordable than its predecessors. Other companies distributed free software, or free with an optional paid upgrade, for download via the Internet. In tandem with the decreased costs in production software, physical tools for digital production, such as computers and cameras, also grew more affordable while simultaneously expanding in capacity and complexity. Thus, large numbers of people gained access to previously unaffordable tools for image manipulation, audio editing and mixing, video production, and universal document creation, to name some of the most important.

Expansion of DIY Distribution Channels

As more people gained access to production tools and began to create material, social media sites like Flickr and YouTube emerged as free distribution channels with the capacity to reach audiences around the world. Creators no longer had to navigate the traditional distribution channels or go through cultural gatekeepers to have their work seen and/or heard by the public. With a click of the mouse or keyboard, individuals could now distribute their work to a potential audience of millions. For example, YouTube is the third most visited website in the world with nearly 33% of global Internet users visiting the site on any given day. As of this writing, 48 hours of video are uploaded to YouTube every minute, and over 3 billion videos are viewed each day.

Communities of Interest

Along with offering the capacity to distribute self-created media to Internet users around the world, social media sites enabled content producers and consumers to develop virtual communities based upon mutually held interests. Through a variety of means (*e.g.*, profiles, comments, discussion forums, groups, and wikis), geographically dispersed individuals with shared passions grew able to identify each other and converse in real-time as well as asynchronously. In these new communities, participants would share resources and ideas and engage in mutual mentoring.

This form of community, bound by common interest and in which geography is irrelevant (or nearly so), is not the only type of community that can be created or enhanced via social media. Social scientists commonly identify physically-based communities that augment their mutual support via technology as a second category of virtual community. A hybrid of these two trends is also developing–a community that supplements the experience of those in a shared location while simultaneously bringing together geographically dispersed people with a shared interest.

It is these last two forms of virtual community–those tied in some way to location–that have the most relevance for arts institutions. Touring exhibitions and performances have always sought to expand the impact of arts organizations beyond their home boundaries, although these grew out of the old authority-based model. On-going relationships–via experiencing art (virtually or in person) and giving feedback–are now possible. This provides the prospect of connections with arts audiences in far-flung locations as well as deeper relationships with those in geographic proximity.

PARTICIPATORY CULTURE MEETS THE ARTS

When arts organizations began utilizing the Internet to reach out to audiences in the 1990s, they communicated unidirectionally through e-mail and static websites, thereby replicating certain traditional practices in the online environment. Static websites were the web-based version of a season brochure or an annual report, while email campaigns served as digital press releases and direct mail. At that time, online audience feedback was limited to email messages sent to the organization's Inbox, and even that practice was rare.

This approach has become dated. People increasingly expect to be part of a dialogue about every important aspect of their lives. They will not long be content to receive arts experiences from a relationally remote institution. This will be particularly true of arts organizations that focus on a cultural expression that is foreign (or at least not indigenous) to the people they are trying to reach.

176

For a portion of the arts community, the prospect of dialogue about the merits of specific works of art can lead to an existential crisis. There is a sense, whether conscious or not, that the artistic canon is *and should be* fixed, occasionally allowing for contemporary additions. Negotiation with those outside the arts establishment about what is artistically valuable is, if not anathema, at least highly suspect. As is discussed at length elsewhere in this book, even if rigid adherence to an artistic canon within a specific culture is justifiable, the co-existence of so many cultures in our society makes an industry-wide focus on one (or even a small handful) problematic for the future of that industry.

On a less philosophical level, there is also in the arts community a frequently expressed concern that opportunities for largely uncensored feedback will invite negative comments. Yes, they will. They will also generate positive comments. An intriguing aspect of online commentary is the self-policing that frequently occurs in virtual communities. Erroneous conclusions or outright misstatements of fact often bring corrective responses not from institutional agents but from external defenders. Such responses carry more weight in the public arena than would those from insiders with vested interests. Further, when justifiable criticisms are voiced and the organization responds by fixing the problem, its reputation is enhanced, not diminished. Some vendors on Amazon.com monitor customer reviews and, when legitimate concerns are raised, they address them publicly. This is highly effective image maintenance (or enhancement). Moreover, sometimes without external input, situations in need of remedy go unobserved for longer than is needed. Feedback can lead to healthier organizations.

Participatory culture is the future. Like every other segment of collective enterprise, arts institutions cannot opt out of that future. It is therefore important to develop and implement plans to incorporate its benefits into the work of the organization.

In the context of this book, participatory culture is a particularly important development. If community engagement is fundamentally the building of relationships, the options for interactive response made possible by the Internet make social media ideal, if not central, tools for engagement.

This book argues that arts organizations must accept the necessity of developing relationships with the members of their communities (however those communities are defined). Social media will prove key to that end. Future generations will expect such interaction, and the technology will make it possible to foster meaningful (though perhaps with new meanings of "meaningful") relationships with a far wider portion of the population.

PARTICIPATORY CULTURE IN ACTION IN THE ARTS

Simple means of interactive communication through blogs, Facebook, or Twitter have been discussed in detail by many marketing experts in many other sources. What follow are possibilities for engagement that go beyond "mere marketing" and suggest fascinating possibilities both for art and for engagement. Other options are waiting in the arena of the yet-to-be-imagined.

In 2006, media scholar Henry Jenkins and his colleagues published a white paper titled *Confronting the Challenges of a Participatory Culture* in which they described five defining elements for participatory culture[9]. Those elements are listed below along with examples of each in practice in the arts.

1) **A participatory culture has relatively low barriers to artistic expression and civic engagement.**

 In April of 2011, the **New York Neofuturists** produced *30 Plays in 30 Blocks*, geolocated audio-plays inspired by separate blocks in the East Village. Via Facebook, potential audience members were invited to "Meet us at 3pm on the NE corner of 2nd Avenue and Houston. Bring your headphones and an iPhone." [http://plancast.com/p/4t8s/new-york-neo-futurists-broadcastr-present-30-plays-30-blocks]

 The **San Francisco Playhouse** encourages attendees to tweet during shows (in assigned seats so as not to unduly distract non-tweeters). This real-time feedback is available to all and it is also a platform for reflection for audience members after the performance is over. [http://www.technologyinthearts.org/?p=1651]

2) **A participatory culture has strong support for creating and sharing one's creations with others.**

 Composer/conductor **Eric Whitacre** has created **virtual online choirs** by aggregating individually produced videos submitted by singers from around the world. [http://ericwhitacre.com/the-virtual-choir][See also: http://www.ted.com/talks/eric_whitacre_a_virtual_choir_2_000_voices_strong.html]

 Misnomer Dance Theater uses Livestream to share performances with audiences around the world and has been doing so for years. [http://www.arrowrootmedia.com/2011/12/09/misnomer-dance-live-online/; http://artsmarketing.org/resources/article/2009-07/sharing-staged-performance-across-world-pt-1]

The **Detroit Symphony Orchestra** also uses Livestream to share concerts free on the web and via their mobile apps. [http://wyandotte.patch.com/articles/live-from-orchestra-hall-a-dso-concert-is-just-a-click-away]

3) **A participatory culture has some type of informal mentorship whereby what is known by the most experienced is passed along to novices.**

The **San Francisco Symphony** sponsors Community Music Makers, a program that mixes the live community and coaching with online coaching experiences from professional musicians. [http://www.sfsymphony.org/community/default.aspx?id=52442].

SITI, a New York theatre company has established an online vehicle to promote community among its audience members (SITI's Extended Ensemble–SEE). The web-based platform serves as something like Facebook sharing mechanism for SITI patrons and friends. [http://siti.groupsite.com/main/summary]

4) **In a participatory culture, members believe that their contributions matter.**

The **YouTube Symphony Orchestra** is an online collaborative orchestra. In 2011, musicians from around the world, selected via YouTube auditions, assembled in Australia for a week of rehearsals culminating in a performance in Sydney, Australia. [http://www.youtube.com/user/symphony]

Jonah Boaker, a dancer, has used a mobile app to allow the audience to co-create the performance with him. Audience choices affect the lighting of the performance and/or guide the dancer's location on stage. [http://www.technologyinthearts.org/?p=1822]

5) **In a participatory culture, members feel some degree of social connection with one another.**

Improv Everywhere's MP3 Experiment guides members of the public in collective "performance" in a flash mob style event. [http://improveverywhere.com/2011/07/25/the-mp3-experiment-eight/]

The **2amtheatre Challenge** was a scavenger hunt (using the web-based smartphone resource SCVNGR) that took place at the 2011 Humana Festival of American Plays in Louisville, KY. Participants took photographs or made recordings of pre-arranged "finds" at the Festival. [http://www.technologyinthearts.org/2011/05/social-media-spotlight-2amtheatre-uses-scvngr/]

Some of these examples are inspiring. Others may be considered odd or outside the realm of serious art (whatever that means). They all, however, foster thought about the nature of art, community, or engagement and about means to draw members of the public together with arts organizations in new ways.

CONCLUSION

The melding of participatory culture and arts institutions is a process that has barely begun. The examples cited here are comparatively early efforts that may or may not prove to be models for the future. But the need to experiment with and develop approaches to engagement taking advantage of the rise of participatory culture and utilizing social media is undeniable. Properly planned and implemented, new programming and new opportunities in this arena can significantly improve the prospects for the arts well into this century.

It may be that the emergence of participatory culture will provide its own self-generated demand for change in the arts. The expectation of participation that arises from involvement with social media will inevitably spill over to interaction with cultural options. This expectation may then become a self-fulfilling vehicle for transformation. The public will expect arts organizations to engage with them. Those that do will succeed. Those that do not will gradually lose the support of their community.

PUBLIC ART

Of all categories of art, public art has the greatest potential for community engagement simply because it is public. In addition, over the last thirty years, the public art community has learned many valuable lessons about how to engage effectively with communities. Public art projects afford excellent means and opportunities for the world of the arts to work with constituencies with whom they are not typically connected, enhancing community relationships, raising visibility, and improving credibility.

PUBLIC ART FOR COMMUNITY CHANGE
by Helen Lessick

INTRODUCTION

Public art, a recognized and reliable tool for aesthetic enhancement, is often omitted from the community advocate's palette. The experience of seeing a statue added to a municipal or commercial plaza after your neighborhood endured 18 months of construction noise and dust is rarely as inspiring as the process. But it doesn't have to be that way.

Traditional public art projects are structured to enhance municipal facilities by applying a fiscal formula to certain project costs to fund commissioned artworks (the "percent for art"). Artists are given a fixed budget and often told where to put the art and what theme to address. The artist's presentation of her design is sometimes the only community outreach a department will undertake in the typical five-year planning, design, and construction period. The public art team, the artist, and administrators are left to reach out to communities on their issues and identities.

After four decades of "art in public places" programs, a new type of visual artist has emerged. Civic engagement artists include site and community aspirations, listening skills, and political support as part of their creative palette. The artists' work requires partnership with administrators and municipal entities early in the planning process.

By harnessing the constituent parts of art in public places, including artists' creativity and business skills in master planning and policy reinterpretation, communities can harness the power of contemporary artists and community

innovation. Socrates Sculpture Park in New York City, the *in situ* and *intersections* programs of Portland's Regional Art and Culture Council, and the Airport Master Plan for San José's Norman Y. Mineta Airport are examples of how public art can enhance community and context.

SOCRATES SCULPTURE PARK, NEW YORK CITY, NEW YORK

An example of an early, continued community art success is Socrates Sculpture Park, a 5-acre waterfront park in the Borough of Queens in New York. Long Island City was a working class neighborhood full of trash, rats, and abandoned warehouses in 1986. Hallets Cove, a backwater on the East River, was a shooting gallery where crack vials glittered among the junk cars on Vernon Boulevard. From the dilapidated City pier you could look west to the high rises of Manhattan. North of the cove were the towering, fenced housing projects for Queens' low-income residents; south was an industrial site of Thypin Steel works.

Amid this hardscape were studios of internationally renowned artists Mark di Suvero and Isamu Noguchi. Both artists worked with industrial materials and physical space. Di Suvero has special need for an open-air site to preview his outsized welded and balanced steel works. His waterfront studio held a working bridge crane under 40 foot ceilings. Noguchi's studio, now his museum, was work space and storage for huge stones and delicate paper lamps.

Di Suvero used one of his buildings for the Athena Foundation, his non-profit dedicated to helping artists make art. Professional artists were invited to work on site in an open studio, availing themselves, within reason, of his extensive tools and material surplus. After a decade of helping four to ten artists a year, di Suvero recognized a need to have an outdoor exhibition space. Many artists wanted to create outdoor scale pieces; few had the commercial representation to allow them to exhibit in Manhattan or across the Northeast corridor.

The artists' assistants and family members worked to get permission to use a dilapidated pier and marine terminal as an open space for sculpture. Harnessing political, legal, and community activists, the weed-choked lot opened as an art space in 1987 with the Inaugural Show.

Initially funded by the Athena Foundation, Socrates Sculpture Park's program began to attract regional and national grants. International artists came doing residency projects and bringing their own partnerships. Artists Choose Artists, Emerging Artists Programs, temporary parades, films, and dance performances were funded through

experimental partnerships, utilizing artists and curators who wanted to work with communities.

With perseverance, charm, and a visionary team of supporters led over the next decade by Socrates powerhouse Enrico Martignoni, land was sweetened and planted; temporary generators became permanent power lines; rough trailers made room for elegant office space. The Park's land moved out of the City of New York's Department of Ports and Terminals jurisdiction and into the City's Department of Parks and Recreation. This significant transfer gave the land protection; it could not be sold to developers for waterfront condos or offices.

Di Suvero's and Martignoni's brilliance was to work the political, cultural, and social realms simultaneously. Hiring and training local residents-men and women from the projects, Socrates developed a homegrown community outreach program. Over time, this group became advertisers for, then advocates of, the Park. Setbacks happened. Opening events were rained out, donated soil was found to contain contaminants, celebratory bonfires caught the NYFD's attention. But 2011 brought the 25th anniversary of the Park. Songbirds nest in mature trees; a meadow houses pheasants and native flowers; a paved, level sidewalk takes all, including differently-abled visitors, to the water's edge.

How is this public art?

The inspirational example of Socrates Sculpture Park underscores the importance of artists' leadership in community change. Artists supplied the vital long-term vision for the decrepit land. Looking at rat droppings and crack vials amid the weeds, they saw sculpture pads, waterfront trails, and wildflowers framing contemporary art.

The progressive, prolonged community efforts of internationally respected artists may seem difficult to replicate outside of New York, but experience has shown that creatives are willing to participate in municipal enhancements when their time can be used effectively.

Long Island City was a working class neighborhood. It grew and changed. Hipster artists, film studios, Greek restaurants, and the projects adapted to the changing communities. Now LIC boasts an arts magnet high school, a quality supermarket, extensive signage, and street lighting. The park holds free film screenings, classes, and performances. Socrates is a stop for Manhattan art museum group tours, college and university classes, and peripatetic artists in residence. SSP is a public art process, creating a shared space for community members to meet, walk dogs, discuss artworks, or plan for an upcoming political campaign.

Lesson Learned I

Public art is a process, not a project with an end date. When you engage working artists in visioning exercises, discussions about community needs, public space, and community interaction come to the fore.

Visual artists are excellent observers. For economic reasons they usually work in marginal or affordable areas in the community. Canny community builders ask artists-especially sculptors, installation artists, and public artists-what is lacking in their neighborhood, then harness their answers to specific tasks.

REGIONAL ARTS AND CULTURE COUNCIL, PORTLAND, OREGON

Public artists engage with what interests them. Yes, they want money, but they also desire audience involvement and the ability to speak directly to community rather than through a gallery representative or arts fair banner. How can an artist test out ideas and find direct public interface in a small city or neighborhood?

Portland, Oregon's Regional Arts and Culture Council (RACC.org) was created in 1995 to "integrate arts and culture in all aspects of community life" in the tri-county region surrounding the city. RACC works with municipal clients-the city of Portland, Multnomah County, Portland Public Schools, and the cities of Gresham and Lake Oswego.

Funded through a wide consortium of grants and partnerships, RACC's core values include making a community in which everyone can participate in arts and culture. It also seeks to celebrate and support local artists, art, and cultural organizations.

Their multiple programs include public art. The purpose of the Public Art Program is to integrate a wide range of art into public spaces in the community and reflect a diversity of artistic disciplines and points of view. The program promotes education about public art through its collection and related programming, raises the public's awareness of their environment, and expands the region's knowledge and understanding of the arts.

In the mid-1990's, at the urging of local artists, RACC began offering opportunities for temporary art works which enable artists to address timely issues, experiment with scale, and experiment with a wide range of inexpensive and impermanent materials.

RACC offers three temporary opportunities for artists to engage the public without the parameters a permanent installation. One is a typical municipal gallery, showcasing artists' works in an indoor niche in the downtown core. The others, *in situ Portland* and *intersections*, take artwork out to citizens.

In situ Portland is designed to place challenging temporary artworks in outdoor public sites. The intent is for these works to serve as catalysts for conversations about art and/or community issues. RACC invites artists to submit conceptual approaches for a maximum duration of one year–there is no minimum. *In situ* is funded through a zoning bonus program for developers. Some public sites have been pre-approval by the property owners, but artists may seek permission to use locations of their own choosing. Prior to final acceptance by a panel, semi-finalists' proposals are reviewed for safety, environmental impact, and right-of-way issues by site owners and municipal personnel.

An exemplary *in situ* effort was Adam Kuby's Portland Acupuncture Project. In 2010 the artist researched then installed landscape-sized acupuncture needles in ten city sites to focus on, and (metaphorically) relieve, community problem areas. Combining traditional Chinese medical techniques with contemporary American urban planning, Kuby harnessed the ability of public art to give voice to community concerns. Working in partnership with the City's Bureau of Planning and Sustainability and community workshops held by the City to get input for the Portland Plan, Kuby created a temporary site-specific sculpture series to relieve pressure and address pain. Participants in the artist's workshops discussed the City's health, placed issues on urban maps, and correlated acupuncture points with City functions. The spleen, ruling distribution and draining, correlated to mass transit and infrastructure systems; the heart, a spiritual guide and ruler, suggested the mayor, religious leaders, and cultural arbiters. The Northwest Health Foundation, hearing of the effort, provided funding, meeting space, and media outreach.

Intersections is a related program placing professional artists within City departments to develop socially engaging, interactive art experiences in community settings. Artists are selected to work within a municipal agency and discover one or more public art opportunities within. In the ten years of the program, artists have worked with City and County agencies in the Portland metropolitan region.

"The Hidden Life of Bridges" was a video and sound work presented in 2011 by artists Ed Purver and Tim DuRoche through *intersections*. Portland is a port city split by a river running north and south. Multnomah County maintains the five street traffic bridges that cross it; railroad and interstate spans under separate management are also in the mix. The bridges are a blessing and curse for citizens as they close irregularly to allow for river traffic. Pedestrians, bicyclists, and motorized transit have to sit on the bridge and wait.

Purver and DuRoche, working in residence for a year, researched the County's bridge operations then documented in image and sound the literal hidden life in bridges. The resulting public art was a 2-hour visual event, projected over three days on the south-facing pylons of one bridge. The accompanying audio piece was narrowcast along the bridge sidewalks for ten hours daily for five weeks and was available on both the City's and artists' web sites. Literally and figuratively revealing the operations of bridges, the art engendered municipal pride and community understanding.

Lessons Learned II

Many non-profit organizations and municipalities aim to make art available to every citizen. RACC went a step further, creating programs enabling artists to address underserved audiences and/or community issues by creating their own projects with municipal imprimatur. Given an open hand, artists are best at identifying the opportunities for their involvement. Additionally, these RACC programs allow for temporary artworks, giving voice to provocative art addressing issues mitigated by the passing of time.

NORMAN Y. MINETA INTERNATIONAL AIRPORT, SAN JOSÉ, CALIFORNIA

"Community" is a polymorphous term, often referencing ethnic or cultural heritage. It must include our business communities, corporate citizens, and economic engines. For those interested in engaging the business communities through public art, there are very few working models.

San José, California, the acknowledged capitol of Silicon Valley, is home to the corporate headquarters of Adobe, Cisco, and eBay, and the chosen home for major facilities of Hewlitt Packard, Hitachi, IBM, and Lockheed Martin. Apple and the Googleplex are outside the city limits, but part of the Valley's bright lights. Smaller stars of 21st century technology abound, ready to showcase innovation and new software.

When the opportunity to develop a public art program for Norman Y. Mineta San Jose International Airport's new terminal, City of San José's Public Art Program Director Barbara Goldstein had a vision to build communities. In a program titled "Art and Technology" the Commission sought out art that uses technology, was inspired by technology, was developed with technology, and/or is intended as a comment on technology.

But this is not simply a curatorial focus. Engendering innovation requires more than issuing a call for it. Championed by Goldstein, the City Cultural Affairs Department issued a call for a master planner to develop a workable program and vision.

The planners decided to prioritize context, commissioning flexible platforms to support changing public artworks. In addition to the walls that literally hold fine art, program leadership developed a creative Art & Technology program to feature a changing showcase of contracted temporary media works. Municipal government developed collaborative partnerships with local industries, cultural organizations, educational entities and non-profits. The result is innovation in informational media and foundation funding, tech art, and public art policy.

Created by the Rome Group in close partnership with the city's industries, the plan reflects Silicon Valley's innovative attitude. It provides artists a framework to use new technology and to change and diversify commissioned artworks as technology changes. Permissive, not proscriptive, the plan encourages partnership between industries, artists, and the multiple communities using the airport. Artists, graduate students in public art, critics, and anyone who opines that administrators are not creative, must study San José's Airport Public Art Master Plan.

The meta-commission of the Airport Master Plan is the Art Activation Infrastructure by the technical team of Banergee Gorbet + Gorbet. The activation infrastructure is a network of internet-wired ports. Acknowledging that artists stretch boundaries, explore, and think of ways to break the system, BG+G stretched the very canvas of the public art experience through its visionary infrastructure design for future commissions. Infrastructure 2.0, it exceeds and extends 20th -Century art support systems of walls, pedestals, and monitors.

One of the many exceptional collaborative works has been the Wunderkammer, an assemblage cabinet of curiosities created by the team of SuttonBeresCuller in 2010. This temporary artwork is a collection of outdated motherboards and computer guts cleverly reassembled as inorganic trees, computer "bugs," and suitcases. Using recycled materials particularly resonant in Silicon Valley, the artists harnessed the wonder and possibility of computer age with old-fashioned gee-whiz imagination. Located in the airport's arrivals hall, the artists created a convoluted natural history diorama appealing to kids, geeks, hipsters, and grannies alike.

Creative art and high-tech research partnerships are showcased throughout Terminal 3, and the work is both simple and rigorous. It is, in addition, outstanding community-based public art in product and process.

Lessons Learned III

Local artists are businesses, looking for growth opportunities like every other business in the community. Local businesses are looking for growth as well. Adventuresome communities can harness planning tools to create opportunities for both. Whether your community silos grain, processes scrap steel, or houses a call center, consider progressive planning as a community tool. Artists working in residence within an industry will challenge themselves and the industry-and provide an outsider's fresh perspective.

LESSONS LEARNED REVISITED

Recognizing communities are fluid entities, not static sites, public art can harness community strengths through existing resources. Contemporary public artists especially are constituents as well as thinkers.

1) Artists are everywhere; find them, ask how they see their community's future, and listen to what they can offer.

2) Artists seek audiences; re-examine your local policies to see how independent artists can address truly local constituencies within your guidelines.

3) Artists are business partners; encourage work between local artists and other industries with master planning, policies, and grants.

Traditional public art is a hallowed part of civic space and public life. Contemporary civic artists work with the conditions on the ground, including creativity in the palette of municipal life. By embracing the creativity, experience, and strengths of seasoned public artists and allowing ample time for outreach and interaction, communities can harness the benefits of public art to enliven and enhance shared civic space.

The results, with Socrates Sculpture Park, RACC's *in situ Portland* and *intersections*, and San José's Mineta Airport Master Plan, offer extraordinary colors in the palette of public art for community change. Communities and their creatives need only connect.

LINKS
www.racc.org(Regional Arts and Culture Council)
http://acuportland.org (Portland Acupuncture Project)
www.hiddenlifeofbridges.org (Hidden Life of Bridges)
www.sanjoseculture.org (City of San José Cultural Affairs)
 cf: www.sanjoseculture.org/downloads/SJA_MasterPlan.pdf
http://www.socratessculpturepark.org (Socrates Sculpture Park)

The Practice of Engagement

Examples and Case Studies

EXAMPLES AND CASE STUDIES

For a typical citizen of the arts community facing the issues presented in this book, the key question screaming for an answer is, "But how can community engagement be made to work?" or "How can we get from where we are to where we need to be?" The impediments described in the opening of this book are no less daunting for the fact that they *must* be faced. Examples can be helpful as to detail as well as in lending courage.

For arts organization not already fully committed to community engagement work, it is sometimes impossible to imagine what shifting to such a focus might look like, what it would entail, or even whether such a thing is possible. The examples presented in Chapter 14 are intended to pique curiosity, to suggest possibilities, to stimulate the imagination, and to open the mind to new ways of thinking about the relationship between the arts and communities. They also serve to illustrate categories into which community arts projects can organized.

The examples and case studies presented in Chapters 15-20 serve to provide a fuller picture of what community engagement looks like and how it is beneficial to the arts organization. Simply and in particular, they serve to demonstrate that a community engagement agenda can be undertaken successfully. These institutions have done so and survived.

As a caveat, however, it should be noted that community engagement activities do not offer a guaranteed path to viability. Other factors inevitably intervene. The Philadelphia Orchestra hired an *animateur* in 2005 and declared bankruptcy in 2011. No one believes there is a causal link between the two. Clearly the former did not prevent the latter, though it is interesting to wonder whether taking the motivation that led to that hiring to a systemic level, with community engagement permeating all of the Orchestra's work, might have provided a different result. That said, it is impossible to know what the future holds for any of the organizations featured here. The case can only be made that each one today views community engagement as central to its mission and that the results thus far have been beneficial.

A TAXONOMY OF COMMUNITY ARTS PROJECTS

ARTS-BASED
Community-Focused Arts

Presenting examples of arts organizations engaged in establishing deep community connections runs the risk of being counter-productive. In many fields of management today, there is a growing suspicion of "best practices," given the difficulty of transplanting specific practices from one organization to another. This is especially true in this instance. Each community and arts organization is unique, with unique assets and problems. The examples given here are presented solely to illustrate the possibilities that result when arts organizations transform their own understanding of their relationship with the communities in which they operate.

Orchestra

Formed in 1988 after the collapse of the Oakland Symphony, the Oakland East Bay Symphony has, from its inception, operated from with a community-centered vision. Music Director Michael Morgan gives this description of the mission of the OEBS: "At this time in the history of orchestral music, every orchestra must be a community orchestra. The Oakland East Bay Symphony is setting an example for other arts organizations by demonstrating the convergence of artistic excellence and community service. Hence our relationship with other local arts organizations, civic organizations and, of course, the public and private schools. Our concerts are envisioned as community building events." (All information about the OEBS is taken from their website, www.oebs.org.)

At the beginning of the Symphony's life, three broad goals were set. First was to become a community orchestra; second, to cultivate a non-traditional audience; and third, to maintain traditional patrons. The OEBS pursues the first goal by intensive work with local schools (including a comprehensive music education program), partnering with other nonprofits to increase mutual visibility and share fundraising, and expanding performing venues in non-traditional locations (such as community centers). The second goal is addressed by presenting more culturally

diverse programming, utilizing local performers, and, in particular, sponsoring innovative commissions for new works. (A commission several years ago was for a piece by Afro-Cuban composer Omar Sosa. In November 2010, OEBS premiered the first composition for full orchestra by multi Grammy-winning songwriter, producer, and performer Narada Michael Walden, featuring Carlos Santana on guitar.) OEBS works to maintain traditional audiences with a judicious mix of programming that invites people of a broad range of backgrounds to come together in appreciation of reflective music.

Today, more than 60,000 people annually attend the Symphony's performances at the Paramount Theatre, at churches and senior centers, and at other community sites each year. Its current goals are:

- To present live professional symphonic and collaborative artistic performances to diverse audiences in Oakland and East Bay communities.
- To serve as a community resource, offering education, performances and outreach to schools and the community, introducing new audiences of children and adults to symphonic music.
- To help ensure the future of symphonic music through the commission and performance of works by contemporary American composers.
- To provide leadership in the artistic community by fostering unity, collaboration and co-creation among Oakland and East Bay arts organizations.

Maestro Morgan summarizes the current state of the Symphony by saying,

"It is my hope that our largest contribution to the art will be the exposure of it to those least likely to encounter it on their own. By reaching out to those communities not traditionally involved in symphonic music, I hope we can show them the human connections, which can be made by different peoples through art. Our concerts will continue to include music from various traditions and periods. We will continue to perform works, which not only demonstrate the great history of this art form, but also demonstrate that it has a vibrant, viable future and therefore relevance to a younger, more diverse audience.

"OEBS has made great strides toward becoming an integral part of an extremely diverse community. Collaborations with new local organizations and artists are generating new audiences and serve as a force for positive change and community building. . . . OEBS has demonstrated that it can be artistically excellent and fiscally responsible. It is now regularly cited as an orchestra that has found the pulse of its community."

Visual Arts

Minneapolis' Walker Art Center has long been devoted to community involvement. Daniel Defenbacher, Center Director, said in 1944, "An Art Center is a 'town meeting' in a field of human endeavor as old as man himself. By definition, it is a meeting place for all the arts. It provides space in which the public can both participate and be a spectator." Kathy Halbreich, the Center's former Director said, "The metaphor for the museum is no longer a church or temple, but a lively forum or town square." (Material for this section is taken from a Walker Art Center brochure written by Sarah Peters, Reggie Prim, and Sarah Shultz and designed by Amy Pogue Brady. The material in it is copyrighted by the Walker Art Center, 2005.)

In 2003, the Center completed a community dialogue project to address the question, "How can a contemporary art center become a forum for civic engagement?" The result of that inquiry was the development of a vision in which the Walker saw itself as Container, Convener, Connector, and Catalyst for civic engagement. They define the terms as follows: Container–a place and environment in which the community can come together; Convener–calling together members of the community for some mutual purpose; Connector–linking people and ideas to recognize similarities and bridge differences; and Catalyst–sparking action on a community issue that in need of attention but not yet on the public agenda.

Examples of projects related to this vision are:

1) Container: An artist residency in which "[p]ainter Julie Mehretu taught 30 high school students from the Twin Cities' East African community to document their daily activities through photographs, sound recordings, and writings.

2) Convener: Event celebrating Minnesota boxing history in conjunction with the Center exhibition *The Squared Circle: Boxing in Contemporary Art*. It brought together members of the Minnesota boxing community to celebrate the sport's role in their lives.

3) Connector: A yearlong artist residency in which a sculptor worked with Native American students, resulting in a work "installed in the Minneapolis Sculpture Garden that links the history of Minnesota's native tribes with the local history of European lumber barons."

4) Catalyst: Artists' residency project "that addressed issues of media ownership . . . in which participants built legal, low-wattage transmitters to broadcast their own micro radio stations." (See: projects.walkerart.org/radio)

Community-Based Arts
Dance

The Dance Exchange (formerly Liz Lerman Dance Exchange) has both a home base and a vibrant residency program. It was founded in 1976 with a mission to create, perform, teach and engage people in making art, defining dance broadly to include "movement, music, imagery, and the spoken word." A hallmark of the company's residencies is the engagement of "individuals, institutions, and communities in making and performing dances." The company worked with another Liz Lerman enterprise, Dancers of the Third Age, an ensemble of older adults ranging in age from 50 to 90. In a 1992 article, Ms. Lerman was quoted as saying, "When dancing belonged to the community, everybody got to dance! . . . Art belongs to everyone and dancing is a birthright," (*High Performance* #60, Winter 1992, available at http://wayback. archive-it.org/2077/20100906202323/http://www.communityarts.net/readingroom/ archivefiles/1999/12/liz_lerman.php) (In 1993, Dancers of the Third Age and the Dance Exchange merged.) The Dance Exchange's community residencies are designed to be a "vehicle for partnerships within local communities" to "explore issues of concern, including violence, education, aging, healthcare, and understanding of community history." "The Dance Exchange has facilitated projects linking such partners as a dance performance space and a prison; a civic center and a senior center; a dance festival and a hospital; a local community center, a local arts council, and a textile mill." (This quotation was taken from a Dance Exchange web page that is no longer live.)

"In 1998, [the company] began a multiyear, nationwide initiative called 'Hallelujah,' creating new performance works with communities all across the U.S. intended to 'celebrate edge-of-the-millennium America in all of its vividness, beauty, strength and quirkiness.' In residencies in some 15 cities and towns across the country, the Dance Exchange [met] with presenters and community organizations to gather from all walks of life a core of interested individuals. . . . Their interaction [produced] a series of evening-length performances [that brought] together the professional dance company onstage with local people of all ages, disciplines and backgrounds. Each project [focused] on an array of new dance works called 'In Praise of . . . ' intended to reflect the community's issues, ideas and aspirations. Each event also [featured] a sampling of work from previous "Hallelujahs" threading all the projects together." (Source: http:// wayback.archive-it.org/2077/20100906201053/http://www.communityarts.net/ readingroom/archivefiles/2001/05/everybody_say_h.php)

The Dance Exchange's work, like that of the other cases mentioned here, is rooted in a belief that the artistic enterprise is and should be a participant in and supporter

of the broad community. Acknowledging that is perhaps the most important element of an approach to the arts that builds communities; doing so contributes to the long-term viability of the organization.

Theater

The Oakland East Bay Symphony is an example of a performing arts organization that has its roots in a very large, very diverse community. The Roadside Theater Company has a radically different base. It is a professional theatre troupe which tours throughout Appalachia but is resident in a town of 1500, Whitesburg, KY. Growing out of the War on Poverty program of the 1960's, their mission statement says that "Roadside Theater is creating a body of drama based on the history and lives of Appalachian people and collaborating with others nationally who are dramatizing their local life." (All material is taken from their website: www.roadside.org.)

Their stated target market is the entire population of the region they serve. They create and perform reflective art of a high order, drawn from the traditions and rooted in the experience of the people they are attempting to reach. They have become an integral part of the lives of the people in their communities; not as "others" bringing greatness down from on high but as fellow laborers on this earth. The results are impressive. The Company has a record of playing to sold out houses in the small towns in which they perform.

Perhaps not surprisingly, their appeal is not limited to their home region. Over the last thirty-six years they have, in addition to success in their home base, toured to 43 states, been in residence at the Manhattan Theatre Club, performed at Lincoln Center, and represented the United States at international theater festivals in London, the Czech Republic, Sweden, Denmark, Los Angeles, Seattle, and Philadelphia. Wherever they perform, they attract an audience fully reflective of the host community.

There are probably more examples of community-aware theater than of any other reflective arts media. The community-based theater movement is one of the oldest of such traditions in the U.S. In addition, the immediacy of theatrical language (in comparison with music or dance) makes it ideal for telling the stories of "real people." Excellent examples include Swamp Gravy from Colquitt, GA, Junebug Productions from New Orleans, Cornerstone Theater in Los Angeles, and Carpetbag Theater from Knoxville.

THE ARTS AS COMMUNITY CITIZEN
(ENGAGEMENT AS A GOOD NEIGHBOR)

To close this section, it is important, simply, to present a reminder that, as discussed in Lyz Crane's essay, there are paths to engagement that do not lie in arts-based projects. Certainly, arts-based expertise and enterprise will form the core of any arts organization's engagement efforts. However, an institutional view of "self" as a responsible member of the community will also lead to resource-sharing means (not necessarily arts-based) as a means of establishing credibility (*e.g.,* use of organizational space as community center, provision of assistance with brochure design for neighborhood organizations, partnering with libraries or recreation centers highlighting neighborhood issues). Such efforts can serve as an important element (often as a critical first step) in a portfolio of engagement efforts.

ART MUSEUMS:
QUEENS MUSEUM OF ART

Historically, the functions of museums have been preservation, research, and education. The last of those three has been the means through which they have connected with their communities, although the emphasis has traditionally been on the first two. Over the last several decades, museum education programs have become increasingly important as the hub for bringing the institutions together with their communities. It is through education programs, for instance, that museums began to present performing arts events that provided context for and highlighted themes of exhibitions.

In 1992 the American Association of Museums issued a report, *Excellence and Equity*, which amplified upon the museum's role in serving communities through educational programming. In 2003, the Walker Art Center in Minneapolis developed an expanded vision of the museum's education function, re-imagined as "art and civic engagement." One result of this work is the Center's four categories of museum roles for engagement presented earlier. This understanding of museum roles positions the museum as a vital community asset.

Many museums have moved vigorously to establish close ties to the neighborhoods and communities they serve. Few, however, have gone as far as the Queens Museum of Art (http://community.queensmuseum.org/) in identifying itself as a community asset and resource.

BEING A GOOD NEIGHBOR:
QUEENS MUSEUM OF ART'S
EXPERIMENTS IN COMMUNITY ENGAGEMENT
Prerana Reddy, with Tom Finkelpearl and Naila Rosario

OPENING THE DOORS, LISTENING TO NEEDS

The Queens Museum of Art's community, the Borough of Queens in New York City, is one of the most diverse places in the country, and the world, in terms of

the number of languages spoken and nations from which residents hail. However, though various ethnic groups may live in the same neighborhoods, Queens is not quite the proverbial "melting pot." Rather it is divided among the paradigm of old and new Queens. Old Queens is the community characterized or caricatured in situation comedies like "All in the Family" and "The King of Queens"; it is a community of working and middle class–black and white–families and accounts for approximately 30% of the residents in the neighborhoods nearest to the museum: Flushing, Corona, Elmhurst and Jackson Heights. New Queens accounts for 7 out of 10 residents in the Museum's tri-neighborhood community and includes mostly South and East Asian and Latino immigrants from countries such as India and Pakistan, South Korea, Taiwan, and China, the Dominican Republic, Colombia, Ecuador and Mexico.[1] There has been a wide range of social and economic integration amongst these groups, often dependent on their educational attainment and profession in their home country, as well as immigration status upon arrival here.

Just as individual families make a gradual transition to life here, institutions reflect a time lag. So it is not unusual to see a Polish monument in a Caribbean community–vestigial manifestation of the community's sense of allegiance to its roots. Just so in civic associations. We have traveled through Queens and visited community boards (the most local and grassroots element of New York City government) and found that the staff and many of the Boards themselves reflect of the make-up of the community one or two generations ago. These are not bad people. In fact, Board members are generously volunteering their time to for the betterment of the neighborhood. But there is often a divide between the boards and the newcomers circulating outside their doors in terms of language, culture, religion, race and so on. New Queens has been creating its own groups–from community-specific associations like Mexicanos Unidos de Queens to issue-oriented groups like New Immigrant Community Empowerment (NICE).

When Tom Finkelpearl became director of QMA in the spring of 2002, the museum was firmly entrenched as an old Queens institution. It is illustrative that nobody on the administrative staff spoke Spanish fluently. The audience was generally much older and whiter than the surrounding community. So, the question at hand was how to embrace the energy and unique diversity of new Queens without abandoning old Queens. The founders of the museum were still on the Board of Trustees, and they were the same sort of civic- and community-minded people we saw on the Community Boards (though considerably more affluent and influential). The goal was to open the doors to the community without turning our back on the people who had created the

museum. This was not simply out of gratitude, but because it seemed like a valuable idea for all involved –the hybrid new-and-old Queens institution that could ideally feel as comfortable to a Jewish family from Forest Hills as to a Taiwanese grandmother from Flushing or a Mexican teen from Corona.

The first two new employees hired under the new regime are emblematic of this approach. The first was Debra Wimpfheimer. She was born and bred in old Queens, but she had been working as a non-profit fundraiser in Boston for eight years. Though of a younger generation herself (she was around 30 at the time), she was an impeccable guide through the complexities of old Queens institutions, most particularly the halls of political power that she knew quite well. She also had enough distance from her roots in Queens that she could see clearly how the communities were changing, and it was her observations on old and new Queens that opened our eyes to a series of social dynamics that are still the basis of our vocabulary. As we were learning about our environment, the first shows put on the books reflected the arts and experiences of local immigrant communities such as: *Nexus: Taiwan in Queens*, QMA's biennial of Queens-based artists entitled *Queens International; Crossing the BLVD*, Warren Lehrer and Judith Sloan's multimedia project based on oral histories of new immigrants and refugees in Queens. Wendy Ewald's traveling retrospective, *Secret Games* came to the museum and she created a new work with a group of Arabic students from a middle school in Jackson Heights. These projects were highly educational for the staff, but they did not differ in essence from the curatorial practice at the museum in previous years. Many shows had investigated cultural diversity.

The second new hire was long-time Queens resident and artist Jaishri Abichandani, herself an immigrant from India, to head a new Public Events department that would work to transform QMA into a nexus where old and new Queens would meet. Abichandani, a natural connector of communities, had recently honed her knowledge while working on the 2000 census in Queens. Under her tenure we hosted a wide range of activities–including South Asian events like the annual celebration, "Fatal Love" that remarkably combined Indian and Pakistani independence days into one, and the national Immigrant Workers Freedom Ride, where caravans of immigrant rights advocates from nine cities converged on Flushing Meadows Corona Park in 2003. Simultaneously, the Museum began literally to open its doors by providing complimentary use of our space to numerous small non-profit community groups for their meetings, cultural celebrations, and fundraising events. Several nights a week our theater would be filled by Colombian, Ecuadorian, Korean, or Indian celebrations. Once a month we welcomed CINEMAROSA, a mostly Latino LGBT film organization.

In so doing, QMA began to develop relationships with their members and leadership, allowing us to have frank conversations about their organizational challenges, which included lack of financial resources and space for their activities and greater visibility outside the communities they serve.

With multi-year funding from the Ford Foundation, QMA then launched its first long term initiative designed to bridge gaps between old and new Queens by initiating a *Leadership Through the Arts* (LTAP) program, which I was brought on board to coordinate. *LTAP* targeted young folks aged 16-23 that met every Saturday for a year. The reason we reached out to this age group was two fold: we knew new immigrant adults were working long hours and didn't always have time to be involved in a year-long intensive program, and we would be able to access adults if we provided a service for their children. We also knew that a lot of immigrant youth are unable to pursue higher education as they need to contribute to family finances, and at the same time, they age out of most enrichment programs once they graduate high school. [Editor's Note: QMA knew this because of its knowledge, based upon relationships in the community, of the community's needs.]

Using the arts as a uniquely powerful communication device, the youth were equipped with the skills and tools needed to navigate American civic and educational power structures. The program combined an anti-oppression and political education curriculum developed by local activist groups with art-making workshops led by established artists and art educators to develop critical thinking skills. To these activities were added opportunities to coordinate concerts, performances, lectures, and workshops to be held at the Museum and at sites throughout the community. Each cohort of 25 young adults, who were paid a stipend to participate, addressed the tension points in their communities and interacted with community and political leaders, seniors, local businesses and entrepreneurs, and faith communities through exhibitions, photography, film and art projects.[2] Finally they had funds with which to administer grants to community-based organizations, through a rigorous process guided by the North Star Fund. In the short term, the initiative sought to promote social integration through cross-cultural interaction amongst the participants. In the long term, it sought to create upwardly mobile engaged citizens of tomorrow trained to effect positive social change in Queens neighborhoods.

FOCUS ON CORONA

While *Leadership Through the Arts* produced many individual success stories in terms of youth development objectives and the museum's ability to connect to

families and neighborhoods and identify local tension points, it was difficult to realize community development goals with just this youth program model. Since the program did not target youth from any one neighborhood, it was difficult to focus on local situations that could be tackled over the long term–the geographic scope was too large to make a visible dent.

We realized that we needed to re-strategize to maximize our impact and focus our efforts on a single neighborhood adjacent to the museum. Equally as important, we needed hire a community organizer to be on the ground. While Jackson Heights and Flushing have emerged as thriving neighborhoods with strong identities, successful Business Improvement Districts, and services for immigrants, Corona, within which the museum resides, has encountered some challenges in its development. It is a "majority-minority neighborhood" with Latino immigrants, who comprise the largest part of the population, mixing with South and East Asian immigrants and the African American and white European homeowners who represent the heart of Corona's recent past. Highways surround the area, and large thoroughfares like Roosevelt Avenue and Northern Boulevard cut through it creating isolated individuals and groups. Sections of Corona lack access to full public transportation service and, while some businesses are able to sustain themselves long-term, the residential immigrant populations tend to be transient. There tends to be a small-business orientation with a significant informal economy. In addition, many residents are undocumented or in mixed status families and live in fear of deportation, diminishing the likelihood of political and social engagement. Consequently, we felt that our efforts would make the most impact in Corona.[3]

In November of 2006 we hired Naila Rosario to play the important role of QMA's community organizer, an unusual move for a fine arts museum. Rosario's familiarity with elected officials and community groups in the area, long history of immigrant rights advocacy, and ability to speak Spanish (70% of Corona residents speak Spanish as their primary language) were all key in deepening the level of communication and trust between community members and the museum. The transformation of our project was quite dramatic, helping us listen more deeply to community voices. Language was not the only barrier that Rosario could cross. She could also translate socio-political and community back-stories. The local rivalries and coalitions became more apparent–almost the same role that Wimpfheimer had played in old Queens a couple of years earlier. This allowed us to begin to develop projects that connect to our core competencies as an arts institution yet still have clear development goals in mind. These included: improving cardiovascular health outcomes and healthcare access;

cleaning up, beautifying, and programming Corona's public spaces; marketing the businesses in the area, particularly the numerous ethnic eateries in the neighborhood, and generally bringing disparate segments of the community together to develop and achieve their goals. We put all these elements together under the rubric of the "Heart of Corona," attempting to catalyze the transformation of Corona Plaza from simply a circulatory and commercial center into a site for neighborhood pride, cultural activity, and a space to access health and social services.

Historically, Corona had been an Italian immigrant stronghold with a long-standing and thriving business district in "Corona Heights", complete with a bocce court, and numerous *salumerias* and Italian Ice stores. Beginning in the 1940s, Corona was also a haven for middle and upper-middle class African Americans who were shut out of the housing market in Manhattan. Local residents included Louis Armstrong, Count Basie, Ella Fitzgerald, and Malcolm X. In the last twenty years, Corona has become home to the fastest-growing Latino community in New York City. At the center of Corona is a public space, a triangle known as "Corona Plaza." Once the proud meeting center of the community, with a grand movie house, the plaza has now fallen into disrepair. While businesses surround the open space, it was seldom used for public events; it needed better maintenance, and lacked a clear sense of purpose or centrality to the community. Businesses come and go in Corona Plaza, while people stream through on foot, by car, and on the subway. QMA felt that the space could mean more and be more productive for the community, so along with Corona Community Action Network, an association of local businesses, we helped gather a broad coalition of Corona stakeholders to provide ongoing attention to the plaza. The initiative includes several projects, including Beautification and Clean-Up events, a *Healthy Taste of Corona Cookbook*, and a series of street celebrations and public art projects spearheaded by working groups that are collaborations among community-based organizations, health institutions, elected officials, and local businesses.[4]

For the next two years the initiative's sustained programming aimed to beautify the space and populate it through a series of art projects entitled *Corona Plaza: Center of Everywhere* attracting local residents and cultural tourists alike. In 2007 and 2008, with additional funding from the Institute of Museum and Library Services (IMLS), QMA commissioned four emerging artists each year to produce temporary site-specific art in Corona Plaza. Participating artists were asked to develop projects that would integrate with the specific conditions of the plaza and Corona, resulting in works that values audience participation, fun, generosity and community engagement. The community organizer played a key role in orienting the artist to the neighborhood,

brokering partnerships and project locations, and facilitating public interaction. This process differed substantially from other public art initiatives in which artists are asked to find community partners. We already had a well-established coalition with scores of partners. [Emphasis added by Editor.] The artists were not assigned the difficult task of wading into unfamiliar territory but were given free rein to explore with the community organizer as an expert consultant. If they wanted to work in a beauty salon or Western Union, an introduction was made. Additionally, the museum hired a curator each year to manage the projects. An accompanying exhibition at the Museum described, documented, and centralized the public artworks on view and performed around the plaza. As part of the experience of the exhibition, visitors had access to a map that encouraged them to explore Corona's diverse dining options, unique retail shops, historic sites, and recreational spaces.

During the project, QMA organized several street celebrations and bilingual tours so that community members could interact directly with the artists and in several cases participate in the production of an ongoing work. The street celebrations, which drew thousands of people, became a focal point for a number of the artists. The festivals themselves were organized by QMA in conjunction with more than 16 neighborhood partners, which included Elmhurst Hospital, the City's MetroPlus Health Program, and the American Heart Association (AHA), with a mix of live entertainment, art-making opportunities, and health and social service provision. Local businesses donated refreshments for volunteers and performers, and performances featured a culturally diverse mix of local performers, along with more established touring artists. Established performers included Los Pleneros de la 21, a celebrated Puerto Rican *bomba* and *plena* ensemble; Latin Jazz impresario Pablo Mayor; and Curaçao-based vocalist Izaline Calister. These were interspersed with local Mexican, Colombian, Peruvian, and Ecuadorian folkloric dance troupes, spoken word artists, and singers. Each year through the fairs, over 1,200 people received health screenings, and over 600 attendees who were previously uninsured signed up for free or low-cost health insurance.

Another popular project that combined culture, health, and marketing of local business was our *Healthy Taste of Corona* Cookbook. The full-color, bi-lingual, 150-page cookbook features recipes for much of the tasty fare found in Corona with recipes contributed by more than 30 favorite local officials, community leaders and restaurateurs. Addressing the high rate of heart disease and diabetes in the local community, each recipe was analyzed by an Elmhurst Hospital nutritionist, and suggestions were made to make the dish healthier without losing the basic taste. The book showcases traditional foods from a variety of countries reflecting the diversity of

cultures in the neighborhood. The process of creating the book involved a community photography and oral history project, creating a neighborhood portrait that residents could be proud to share with all New Yorkers. The print run was 7,500. All but a few archive copies of the cookbook (and accompanying flyer featuring discounts on heart-healthy menu items in participating restaurants) have been distributed free at local sites, at the museum, and through our health partners such as MetroHealth Plus. Aside from a W.W. Norton-published book on Robert Moses that accompanied a show at the museum, the cookbook is the most widely circulated publication that the museum has produced in the last decade–easily outstripping every art catalogue. The book has helped put Corona on the culinary map of New York while becoming a cornerstone in our local heart health educational campaign. According to Rosario, our partners were able to tailor the book to the needs of their organizations: some used it within their ESOL classes; others used it in their after school classes to teach kids how to make healthy substitutions to recipes; and another group asked members to pick recipes from the book and bring them for a potluck. The book proved to be a tool that others could use for their own purposes–a community-sourced initiative that made its way through numerous paths back into the community.

INSTITUTION-WIDE IMPACTS

Our community engagement efforts in Corona allowed us to garner attention from new funders to widen our efforts. For example, the J.M. Kaplan Foundation chose the museum to participate in the NYC Immigrants & Parks collaborative and hire a Parks Outreach Fellow, Gabriel Roldós, who worked on such issues as addressing language and communication barriers to accessing parks facilities; navigating the special events, sports fields, and vending permitting process; and ensuring that culturally relevant programming takes place. Regardless of background, neighbors rely on parks for recreation, strengthening social ties, and improving physical and emotional well-being. QMA's efforts in Corona's local parks, including the flagship Flushing Meadows Corona Park where the Museum is located, as well as on a city-wide level through its participation in the Immigrants & Parks Collaborative, aims to ensure our city's open spaces are democratic, are representative of neighbors' wants and needs, and serve as relevant resources for all New Yorkers.

Furthermore, it was not just the Public Events department that was inspired to shift its focus toward working with the local community. With multi-year funding from the Altman Foundation and from IMLS, QMA's Education Department embarked on an ambitious set of programs for New Queens to go with their well-established

programs in primary school arts education and art therapy. This initiative called *New New Yorkers Education Program* centered on a long-term collaboration with the Queens Library system, an international model for immigrant programming. Again, dedicated individuals played a key role. The new Education Director, Lauren Schloss hired Sara Guerrero-Rippberger to manage the program which provides free bilingual multi-session workshops such as digital photography in Spanish or Web Design in Mandarin. Unlike traditional English literacy programs, *New New Yorkers* classes emphasize creative expression of complex, personal, aesthetic, and social ideas, rather than focus solely on practical situations. These communication skills help participants feel more confident in sharing their opinions and communicating with those outside their communities. Visual literacy skills learned through the classes also help participants engage more fully with exhibitions and cultural events at the QMA and other cultural institutions throughout the city. The program continues to be one of our most popular, with classes filling up almost immediately after they are announced. Alumni from the classes help decide on future classes offered and are currently developing a formal group to organize their own activities and programs to continue their educational journeys. In addition, the *New New Yorkers Program* has conducted surveys of museum attendees leading to the development of a Queens Museum Friends Committee comprised of ESOL learners whose voices had rarely been heard at the table because of language barriers. This group has specifically identified a need for enhanced life skills and language acquisition as key to their advancement. They also cited a sense of cultural isolation, saying they would welcome opportunities for social integration through work with other ethnicities on projects and to better understand their cultures. Plans are on the drawing board for even deeper collaborations with our Queens Library partners.

On the exhibitions side, our Curatorial Department was eager to build upon our successful track record of interactive, socially engaged art practice in Corona and to serve as a laboratory for the creation and presentation of socially collaborative art. They conceived of *Launch Pad*, an exhibition program exploring the novel use of our on- and off-site spaces to produce and present original, socially collaborative art projects. *Launch Pad* is built upon re-thinking the Museum as being more than an institution that collects and exhibits art objects, but also a location for interchange amongst museum staff, artists, and community members around particular socio-political phenomena. The Residency Program, supported by the Andy Warhol Foundation for the Arts, offers two artists each year a six-month residency with an artists' workspace, full access to Museum staff and resources along with a stipend.

One example of how *Launch Pad* residencies took advantage of QMA's staff expertise in community engagement was the project of artist Damon Rich, co-founder of the Center for Urban Pedagogy (CUP) and an urban designer based in Newark, NJ. His *Red Lines Housing Crisis Learning Center (2009)* collected the history and material culture behind the current housing crisis, creating an experimental site for reflection and learning. A highlight of the exhibition was an intervention into the Museum's famed architectural model of New York, the *Panorama of the City of New York*, where thousands of small plastic markers were placed on every block that experienced three or more foreclosed homes (based on 2008 data). Viewers were able to see instantly that the crisis was not evenly spread throughout the city, but concentrated on the very same neighborhoods that had been denied access to credit in past through discriminatory lending practices. QMA leveraged the depth of research and excitement around the *Red Lines* exhibition to reach out to organizations and individuals in the community who were already doing something about the housing crisis. We made special efforts to reach out to neighborhoods in Queens and Brooklyn where limited English proficiency and lack of economic literacy attracted predatory lenders. QMA's *Red Lines* programming helped audiences understand the scope of the crisis as well as how to avoid being caught up in it.

QMA's community organizer in 2009, Alexandra García (the successor to Rosario), had experience in housing activism that was a critical asset in being able to fully utilize the exhibition as a catalyst for education and organizing around the mortgage crisis. Her efforts were essential in slowly and patiently winning over those who were skeptical of how an art museum might help them do the job of fighting to improve their community. She oversaw arrangements for two bilingual off-site Town Halls, each involving nearly a dozen housing organizations, elected officials, neighborhood groups, and service providers in a public discussion about housing and foreclosure issues in the hard-hit neighborhoods of Jamaica and East Elmhurst, Queens. She also was able to lead the effort to identify, mail, email, and phone hundreds of New York City housing organizations with invitations to the "Red Lines Housing Advocates Thank You Party," that expressed appreciation for the New Yorkers who devote their careers to improving housing in the City. This celebratory event featured a public discussion with Ken Jackson, a noted historian of urban disinvestment, and housing and fair lending advocates Sarah Ludwig of NEDAP (Neighborhood Economic Development Advocacy Project), and Michelle O'Brian of the Housing Here and Now Coalition.

The Museum's efforts also resulted in significant media exposure for how the mortgage crisis was not just a question of individual families losing their homes

but also represented the "theft of wealth" from low- and middle-income people in African American and immigrant neighborhoods. The stunning visual display of the foreclosures on the Panorama, the "map of tragedy" created a unique visual draw that proved appealing to the *New York Times* and other papers. Perhaps the highlight was an in-depth story on PBS's *NewsHour* that featured the exhibit, but then spread out through our community networks into Queens to meet individuals affected by the housing meltdown.

NewsHour used the exhibition as a visual backdrop for a story about the foreclosure crisis, followed by interviews on local conditions with representatives of CHANGER (Communities, Homeowners, and Neighbors Gaining Economic Rights). CHANGER also organized transportation and a customized exhibition tour for their constituents, followed by a workshop to plan a campaign for financial consumer protection. Furthermore, having a community organizer onboard helped us to build upon the collaborations even beyond the timeframe of the artist project itself. For example Neighborhood Housing Services of Northern Queens and Rebuilding Together NYC who participated in our town halls continued working with us, co-sponsoring the block rehabilitation event, *My Block, My Home*, that took place in June 2010 on 107th Street in Corona, in which over 100 volunteers rehabbed homes, cleaned the block, distributed free plants, and celebrated a mural project to commemorate the upcoming building of a visitors center for the Louis Armstrong House Museum.

NEXT STEPS

While we have had some modest successes in our efforts, QMA has found that we can increase the effectiveness of our programs and remain responsive to shifting priorities by spending time listening to participants' feedback, engaging in personal reflection, and being honest about our challenges. Our program development is an iterative process, one that we hope allows for innovation to come from a variety of voices and which respects the complexity of the neighborhood in which we hope to play a constructive role. For example, after two years worth of *Corona Plaza: Center of Everywhere* projects and several *Launch Pad* residencies, we took time to collect feedback from the community, collaborators, and artists. First, many of the projects deemed most successful both by community members and by the artists themselves were those by Spanish-speaking artists. Feedback also indicated that meaningful participation of the community in the projects would necessitate longer residencies. Some artists wanted access to a dedicated physical space within Corona. Based on our reflective dialogue, we went back to the drawing board to develop the next generation

of projects in Corona: *Taller Corona* or *Corona Studio*, with support from the Rockefeller Foundation's NYC Cultural Innovations Grant. Neither a traditional residency nor a commission, *Corona Studio* will collect a roster of eight proposals in which two to four artists will undertake a year-long project-based residency based in and engaging with community partners in Corona. Simultaneously, QMA is partnering with nearby Queens College to begin developing a Masters in Fine Art program in Social Practice that would reach beyond the traditional space of the studio and directly into the public arena and everyday life. Corona Studio artists' projects would provide up-close examples of social practice in which students can experience and participate directly.

At the beginning of 2011, the first of these year-long artist projects began, in collaboration with the veteran public art organization Creative Time. Cuban artist Tania Bruguera, who primarily works in behavior art (*arte de conducta*), performance, video, and installation, will use Corona, Queens as the launch point for a multi-year, multi-site project "Immigrant Movement International." Bruguera will live and work in the neighborhood with a base of operations in a 1500sf studio/event space on Roosevelt Avenue, just a few blocks from Corona Plaza. She has set up an interactive, relational art project that is simultaneously a year-long performance, a community center, and a consideration of the role and image of immigrants in the 21st century. With QMA's current Community Organizer, Jose Serrano-McClain, she is connecting to local elected officials, immigrant services and advocacy organizations, immigrant law specialists, and leaders of various immigrant communities. As I write, her bustling storefront space is hosting ESOL classes with a "Know Your Rights" focus for members of New Immigrant Community Empowerment, workshops of the Corona Youth Music Ensemble–inspired by Venezuela's "El Sistema" methodology, citizenship classes, regular one-on-one legal consultations, an ongoing conversation about the "usefulness" of art, and organizing monthly "Make a Movement Sundays" workshops and seminars.[5]

CONCLUSION

I have tried to provide some examples of the evolution of QMA's experiments in arts-based community engagement over the course of more than 6 years. In that process, in no way have we put aside the commitment to our role as a fine arts collecting and exhibiting institution. Rather, we have attempted to apply the same sort of imagination, experimentation, and resources to community engagement that we do to the galleries. This article is not meant to provide other arts institutions with a roadmap to community engagement in their own locales. Rather, it is an interim

report on some promising and creative approaches. Even after several years of development, many of these initiatives are just getting started. Ironically, while these programs were not conceived as audience development, one of the clearest successes is that the museum is now livelier, more active, and better attended than ever.

That being said, we do hope to catalyze interaction by sharing our experiments with others in the field. To that end, the online version of this book (available at www.artsengaged.com/bcna) includes three appendices to this article which share personal reflections written in May 2008 on the Museum's community engagement projects in Corona from three different institutional perspectives: Tom Finkelpearl, the Museum's Director; Naila Rosario, QMA's Community Organizer from 2006-2009, and myself, the Director of the Public Events Department. I hope that these three perspectives will together provide a useful resource for other organizations considering working on community development issues in their neighborhoods and what challenges they are likely to face. Furthermore, the Museum has since developed a community engagement blog, a multi-vocal archive and social networking platform devoted to the role of arts and culture in community growth. We invite you to read, contribute, and participate in on-going discussions at http://community.queensmuseum.org. We are still straddling old and new Queens, seeing the two blur through a range of business deals, intermarriage, and social bonding. Our own institution is in flux, reinventing itself both socially and physically, trying to stay fluid in one of the quickest changing places in America.

FOOTNOTES

1) Demographic Data used in this essay is based on information made available by the NYC Department of City Planning (http://www.nyc.gov/planning) based on 2000 Census Data in Queens Community Boards 3 & 4, as Corona straddles both. Special thanks are due to Arun Peter Lobo of the Population Division of the NYC Department Planning for helping the QMA to understand the demographic trends of Corona, and Queens more generally.

2) LTAP youth participants collaborated with several artists including Judith Sloan & Warren Lehrer, Pedro Lasch, and Chankika Svetvilas on the topic of immigration. Brief descriptions of these collaborations can be found on QMA's Community Engagement Blog: http://community.queensmuseum.org/lang/en/blog/corona-plaza/working-with-artists-on-reframing-discourse-on-immigrants/

3) A detailed account of Corona's history and demographic shifts, as well as a focused study on quality of life factors in an around the area of Corona Plaza, can be found in the final report made by students at Department of Urban Affairs and Planning at Hunter College who undertook a 2-semester studio in Fall of 2003 and Spring of 2004, supervised by Professors Tom Angotti and Lynn McCormick. The report is available for download at http://maxweber.hunter.cuny.edu/urban/resources/Corona.pdf.

4) Many thanks are due to Miguel García, the visionary Program Officer then at the Ford Foundation, who believed that arts and cultural organizations could play a key role in community development and who established the Shifting Sands Initiative to support arts organizations throughout the United States in pushing themselves to achieve actual social change outcomes in their communities. Partners

for Livable Communities, which administered this initiative were critical in sharing nation-wide best practices and up-to-date research, as well as for creating a network of like-minded institutions and individuals who continue to inspire and educate each other. Much patient encouragement and invigorating insight were also generously shared with us by several technical advisors provided by the Ford Foundation over the years who helped us in this difficult process of institutional change and cross-sector work, particularly Esther Robinson and Tom Borrup.

5) For up-to-date information on Tania Bruguera's project Immigrant Movement International, please visit the website: http://www.immigrant-movement.us

DANCE: BALLET MEMPHIS

In the public mind, "Dance" is often associated with graceful, lithe young bodies moving in stylized fashion accompanied by "classical" music. The image is not one all find welcoming. Yet dance is a form of artistic expression that may be more widely understood and appreciated across cultures than any other. Acknowledging that generalizations are dangerous, the sounds of traditional Chinese opera and some Native American chant can be off-putting to Western-trained ears; the dances of both cultures can be more immediately recognized for their expressive value in spite of their unfamiliarity than is the music.

Nearly all humans have access to "the instrument" of dance. The Liz Lerman Dance Exhange's Dancers of the Third Age (made up of dancers from 40-90) is simply one example that the participatory aspects of dance, in addition to its potential for fostering cross-cultural understanding, are a rich vehicle for community engagement. Even ballet companies rooted in the European tradition have found ways to configure their work to take advantage of that potential.

A DANCE COMPANY'S IRRESISTIBLE CALL TO COMMUNITY ENGAGEMENT
by Dorothy Gunther Pugh

My company, Ballet Memphis, continues to stand in its first position: one foot firmly planted on the board of ballet tradition, the other on concern for and responsibility to the city that is our home. We began committed to each; experience has drawn us more deeply into both. Contrary to the thinking of some in the ballet community or in the community development world, it *is* possible. In the case of Memphis, it is not only possible, it has proven essential.

Before I begin our story, I need to clarify one point. My definition of community engagement is *not* "being engaged in the community as a social worker with an arts skill." I don't take issue with that, but I do take issue with what is sometimes the result–minimizing, misunderstanding, and occasionally dismissing the deep and vital connection to creating art itself. There are deep and vital wellsprings from which most artists must draw their life's breath. This breath is what artists must be encouraged to

inhale; it is the breath from which all human beings draw sustenance. My first plea is that the creation, production, and performance of art not be tossed out as archaic or aloof as the community activism model is embraced.

Arts institutions must support this need to be alive in our art as all of us in the world of art live and move with our community's populations. We are all evolving results of what and who have preceded us, as well as what and who surround us and affect us. Understanding this should be the base for creating and engaging in art, in performance, in curating, or in community enrichment.

We are well served if we do not turn our backs on who we are, but examine, search, discover, feel, and think about this. For me, a fifth generation Memphian, I knew something of my community's deep and often tragic history, its amazing cultural gifts to the world in the form of its literature and music, and its entrepreneurial business successes.

HISTORY

I knew from the beginning that art must reflect who we are as people. That's not a terribly difficult concept. So, when I first started a young performer's group that eventually became a professional company, that's what my art did. I loved tutoring in the inner city on Saturdays when I was in junior high. I loved directing a day camp in the summers between college years. I loved English and French literature, playing basketball, being Student Government President, studio art classes on Saturdays. I loved thinking and academic challenges. I loved my ballet classes–but not enough to pass up going to college.

I was always going back and forth across fences, never realizing they were even there. The result now is that I know many of them are artificially constructed. They don't scare me, nor do they constrict me. And they don't need to constrict people in the ballet world. If a talented dancer should go right into a company at age 18, so be it. But he or she must know the world and our capacities for involvement in that world– even when they are first and foremost performers. Maybe *especially* as performers.

That's because what we dance and how we dance it matters. What we teach about dance and how we teach it matters. The context and content of what we create and transmit should be scrupulously examined and explored.

Start with what you know. After college, where I majored in English Literature, I taught in an inner-city junior high in the day and danced with a semi-professional company at night. I turned down a full time professional job offer to dance with Pittsburgh Ballet Theatre and went home to take over a small ballet school. Enrollment

jumped from 75 to 175 in 2 years, and I started a young performers group. We danced what we knew–meaningful stories from children's literature. We grew to be a civic-sized company in which we were commissioning music from Memphis musicians, dancing to music by W.C. Handy and Elvis Presley and to stories of life's passages based on a local poet's work.

I apprenticed my small company as "little sister" to Tulsa Ballet Theatre, to become more involved with a company which was founded by a Native American Tulsan ballerina, Moscelyne Larkin and her European husband Roman Jasinski. I learned from their lighting, costume, and production staffs. Our children danced with their company when we presented them here. This was a two-year collaboration.

Eventually, we had our own professional company. But we never stopped paying attention to our school and the Junior Company which keep us rooted in the community. Out of these grew a Pilates program and center, and together, the three supported our mission by nurturing healthy bodies, offering Memphians entry into our institution, and supplying ticket buyers and donors.

When we built our new building 12 years ago, it won local, national, and international awards for design excellence and our school enrollment doubled. As our city's demographics have changed, so has our student population, It is now estimated at 25% minority (which is soon to become the majority in Memphis), and 40% are on scholarships.

This past June, we were asked to perform with nine other significant companies from across America at the Kennedy Center, and were singled out with excellent reviews and commended for our unique, heartfelt connection with our community's culture as we performed to the music of Roy Orbison.

This abbreviated history should give some idea of how I built upon what I knew. But as institutions develop, many people falter in what I'll call the "stopping" of knowing–a person and an institution can quit learning. Why this happens is not for me to discuss here, but I will say that I began to notice the stopping as I became more and more engaged in the national ballet scene.

QUESTIONS

I was asking questions I wanted to hear raised by my peers, questions I am now, gradually, starting to hear. Ten years ago, the common questions were "How can we get so-and-so's work in our rep?" when I was wondering how our European-based art form would resonate with the changing demographic in our country and how we were going to participate in an important national dialogue about meaning, inclusion,

tolerance, gender issues, etc. Where would our art form help out? Still, too often I hear "This ballet really sold a lot of tickets ... (or not)." and not, "This work resonated with our audience because. . . ."

So, I continued with what I knew, exploring these questions with people mostly outside of my field so I could think harder and learn more. One of the things I learned early on was how much there would always be to learn from others. But make no mistake–a huge part of what I knew and still believe, is that the production of meaningful, relevant art is at the heart of who we are. But we have to find new avenues, open new partnerships so that people will experience what we so passionately believe is vital.

I had been wrestling with ideas about art and community for many years before I wrote to the Andrew W. Mellon Foundation. The second paragraph of my spring 2006 letter to the Foundation began, "Performing arts organizations, particularly in mid sized cites–and perhaps even more so those in the oft-neglected 'fly over zone' of the heartland–are at a crossroads." I went on to say that the things we had been presenting and selling as "artistic products" for many years have come to seem increasingly obsolete. Ticket sales were down, donations remained essentially flat, and costs were increasing dramatically. Audiences–along with the world–are changing. Nearly everyone, artist or not, wants to connect with others. But how do we do that today? Where do we find places to meet, learn, and grow together? Do we really even share a notion of the common good? Two and a half years later, I still wonder how arts organizations can serve as common ground for our communities and be seen by them as invaluable points and means of connection.

For brevity's sake, these were my basic questions: What is ballet to look like in this rapidly changing democracy? Who are we supposed to be as a reflection of our community and our nation? What should we express, create, and explore, in the midst of national and international division? Pragmatically, how can my company continue to do its work? Should it? How can I structure Ballet Memphis so that it is flexible, fast-moving, and always open to change, without losing sight of the idealism and beauty ballet inherently carries and preserves?

By the time the 2004 election sparked a national conversation about cultural differences, I was feeling almost stranded in the middle of the "red-state" territory. For those of us who wrestle to create meaningful art in places like my city, Memphis–plagued by overwhelming poverty, high crime, and a lack of educational resources–the "blue states" and their bounty can seem like a different world. I began to feel that "red states" needed attention, compassion, and help.

Yet, in a city with 24 percent of its population below the poverty level, the highest U. S. infant mortality rate in some of its areas, and the lowest wages in the U.S. paid to women, there are a few pockets of excellence, and a history of creativity and entrepreneurship celebrated around the world. Memphis is a city where giving to churches is significantly above the U.S. average and giving to the arts is significantly below. But Memphis is the city that gave the world rock and roll, soul, and blues music. The list of musical artists who have lived and worked here is astounding: not just Elvis Presley, Jerry Lee Lewis, B.B. King and Johnny Cash, but also John Lee Hooker, Al Green, Sam and Dave, Isaac Hayes, W. C. Handy, Jimmy Lunceford, Phineas Newborn, Three 6 Mafia, and Justin Timberlake–this is just the tip of the iceberg. The literary giants of our region make for another staggering list: Eudora Welty, William Faulkner, Walker Percy, Carson McCullars, Flannery O'Connor, Tennessee Williams, playwright Tony Kushner, and even John Grisham. The first supermarket was in Memphis (Clarence Saunder's Piggly Wiggly); the first motel was here (Kemmons Wilson's Holiday Inn); and the world's first air-freight carrier was founded and is head quartered here (FEDEX). WDIA in Memphis was the nation's first radio station with an all-black format. Memphis has a history of exploring and creating new forms.

Today, more than ever, new forms are needed to keep the performing arts vibrant and to help hold our communities together. As Ballet Memphis was a company founded to serve its community and a company that has built a national reputation of creating fine new work, it seems natural to have built much of that work on the rich musical and narrative regional heritage which have contributed so markedly to our national culture. What more can we do to add meaning and content to our field nationally? As a dance company that has never quite followed the pack, like the celebrated entrepreneurs from our city, what can our entrepreneurial spirit do that benefits as many people as we can reach?

I saw my path as a journey in three parts. First, formulate questions for a broad cross-section of national and local business and civic leaders, futurists, marketing and trends experts, innovative non-profit leaders, educators, etc. Next, develop innovative answers to those questions. Third, use Ballet Memphis as a lab to test the ideas. As they unfold, perhaps these ideas can be adjusted by Ballet Memphis and others in the field to become a part of even better models.

The Mellon Foundation responded that they would like to begin by providing the funding to support the exploration phase of forming the questions and providing the way to make the interviewing, connecting, and incubation of ideas possible. With their support, we came up with a list of over 40 interviewees, local and national, that

grew to 60 over the course of the year-long process (which began in the spring of 2007). The interviews were based on these questions:

1) What are the current civic imperatives facing cities, and how are the arts currently involved in addressing these issues?

2) What does it mean to be a successful community organization, and what are the exemplars?

3) What is the relevance of dance companies to the current civic imperatives?

There were clear benefits to meeting local leaders not as Ballet Memphis's ticket seller or fundraiser but as a community leader presenting questions and ideas, attempting to discover their deep concerns and heartfelt interests. What's more, the meetings helped them see us as a different kind of arts organization, concerned for the community and interested in solving problems. Several knew of our many local successes; but few knew of our national honors seven years previously from the Ford Foundation or recently from the Andrew W. Mellon Foundation-not just for artistic excellence and sound fiscal management but also for our deep involvement in our community's culture.

Now that the exploratory phase is over and I've had the opportunity to focus closely on questions and possibilities, I realize that I must make this type of big-picture thinking my top priority. This is an unending process vital to the continued health of my institution.

ENGAGEMENT

Ballet Memphis's commitment to community engagement has led to significant work in economic development, education, and community building, raising our visibility at home. It has also provided opportunities to grow artistically and enhance our reputation beyond the confines of the city.

Economic Development

Ballet Memphis was a guiding force in the development of "Investing In Inspiration," a collaboration with the Chamber of Commerce to support economic growth by fostering civic dialogue. This project is having the additional benefit of showing arts institutions as vehicles to make the city a better place to live, as opposed to simply selling tickets. We invited many other groups to participate and almost all Chamber breakfasts and lunches and Chamber circle meetings now include arts content.

Education

In the local leadership community, the widening gap between rich and poor and the city's racial tensions are particularly concerning. The role of education in correcting these problems is almost universally agreed to be key.

To our work with the public schools, we have added a long term dance program called Dance Avenue serving third graders in three elementary schools and a dance instruction program at Youth Villages, a secured facility for highly troubled teenagers. We have also initiated a program called "FUSE" matching our professional dancers with youth groups in dance-focused mentoring.

Community Building

More and more I've felt that in a democracy, and a rapidly changing one, we should be highly attuned to our population and its issues. For years, I have carefully curated our professional company's performances with the community in mind—exploring community issues in order to have a "conversation" with our audience that is relevant to all of us. This is best exemplified over the last five years with our "Connections" series and our February "AbunDANCE" performances. Architecture, food, the environment, religion, human sound, fashion and gender issues have all been addressed in these series. Dancers and choreographers and audiences are vigorously challenged while simultaneously being entertained and transformed.

In *Connections: Food*, choreographers and chefs created new work together, (an appetizer was made; dance was derived from it.) A particularly stunning piece was Trey McIntyre's work built around the main course called "The Barramundi." This fish starts life as a male, but later in life many of the fish become female; the relevant gender issues were gently portrayed in an area of the country where much intolerance and anger too frequently surround this dialogue. *Connections: Food* has become our major fundraiser.

More recently, *Connections: Earth and Sky* featured an outdoor performance including dances based on land, air, and water. In a time when Memphis has been much focused on tragedy resulting from floods, this proved to be a moving event that brought many disparate people together.

Memphis has a high rate of childhood obesity, We have recently received funding to begin a program addressing this problem and, working with Healthy Memphis Roundtable, will be appearing monthly at schools and community centers with tailored performances, dialogue and teaching materials addressing the issue.

In the Mellon interview process, many civic leaders stressed the need to find ways of embracing Memphis's racial diversity through cultural activities. Much can be done to help our local leaders understand the deeply vibrant and life-enhancing effect the best artistic experience can have on human beings, going beyond the tired assumption of "art is great for the economic development of our city." This continues to pigeon-hole us and places us in a constricted mind-set that is exactly the opposite of the amazing effect we can have on the deeper places of the human heart. Our education and community building programs help counteract this tendency.

Artistic Growth and Reputation

In the early 1990's we produced *Dancing Together*, collaborative dance programs teaming with companies from around the country. In doing so, Ballet Memphis became the first U.S. ballet company to share the stage, the choreographer, and its professional dancers with Rennie Harris' Pure Movement Hip Hop Company and with Chuck Davis' African American Dance Ensemble.

New work is central to artistic vitality. Ballet Memphis's community engagement emphasis has led it to (and provided access to support for) many new dances, especially in the Connections and AbunDANCE series. As but one additional example, Ballet Memphis has become part of a fascinating work in progress about fused dance with one of the Mellon interviewees and an African dancer with whom she is working. Work is being done on this project in Memphis, New Haven, New York, and Burkina Faso in Africa.

At the time of this writing, we counted nearly 150 new works created in our repertories (this may be more new work than any company in the U.S.) and two resident dancers nurtured as choreographers who had been recognized nationally in choreographic competitions.

As word of our innovations and success has begun to spread, our touring program has become increasingly important not only as a revenue generator and opportunity for more dance and learning by our staff, but also for us as ambassadors for our city. Our successful 2007 week in New York City, this past June's Kennedy Center successes, and two years of taking our full Nutcracker to Spokane, Washington are examples. We are recent recipients of a national dance project grant to tour one of our Memphis project works.

CONCLUSION

And what have been the results of all this work? For the first 2 years of the

recession, in contrast to national trends, we increased donations and ticket sales by 17%. Although this growth did not continue in the third year of the recession, we have made tremendous strides in securing major gifts for our endowment and for capital reserves to sustain our annual operations. The future looks quite stable. Exciting new partnerships with minority arts institutions are in the works as well–partnerships which will prove beneficial for our city.

For Ballet Memphis, community engagement has been an inevitable aspect of our work and our growth, a center of gravity whose pull has been irresistible. And, along with commitment to artistic excellence, in defining us it has also provided us a unique market niche and enhanced our financial viability. We simply cannot turn our backs on creating transformative, beautiful, and challenging work. Nor can we resist learning to speak the language of others. Around the world, ballet keeps being produced, but in ways that have lost meaning to many people. My sense is that at the heart of our discipline is belief in the ability of humans to imagine more glorious worlds and build those worlds accordingly. There are truly valuable reasons to use the ground to reach the stars, and that is at the basis of our work. There are truly valuable reasons to present, and explore with our bodies, forms and shapes and lines that go on forever. There are reasons for a corps to work together to further a human narrative, to support a vision. These beliefs, if somehow adopted by the soul of others who see us, support us, work with us, help the progress of humanity. It is up to artistic directors to be in touch with that heart and create, plan, and nurture accordingly.

For details of Ballet Memphis' artistic and community achievements, see the online version of this book at www.artsengaged.com/bcna.

CHAMBER MUSIC:
PROVIDENCE STRING QUARTET/
COMMUNITY MUSICWORKS

CHAMBER MUSIC

Chamber music is usually characterized as a small musical ensemble with one performer on each musical line. Insofar as it best fits an intimate homelike setting and is relatively affordable (due to the small number of musicians), it can be ideal for community engagement work. Insofar as it is associated with wealthy patrons entertaining their friends, it is far less so. The issue is also complicated by the fact that the term has been associated with performing ensembles of the European reflective tradition (string quartets, piano trios, song recitals). However, there is nothing in the definition that precludes bluegrass bands or jazz ensembles.

There is great potential for chamber music as a vehicle to bring people together. A mini-movement already exists involving informal house concerts organized by individuals who invite friends to a potluck dinner followed by a few musicians performing. As a means to promote social relationships among people who share a particular musical interest, these house concerts have much to offer.

The following case study, however, has a different focus. In this, chamber music is a vehicle to promote the pursuit of excellence, and thus personal growth, in children who would otherwise likely not have any opportunity to do so.

ENGAGING COMMUNITY FROM A STOREFRONT: COMMUNITY MUSICWORKS' ONGOING EXPERIMENT
by Sebastian Ruth

On one fall afternoon a few years ago, my quartet colleagues and I were rehearsing a slow movement of a Haydn string quartet in our storefront studio when we had unexpected visitors. As was typical at three o'clock in the afternoon, the parade of school children leaving school had begun, and on this day, two small children, probably brother and sister, about six and eight years old, stopped, opened the door, and looked

tentatively in. One of us looked up while playing and smiled encouragingly for them to come in. The kids did come in, and stood together watching and listening. I forget now which of the Haydn quartets it was, but I remember the special quality that slow movement took on that afternoon. It was as if this audience of two challenged us to search ever more for the moments of beauty and interest in each of our parts, made us eager to give a convincing performance. After five minutes of music, the kids waved and let themselves out, continuing on their way home. For them it was a 5-minute concert experience on their way home, and for us a good reminder of why we play music.

Although a small moment, this kind of visit is exactly the kind of interaction we hope for in our ongoing residency in an urban neighborhood of Providence, Rhode Island. By being a fixture in the neighborhood, rehearsing in a space that once served the neighborhood as a grocery store and later a café, we are trying to make it possible for young people growing up in the West End of Providence to have opportunities to meet and hear musicians engaged in their craft as a normal feature of the community.

When Doug Borwick asked me to write about Community MusicWorks' community engagement agenda, it seemed like a fairly simple task, since our organization's work is all about engaging community. But given the opportunity to think about this topic, I'm realizing there are many dimensions–philosophical and practical. In the following paragraphs I will try to cover soup to nuts as efficiently as possible.

I started Community MusicWorks in 1997 with the basic premise that musicians can and should play a role in public life. I had been an undergraduate at Brown University and a life-long music student. In college I was passionate about string quartet playing, and knew I wanted to continue playing professionally after college. I was also working on a project studying music and moral education and pursuing the question of how an education in music could be transformative for kids' lives if planned intentionally. At the same time, I was teaching violin lessons in a small arts-based community center in the heart of a challenged urban neighborhood in Providence and was enjoying the mentoring relationship I was developing with my students there.

This constellation of experiences led me to pursue a public service fellowship offered by the Howard R. Swearer Center for Public Service at Brown, to design and carry out a post-graduate year as an artist in residence in the community, experimenting with a practice of pedagogy, performance, and community engagement. This fellowship provided the seed funding for what would become Community MusicWorks.

My fellowship application proposed establishing a permanent residency for a chamber ensemble to live, work, teach, and perform in an under-resourced neighborhood with the idea that musicians can make their careers in a rewarding way while contributing to the health of a community and its young people.

Since those beginning days, we have tried to build an organization that can support musicians to focus their efforts under the roof of one organization–teaching, performing, participating in the life of a community as residents, not outsiders, all while making a living competitive with what they might make elsewhere in the music world. Just as string quartets are in residence at colleges and universities, where the members are expected to have a role as performers, teachers to young people, mentors, and contributors to the cultural life of the institutions, we have strived to build Community MusicWorks into such a host institution, where the community served is a neighborhood or region of a city rather than a college.

There are many philosophical underpinnings to our experiment, central among them being the question of how we can do this work as residents of a community and not outsiders to it. Because we're trying to normalize the presence of musicians by being residents of a neighborhood, it's been important to look critically at our role and how we're perceived.

I've been inspired by the writing of Paolo Freire, the Brazilian educator and theorist whose educational principles were based on his work teaching rural poor adults to be literate as a method of empowering them to represent themselves in the political process. A central point for Freire was critically examining the role that a teacher plays in the classroom, to ensure that the teacher not assume a position of superiority or see his/her role as filling the student with knowledge without considering the knowledge and experience the student already brings to the educational situation. Freire was interested in developing an educational experience where students and teachers saw themselves on equal footing–together discovering the reality of the conditions surrounding them, together growing in understanding. In this way, Freire felt that the teacher would not reinforce the already problematic dynamic of poor populations being oppressed by people with greater wealth or education.

For us, entering a community to offer lessons and performances, the question is how to be authentically engaged in the life of a community in such a way that we are not playing a role of cultural missionaries taking classical music to underprivileged populations but instead are making music in the context of a neighborhood, inviting a dialogue with the community around us. Taking a lesson from Freire, we've been very deliberate in not seeing the young people and adults in our community as lacking

cultural assets. Rather we want to engage the community by living and working there and entering into a process of creating a musical community together. In a sense this has been turning the idea of outreach on its head and engaging in a practice of *inreach*–living and working among a community. (Incidentally, having used that word for many years, we have periodically run into colleagues in the field who have also coined the word.)

Freire talks about the need to never assume we know reality, because reality is a constantly evolving phenomenon. Underlying the concept of inreach for us is the idea that we are not simply trying to mirror the work of an existing musical institution, but in fact are trying to create a new one paying attention to the reality of who is involved. What do the students and families bring that's unique to them and their backgrounds and that would not exist anywhere else? How do our passions for music become infectious for the kids we're working with? How is it that they will want to become involved by apprenticing with us in our work discovering great music? And how will we create new work together? How can we conceive of a locally-centered musical community?

We tend to have a fascination with periods in musical or artistic history where a community of artists works together and creates work influenced by one another and the context of the time and place they were working. Thinking about the incredible period that was the Bauhaus, or Paris at the time that Picasso, Miro, Dali, and others were working, or Brahms and the Schumanns, people celebrate those periods as times of great innovation, forward looking, creativity based on artists considering the elements around them and finding ways of expressing them in their material.

At its most idealized, Community MusicWorks is aiming to accomplish something similar, to create a musical community where musicians are engaged together in creating meaningful chamber music performances that reflect a commitment to where we are based. This kind of commitment to place and to the community adds value to the neighborhoods in which we're working. The young people growing up in these neighborhoods have opportunities to witness, participate, and in fact apprentice to the musicians making their life and work in these neighborhoods, and by the nature of the collective commitment to the neighborhood, begin to envision their neighborhood as a place of quality. By extension, we hope this commitment to musical community gives kids and adults a sense of belonging to something important and beautiful.

While we hope this commitment to our community comes across in performances of great works of chamber music from the 18th, 19th, and 20th centuries, part of our life

must also be about engaging with new work that is either written by or written for our community of musicians.

In recent seasons we've had the opportunity to begin to commission works that particularly reflect this philosophy. Examples include a commission of Daniel Bernard Roumain of a string octet written to feature the relationship between professionals and students, with the Providence String Quartet performing alongside the Phase III student quartet. Also, the work was based on a Haitian "Kompa" rhythm, reflecting both the composer's heritage and the area's significant Haitian-American population. A second example is a commission we provided Anthony Greene, a young African-American composer originally from Providence, who wrote an octet on the theme of immigration, reflecting the various immigrant communities living in Providence and their music. Both pieces reflect the idea of putting two string quartets together in conversation.

DAY TO DAY LIFE IN A STOREFRONT

Our operation is in a pair of storefronts in the West End neighborhood of Providence. We elected to work in the south and west side neighborhoods of Providence because they are the most racially and ethnically diverse in the city with large populations of recent immigrants, and also because they are the most economically distressed in the city. Young people growing up in these neighborhoods face the highest risk factors, including a 50% high school drop-out rate, and the highest childhood poverty, gang violence, and teen pregnancy rates in the city. Our storefronts represent our commitment to be visible to the neighborhood and our commitment to make music an accessible resource for positive change in the neighborhood.

Although in some ways the storefronts are merely symbolic of our commitment to impacting the neighborhood, sometimes, as with the young children who stopped to listen to our Haydn quartet, they become an opportunity for direct engagement. On one occasion, a group of teenage boys walked by our rehearsal and made a teasing gesture at us when we were rehearsing, (also shouting a profanity that we assumed to be aimed in our direction). Every day for several months at about the same time, the same group of kids would walk by, and each time we waved and continued to rehearse. Over time that year, we developed a relationship, simply through the glass windows, with these kids as they walked by and gradually their gestures and comments morphed into a friendly exchange. By the end of the year they were waving back and dancing as they walked by.

We think of there being many circles of impact we make on our community. At the innermost ring are the hundred or so young people who participate in our programs, coming multiple times per week for lessons, special classes in improvisation, fiddle styles, ensembles, studio classes, and more. At the next ring might be the audiences who hear our concerts in public settings, get to know our musicians, and support the mission of the organization. The passers-by, the kids who see us through the windows of the storefront and may or may not stop to listen, are part of our outer ring of influence. My hope is that even if they're not deeply involved in our programs and music making, these kids know what it is to see a string quartet rehearsing, and the next time they encounter one, they are less likely to find it something completely foreign, and more likely to say, "Oh yeah, I've got one of those on my block." Whether or not a member of the neighborhood participates in our programs, at least they understand that it's available and that it can be a normal feature of community life.

INVESTMENT IN THE COMMUNITY

We think of Community MusicWorks as an investment in the community, not only in terms of the kids' musical education but in terms of the ways that we build social capital in the neighborhood. Through our relationships with families, through opportunities for families to form a community by assembling at performances, through connecting students and families with other important resources in the city, we are facilitating pathways to opportunity even beyond music. While we are not trying to take on the deep and complex issues of poverty, unemployment, or crises in families' lives, we do play a role in connecting people to opportunities when they need them.

A few examples of these efforts include:

1) Sending all of our high school seniors through a year-long college advising program called College Visions, which coaches first generation college-bound students and their parents through the college admissions process. Early on, we found that although we had invested many years into kids' lives through mentorship and music education, their prospects for attending college were not great because their schools didn't provide adequate support. I remember trying to fill that gap myself for two students before realizing that I was not qualified to help kids and their families navigate the complex college and financial aid application process nor was that the best use of my time. We would need to stop violin playing for months in order to work on college essays. While sending kids through College Visions is an expense for

Community MusicWorks, we feel it is a necessary support and a complement to the deep and long-term work we do with kids.

2) Providing access to information on opportunities like job postings, summer camps, academic support when families need them.

3) Providing coordination so that our network of families can help one another with transportation and childcare or supporting a single mother when a medical condition arises.

Beyond these specific investments we make in the community, there is another important dimension to our impact. I mentioned earlier that our neighborhoods are racially and ethnically very diverse. Over time we've realized that Community MusicWorks has become one of the few contexts in which people from diverse backgrounds assemble to form community. Churches tend to gather people from similar backgrounds; community festivals are often set up to celebrate one culture—the African American festival, the Dominican festival, the Guatemalan festival, etc; and schools, while having diverse student bodies, rarely provide opportunities for whole families to assemble. Families have remarked that Community MusicWorks is unique for being the place in their lives where they form community with people from many backgrounds.

COMMUNITY SUPPORTING PERFORMANCE

An important feature of the success of Community MusicWorks is inviting high-profile musicians to our community each season to support our mission, carry the mission of our work outward, and reenergize our musicians. Early on, we identified this need, and in 2003, my colleague Heath Marlow made calls and sent letters to 10 chamber groups, conductors, and solo musicians asking them to lend their name and their endorsement to our project as part of an artistic advisory council. Over the years we experimented with different kinds of residencies for these musicians, finding that it wasn't enough to simply have a group visit us for a fundraising concert with donors, but that to really honor our mission, we needed to find a way to have the visits of these musicians impact our whole community.

Whereas the early years of this experiment led to some disappointments—one group that visited saw an outreach gig on their contract and didn't inquire much beyond that, and another time, we arranged the concert in a community setting but had a poor showing from our students—eventually we realized that we needed to move beyond the normal concert expectations and create an event or festival out of this annual experience.

When pianist Jonathan Biss came in 2004, we decided to turn his visit into the most exciting community event we could. First of all, we chose to do the concert at center court of the local community center's basketball court as a symbol of putting the music directly where the community already assembles. We talked with schools and community groups around the neighborhood to drum up interest and enthusiasm for the event, and the community center staff got so invested that they cooked a spaghetti dinner for the audience and baked a cake saying "Welcome Jonathan Biss." Now we were talking! For a community center that is central to the African American and Latino community of Providence, and where many of the staff told me they had never been to a classical music concert, the concert in their building had a very special significance. Furthermore, we arranged for Jonathan, in addition to his collaboration with our Providence String Quartet on the Brahms Piano Quintet, to accompany our students on pieces they were playing. Afterwards, they would be able to casually remark that they had performed with Jonathan Biss on his tour through Providence!

At that event, and in subsequent visits by groups such as the Orion String Quartet, the St. Lawrence String Quartet, and violist Kim Kashkashian, we've seen that these aren't simply concerts *for* the audience, but really an exchange between the musicians and the community. After the Orion Quartet left, we received a beautiful note from Steven Tenenbaum, the violist, saying that ours was one of the favorite concerts in their career, and that so rarely did they get the opportunity to perform for such a diverse crowd in a community setting where everyone was so focused and hanging on every note. We've come to realize that these concerts are, in fact, a true expression of our mission, where students, families, and musicians–both visiting and permanent–are transformed by the community of which they are a part.

HOW WE PAY FOR IT

One of the ongoing ambitions of Community MusicWorks is to set a precedent that musicians can make careers doing meaningful public service and investing in long-term change for a community. This ambition has challenged us to find a business model that works to support musicians. There are several factors involved in this.

Whereas many community-based non-profits pay teaching artists on an hourly basis, we pay musicians a salary including benefits so they can make Community MusicWorks a central commitment of their careers. From the standpoint of allowing musicians to truly invest their careers into this project this has been a tremendous success; we have at this point five staff members who have been with the organization for 10 years or more. Musicians working at Community MusicWorks have the unusual

opportunity to work for an employer who pays for health insurance and retirement benefits, providing a financial stability usually experienced only by musicians working for symphony orchestras or large institutions like colleges or conservatories.

We have set up our musicians' jobs such that each person is a generalist-each person plays a role in teaching, performing, planning programs, and doing a piece of administration, whether that means leading our mentor program, taking responsibility for our instrument purchase and maintenance, or in my case serving as Executive & Artistic Director. In the beginning years, our staff consisted only of the musicians involved in the string quartet; gradually we began adding administrative staff to support the work of the organization. In our recently completed fourteenth season we began to find ways of specializing more than previously, both to streamline our operations and to allow musicians to focus on their teaching and performance to a greater degree. Having the staff consist of musicians doing all aspects of the work in the beginning years made it possible for us to focus our fundraising efforts on building salary and benefits for musicians.

Paying for a workforce of salaried musicians means that we're setting a precedent that it's possible, but doing so comes with the challenge that personnel costs are very high for the organization. Our business model has relied on grants and contributed revenue for the bulk of our income. We have made a choice not to charge tuition or fees to our students, both because many come from families that cannot afford extra activities for their children and because we want to make a statement that music and music education should be a free public resource in the ways that public schools and public libraries are.

The reason it has worked for us from a fundraising standpoint is that our work lies at the nexus of public service, community development, educational opportunity for children living in poverty, and the arts. Some supporters are interested in the very combination of these fields, while others are interested in only one of these issues, but see our strategy as compelling and innovative.

Specifically, our funding comes largely from private foundation grants and individual contributions, with government grants, concert ticket revenue, and corporate support making up a small percentage. Our strategy over the next several years is to increase the percentage of support that comes from individual donors, because we've found this type of revenue to be the most reliable and sustainable over the long term and because we feel it's critical to our model that people in Providence and Rhode Island embrace and support our mission over the long term.

At its best, after fourteen years we are still running an ongoing experiment to find out whether musicians can play a significant role in addressing some of the intractable problems of American cities while building rewarding performing careers for themselves at the same time. The business model relies on there being a community of individuals and institutions compelled by the idea enough that they continue to invest.

CHALLENGES IN ENGAGING COMMUNITY

It would be insincere only to trumpet our accomplishments without discussing some of the significant challenges we've encountered in engaging community. Here are a few anecdotes of these challenges:

Several years ago, one of our families was being profiled in a magazine article about Community MusicWorks. When I read the article one phrase jumped out at me. The mother of my student said that she liked Community MusicWorks because it gave her daughter access to classical music which was access to class. I found it unsettling at the time, because I was aiming for establishing a local musical community vibrant and having merit on its own, not as a symbol of elite society or upper class wealth. Reading this mother's perspective made me realize that while we may have a particular set of ambitions for what music will mean at Community MusicWorks, other people will come to it with their own ideas, and neither is exclusively correct. In fact it would be inappropriate for me to challenge this mother, a recent immigrant from the Dominican Republic eager to give her daughter a chance to succeed, on what music can do for her family. This experience taught me that we have to continue to be clear on why we do things, and to communicate better the reasons for why we're doing them, but that in the end we can't control the reasons people participate.

Over the years we have several times encountered families who seem to undervalue Community MusicWorks because it is a free program while they pay for other programs for their children. Typically the scenario goes like this: when one of our teachers is in discussion with a family about a problem with attendance, the family says that they have to miss because the child has a conflicting after school program, be it dance or martial arts, where they have to pay. We've had many long discussions as a staff about this problem, because we are striving to offer the highest quality musical experiences to kids and purposely provide it free of charge. The problem beyond our control is that in a capitalist economy we're often accustomed to equating cost with value and sometimes unconsciously assuming that something free therefore must not be as good as something one pays for. The question for us centers on whether we need

to articulate cost in order for people to see this program as valuable, even if it means most kids would participate on a full scholarship. The conclusion I continue to draw is not to articulate cost just for the sake of articulating value, but leaving it to the families to discover the inherent value of our program. Nonetheless this remains a tension we have to consider.

We frequently need to bridge the gap between classical music norms and community norms and be willing to redefine each at times. When we had our first "Performance Parties," the events where students perform for the community, we were intentionally trying to set up an atmosphere of celebration and not a strict or somber recital atmosphere. We weren't interested in imposing the rigidity of a concert hall on this event, but rather taking more of the spirit of a Latino festival to it. This attitude remains today, although some major adjustments were required in the beginning, when at the first performances you couldn't hear the performers over the noise of people talking, babies crying, and kids running around! We had to find a way to communicate the value of quiet so that we could respect the performers while they were on stage, without imposing a strict atmosphere. This happened over the course of a couple of years by making announcements from the stage to let the audience know that they should give the same attention to the performer on stage that they would a close friend telling them something important. There were no rules to follow for the sake of rules, but we communicated that performers feeling disrespected wasn't acceptable either. At their best, our performances have grown to have the positive features of both the concert hall's quiet and the community festival's celebratory aspects.

Earlier I spoke about the community concerts in the gym with members of our Artistic Advisory Council. One of the challenges remains that even positioning the concert in the center of the neighborhood doesn't guarantee that neighbors will come. In fact, one of the trends we've seen and continue to address is that those concerts tend to fill with classical music enthusiasts from other parts of the city easily but not necessarily with people from the neighborhood. My hope is that over time, our students will grow up and begin coming as audience members to these, but in the meantime, we need to do what I consider the above-and-beyond marketing and community recruiting approaches to fill the gym with neighbors.

CONCLUSION

I'm often asked what the best success of Community MusicWorks would be. The most succinct picture of success I can give now is that our students become engaged,

happy adults who see their lives as being full of possibility, and that our community continues to be one that features artistic vibrancy. So far, we have seen most of our students graduate high school and go on to college, and increasingly we see a population of students who report that their musical community is an anchor in their lives.

In terms of the musicians involved, I would say that our musicians' practice and commitment has been fed by this work and by a sense of purpose. While the work is difficult and takes a great deal of time and energy, my colleagues and I are motivated to continue to invest in our performance careers not by an economic need-our salaries are fixed and we're not paid per concert-but by a sense of how our artistry is adding to the vibrancy of our neighborhood and our city. I like to think that we're broadening the definition of what it means to be a musician-that it's not simply playing our instruments that makes us musicians, but the combination of performance, education, and citizenship that together constitute the whole of musicianship.

Freire says that reality is a changing concept, and his concept about educational practice applies well to the problem of community engagement for arts organizations. He admonishes educators to be very attentive to the world around them, and the realities of the lives of their students, and not to get trapped in presenting a world view too neatly packaged or too locked into a past way of thinking. The most vibrant educational practice, he says, is one where the teacher and student are engaged in dialectical inquiry to understand what current reality is, and how to best understand it. For us, and I for imagine many arts organizations, it's important to stay tuned to who is in the community, what they need, and how the arts organization can play a role. We should continually ask ourselves who is coming to participate and who isn't, and how we can push the envelope of creativity such that we're simultaneously engaging people and furthering creative art making. If, as Freire says, reality is an always-changing concept, we must be always ready to grow into a changing world.

OPERA:
HOUSTON GRAND OPERA

Of all the arts, in the United States opera is arguably the one most widely associated with Old and New World elitism. Historically performed in non-English European languages (save only pre-20ᵗʰ century operas of Purcell), often devoted to mythological or historically remote plots, and supported by a fairly select group of wealthy individuals, the reputation of opera in this country, at least among the general population, is that of a genre not welcoming to the person on the street.

This reputation is particularly striking when compared to the situation in Italy, where opera is viewed as a national treasure that relates to all the people. That Verdi's operas have been associated with Italian nationalism (however erroneously) attests to the fact that opera is widely popular there. Clearly, of course, the advantage of performance in Italian is a significant factor in this.

That said, there is much that opera has to offer in terms of community engagement. With plots that resonate within a community in a vernacular language, text emotionally enriched by music has great power to form the basis for social change advocacy or open doors of understanding between cultures. *Porgy and Bess* certainly comes to mind, as do more recent works like San Francisco Opera's *Dead Man Walking* and Houston Grand Opera's *To Cross the Face of the Moon/Cruzar la Cara de la Luna*, a "mariachi opera."

The case study of Houston Grand Opera that follows describes an opera company that puts the community at the core of its mission. Its principal vehicle for doing so is called HGOco.

HGOCO: COMPANY, COMMUNITY, AND COLLABORATION
by Sandra Bernhard and Doug Borwick

HGOCO CONNECTS OUR COMPANY TO OUR COMMUNITY THROUGH COLLABORATION.

Through HGOco, Houston Grand Opera creates opportunities for Houstonians of all ages and backgrounds to observe, participate in and create art. Its Song of Houston project is an ongoing initiative to create and share work based on stories that define the unique character of our city and its diverse cultures. Since 2007, HGOco has commissioned ten new works along with countless innovative community projects, reaching more than 750,000 people in the greater Houston metropolitan area.

OPERA REDEFINED, A COMPANY RE-IMAGINED

Stories set to music, acted out on a stage: that is the essence of opera. The masterworks of 18th-, 19th-, and 20th-century opera are treasures of Western civilization; but they are neither the beginning nor the ending of the genre.

The history of opera companies in the U.S. is one of institutions built to present opera and promote cultural education. Houston Grand Opera has been a part of that tradition for over half a century. Five years ago, HGO embarked on a new path, one that reclaims opera's roots and blazes a trail for its future. The establishment of HGOco made community engagement, broadly understood, central to HGO's existence. So what does HGOco do beyond traditional "education and outreach?" And what do those things do for HGO, a major opera company in our nation's fourth largest city[1] and our nation's first 21st century city[2]?

Those questions are the ones I am most frequently asked. They are often accompanied by either, "What does this have to do with opera?" or "What's an opera company doing here?"

I'm not opposed to fielding these questions and stand firmly behind the name HGOco for the very reason that the name itself makes our audience, supporters, and community ask who we are, what we do, and why we are here. The rationale for HGOco's branding is to provoke the question. There can be no assumption about what it is that we do, because HGOco causes no assumptions. We are not the "department" which handles education in schools, we do not teach music, and we are not an

outreach program that brings a 19th century European form called opera to our city's neighborhoods and tells them "why they should like it;" nor are we trying to engage audiences who have never been to the Wortham Theatre Center, the home to Houston Grand Opera's productions, to become ticket buyers, subscribers, patrons, trustees, or donors. In fact, we often don't sell tickets at all.

Rather, HGOco reinvents how a 21st century opera company lives and works in a 21st century city defined by a minority-majority population. HGOco connects our company to our community through collaboration. We are a cultural resource for the city of Houston through programs that promote observation, participation, and creation. HGOco tells the stories of Houston's citizens through the universal language of art and music and through the fundamentals of storytelling to create individual stories with universal themes. HGOco is a center for exploration and creativity–the catalyst for a revolution in cultural service and new works. HGOco expands, re-imagines, and redefines the purpose of opera and music theater, establishing HGO as a relevant and indispensable cultural resource for our city and our art form.

WHAT DOES THIS HAVE TO DO WITH OPERA?
A VISION FOR HGO AND BUILDING HGOCO

Since its inception in 1955, Houston Grand Opera has grown from a small regional organization into an internationally renowned opera company. HGO enjoys a reputation for commissioning and producing new works, including 45 world premieres and six American premieres since 1973. In addition to producing and performing world-class opera, HGO contributes to the cultural enrichment of Houston and the nation through a diverse and innovative program of performances, community events, and education projects that reaches the widest possible public. HGO has toured extensively, including trips to Europe and Asia, and it is the only opera company to have won a Tony, two Grammy awards, and two Emmy awards. HGO's performances are broadcast nationally and internationally over the WFMT Radio Network, New York City's WQXR, the European Broadcasting Union and the Australian Broadcasting Corporation.

Anthony Freud, OBE was General Director and CEO of Houston Grand Opera from 2006-2011. Freud and Patrick Summers, HGO's Music Director, shared an acute awareness of the changing dynamic between an opera house and a 21st-century city. They understood the changes of perception, both internally and externally, necessary for an opera company to be seen as relevant to today's community and not regarded as an out of date, expensive, elitist art form. HGO had tremendous

resources on which to build: decades of excellent art on the Houston Grand Opera stage, the internationally regarded Houston Grand Opera Studio training program, and a vibrant company of Houston artists involved in all facets of the company-from chorus, orchestra, educational touring, technical and production and administrative areas of the company. The two men sought to use these resources as means through which HGO could interact and connect with the community on multiple levels. Their work began to change the perception of opera in Houston from an art form reserved for a few to a cultural resource that speaks to everyone by telling the stories of who we are. What could be regarded as a simple paradigm shift was actually a monumental internal and external cultural change in an arts organization. Under their leadership, HGO developed two principal subunits, one to produce the company's subscription series and the other, HGOco, to produce other work. Functioning together, HGO and HGOco would create internal and external partnerships to connect the company to the community by making use of the organization's resources.

When Mr. Freud came on board in 2006, Houston Grand Opera had been in a slow spiral of decline for a number of years, characterized by a shrinking pool of donors and ticket buyers. To correct this decline, Mr. Freud and the Senior Management Team wrote a strategic plan based on the fundamental pillars of Excellence, Affordability, and Relevance[3]. Implementation of the plan created an expectation and renewal of excellence throughout HGO, lowered ticket prices in sections of the house, shaped a ticket accessibility program called NEXUS, and formed HGOco, a community engagement program modeled on Welsh National Opera's MAX program that was developed under Mr. Freud's leadership.

FIRST FRUIT OF HGOCO'S COMMITMENT TO COMMUNITY: *THE REFUGE*

The concept for HGOco had been born early in 2006, when Freud a native of London, sat down with an opera patron and began asking questions about the city he had just claimed as his own. In the course of the conversation it became clear to him that Houston was in many ways a quintessential American city, a product of immigration that had never ceased welcoming immigrants. He believed that HGO should do something to reflect that, and the idea for what was then called Song of Houston emerged. At the time, Song of Houston was simply envisioned as a musical work that would tell the stories of different Houston immigrant communities. Soon, however, the concept of Song of Houston grew, even as the musical work was given a new name, *The Refuge*.

Inspired by the true story of a family's journey from El Salvador to Houston, *The Refuge* presented a collection of individual journey stories from seven Houston's immigrant communities: African, Central American, Indian, Mexican, Pakistani, Vietnamese, and Soviet-era Jewish which were collected by and crafted into a libretto by Leah Lax and set to music by award-winning composer Christopher Theofanidis.

Two performances of *The Refuge* were presented on the Brown Stage at the Wortham Theatre Center on November 10, 2007. This was followed by outdoor performances at Miller Outdoor Theatre on May 4 and 5, 2008 presented by members of the HGO Orchestra, Chorus, Children's Chorus, soloists from the HGO Studio, and community musicians. All design, technical, and production elements were created, built, and administered by Houston Grand Opera. A recording was released in the spring of 2008 by Albany Records.

External Culture Shift: Changing the perception of HGO in Houston

The many projects surrounding the creation of *The Refuge* were vital to HGOco's unique initiative: connecting the community through collaboration. The opera was created through people's stories in community centers, apartment buildings, libraries, and restaurants–frankly, anywhere where we could communicate, collaborate, and connect. Sue Elliott, HGO Manager of Planning and Special Projects, sought community members, community leaders, and community task forces to build connections around storytelling. Projects with National Geographic's Photo camp for African refugee teenagers in Southwest Houston and HGOco's Create an Opera camp (serving two dozen children from different immigrant communities from greater Houston) were two such projects. The premiere of each community movement from *The Refuge* was presented in a local venue chosen by the community to celebrate the stories told. These were performed by artists from the HGO studio along with community musicians and leaders. By the time *The Refuge* opened in November, every movement had had a community premiere–some in restaurants for 100 people and some in town squares for over 10,000 people.

The challenge of *The Refuge* was finding the community members, centers, and leaders who would talk with and work with the Opera. For most community members, one of two views of opera (and of HGO) prevailed: Opera was an art form devoid of meaning in contemporary society, and HGO was a company that only called upon the community when it was in its own interests to do so. That is, it would appeal to a community when a mainstage offering had (potentially) "something to say" to a particular community. Once that show was over, so was the community connection.

Those communities viewed such contact as opportunistic marketing and, therefore, the efforts bore little lasting fruit. Common examples include *Margaret Garner*, for the black community, or *Madame Butterfly*, for the Japanese community.

If our communities had collaborated with HGO in the past, they were, therefore, suspicious of *The Refuge* and Song of Houston projects. Other communities with whom we had not collaborated were suspicious of us because we were unknown.

Internal Cultural Shift: Defining Home and the "New Normal"

The Refuge was a million dollar project whose funds were raised solely for that project. *The Refuge* was the catalyst for the cultural shift in how an opera company was perceived by the Houston community beyond the mainstage, a shift which in turn transformed HGO's internal culture. It redefined the understanding we had of ourselves as a company.

Mr. Freud led the project with the expectation that everyone in the company, regardless of job or position, would be involved. *The Refuge* was valued by the CEO on the same level of importance as any mainstage opera. *The Refuge* was not a frill nor was it treated as solely a project of the education or community engagement department. *The Refuge* was defined as an HGOco project–a part of the mission of HGO and supported by every member of the company as an important work of art that connected the company to the community. In Mr. Freud's view, the health of HGOco depended on the health of Houston Grand Opera and the health of a 21st-century opera company in a 21st-century city depended on the support of HGOco projects that connected its communities to the city as a whole.

The importance of an internal cultural shift cannot be underestimated. The new paradigm required the vision of the leader, the continual messaging of the mission, and the expectation that everyone would be involved in every project: no exceptions. As with any cultural change, there were those who did not fully embrace or understand the change. The new paradigm was supported in word and deed by the CEO and would slowly permeate every fiber of the company. HGOco became a part of the language of the company and the language of the company included HGOco.

The Board of Directors quickly became an asset in the new paradigm shift and would speak about the projects in the board room and to potential opera patrons or community partners. Company leadership, trustees, and donors would hear the message and tell the story. The new paradigm became the story of the opera company and continues to be the story under Houston Grand Opera's new leadership team with

Patrick Summers, Artistic and Music Director and Perryn Leech, Managing Director.

The Refuge was the first project. The pride that the company took in producing *The Refuge* garnered important results. The production took place on the mainstage and was celebrated by the press. It was easy to support. But this project was only the beginning.

HGOCO: SONG OF HOUSTON

HGOco recognizes *The Refuge* as the beginning of the Song of Houston, a series of projects which tell the stories of Houston in music. It is "an ongoing initiative that commissions works based on stories that define the unique character of our city." HGOco's website identifies Song of Houston as "Our stories in words and music." In many ways it represents HGOco's own core mission.

Today, Song of Houston has grown to become an umbrella under which a variety of community centered programming has been and is being presented. A few of these include The Neff Project, Mexico 2010, East + West, and Home and Place.

The Neff Project

The Refuge inspired Principal Anita Lundvall at Gulfton/Sharpstown's Pat Neff Elementary School where 34 different languages are spoken on campus. Supported by a 100% commitment from faculty, administration, and students, Principal Lundvall wanted to use the journey story as expressed through interviews and art to create a more cohesive community at Pat Neff school and to establish relationships with the school's surrounding neighborhood.

This vision became the source of a year-long (2008-2009) curriculum-based exploration of the distinct character of the community. Its culmination was school-wide "book report," the *Hooray for Neff* Festival, celebrating the stories and people of Sharpstown through visual art, song, dance, quilts, photography exhibits, and original writing.

Mexico 2010

Opera to Go!, an HGOco program presenting short operas and opera excerpts in community settings, led the next Song of Houston program–"Mexico 2010." This project celebrated the bicentennial and centennial of Mexico's revolution and constitution respectively with a commission of *A Way Home* by composer Ethan Frederick Green, Shepherd School of Music at Rice University graduate and writer Irene Keliher, a

graduate of the University of Houston writer's program. This 45-minute opera, created to tour classrooms, libraries, parks, corporations, and other public spaces, is a coming of age story set against a backdrop of the monarch butterfly migration. It tells the story of Gracie, a Houston teenager who grows up in a two-cultures family, a situation common to many children growing up in Houston.

East + West

East + West is a four-year (2010-2014) celebration of Houston as a meeting place for eastern and western cultures. A series of chamber operas explores the relationship between first- and second-generation immigrants, displacement of war refugees, storytelling traditions, and cultural inheritance. Each chamber opera celebrates culture and community through storytelling and music. Engaging artists and individuals from different countries allows HGOco to create art about, by, and for Houston's vibrant Asian cultures. In 2012, *The Bricklayer*, dealing with Iranian exiles, and *New Arrivals*, about a Cambodian refugee have their premieres.

Home and Place

Building upon lessons learned and relationships developed in the Neff Project and others, HGOco created an expanded range of community-focused programs called Home and Place. In partnership with the Houston Independent School District and Neighborhood Centers, Inc. (NCI brings resources, education, and connection to more than 236,000 people throughout Houston and the Texas Gulf Coast area each year.) Home and Place will serve three Houston neighborhoods. Trained educators and artists "will record oral history interviews of community members, and use them as a basis to create a variety of artistic projects including song, visual arts, dance, photography and writing. These artworks will be presented at community festivals and will also be stored on durable media to serve as an archive of each community's stories."

Home and Place was among the first recipients of grants from ArtPlace, a consortium of funders including nine national foundations, eight federal agencies, and six of the nation's largest banks. ArtPlace is designed to provide money for "creative placemaking" activities, arts projects that "create vibrant communities, thus increasing the desire and the economic opportunity for people to thrive in place."

HGOco is by no means solely concerned with Song of Houston. In addition to it, HGOco manages HGO's long-standing (and somewhat more traditional) educational programs–*Opera to Go!*, the education and community touring program, the Storybook Opera program (bringing books to life through reading and singing), student

240

performances, teacher workshops, lectures, and other unique programs[4]. However, the focus in each of these continues to be upon community engagement. Without losing the long-standing commitment to educational excellence, these older programs have been fine-tuned to focus on "connecting our community through collaboration" and "celebrating those who call Houston their home."

WHAT DOES THIS HAVE TO DO WITH OPERA?
THE PRACTICAL BENEFITS OF ENGAGEMENT

HGOco is a significant generator of its own funds. Since its inception, HGOco's budget has grown from slightly under $600k to over $1.3 million of funds restricted to HGOco activities–new work, community creation projects, and new community initiatives. The ArtPlace grant referred to above was for $250,000. Money for such work is often available from sources that would never consider supporting "opera" as traditionally understood.

HGOco is a highly visible face of HGO. Since its creation in 2007, HGOco has reached over 700,000 people through community collaborations and education programs; it has partnered with over 90 schools, universities, nonprofits and other organizations in the Houston area and beyond. In doing so, HGOco helps build dialogue about the importance of opera as a cultural resource which in turn raises the value of HGO to the community of Houston. Its work also changes the perception of opera as an elitist art form in Houston as we push the boundaries of where opera can be performed: the Chinese Community Center, Talento Bilingüe de Houston, Arab American Cultural Center, and Neighborhood Centers, Incorporated. It also helps transform understanding of what opera is: 9/11 songs, songs about the community, an opera with a Dan Bau onstage, and operas telling the stories of individual Houston residents.

HGOco provides practical support for HGO. Its national recognition from organizations such as Opera America, Partners for Livable Communities, the National MultiCultural Institute, ArtPlace, the Arts Education Partnership, the National Endowment for the Arts, the Mellon Foundation, the Target Foundation, and Bank of America provides spillover benefits to HGO. It also helps stabilize the company by providing jobs to Houston's artists through Opera *to Go!*, Storybook Opera, Teaching Artists, designers, singers and production crew for the creation of new ideas and the development of new works.

HGOco is enriching the field of opera by commissioning work that is gradually becoming part of the established repertoire. *To Cross the Face of the Moon*, a mariachi

opera commissioned as part of the Mexico 2010 project, and a Song of Houston project, *Pieces of 9/11: Memories from Houston*, are receiving recognition and performance beyond the city.

Are there other benefits to HGO from HGOco programming? A small direct impact on ticket sales can be seen where HGOco sponsors events highlighting the community relevance of mainstage productions. One such case was HGO's performance of *Dead Man Walking*. But HGOco's most important benefit to HGO is future-focused. Its work will have the long-term effect of winning people to the value of opera in ways not otherwise conceivable. It is also establishing connections with populations previously uninvolved with opera that represent the future of Houston and of the United States.

CONCLUSION

Rebranding opera from an enterprise understood and appreciated by only a few to a genre vitally connected to the people of Houston provides a base (and visibility) that can only enhance HGO's marketing efforts. But it would not be having this effect if HGOco's purpose were simply marketing, public relations, or even traditional education. It is successful because its work is rooted in a true desire to be part of the community. Clearly, collaboration is key. The secret is to show up, keep showing up, shut up, and listen . . . and never leave. Through this approach, the company is now a member of the community, a partner in making Houston a better place to live.

The work of HGOco is vital to HGO's mission. In reclaiming the definition of opera as stories told in music, it is revitalizing the art form–by winning new audiences and building the repertoire. And it is creating a healthier HGO. HGOco does not represent an incremental change in approaches to arts education, arts marketing, or community involvement. It is not an optional "add-on." It is as fundamental to HGO as are mainstage productions of operatic masterworks. As advocated for elsewhere in this book, it is the vehicle through which community engagement is "mainstreamed" by the company.

The results have been revolutionary both in terms of what is onstage and in the changes to the company offstage. Houston Grand Opera is now perceived by Houston communities in new ways. Internally, the expectations of embracing this kind of work have changed how we do business–every day.

FOOTNOTES

1) 2010 Census Data
2) Kinder Institute for Urban Research, Rice University, Stephen Klineberg
3) Houston Grand Opera Strategic Plan, 2006
4) HGO and HGOco programs are listed on website at: www.HGO.HGOco.org

ORCHESTRA

The orchestra, a product of the European cultural tradition, is a particularly expensive enterprise. While its baroque and classic era iterations can be of a manageable size, the mid- to late-Romantic Era symphony, created when labor was far less costly than today, requires human resources for performance that are very nearly unaffordable.

This is not the place to cite the difficulties faced by professional orchestras; however, as a prelude to these examples and the case study, it is illuminating to point out that at the 2011 conference of the League of American Orchestras, Jesse Rosen, the LAO's President and CEO, noted that "over the last 25 years . . . per concert attendance and sales revenue were declining every year." Citing a variety of other negatives on the resource side, he identified three priorities for success. One of these was "Realign with community needs." In articulating this priority, Mr. Rosen cited Milwaukee Symphony principal violist Robert Levine who said, "Getting community engagement right will involve orchestras rethinking themselves from top to bottom as cultural service agencies rather than high-end entertainment companies."

The glimmers of good news to be found in the orchestra world are largely in those organizations that have taken responsibility to and engagement with the community to heart. The three groups cited here do so in differing ways, demonstrating a range of possibilities for community connection.

FEARLESS JOURNEYS

Fearless Journeys is a 2010 publication of the League of American Orchestras consisting of case studies of five successful U.S. orchestras. Two of them will be summarized here. A third, the St. Paul Chamber Orchestra, will be discussed in more detail below.

The **Los Angeles Philharmonic** has a history of innovation, focused on championing new music and young, energetic conductors. The opening of the Walt Disney Concert Hall in 2003 "provided a provocative new challenge for the orchestra. . . . It needed to make good on its vision of bringing music to the people . . . shunning the field's legacy of orchestras as status-driven elitist organizations and becoming an orchestra of the people and for the people." (17) To this end, "[t]he Philharmonic

makes a conscious effort to be universally present, participating in important community activities and listening to what is going on [It] has also redefined its educational programs as community-building projects" The Philharmonic's young, new Argentine conductor, Gustavo Dudamel, "sees the orchestra as a metaphor for community [and] has a very deep sense of social process and the importance of art and community." (20) Following this commitment to community engagement, "[t]he number of subscribers has risen from 18,000 . . . to 23,000 [from 2003-2010]. The orchestra regularly sells 90 percent of its tickets. It reaches 120,000 children through its education programs." (23)

The city of Memphis, Tennessee "has long faced problems of poverty, segregations, and racial tension." (26) Founded in 1952, by 2002 the **Memphis Symphony Orchestra** "was in serious trouble. . . . As the city became more and more racially diverse, the orchestra was challenged to make meaningful connections with the largest demographic of its populations–a population that cares deeply about music, but not the classical traditions of Western Europe." (27) The leadership of the MSO observed that

For years, the MSO had thought of its role in the community as one of providing community-related services, such as family concerts, in-school programs, and special performances. But although the MSO offered these services in earnest to enrich the landscape of the city, it was essentially a one-way street. The MSO did not know how to recreate itself in the image of its city–to be of Memphis in a way that truly engaged the community and made people care if the orchestra lived or died. In the end the MSO leadership decided to confront the indifference of the Memphis community boldly and with a new sense of civic activism. It would no longer be a passive onlooker but an active stakeholder and participant in the city's future. (27-28)

In 2003, in his first meeting the Memphis' mayor, Ryan Fleur, the then-new President and CEO of the MSO, "surprised everyone Instead of asking for help from the city, he asked the mayor how the orchestra could help him and the city of Memphis." (Emphasis added, 28) Taking that service mentality to strategic and programming decisions, the MSO has invested in community partnerships that help "the orchestra discover new audiences and patrons, and they are doing so because they are based on authentic engagements" (Emphasis added, 36) One of the principal lessons from this case study is that "The value of community partnerships is real. They promote innovation and learning, and they can be a healthy source of revenue." (37) "[T]he MSO now operates on a 'People-Service-Revenue' model: invest in the right people, deliver the right service, and revenue opportunities will become

available. Today, this principle guides all the organization's decision-making. . . . [T]he MSO does not believe that a traditional institutional formula–defined by performing concerts, selling tickets, and raising money–meets the community needs of 21ˢᵗ-century Memphis." (38)

Source: Tepavac, Lela. *Fearless Journeys: Innovation in Five American Orchestras*. NY: League of American Orchestras, 2010.

ST. PAUL CHAMBER ORCHESTRA

In its history of over fifty years, the **St. Paul Chamber Orchestra** has developed a reputation as "the little orchestra that could." Formed in 1959 as an alternative to the much larger and longer-established Minneapolis Symphony Orchestra (the MSO was already fifty years old), the SPCO from the beginning saw itself as a citizen of St. Paul. Today, the SPCO and the Minnesota Orchestra (formerly the MSO), serve "the only metropolitan area in America with two full-time . . . professional orchestras, offering more concerts per capita each year then anywhere else in the country." (14)

The SPCO is noted for its history of innovation in programming and in administrative structure. As will be shown, the Orchestra's approach to community engagement, while rooted in an historic commitment to community involvement, is currently based more upon venue selection and ticket pricing than on programming.

History of Community Engagement and Focus

From its inception, SPCO concerts were presented where the people were, so much so that early on the Orchestra adopted the motto: Music on the Move. Its three earliest initiatives were designed "to encourage the community's involvement with music: a new youth orchestra, a music-in-the-schools program, and an amateur community orchestra." (24)

By the early 1970's, the SPCO was leading in several important orchestral trends that embraced and enhanced its connections with the community. First, it adopted and expanded the concept of last-minute-rush tickets to broaden its audience base. This option was made available not just to students, but also to military personnel and senior citizens. And Music on the Move came to include a wide variety of "where the people are" activities: week-long residencies in communities and at colleges outside the Twin Cities, outdoor lunch-hour woodwind quintet performances called Sandwich Serenades, and an elaborate musicians-in-the-schools program. The tenure of Dennis Russell Davies as music director (1972-1980) marked an era of growth to prominence of the SPCO via touring and innovative programming that emphasized new music.

In 1980, world-renowned violinist Pinchas Zukerman became music director and solidified the SPCO's international reputation. His leadership instantly raised the Orchestra's visibility and Mr. Zukerman sought to enhance its reputation and increase its stature on the international music scene. He also was a leading force in the effort to build the Ordway Center for the Performing Arts and have it be the principal home for the Orchestra. In the end, however, the desire to perform larger works and to participate more in the international arena caused a shift in focus away from the SPCO's roots and generated a significant debt.

In 1986, the SPCO hired the Deborah Borda (now President and CEO of the Los Angeles Philharmonic) to be its President and Managing Director. During her brief tenure (she left for the Detroit Symphony in 1989) she initiated a shared artistic management structure that resonated with the Orchestra's non-hierarchical roots and laid the groundwork for later adaptation. Beginning in 1988, composer John Adams, early music expert Christopher Hogwood, and conductor Hugh Wolff shared conducting duties and the artistic direction of the Orchestra. A noble experiment, it was insufficiently focused to survive Borda's departure.

The end of the Zukerman era through the early 1990's was a difficult time for the SPCO. By 1993 the Orchestra had an accumulated debt of $1.6 million. At that point, the SPCO's long-standing commitment to community yielded practical dividends. During a thirty-five hour "Save Our SPCO" radiothon, three quarters of a million dollars was raised not from a few wealthy individuals but from 5,300 residents of the area, including one "50-cent donation from a child who loved music." (12) This demonstrated a level of support for the Orchestra that shocked all involved. Music director Hugh Wolff observed at the time, "Each of us . . . was made to realize that there was . . . a great level of support and concern and generosity in the community." (95)

In 1994 pop vocalist Bobby McFerrin was added to the artistic staff of the Orchestra. He developed an educational program called CONNECT (Chamber Orchestra's neighborhood Network of Education, Curriculum, and Teachers) that strengthened the SPCO's local reputation and brought in foundation and corporate support. McFerrin's fame and popularity also helped ticket sales, improving the bottom line even further. However, the Twentieth Century ended with the SPCO needing to make hard decisions about its relationship with the Ordway brought on by that facility's budgetary problems and to re-evaluate its role in Minnesota and the Twin Cities region.

Bruce Coppock became President and Managing Director of the Orchestra in 1999. Even though the shared artistic directorship of the late 1980's had not worked, Coppock became convinced that "the SPCO must . . . shift its artistic focus to 'the ensemble itself.' As he saw it, the orchestra had no choice but to move away from traditional 'hierarchical artistic and executive leadership models' and put more artistic 'power' in the hands of the musicians." (109) To do so he created a group of five artistic partners–all instrumentalists, composers, or conductors–to share music director responsibilities and two committees made up of musician and management personnel to oversee artistic vision (programming, touring, and recording) and artistic personnel (auditions, tenure, and musical personnel issues). (111) In addition, he believed that the solution to the Orchestra's outstanding venue issue lay not in expanded commitment to the Ordway but in reaffirming its role in the community.

Source: Kenney, David. *50 Years of Music: The Saint Paul Chamber Orchestra.* Minneapolis: Nodin Press, 2009.

Community Engagement Practices Today:
Infrastructure for Deepening Relationships

This background sets the stage to describe the current efforts of the SPCO to stake its claim as one of the most community-oriented orchestras in the country.

Management Structure

The artistic partnership team along with the artistic vision and artistic personnel committee structure (including musicians and administrative staff) mentioned above is rooted in a broader "artistic leadership model" that informs the SPCO's decision-making processes. Board chairman Lowell Noteboom says of this model, "The musicians here are now totally involved, probably more involved than in any other orchestra in the country." (*50 Years*: 111-112) While not eliminating labor strife, it has eased some transitions envisioned in the Orchestra's planning processes. In addition, it has provided experience in spreading programming decisions to a wider group, experience that could support expansion of community engagement work.

Venues

One result of the SPCO's 2002 Strategic Plan was the formation of a Venues Task Force. Through the preceding twenty years, the Orchestra had focused the bulk of its attention on performances at its principal venue, the Ordway Center. This focus had the effect of marginalizing performances at other locations. Realizing the Orchestra's

historic commitment to varied performing locations, Coppock felt that "being rooted in the neighborhoods and suburbs is part and parcel of the special connection SPCO has with the community. It's one of our core values." (*50 Years*: 114) In the end, strongly influenced by the Orchestra's Music on the Move heritage, the Task Force "concluded that a multiple-venue approach was an essential strategy for the SPCO to differentiate itself." (*Fearless Journeys*: 60)

Pricing

In September 2004 the SPCO formed a Business Model Task Force charged with answering the question "How can the SPCO sustain itself over the long term if its earned income ration remains where it is at less than 30 percent?" ("Radical Revenue": 21.) A central result of the Task Force's work was the realization, as Coppock put it, that "[I]f we came to think of ourselves as being in the concert production business, with ticket revenue as our core revenue, we severely limit potential income. However, if we think of ourselves as being in the patron-development business and think of producing concerts as our mission, new horizons appear." ("Radical Revenue": 23) In the research conducted as part of the Task Force's work, it was discovered that before the pricing change, buyers of the lowest price tickets were donors at the same percentage as higher priced ticket holders. The pricing structure as implemented was a radical departure from tradition—all SPCO tickets are now $10, $25, or $40. The new business model focuses on maximizing patron-generated revenue, without regard to whether that comes from ticket sales or contributed income. The experience has been that even $10 ticket buyers are willing to consider becoming donors as well.

The results have been impressive and widely reported in the symphony world. "Since the institution of this new pricing structure and subsequent aggressive expansion of neighborhood series concerts, our neighborhood series subscriber base has more than doubled, and our overall subscriber base has grown by over 35 percent. During this period, net patron revenue has increased by almost $500,000." ("Radical Revenue": 26) And, from 2005-2009 there was a 2.5-fold increase in the number of subscriber households. (*50 Years*: 15)

Service to audience patrons and the community forms the core of the SPCO's mission today. As Mr. Coppock said in 2008, "We exist in order to serve our communities with great musical experiences." ("Radical Revenue": 27) This commitment did not begin recently. And interestingly in the context of this book, it did not begin with a systemic reconsideration of its programming. It began with its original mission to be a community resource, present in the community. Its strategic approach to performance

venues and pricing structure will inevitably keep it community-focused. The results have proven that in purely practical terms community engagement is viable.

It remains to be seen what the next steps for the SPCO will be. The Orchestra now has deep experience in shared artistic decision making. This could serve as an excellent basis for deepening its community engagement via conversations about programming as suggested elsewhere in this book. Whether it chooses to do so or not, "the little orchestra that could" has demonstrated that a focus on community engagement can be the basis of a successful business model.

REFERENCES

Coppock, Bruce. "Radical Revenue," In *Symphony*. January/February 2008: 21-27.
Kenney, David. *50 Years of Music: The Saint Paul Chamber Orchestra.*
Minneapolis: Nodin Press, 2009.
Tepavac, Lela. *Fearless Journeys: Innovation in Five American Orchestras.*
NY: League of American Orchestras, 2010.

THEATRE:
PILLSBURY HOUSE THEATRE
(MINNEAPOLIS)

Theatre is the art that in the Western tradition has historically been closest to the people. This is both because of its reliance on the vernacular language and recognizable "cause and effect" plots and because of its ostracism from polite society, notably in England. Thus cut off from the patronage that supported music, dance, and the visual arts in the courts, the church, and the homes of the wealthy, it was forced to sustain itself through ticket sales and appeals to the masses. Thus were the Globe and the Rose born on the wrong side of the Thames.

The case study that follows is one of many theatres in the U.S. today that have taken the view that their role is to be a member and supporter of the community in which they exist. Pillsbury House Theatre in Minneapolis is a product of the social service tradition, the Settlement House movement that began in the Nineteenth Century. As such, its path toward community engagement comes from the opposite direction of all the previous case studies; and yet it has ended in the same place: committed to artistic excellence, committed to community. It is the story of an arts organization and a community organization that grew in tandem. It provides insights valuable not only for cross sector collaborations but also for the establishment of new entities that combine arts and community interests from the beginning. PHT also provides some practical lessons in how to connect with community constituencies in meaningful ways.

PILLSBURY HOUSE THEATRE: AN AUDIENCE OF ONE—BUILDING COMMUNITY FROM THE INSIDE OUT
by Noel Raymond, Pillsbury House Theatre and Denise Kulawik, Oneiros, LLC.

Pillsbury House Theatre is a professional Equity theater launched in 1992. As part of both Pillsbury House, a neighborhood center serving core-city neighborhoods of South Minneapolis, and Pillsbury United Communities, a large and respected human

"Art is what makes our communities special, exciting, and unique - from community celebrations like the MayDay Parade to private displays of art like garage murals and front and back yard art gardens. Community arts organizations, like Pillsbury House Theatre, provide a gathering place, help introduce young artists to their budding talent, and foster an environment that values art as integral to our beloved community."

Elizabeth Glidden, Council Member, Minneapolis 8th Ward

service agency, the Theatre upholds the tradition of the arts as part and parcel of the life of all communities and emphasizes developing diverse new voices and theatre artists. At this point in its history, Pillsbury House + Theatre: A Center for Creativity and Community, is emerging as a model for arts-based community development, especially in terms of integrating the arts and human services programming.

As a professional theatre operating within the context of (and subordinate to) a large human services agency with a mission of both social service and social change, Pillsbury House Theatre is a rare, hybrid organization. We do not simply approach "community building" as a way of building audiences. Rather, it is more accurate to say that we build audiences as a strategy toward our ultimate purpose of community building. is our hope that this case study chronicling the Theatre's founding, history, success, and current opportunities and challenges; its relationship with the Pillsbury House Neighborhood Center; its mission of community building as well as the major lessons its leadership has learned along the way will serve as a useful resource to arts organizations, human services organizations that develop and implement arts programming, and community and economic development organizations that use the arts to enhance their effectiveness.

MISE-EN-SCÈNE: MINNEAPOLIS AND THE CENTRAL AND POWDERHORN NEIGHBORHOODS

By any measure, Minneapolis and the Twin Cities Metropolitan Area have cultivated an enviable arts and cultural environment tailor-made for building arts organizations and audiences. One of the cultural centers of the Midwest, Minneapolis is relatively affluent compared to many other major metropolitan areas, boasts high educational attainment and literacy rates, and is home to numerous corporate headquarters and financial institutions, major institutions of higher learning, and nationally recognized flagship arts institutions such as the Guthrie Theater, the Minneapolis Institute of Arts, and the Walker Art Center, among others. Particularly relevant for this study, with the exception of New York City, Minneapolis supports more professional theatre companies per capita than any other metropolitan area in the U.S. It also benefits from the active engagement and support of major foundations such the McKnight, Bush, and Jerome Foundations, a dynamic and effective state-wide arts lobbying organization, Minnesota Citizens for the Arts, as well as significant public funding for the arts. As of 2011, Minnesota ranks first in the nation in terms of per capita state appropriations for the arts and total agency revenue. Minnesota is the only state in the nation, and the only governmental entity in the world, that, to our knowledge, has passed a constitutional amendment to create a "perpetual" funding mechanism for the arts through the levy of a small sales tax. The Minnesota State Arts Board is one of the most robust and effective state arts agencies in the nation and ranks second in the nation, behind only New York, in total dollar value of grants awarded.

In this seemingly idyllic context for arts organization and audience building, the neighborhoods of the 8th City Council Ward, in particular the Powderhorn and Central neighborhoods of South Minneapolis, stand in marked contrast, conforming neither to the statistical profile of the community as a whole, nor to the racial and cultural stereotypes that characterize Minnesota and the Twin Cities for those who do not live here. The Central-Powderhorn community is both economically disadvantaged and racially diverse–a far remove from the austere Lutheranism and Scandinavian culture for which the city and region are commonly known. Many Powderhorn-Central community members face a host of barriers to their own advancement including low educational attainment, unemployment, insufficient job skills, discrimination and racism, language barriers, the experience of personal and political trauma and violence, family instability, isolation, social dislocation, mental health issues, and drug abuse.

In the Central-Powderhorn area, poverty rates among its approximately 30,000 households hover in the range of 25-30 percent. According to most recent available census data, median household income is roughly $33,000–more than $10,000 less than the national median. In terms of diversity, just over half the population is of European descent. African, African-American, Latino, Asian, Native-American and multi-ethnic peoples comprise approximately 49 percent of the population. And, due to a legacy of work on the part of numerous international organizations based in the Twin Cities, there is a significant Somali community and other New Americans who now call the neighborhood home.

Latino and North African bodegas and soul food restaurants abound. Empty storefronts and dilapidated houses dot sections of Chicago Avenue, the main street running the neighborhood's North-South axis. Its major retail development, Midtown Global Market, provides space to take-out restaurants offering Middle-Eastern, Vietnamese, Caribbean and Latin American food and small vendors selling Native American goods and imports from Africa and Asia.

Lastly, many artists make their homes here, as they often do in low-income communities. In 2006, the office of Elizabeth Glidden, the Minneapolis City Council representative for the 8th Ward, conducted an artist-mapping project, identifying over 1,300 artists and arts organizations living in the district. The artists who live in the Powderhorn-Central neighborhood share some distinguishing characteristics. By and large, they are deeply engaged in community affairs. Individual artists serve on the boards of neighborhood associations, participate in voter registration drives and organize around issues of importance to the local community. By and large, Powderhorn-Central artists are invested in the idea that art is a powerful community

PILLSBURY HOUSE & THE SETTLEMENT HOUSE MOVEMENT

From its beginnings in the last third of the 19th century, leaders of the settlement house movement have understood the important role that artistic expression and engagement play in the development of the human being. As much as food and water sustains our bodies and academic study enlarges our capacity to understand, art nourishes our very souls.

We continue to believe that art and learning are as essential to the human experience as food and shelter and that the relegation of art to a "nice-but-not-necessary" category, especially for the urban poor, limits individual growth, the development of community, and societal health and well-being.

building tool and actively seek to engage their neighbors in collaborative art making and community building.

For example, since 1975, In the Heart of the Beast Puppet and Mask Theatre has spearheaded the MayDay parade and festival that culminates in what has become a large-scale community gathering in Powderhorn Park, drawing residents from throughout the Twin Cities. On a smaller scale, Artist Julian McFaul created the 'Art Sled Rally' to bring the community out in the winter months to celebrate the vitality and creativity of the neighborhood. A small grass roots effort initially, the rally now brings over 3,000 people to the park. More recently, in December of 2010, crime victims, activists, artists and neighborhood organizations came together to organize a candelight vigil at Powderhorn Park featuring art, song and ritual in a creative effort to "reclaim the park," and promote principles of restorative justice in response to a spate of violent crime committed in and around Powderhorn. The event was attended by hundreds of community members.

It is in this context that Pillsbury House Theatre was founded in 1992 and has evolved from a programmatic extension of Pillsbury House, a neighborhood community center, to a nationally recognized and respected professional Equity theatre with an annual audience of nearly 6,000 and community programs that reach an additional 5,000. The Theatre's audience includes a significant portion of people of color (50%), people under 35 years of age (38%), and people from economically disadvantaged neighborhoods (21%). Throughout its history, the Theatre has grown steadily from an annual budget of under $200,000 to an organization with annual expenses of just under $1 million.

Pillsbury House has managed this growth while focusing its energies on the development of new and risky work by diverse artists. The Theatre serves as the training

The arts are foundational to our work because we know this: the well-off in our city, state, and country consistently and systematically participate in and support the "arts." We know that they expose and engage their children in artistic expression and intellectual experiences, and where these opportunities do not exist, they go to extraordinary measures and cost to see that they do. They understand that art is essential to the human experience. To imagine that the urban poor can succeed without it is illogical and confounding.

- Tony Wagner, former President and CEO, Pillsbury United Communities

ground for numerous local artists who go on to make significant contributions to the field. Many artists, especially artists of color, have opportunities to hone their craft, develop new work, connect directly to audiences, and take artistic risks at Pillsbury House that they would not have elsewhere. For example, the Theatre's performance-art programs, Non-English Spoken Here: The Late Nite Series, and Naked Stages develop emerging, experimental, and interdisciplinary artists from diverse racial and cultural backgrounds. Late Nite provides an opportunity for local artists to connect and network with colleagues in New York City, a crucial opportunity for live performance artists. The Theatre's new play commissioning program is dedicated to outstanding writers of diverse racial and cultural backgrounds and challenging aesthetics such as Tracey Scott Wilson and Aditi Brennan Kapil. National artists such as Marion McClinton, Stephen DiMenna, James A. Williams, Laurie Carlos, and Daniel Alexander Jones regularly propose projects for the mainstage season that they feel are 'Pillsbury House Theatre plays.' Due to its success and growth during a time when many live performing arts organizations struggle with declining ticket sales, Pillsbury House is regularly consulted by theatres around the country on reaching out to and developing non-traditional audiences.

At this point in its history, Pillsbury House Theatre and Pillsbury House Neighborhood Center have integrated their management and operations into one organizational body. The blended organization, the Pillsbury House + Theatre (A Center for Creativity and Community), is now implementing a bold plan to serve as a "cultural community hub," with a vision to serve as a nexus and catalyst for community building, creative placemaking and neighborhood vitality in South Minneapolis. Ultimately, Pillsbury House + Theatre will act as a vibrant, buzzing hive of activity–a multi-service, multi-arts community hub, providing an environment that offers nurturance and support both for the personal growth of individuals as well as promoting community and economic development. The idea is to create a center that will sustain community members, enabling them to grow, learn, collaborate, pollinate and cross-pollinate ideas and projects, creating art, business and commercial opportunities, and creative solutions to pressing community challenges.

PROLOGUE: PILLSBURY HOUSE THEATRE AND
THE NEW SETTLEMENT WAY

In 1992, Ralph Remington, now the Theater and Musical Theater Director for the National Endowment for the Arts, and then a notable Twin Cities actor and teaching artist working with Pillsbury House Neighborhood Center, launched the

Pillsbury House Theatre-a professional arts organization with a mission to "provide a platform for marginalized people to have their muted voices heard." In 2000, the Theatre's mission was revised to "create challenging theatre to inspire choice, change and connection," a charge consistent with the broader mission of Pillsbury United Communities to "create choice, change and connection one person at a time."

Pillsbury United Communities (PUC) and Pillsbury House trace their roots to the settlement house movement, a progressive reformist movement beginning in the late 19th century that stressed social justice and social reform while providing services to impoverished communities. In fact, arts programming was always a part of the settlement house experience and was a part of Pillsbury House programming from its very beginning. Historically, all settlement houses used arts programming as a way to engage neighbors and preserve cultural traditions. The "Little Theatre" and community theatre movements in this country are thought to have come out of the Settlement House tradition and ultimately served as progenitors to the regional/resident theatre movement.

Pillsbury House Theatre evolved out of the gradual expansion of arts programming held at Pillsbury House. Over 26,000 residents of Minneapolis, the great majority from the Central-Powderhorn neighborhoods, look to Pillsbury House for bedrock services such as childcare, after-school programming, emergency assistance, and health and wellness programming including an alternative health center, support to homeless youth and other services.

Any person or organization that has worked for long on the serious issues that typically plague impoverished core-city neighborhoods knows that there is a maddening gestalt to the experience. Whether the context of the work at hand is economic and community development, education, public health, or human services, the same giant tangle of issues, a proverbial Gordion Knot, appears: poverty, low-educational attainment, joblessness, homelessness, language barriers, racism and discrimination, family instability and violence, gang activity, street violence, social isolation, poor health, and mental health issues-including emotional or psychiatric disorders coupled with alcohol and/or drug abuse.

The combinations of issues and challenges trace back, but never fully lead back, to the particular experience of unique individuals who create the community around them-whether for good or for ill. The persistent trauma of poverty-the contracted opportunities, isolation, discrimination, violence, and crime typically experienced by the impoverished members of low-income communities-wears away not only at the individual's hope and aspirations, but also the will to act on them, robbing individuals

"Both adults and kids can use the arts to access their inner beauty, to realize their basic human dignity and value, and to access the most important tool they carry with them–their imaginations. While this philosophical belief in the value of art was always part of the Settlement House ethos, in the early days of founding Pillsbury House Theatre, this concept was controversial. Internally, I had to sell the arts as a social service to my peers in order to justify using precious resources to create arts programming, while externally trying to distance the theatre from the idea of social services in order to gain credibility as an arts organization."

Ralph Remington

of a sense of self-efficacy and agency as well as the collective efficacy necessary to build positive social networks and community.

For those working on the ground in the core-city and who accept the practical challenge of helping nurture healthy individuals and build healthy communities out of the rubble of poverty, people are best understood as *whole individuals* with their own particular and unique personal stories and experiences, and best approached and *worked with* through long-term relationship building–one person at time.

Pillsbury United Communities has always operated and developed programming from a "whole-person" perspective. When the agency was founded in 1879, taking a "whole person" perspective meant focusing efforts on low-income women and children and offering services that included a day nursery that enabled mothers to go to work, a health clinic, industrial training, sewing classes, and arts programming that included a regular Friday night vaudeville show with admission fee of 5-to-10 cents, dance classes, a brass band, a children's chorus, and various singing societies. Pillsbury House settlement workers laboring

at the turn of the 19th century knew intuitively what contemporary research on the arts increasingly bears out: cultural development is essential for healthy community building–as essential to the human experience as food and shelter–and that the relegation of art to a "nice-but-not-necessary" category, especially for the urban poor, impedes both individual growth and community advancement.

In fact, art and art making provide the perfect vehicles for the development of both individuals and communities. Life is inherently creative. Our very bodies are inherently creative at systemic and cellular levels. The ability to use the same set of materials to generate matter and to sustainably weave together complex processes is imprinted in our very genes. Art making brings these processes to a conscious level, awakening a sense of possibility and an appreciation for complexity and interrelationships within any given community or social network. The arts, the performing arts, especially theatre arts, provide excellent vehicles for the process of nurturing individuals and empowering communities, accomplishing a number of key objectives necessary to the development of individuals and the process of community building:

- *They encourage self-awareness and self-understanding.* A sense of self, of one's feelings, boundaries, desires and intentions as well as the ability to self-reflect and self-assess are prerequisite to developing the self-control necessary for true efficacy and agency. Furthermore, as an art form, drama focuses on action, its causes and consequences, reinforcing the idea that personal choice and behavior not only create our own narratives, but also influence our communal destiny.

- *They encourage a sense of complexity and interdependence.* As a collaborative art form that demands interaction and relationship-building among collaborators, theatre encourages participants to see themselves in the context of their complex and interdependent relationships with others

- *They develop essential skills.* It is commonly known that theatre training aids in the development of literacy; however, its benefits extend far beyond basic skills. Theatre arts involve the entire body in learning, enabling individuals to integrate emotional, intellectual and somatic experience as well as gain presentational skills, providing a foundation for emotional intelligence and leadership development.

- *They engage creative faculties.* Theatre encourages creative thinking, visioning, and problem-solving in the context of the creation of new work–through writing, ensemble collaboration, staging and stage-craft. To see a blank stage, a blank canvass, or a blank page is to be presented with opportunities

and possibilities as well as being confronted with personal choices and responsibility for making the most of them.

- *They demand team building and collaboration.* As a fusional art form that includes dramatic literature, acting, dancing and choreography, stagecraft, and art and music, theatre demands the marshalling and organizing of many and diverse specialists and resources in order to mount productions.
- *They require storytelling.* The act of storytelling provides cathartic benefits, helping individuals explore and transcend challenging personal experiences.
- *They create civic space and opportunities for dialog, ritualizing communal experience.* In a secular, pluralistic society, safe space must be created where individuals of diverse beliefs can gather, in a meaningful and memorable way, to consider complex issues of life, morality and ethics.

These characteristics of art and theatre-making now serve as the foundation for the integration of Pillsbury House Theatre and Pillsbury House Neighborhood Center, the creation of our "cultural community hub," and the basis for a new, emerging model for arts-based community development.

The founding of Pillsbury House Theatre, its success and growth, and the reintegration of Pillsbury House and the Theatre into a single entity dedicated to community building and creative placemaking have never been foregone conclusions. This history has required volition, a constant evolution in thinking and a willingness to take significant risks. It has required programmatic choices and investments made by leaders of Pillsbury United Communities and Pillsbury House. Nevertheless, the story of Pillsbury House Theatre follows an unassailable logic that makes the organization inherently sensible, effective, sustainable and most importantly, compelling to those community members who look to Pillsbury House for support and act as its co-creators and collaborators.

ACT I. ACTIVIST ROOTS AND REDEFINING "COMMUNITY THEATRE."
The Politics of Funding

The founding of Pillsbury House Theatre was itself a feat of activism and advocacy. The Theatre's launch was made possible, in part, through funding from the Minnesota State Arts Board (MSAB). The grant represented a significant victory for the Powderhorn-Central neighborhood. Initially, Pillsbury House was precluded from receiving funding from the MSAB, determined merely by the fact that the Theatre was an operating unit of Pillsbury United Communities and did not have its own 501(c)(3) status. Ralph Remington challenged the MSAB policy as discriminatory, saying that it effectively

excluded low-income communities of color from receiving arts funding by virtue of the "non-professional" status of most of their cultural activities. Ralph Remington challenged the MSAB policy, saying that it effectively excluded low-income communities of color from receiving arts funding by virtue of the "non-professional" status of most of their cultural activities. Remington's challenge proved to be a watershed moment for diverse, low-income communities as well as the arts funding landscape in Minnesota, generally. In the end, the MSAB recognized the validity of Remington's position, opening up opportunities not only for Pillsbury House Theatre, but also for other arts organizations across the state operating in non-traditional contexts. The change in policy has been crucial to expanding arts access throughout Minnesota.

The lesson for arts advocates could not be clearer and mirrors some of the most important lessons we try to inculcate in our own community. Communities and institutions rarely change of their own accord and advocacy is not for the faint of heart. Among other things, leadership and advocacy require standing–often uncomfortably–in opposition to the status quo, as well as learning how to identify and capitalize on strategies, political levers, and opportunities to compel change. Fortunately, the arts themselves teach us how to do this. Reading contextual clues, interpreting the subtext underlying the nature of things and the ways of the world, and then portraying stories of how culture, ideas, relationships and situations affect individuals is our stock in trade. It has always been a goal of Pillsbury House Theatre to use these tools to effect change in the community. A few years after Ralph Remington left Pillsbury House Theatre, he ran for Minneapolis City Council and won a seat as the 10th Ward Council Member. He says of this transition that he "felt moved to take his political advocacy to the next level and try to effect change directly through policy making." His current role at the NEA represents an ideal blend of the passions he forged as founder of Pillsbury House Theatre.

Art Making in Collaboration with Community

In 1992, when Ralph Remington came to Pillsbury House to coordinate community rentals of the Center's theatre space and teach classes for kids and adults in the neighborhood, he immediately saw more possibilities in the performing space and began programming the space himself, producing the kind of provocative, edgy work for which the Theatre is now known. Within three years Remington was running what was initially known as, "The Center for Cultural Arts and Heritage," the programming for which included a mainstage season held in the main producing space, the afterschool youth program, a "mini-school" program for adolescents at high

risk for truancy and failure in school, and a day program for adults with developmental disabilities.

In 1995, Noël Raymond, an accomplished actress and recent MFA graduate from the University of Minnesota, who now serves as both the Co-Artistic Managing Director of Pillsbury House Theatre and the Co-Director of Pillsbury House, was hired through a grant to use theatre techniques to support low-income women in obtaining and maintaining employment. In 1996, three additional theatre artists were hired, and the name was officially changed from "The Center for Cultural Arts and Heritage," to Pillsbury House Theatre.

At this time, the Theatre started one key community program and resurrected another. Pillsbury House launched the Chicago Avenue Project, a theatre mentoring program that brings youth together with adult volunteer professional artists to create original theatre. Modeled after the 52nd Street Project in New York, the Chicago Avenue Project includes acting classes at inner-city community centers, an intensive playwriting class, a countryside writing retreat, two fully-staged productions each year, and ongoing arts outings. The Chicago Avenue Project was eventually installed as an ongoing program of the Theatre and in 2005 received the Coming Up Taller Award given by the President's Committee on the Arts and the Humanities. The Theatre also resumed one of its initial programs–Breaking Ice–a multi-racial, socio-political improvisational theatre program that develops performances and workshops for schools, corporations and community groups around social issues such as racism, homophobia, sexism, and domestic violence. Breaking Ice, an on-going program as of this writing, received the 2007 Leading Lights Diversity Award for significant achievements in promoting diversity and inclusion to affect social change through the performing arts from the National Multicultural Institute.

From 1996-1998, the Theatre explored separating from Pillsbury United Communities and moving out of Pillsbury House, primarily due to perceptual concerns. The Theatre's professional mainstage performances were hampered by the view that Pillsbury House was a "community theatre" rather than a professional theatre staging productions "for the community." Furthermore, the perception of the neighborhood as dangerous discouraged the general theatre-going audience from attending Pillsbury House Theatre productions. While partnership with the Pillsbury House Neighborhood Center continued, the Theatre focused on developing a separate identity in order to establish its professional credibility and reputation for high-quality work.

As the Theatre's reputation began to solidify, it convened an advisory committee in 1998 to improve organizational capacity and define strategies that would enable it to grow audiences and funding, expand programming, heighten visibility, and take a significant step toward long-term sustainability. Shortly thereafter Ralph Remington left to pursue his individual artistic goals and fulfill his political aspirations. Faye M. Price, a local actress and Dramaturg at the Guthrie was hired as a replacement, and a Co-Artistic Director structure was adopted, with Price and Raymond leading the theatre. Price brought to Pillsbury House strong connections with young, emerging, and diverse playwrights, advancing the Theatre's interest in developing new work.

Geol Weirs, at that time the arts program officer at the Dayton's Foundation, joined the Pillsbury House Theatre advisory group in 1999. At one point, Weirs made an observation that has had an impact on the Theatre's direction ever since. To Weirs, the identity of Pillsbury House Theatre was based on its position within Pillsbury United Communities; its settlement house history a huge asset and unique competency on which the Theatre needed to capitalize. This observation seems obvious in hindsight, especially in the context of this case study, but at the time, after many years of fighting for legitimacy in artistic and funding circles, Weirs' comment provided the Theatre's leadership with a significant "aha!" moment. Energies that had previously been spent in an effort to distance the Theatre from its relationship to the human services and community building mission of Pillsbury House were redirected into embracing the relationship.

This philosophical sea-change led to a strategic planning process in 2000 which, in turn, led to a new mission statement consistent with the newly revised mission of the larger organization, i.e., "To create challenging theatre to inspire choice, change and connection." The process also refocused PHT's programs on the settlement house tradition of working in partnership with the community. Committed to using the dynamic tension between its professional artistic and community aspirations and to reframing its identity as providing excellent professional theatre with and for the community, the Theatre provided Pillsbury House a unique opportunity to fulfill the Pillsbury United Communities mission and settlement house objectives.

The lessons to be learned here are the importance of intentionality and the ability to accommodate the tension between apparently disparate missions. Many organizations, especially organizations that encourage an entrepreneurial culture, find that programming has a way of growing organically, almost of its own accord to the point of unintentionally reengineering an organization. To a degree, the Theatre emerged from just such a process. Remington saw potential in the Pillsbury House

Neighborhood Center facility and began to develop programming accordingly. After a period of growth and success, however, the organization was faced with making intentional choices about the Theatre's future.

There were at least two reasonable alternative paths that Pillsbury House Theatre considered taking: spin-off as a separate arts organization dedicated solely to professional theatrical production, or take on a role as a "community theatre," providing artistic opportunities for amateur performers. Instead, leaders of Pillsbury House Theatre made the conscious decision to accept the challenge of working in a unique, hybrid form and to accept that doing so put them in a world where existing models for success did not transfer simply or easily. Nevertheless, this decision proved to be the reason for the Theatre's unique, current success.

ACT TWO: EXPANSION

In 2000, Pillsbury House Theatre entered a period of seven years of incremental growth, reputation building, and reconnecting with the community. The Theatre's community engagement strategy has always been a function of focusing on the programming itself, as opposed to targeted marketing strategies and techniques that are proven to "put butts in seats" in most conventional performing arts contexts. Instead, the Theatre chooses work by artists who reflect the diversity of the neighborhood and are telling stories that feel in some way germane or related to the experience of the people in the community.

Here are just a few examples that reflect the kind of repertoire that Pillsbury House Theatre stages every year: *Hot Comb: Brandin' One Mark of Oppression*, written and performed by Kimberly Joy Morgan about Black Women and their hair; *Broke-ology* by Nathan Louis Jackson about a low-income family struggling to deal with the compounding effect of illness and an aging parent; *No Child* by Nilaja Sun about the impact of NCLB legislation on low-income youth of color; *Angels in America: Parts One and Two*; and *Far Away* by Caryl Churchill exploring the psychosocial effects of war and large scale social issues on individuals and societies. For every mainstage show produced at Pillsbury House Theatre we partner with a community organization that has a mission connected to the themes explored in the show. This community partner then helps to connect the production to its constituents and co-facilitates post-performance dialogues. In return, Pillsbury House Theatre spotlights its organizational partners and their work to its audiences and the people who visit the Neighborhood Center.

There are, however, two particular "marketing and outreach" strategies that the Theatre has always embraced. The first is to offer "positive gateway experiences" in order to attract audiences that are otherwise disinclined to participate in the arts. The second is to create a "street presence" much in the same way that organizers raise awareness and mobilize a community around a given issue or cause.

Gateway Experience

There are two aspects of the "gateway" strategy that are particularly important. First, "gateway experience" is fundamental to the process of dispelling common, negative associations with 'high art' in the minds and hearts of community members (*i.e.*, that art is expensive, that it is just for the wealthy, that it is not reflective of diverse perspectives and experiences). Secondly, "gateway experience" is crucial to the process of helping people overcome internal obstacles to participation, especially their own lack of "familiarity" with the rituals of arts participation. For individuals new to a country, a community, a language, or a culture, acts such as making reservations, or being escorted to a seat by an usher can create anxiety and discomfort and a feeling of not belonging.

Pillsbury House Theatre has found that its community engagement programs such as the Chicago Avenue Project, Breaking Ice, and the Late Nite series (which invites the community to participate through a shared meal prior to each performance) provide excellent vehicles to introduce its constituents to the rituals that surround the participation in live performing arts, creating familiarity and encouraging confidence in the uninitiated that they can navigate the terrain of arts participation successfully and without embarrassment. Very often, especially with Chicago Avenue Project, youth and child participants become the "gateway" through which an entire family becomes involved in the arts. Our recent pilot project that animates human services programming with the arts (explained under The Pillsbury House Cultural Community Hub-A New Level of Integration) is a logical extension of this strategy to introduce individuals to arts participation in a way that is naturally integrated into their broader lives.

Presuming that a given program or production is well executed, an opportunity is created for repeat experience; however, content and quality are key. If the program or production is lacking in terms of either substance or execution, doors to deeper relationship building and repeat participation close quickly. No one should confuse new or non-traditional audiences with unthinking or unsophisticated consumers of art and performance. If anything, we have found that while new, "non-traditional"

audiences may be at first unfamiliar with the rituals of theatre-going and the critical nomenclature of the theatre, they are naturally well-attuned to the subtleties of symbol, metaphor, language and poetry as well as the psychological subtext and political context underpinning theatre works and performance.

Street Presence and Community Organizing

The Theatre often uses a community organizing approach, building relationships by finding groups and individuals with interests and affinities that intersect with thematic issues in a given production. Through a given play, the Theatre is able to start a relationship with a person, a family, an informal group or an organization.

One example of this strategy in action was the 2007 Pillsbury House presentation of the one-woman play *LOW* by Rha Goddess. Rha Goddess created *LOW* specifically to revolutionize how society in general, and especially the African-American community, deals with mental illness. While we saw the play as a compelling piece of theatre in its own right, we also recognized in it the potential to have a deep and significant social impact in our community by: 1) educating and raising awareness about issues of mental illness, especially in the context of communities of color; 2) opening up a suppressed subject and then creating a safe space for productive problem solving and making connections to resources through dialogues and forums; 3) inspiring individuals and groups to take positive action such as reaching out for personal aid and advocating for policies that address cultural inequities in the identification and treatment of mental illness, and 4) using the show as a catalyst to build a network of relationships with organizations, public institutions, and community members.

In order to catalyze this process, we created a slate of community engagement events in partnership with numerous Twin Cities organizations and individuals. These events included special performances for high school students; speaking engagements by Rha Goddess at the Northpoint Health and Wellness Center serving low-income people of color; post-performance dialogues co-facilitated with the National Alliance on Mental Illness of Minnesota; workshops taught by Rha Goddess for The YWCA Women's Wellness program and the Minnesota Spoken Word Association; and numerous connections with women's shelters, university departments and mental health associations to promote the show and encourage community dialogue. The *LOW* community engagement process was so successful that it has served as our model since that time. We know that it had a significant impact on the individuals who attended the production through direct audience feedback we gathered.

The production also generated a great deal of discussion in the local community about mental health and mental health policy. In fact, the Theatre was contacted by Congresswoman Michelle Bachman's office with regard to a reference to pending mental health legislation made during a post-show discussion that prompted calls to her office. The legislation, championed by MN senator Paul Wellstone, eventually passed in 2008 and was renamed the Paul Wellstone and Pete Domenici Mental Health Parity and Addiction Equity Act.

The Theatre's community engagement strategies worked very well through 2007. The audience grew steadily. Years of effort resulted in 80 percent audience capacity for mainstage performances over the 2006-2007 season. In addition, our gateway and outreach strategies helped us build and maintain significant increases in attendance by young people, people of color, and neighborhood residents. In 2004 and 2005, approximately 36 percent of the mainstage audience was comprised of people under 35 years of age. In 2006 this figure grew to nearly 40 percent. In 2004, 14 percent of the total mainstage audience identified themselves as people of color, compared to 46 percent in 2005 and 53 percent for 2006. In 2004 we worked specifically to increase attendance among people who live in the low-income neighborhoods surrounding the theatre. In that year we were able to increase attendance from an average of 8 percent to 25 percent, and through continued focus, we maintained a 20 percent level in 2005 and 16 percent overall for 2006. (The total number of individuals attending from the neighborhood continues to rise, but as the total audience grows, the percentage of neighborhood patrons is shrinking slightly.)

During this period, the reach and success of our community engagement programs also expanded considerably. For example, contract revenues from Breaking Ice grew over 300 percent, from roughly $60,000 per year for Breaking Ice performances to $200,000 in 2006. The Chicago Avenue Project also grew. The program doubled the number of classes, added performances to each showcase production and necessitated the creation of a Director's position for the program.

ACT III: CRISIS AND OPPORTUNITY

In 2008, the Pillsbury House Neighborhood Center entered a critical juncture in its organizational development. Pillsbury United Communities and Pillsbury House had long been viewed as leaders in the delivery of human services programming. Pillsbury House Theatre's artistic work had already achieved tremendous success locally, regionally, and nationally. Furthermore, the Theatre had grown steadily over the 17 years that it had been in operation. In 2008, in great part due to the effects of

the economic crisis, Pillsbury House Neighborhood Center reached an institutional plateau resulting from diminishing program fees for human services, a reduction in United Way support, and lowered ticket revenues from Theatre performances. Neighborhood Center leaders scrambled to respond to a quickly changing funding landscape and new operating realities.

Leadership for both the Neighborhood Center and the Theatre were consolidated under the Theatre's Co-Artistic Directors, Noel Raymond and Faye Price, who had many years of experience as senior managers within the organizational structure and culture of Pillsbury United Communities. It would have been possible for Raymond and Price to respond in a conventional manner to the economic crisis merely by reducing costs through downsizing staff and programs and decreasing services to the community, but again, as organizational leaders, they chose a different path. Raymond and Price became inspired by the work of Susan Seifert and Mark Stern at the Social Impact of the Arts Project, and especially their presentation of a new model for a 'Neighborhood Based Creative Economy.'

The University of Pennsylvania researchers had posited that community cultural organizations created social networks, which in turn enhanced diversity and community capacity. Research further suggested that "cultural clusters" or "geographic concentrations of inter-connected companies and their associated suppliers in a given field," facilitated social engagement and the cross-pollination of ideas that lead to innovation. Most importantly, this approach had been shown to stimulate community building and economic development without the negative consequences common to other forms of culture-based revitalization, such as social dislocation and the acceleration of economic inequality.

Raymond and Price immediately recognized that Pillsbury House and Pillsbury House Theatre were in an ideal position to serve as a "cultural community hub," anchoring a 'cultural creative cluster' for a number of reasons:

- The breadth of programming and the diversity of program participants had already started to produce new programming ideas and new investment into the organization.
- The Theatre had already started to develop a network of "internally anchored" partnerships, such as its relationships with Upstream Arts, an arts organization that serves youth with disabilities, and the Pillsbury House Integrated Health Clinic. These partnerships were starting to establish the Center as a place for collaboration.
- Partnerships and associations that Pillsbury House Theatre had been involved

in were bringing local artists together to collaborate and share resources. For example, Pillsbury House Theatre was a founding member of South Minneapolis Arts Business Association (SMARTS), the first arts business association in the city of Minneapolis.

- Human and social services offered at Pillsbury House had created crossover to multiple organizations, connections that would not have existed for stand-alone arts organizations. The potential to infuse arts into traditional human and health services and to use arts as the catalyst for transformation was tremendous, as was the potential for helping community members discover the artists in themselves.

- The Center was in an ideal position to facilitate multiple mergers and partnerships and to create new ways to share resources-this was the Neighborhood Center's history and the way that it already operated.

THE PILLSBURY HOUSE CULTURAL COMMUNITY HUB– A NEW LEVEL OF INTEGRATION

In 2009, through its Regional Arts Development Program, the Bush Foundation granted Pillsbury House Theatre a 5-year grant of $500,000 to support an organizational planning process and transition to a Cultural Community Hub–with the goal of serving as a catalyst for arts-based community development in the Central-Powderhorn neighborhoods of South Minneapolis. Price and Raymond immediately enlisted the help of William Cleveland, Director of the Center for the Study of Art and Community, and a thought-leader in the area of arts-based community development. With Cleveland's support and ongoing consultation, Price and Raymond set about reengineering the Theatre and the Pillsbury House Neighborhood Center into a 'cultural community hub'.

While the basic pieces for serving as a 'cultural community hub' were in place, the organization's goals as well as programming and operating model needed to be established. For its first 17 years, Pillsbury House and Pillsbury House Theatre had operated side-by-side, benefitting from resource sharing and a degree of shared community outreach. Nevertheless, their organizational goals, program planning, and implementation had remained fundamentally separate. The new organization was more than the sum of two separate parts. It required genuine integration and a sensible alignment of goals and functions.

Furthermore, Pillsbury House had to be realistic about its expertise, credibility, and the best focus for its efforts. Pillsbury House most certainly had never operated

as an economic development organization, nor does it today. Its goals are to stimulate community building and the "creative economy" of South Minneapolis. But it has never assessed its success by virtue of business starts, job creation, or the effectiveness of job training programs. Instead, looking at its particular and unique expertise, Pillsbury House leadership understood that the particular value of its service and that of Pillsbury House Theatre rested in the relationship between the arts and "individual agency," "social cohesion," and "community building." The new organizational model animates all human and health services programming through the arts. The arts are now the defining characteristic of our human and health services, informing their delivery and enhancing their effectiveness-regardless of whether the goals of a given program are school readiness, educational performance, parenting skills, leadership development, public health outreach, goal setting, or interpersonal skills.

Healthy communities are not necessarily perfect communities, or even communities that have "arrived" at a particular destination in terms of income level or educational attainment. The challenges facing South Minneapolis may never be "solved" in some final sense. It is very likely that the neighborhoods we serve will always lag behind other neighborhoods relative to income as well as standard indicators of community health and wellness. What Pillsbury House could aspire to, however, was perhaps even more important. It could, with speed and immediacy, create an environment, a context in which individuals within the community could be supported to make the best possible choices for themselves regardless of the often overwhelming challenges and obstacles they faced. Pillsbury House could help create an environment that encouraged individuals to develop agency regardless of their external circumstances. It could provide the community with a safe space within which members could develop their minds and bodies. It could, regardless of circumstance, help community members build meaningful lives marked by intelligence, grace, realistic optimism, empathy, compassion, and a desire to serve-all qualities that participation in the arts helps develop. Finally, it could encourage individuals to tap into their own creativity in order to generate opportunities for themselves as well as solutions to community challenges.

The kernel and building block of Pillsbury House's identity and the logic of its programming thus became the integration of the arts with human services for the purpose of the psychosocial development of individuals. Starting at the point of the individual, the Pillsbury House Cultural Community Hub then works outward, serving as a nexus for community building-sometimes taking a central role in whatever

neighborhood project may be on the table for consideration, sometimes simply providing a point of connection or introduction to potential community partners.

In the new model there is not simply a reciprocal relationship between theatre programs and human services and health programs but an integrated relationship. Within the new model, human services and health programs are a primary gateway through which individuals access the theatre. The theatre serves not only as an end in itself, an exemplar of artistic excellence, and a programming center but also as a catalyst that creates opportunities for personal advancement and the social cohesion necessary for community change.

Pillsbury House + Theatre also works to overcome barriers to arts participation among individuals who have not traditionally participated in the arts. Through their involvement in human services programs, such as childcare, out-of-school programs, parenting programs and others, community members are introduced to the arts in a way that does not separate the "arts experience" from the other services the individual requires, so barriers to arts participation–such as perception about the likely value or relevance of the arts to their lives, self-consciousness about whether or not they are capable of participating, or economic choices about whether or not they can afford to participate–are removed. Experience has shown us that once introduced to the arts, participants develop positive associations and greater self-confidence, as well as assign greater value and priority to the arts, paving the way for repeated, intentional experience and increasing the individual's frequency of participation. Increasing participation is crucial to achieving significant long-term benefits.

The new Cultural Community Hub represents a markedly different kind of organization a hybrid organization with a unique approach toward community building. To our knowledge, the systematic effort to integrate arts into the design and delivery of human and health services has never before been attempted in the United States. While there is a long tradition in the Americas, Europe, and globally in the use of the arts in educational, healthcare, and psychotherapeutic contexts, framing, defining, and developing health and human services programming (especially in the context of community revitalization goals) and using the arts as the core methodological driver of such programming is new. By way of example, the distinction lies in the difference between an afterschool program that may include painting and music as part of its scheduled activities and an afterschool program in which the design, goals, staffing, primary activities, and evaluation are built around the arts as a core element of an interdisciplinary approach to program delivery.

For this reason, the Pillsbury House Cultural Community Hub is being looked upon as a potentially powerful new model for arts-based community development and has started to gain the attention of city officials, local and state funders such as the Bush, McKnight and Kresge Foundations, the Minnesota State Arts Board, the Theatre Communications Group, and national thought leaders including Bill Cleveland, and Erik Takeshita, Senior Program Officer at the Twin Cities Local Initiatives Support Corporation (LISC).

As of 2011, we have had an opportunity to pilot our arts integration process with more than half of our social service programs. The next five-year period will serve as laboratory for testing our new integrated and interdisciplinary approach. The challenges are numerous and include:

- **Programming Replication**: The arts are embedded in all programs as foundational strategies. This approach requires dedicated interdisciplinary teams of artists and social services staff who work in constant partnership. It also requires the creation and organization-wide adoption of a critical nomenclature that enables the organization to create, implement and evaluate programming in a nimble, consistent, and meaningful way. For example, at this writing, we are working to create a parallel educational track for parents whose children participate in arts programming at Pillsbury House. The goals are to give parents tools to reinforce their children's learning process as well as to develop their own creativity and enhance their relationships with their children.

- **Programming Expansion and Community Outreach**: To date, our pilot has focused on core programming that happens on-site at the Neighborhood Center; however, if the concept of the 'cultural community hub' is to achieve its potential, the goal is to encourage arts creation in informal contexts well beyond our organizational control. For example, we are now working on street outreach programs with youth, home visiting, and integrating the arts into our health clinic programming. Strategies now under development include street-corner poetry slams, arts activities that are packaged for parents to do with their children in their homes, and play readings during clinic hours for patients waiting for services.

- **Evaluation and Organizational Management**: We realized during the planning of the 'cultural community hub' that experimentation, evaluation, and the ability to adapt programming and organizational strategy in light of evaluation data would be critical to organizational success moving forward.

We invest significant money, time, and resources in developing evaluation systems and methods for collecting and analyzing the data in real-time. We are working with professional evaluator Mary Ellen Murphy developing metrics and establishing baseline data by which we can measure progress. The challenge in this process remains the inherent problem of defining and measuring personal and community transformation. In essence, the challenge is in determining what change looks like and how long it should take.

- **Staff Development and Training**: The work we undertake requires interdisciplinary thinking and collaboration. It also requires staff to be nimble and flexible, able to adapt on the fly to emerging community needs and new programming opportunities. These requirements place significant demands on both artists and human services staff who do not necessarily or easily speak each other's languages. Identifying a set of core competencies and ensuring that staff are trained and encouraged to develop their skills is essential to our long-term sustainability. In the fall of 2010, during the course of the 'cultural community hub' pilot project, Pillsbury House created a Cultural Community Hub Institute (CCHI) in which teams of resident teaching artists and human services staff along with Pillsbury House Co-Directors Price and Raymond; Program Evaluator Mary Ellen Murphy; and Consultant Cleveland and his colleagues Erik Takeshita and Harry Waters, Jr. gathered regularly to plan, implement and evaluate programming. The CCHI now serves not only as a primary managerial instrument but also as the place in which core competencies and organizational training needs are identified and delivered.

- **Infrastructure**: The Pillsbury House Neighborhood Center building is over 30-years old and does not project the image of creative vigor that we have for either the 'cultural community hub' or the neighborhood. Absent a sufficient base of philanthropic support to mount a significant capital campaign for a new facility, we are working in partnership with Natasha Pestich a professor at the Minneapolis College of Art and Design, to implement a community process to redesign and transform the space.

- **The New Normal**: Assaults on funding and the tendency of funders to support only one aspect of an issue-be it early childhood education, truancy, youth development, or health care-carves up what we know to be an interdependent human services system. This creation of funding silos in

turn leads to lack of coordination of services among peer organizations and sometimes supplants cooperation with competition.

- **Urgency**: We feel tremendous urgency around our change process; but innovation requires time, the "luxury" of experimentation and freedom from the tyranny of the "immediately doable." Our goal is to reach a threshold where some percentage of employee time can be devoted to projects outside the scope of their regular responsibilities, providing them the freedom to explore and experiment.

KEY LESSONS

As a hybrid organization with a unique mission, the lessons learned at Pillsbury House + Theatre could be useful in any number of contexts-from arts organizations, to human services organizations that run arts programming, to economic and community development, organizing and advocacy organizations searching for ways to capitalize on the arts for greater organizational effectiveness and visibility.

Summarizing nearly two decades of experience in organization and community building, key lessons that we take from our past and into the future are:

Improvisation. There are times when organizations grow organically by seizing opportunities that arise in the moment. The founding of Pillsbury House Theatre was just such a process, its organizational sustainability built upon incremental programming successes and growth over time. It did not require immediate and grand plans or huge stores of philanthropic capital. Even today, our fundamental operating goal is to behave as an organization that can improvise constantly-capitalizing on opportunities as they come, rather than forcing the creation of programming that either does not fit our community or our capacity for investment. We have, however, grown increasingly sophisticated in our approach to improvisation. Now, more than ever, our programming efforts and experiments are informed by evaluation, a fundamental part of keeping the organization engaged and vibrant.

Intentionality. While improvisation keeps leadership "present-centered," organizations also require intentionality at key decision points. These watershed moments often appear either as a conflict, an intransigent obstacle, or even a crisis. Our history has been no different. In these moments, we were able to chart new ground as an organization with no clear model by undertaking the hard and brave work of organizational assessment,

identifying fundamental organizational conflicts of identity and mission, and resolving them in creative, yet sensible ways.

Quality. While, increasingly, we hear about the need for arts participation independent of any considerations of quality, our experience tells us that the quality of the art created and the overall experience is key to organizational effectiveness. Furthermore, working with underserved communities makes the emphasis on quality of even greater importance.

Advocacy. As an arts organization that is engaged in community building, we are advocates-for our community and for the arts. At different points in time, playing the role of advocate has not necessarily been a comfortable experience; however, it is essential to our mission in the community. We do not shy away from difficult positions or difficult work. As our own expertise as advocates has grown, we have become better able to pass on these skills to our constituents, helping cultivate new community leaders.

Investment. All organizations must invest in themselves if they are to flourish, but the question of what to invest in is ever present. At Pillsbury House + Theatre, we place an emphasis on investing in continuing education and professional development, organizational evaluation, and intellectual and creative capital. For example, our emergence as a 'cultural community hub' has succeeded in attracting significant new interest from major foundations. This interest on the part of donors has followed from intensive efforts on our part to understand major advances in the field of arts-based community development and to take the necessary steps to model ourselves with the latest thinking and best practices in mind. Furthermore, now that we have truly adopted a new operating model, we are making continual investments into the development of personnel so that they are able to function within our new normal. As we build the organization and institute a stronger development program, it is our goal to make commensurate investments in physical infrastructure. Nevertheless, investment in intangible assets will remain our priority.

Integration. Programming at Pillsbury House + Theatre does not sit in independent silos. Rather, all programming, whether sitting (ostensibly) in the area of health and human services or the arts, integrates strategies and goals of all of these fields. Creating theatre is part of a larger mission to integrate individuals into the community and build social capital. This focus echoes back to our roots as part of the settlement house tradition.

With the integration of Pillsbury House and Pillsbury House Theatre, there is a recommitment to this idea. Our theory of community change is that participation in and experience of art encourages and stimulates creativity in and among individuals, which then ripples out to the larger community.

Audience Development. Developing audiences, both in terms of audience demographics and size, has been a natural result of our community engagement strategies rather than a focus of traditional marketing efforts. Our audience building success owes more to strategies gleaned from the fields of community organizing and human services than arts marketing. Building an audience to attend the theatre is not really the goal. Rather, we encourage people to participate in theatre in order to stimulate community building. Figuring out how to eliminate barriers and increase participation in arts programming is a basic function of all segments of the organization because all segments of the organization are engaged in arts programming.

A Brief Overview of Community Arts Practice: Outside the Mainstream

A BRIEF OVERVIEW OF COMMUNITY ARTS PRACTICE:
OUTSIDE THE MAINSTREAM

Concern for community engagement and the arts is nothing new, even if we discount the community-around-the-campfire history of arts development. Art always has and always will be central to a culture. It is important to know that intentional application of the arts to community issues and concern with the establishment of deep connections between members of the broad community and the arts have been commonplace in U.S. history.

The following two articles provide context, establish that "nothing is new under the sun," and provide examples and lessons for effective community engagement based on the experience of those who have gone before. It is important to include these perspectives in this book because, for much of the arts establishment, this history is unknown, these examples invisible. That is why much community engagement work can, with justification, be described as taking place "under the radar." It often exists and is created by institutions and individuals who work outside of the arts mainstream. The examples cited in these two chapters can inspire new work and give hope to those embarking on it.

Maryo Gard Ewell goes back over a century in her review of urban and rural approaches to and support for arts-based community development–a descriptor sometimes used to categorize elements of community engagement work in the arts. (There is much more that could be said, in the years she covers and going back even further, but that must be a separate book.) She points out the "Boston 1915" super-committee charged with addressing "conditions of public health, religion, business, labor, immigration, parks, education, prisons, and more." One of the committee's principal vehicles for doing so was the production of a pageant, "Cave Life to City Life." It presented "findings and issues of the many committees [in] a grand, engaging show. [It] involved, literally, hundreds of ordinary people, bound by the organizers' beliefs that working together on the show would lead to intergroup communication, a better understanding of collective issues and a new commitment to working together to solve them." Ewell also points out the establishment of an artist-in-residence program in the University of Wisconsin's College of Agriculture (!) in 1936. This is indeed thrilling history for us in the arts.

William Cleveland takes up the history in the tumult of the 1960's and discusses how the work has evolved in recent years. He also provides valuable insight into techniques and approaches that work well (or that do not), insight that can save new ventures time and trouble.

278

HISTORY OF COMMUNITY ARTS

ARTS-BASED COMMUNITY DEVELOPMENT: WHERE DID WE COME FROM?
by Maryo Gard Ewell

"History does not refer merely, or even principally . . . to the past. On the contrary, the great force of history comes from the fact that we carry it within us, are unconsciously controlled by it in many ways, and history is literally present in all that we do. It could scarcely be otherwise, since it is to history that we owe our frames of reference, our identities and our aspirations."[1]

CONTEXT

My mother taught grammar, and my father and my husband are writers, so I've always paid attention to words, definitions and meanings. In 1992, I wrote an article in which I suggested eleven different meanings and usages for the term "community arts."[2] Each is valid, but they are very different. For some people, "community arts" is synonymous with "amateur" arts; for other people, it refers to arts-based community development, as Bill Cleveland will describe the term in the next chapter.

And then there are prepositions. Take "for," "of," "by," and "with," for instance, often used carelessly and, in arts administration, too often interchangeably. Art *of* a people refers to shared cultural expressions–"that show truly captures the history, the spirit, of Colquitt, Georgia." Art *by* a group refers to performance or execution–"the mural was done by a group of fourth graders" or "that performance of *Taming of the Shrew* was done by a group from Monroe, Wisconsin." Art *with* people refers to cooperation or collaboration–"the performance was made possible with help from resident artist Susan Smith" or "the Gunnison Art Guild worked with the kids from 4-H to create this exhibit." Art "for" people refers to an offering, or to outreach–"the first performance was for seniors at the Meals on Wheels center" or "they did the show for the residents of Third Ward."

And then, most subtle of all, is the context which assigns meaning. People with very different world-views may both use a phrase like "The arts are for everyone," yet mean quite different things. Here is a fine example:

Meaning #1: John D. Rockefeller, 3rd chaired a seminal panel[3] on the performing arts in the 1960's. Michael Straight quotes the credo of the panel in Rockefeller's introduction to the report: "The arts are not for a privileged few but the many..." but then Straight says:

> "On the other hand, he and the panel feared that government support would in time lead to the substitution of mediocrity for excellence in the performing arts. It was a latter-day expression of the Edwardian view, expressed in noble terms by Herbert Croly in *The Promise of American Life.* Croly held in essence that democracy was a fine idea; too fine to be left to the people as he found them. . . . In that same spirit the Rockefeller Panel held that the arts were 'for the many' but could not be entrusted to the many."[4]

Meaning #2: Robert E. Gard of Wisconsin was writing about arts development in the 1960's as well. His world-view was quite different, although he, too, believed that the "arts are for everyone." Contrast this with the perspective above:

> "In terms of American democracy, the arts are for everyone. . . . As America emerges into a different understanding of her strength, it becomes clear that her strength is in the people and in the places where the people live. The people, if shown the way, can create art in and of themselves."[5]

On the one hand, the people are given access to works of art, presumably in order to appreciate them, learn about them, perhaps to be influenced or changed by them. I think of this as art *for* the people. This is quite different from the second perspective- art *of, with* and *by* people-in which the people can be the creators of art as a part of the process of deepening democracy.

The perspective of the Rockefeller panel, of art *for* people, is an important one, but because it's in large part a perspective of organizations and of gifted professional artists, it tends to be reasonably well documented. The other perspective is equally important, but harder to research, for it often appears within stories about grassroots community development movements or about non-arts institutions (such as Settlement Houses or the federal Extension Service, described later in this chapter). Linda Burnham and Steve Durland said:

> "There is a space opening in the public imagination where people can visualize reaching out to the arts to help them attain a goal-whether they simply want to participate locally in vigorous artmaking, or they articulate a more pointed social need: to research a community's past, to brand a community identity, to heal the local river, to find something productive for kids to do after school, to reduce crime in a neighborhood, to transform an empty lot,

or to help an economically stressed community inventory its assets and come up with a product or service they can market for themselves."[6]

Elsewhere, Durland observes that often this work is not addressed in art-critical terms, but rather, in social and political terms.[7] And, sadly, Art in the Public Interest's Community Arts Network, which had invited and collected writings on arts of, with, and by people, ceased to exist as an active site when funding was lost.[8]

Still, the history and the stories are there. My library and filing cabinets bulge with just a tiny bit of what exists. The stories go back decades–even centuries–depending on what thread you're unraveling.

In the following chapter, Bill Cleveland includes definitions of many terms inherent in his concept of "community-based arts development." Integral to the definitions are core foundational values. For instance, he defines community development in general: "a set of values and practices which play a special role in overcoming poverty and disadvantage, knitting society together at the grass roots and deepening democracy." He defines arts-based community development: "community-based arts activities that equitably and sustainably advance human dignity, health and productivity; that educate and inform us about ourselves and the world; inspire and mobilize individuals or groups; nurture and heal people and/or communities; build and improve community capacity and/or infrastructure."

It's worth foreshadowing Cleveland's definitions here. Vital, in fact. For in addition to speaking an aesthetic *language* that synthesizes process/product, that synthesizes meaning/technique, practitioners of arts-based community development share core *values*: they believe in the worth, dignity, and voice of all people; and they believe in the importance of a decent and meaningful collective life.

Who are some of the people who have paved our way during the last century, whom we can claim as ancestors for this language and these values, and from whom we can draw inspiration? Let's meet a few of them, ask them to walk with us and give our work their blessing.

EARLY TWENTIETH CENTURY: URBAN

The start of the 20th century was a time of great social ferment. W.E.B. DuBois was writing about race and the many facets of segregation and cultural liberation, beginning in 1903 with *The Souls of Black Folk*. He said that "the beauty of truth and freedom which shall some day be our heritage and the heritage of all civilized men is not in our hands yet and that we ourselves must not fail to realize."

But later in that same speech DuBois says,

> "We must come to the place where the work of art when it appears is reviewed and acclaimed by our own free and unfettered judgment. And we are going to have a real and valuable and eternal judgment only as we make ourselves free of mind, proud of body and just of soul to all men.
>
> "And then do you know what will be said? It is already saying. Just as soon as true art emerges; just as soon as the black artist appears, someone touches the race on the shoulder and says, 'He did that because he was an American, not because he was a Negro. . . . He is just human; it is the kind of thing you ought to expect."[9]

Indeed, scholar Cornel West believes that DuBois found art essential for intercultural dialogue, creating "an atmosphere and context so conversation can flow back and forth and we can be influenced by each other."[10] At the same time, the Settlement House movement was underway; at a place like Hull House in Chicago, new European immigrants could take night classes and could learn about their new culture, while staying attuned to their old. Jane Addams describes putting rooms with musical instruments at the disposal of families so that music from home could be remembered and passed on to the next generation. At the same time, there was an art gallery, a crafts school, a theater, a music program (the National Guild of Community Schools of the Arts claims Jane Addams as their progenitor), and there one might find both "high art" events as well as topical or culturally-specific exhibits and shows. Indeed, Addams felt that–in the spirit of W.E.B. DuBois–the arts could help transcend cultural barriers; she describes showcasing Negro music, drama, poetry, and art as a way of addressing racial animosity.[11] [Editor's note: The preceding chapter on the Pillsbury House Theatre documents a legacy of the Settlement House movement.]

Pageantry grew with the Progressive movement of social reform, and–alongside the National Child Labor Committee, the National Association for the Advancement of Colored People, or the Playground Association of America–the American Pageant Association was founded in 1913, with an aim of reforming the arts as well as improving American life. To many of us in the 21st century, the word "pageant" connotes superficial spectacle; not so, a hundred years ago. The choreographers, musicians, and playwrights of the movement felt that in capturing the meaning of a place through drama, in engaging masses of people to tell the stories of their pasts and aspirations for their futures, they were creating a new, powerful movement in contemporary art, creating an "expanded role for art in modern society, in contrast to the conservative genteel ideal of elite cultural leadership."[12]

282

The members of the APA agreed "that pageant productions could be a powerful force for change in American life and they believed in pageants of quality," uniting art and democracy, "mobilizing citizens for various tasks and encouraging them to participate in a secular community ritual."[13] A paper presented at a sociology conference in 1914 was entitled "Municipal Pageants as Destroyers of Race Prejudice." Although the focus of that paper was primarily on prejudice towards new European immigrant groups,[14] in 1925 W.E.B. DuBois urged the people of Los Angeles to attend "The Star of Ethiopia," a grand pageant about "the history, real and legendary of the Negro race"[15] with an African-American cast.

In Boston in 1909 an introspective process was underway. Committees studied conditions of public health, religion, business, labor, immigration, parks, education, prisons, and more. Representatives of each committee sat on the "Boston 1915" super-committee whose goal was to find a way to institute significant improvements by 1915. The Boston 1915 committee decided that a pageant could be key to the process, and they contracted with a young playwright, Percy MacKaye, to coordinate the effort, synthesizing findings and issues of the many committees into a grand, engaging show. "Cave Life To City Life" involved, literally, hundreds of ordinary people, bound by the organizers' beliefs that working together on the show would lead to intergroup communication, a better understanding of collective issues, and a new commitment to working together to solve them. "Indeed, middle-class young people from the Curry School of Expression performed as Dust Clouds and Disease Germs alongside immigrants from Hale House, who depicted Flames. . . . The Boston Teachers' Club dramatized The City of the Future. . . . One reviewer wrote about the pageant, 'Commonwealth Avenue and Beacon Street met with the North and West End.'"[16]

MacKaye was also invited to do a pageant in St. Louis in 1914. The number of participants of "The Masque of St. Louis" was staggering, although they were primarily people of European-American descent despite the relatively large African-American population in the city. Participants included a 100-piece orchestra, a 500-voice chorus, a total cast of 7,000, and there was outdoor seating for 43,000. This pageant was coupled with a national Conference of Cities; the largest city in each state was invited to send an envoy who represented "the best things in the progress and development of [that] city;" moreover, "the representative should also be able to take part in the drama himself, to appear to advantage on horseback."[17] The conference, whose theme was the democratization of art in city life, addressed topics from "Folk Dancing in America" to "People's Orchestra" to "Municipal Recreation: A School of Democracy" to "Humanizing City Government."

Perhaps the big idea of pageantry can most clearly be summarized by three successive chapter titles of Glassberg's *American Historical Pageantry*: "The Place Is the Hero." "Community Development Is the Plot." "To Explain the City to Itself."

Or, more poetically, it is summarized by playwright Percy MacKaye: pageantry reflects "the half-desire of the people not merely to remain receptive to a popular art created by specialists, but to take part themselves in creating it; the desire, that is, of democracy consistently to seek expression through a drama and the people, not merely *for* the people."[18]

EARLY TWENTIETH CENTURY: RURAL

And what was happening in rural areas? Pageantry was not strictly an urban phenomenon. In 1914, "The Social Center Pageant" was presented in the tiny town of Sauk City, Wisconsin, attracting a crowd of 4,000 people from miles around. Wisconsin was at the forefront of many progressive reforms including that of creating Social Centers-places where people from all walks of life could gather to discuss ideas, to work out democracy "down on the ground." "Sauk City's Pageant was a celebration of that city's decision to fully adopt the structure of the school as Social Center. Additionally, they were the first community in the nation to fully adopt the structure in which the Principal of the school became the official 'Civic Secretary' of the community."[19] Ethel Rockwell of the University of Wisconsin-Extension's Community Theater department directed the pageant (assisted by Zona Gale, later the first woman to win a Pulitzer Prize for drama), which moved from venue to venue throughout the town, culminating in a scene at Town Hall where "the Town Board and School Board officials then lofted the symbolic ballot box to their shoulders and marched with it out of the Town Hall, followed by the crowd of citizens, to what was to be its new home-a seat of continual learning and open inquiry: the School House."[20]

1914 was an important year in rural America, for it was then that Congress passed the Smith-Lever Act, creating the federal Extension Service. Of the ten objectives of the Extension Service-such as advancing the educational and spiritual needs of rural people; building appreciation of rural life; fostering cultural, social, recreational and community life-almost all invited a creative, artistic response. Today, Cooperative Extension describes its state offices as being "staffed by one or more experts who provide useful, practical, and research-based information to agricultural producers, small business owners, youth, consumers, and others in rural areas and communities of all sizes."[21] So today we may think of 4-H or agronomy when we think of Extension, but this was not always the case. In 1937, *The Arts Workshop of Rural America* studied

the surge of rural art-making throughout America, and described many Extension Service workers as, in effect, circuit-riding community arts developers.

> "The story of the cultural contributions of the Rural Arts Program of the Agricultural Extension Service has never been fully told. . . . These activities are deeply rooted in the soil. . . . Over wide areas farmers are interested now in opera as well as in corn and hogs, in drama as well as in cheese and cream, and in folk dancing as well as in wheat and cattle. . . . We are accustomed to hearing the voices of the little-theater groups in cities and larger towns. . . . We are not so accustomed to the new voices now making themselves heard from the plains, the prairies, and the mining communities, and from little, remote places in the mountains. . . . They are the voices of men and women who have struggled through drought, thaw, drifts, impassable roads, dust and hail storms; who have fought grasshoppers, chinch bugs, and rust."[22]

As we explore the art-making encouraged by the Extension Service, we meet remarkable people. At North Dakota State University, Alfred Arvold was professor of drama from 1914-1953, with a partial appointment in Extension. His Little Country Theater was intended to be replicable by any of his students in barns, fields, or town halls when they returned home to their farm towns. He urged his students to create pieces of theater or dance from the life they knew, and to see creativity as part of a whole life that included sports, food-making, beautification (his drama students planted lilacs along the road from Fargo to Grand Forks every spring), theater, conversation, and democracy. In the attic above the Little Country Theater, Arvold created the Lincoln Log Cabin Room, a replica of the interior of the cabin where Abraham Lincoln was born, and after a show, the audience would be invited upstairs to join the cast in a meal and a discussion of issues important to them.

At Cornell University at about the same time, Alexander Drummond–who was considered to be one of the "greats" of the American theater at the time–was doing similar work. Like North Dakota State University, Cornell was a Land Grant college and Drummond took that seriously. His students left Cornell trained for the New York stage–but they could also be trained for work among rural people, helping them create their own theater. Drummond put an ad in the *American Agriculturalist* magazine, urging anyone from a small town or a farm in upstate New York to come to Cornell for help turning a story about his or her life or community into a script, and then for helping turning the script into a staged play.

And at the University of North Carolina, Frederick Koch–a contemporary of both Arvold and Drummond–was urging the people of North Carolina to write "folk

plays." Epitomizing the saying, "Write what you know!" he stimulated the writing of hundreds, if not thousands, of plays by "ordinary Americans," addressing the meaning of their lives and their communities. He believed that the American dramatic renaissance, befitting a democracy, would be intensely local, "a drama as many-sided and as multi-colored as are the peoples of our American states–an American regional drama ... which will interpret the interestingness and the rich variety of our American life in a drama worthy of the struggles, the achievement and the common vision of all our people."[23] The folk plays dealt with rural mountain life, with stories of labor struggle, with the historical stories and myths that made up North Carolina's collective identity. They included an anti-lynching play, "Country Sunday," commended by the Southern Interracial Commission, and another, "According to Law," about an innocent Black man caught in a white man's court. They included a play about Durham slum life. Some of his students returned to their native countries–Egypt, Mexico–intending to stimulate folk playwriting at home; others stayed to stimulate folk playwriting at home, as Loretto Carroll Bailey hoped to do with Negro playwriting from her post at Shaw University in Raleigh.

PROGRESSIVE POLITICS AND ARTS

Let's return to Wisconsin, state of the Sauk City pageant. The Wisconsin Idea grew out of the state's Progressive politics in the early 20th century. It reflected a deep commitment to public education and a pledge by the State and the University of Wisconsin to provide the newest, most useful ideas to the people of Wisconsin, access to higher education for all, and the fulfillment of everyone's talents–be they engineering, banking, or art. The University especially assisted music and drama in those early days of the Wisconsin Idea. In 1928, University President Glenn Frank was asked to write a preface to a play, "Goose Money," published by the College of Agriculture. He captured a facet of the Wisconsin Idea when he wrote, "Agriculture is a life as well as a livelihood. There is poetry as well as production on a farm. Art can help us to preserve the poetry while we are battling with the economics of farming."[24] Later, Frank said, "There's a gap somewhere in the soul of the people that troops into the theater but never produces a folk drama...The next great dramatic renaissance in America will come when the theatre is recaptured from the producers by the people, when we become active enough in mind and rich enough in spirit to begin the creation of a folk drama and a folk theatre in America."[25]

Dean Chris Christensen, of the College of Agriculture, agreed. He believed that an agricultural education must include poetry as well as production, and to this end

he envisioned an artist-in-residence who could help farm people express this poetry. Said to be the nation's first artist-in-residence–and not in an art department, but in an agricultural college!–John Steuart Curry's job was to assist anyone who wanted to paint, to capture and communicate their personal vision. Curry began his job in 1936 and the idea caught on fast. Soon there were scores of rural artists "painting what they knew," everywhere in the state, joining Curry's Wisconsin Rural Art Project (which still exists today as the Wisconsin Regional Art Program).

Robert E. Gard was a student of Alexander Drummond's at Cornell, and he was captivated by the notion of rural people creating their own plays, about their own issues. He had heard about the Wisconsin Idea and Wisconsin's Extension programs,[26] and in 1945 he was offered the opportunity to do in writing and playwriting what Curry was doing in the visual arts. He created the Wisconsin Idea Theater–a theater that was not a place, but an idea as big as the state: the idea that all people are creative, with important stories to tell through poetry, prose, drama. In *Grassroots Theater*, a seminal book that linked creative arts to a "sense of place," he recalls a creative writing workshop that he offered in 1948. The three days sped by in conversation, spontaneous acting, dialogue. At the end of the whirlwind he marveled at the profound sense of theater they had shared. One of the participants responded:

> "There must be a great, free expression. If the people of Wisconsin knew that someone would encourage them to express themselves in any way they chose...there would be such a rising of creative expression as is yet unheard of in Wisconsin and it would really all be a part of the kind of theater we had had these past three days, for the whole expression would be of and about ourselves."[27]

The Wisconsin Regional Writers Association–still going strong today as the Wisconsin Writers Association–was born in this moment, attracting scores, then hundreds and then thousands of people statewide who wanted to write, and who supported one another in their writing. The Creed of WRWA was a beautiful statement of belief, penned in 1950, saying in part, "Let us believe in each other, remembering each has tasted bitter with sweet, sorrow with gladness, toil with rest. Let us believe in ourselves and our talents. Let us believe in the worth of the individual and seek to understand him, for from sympathy and understanding will our writings grow."[28] Though the name has changed and the purpose statement is slightly modified from the original Creed, some of the original words, and all of the original intent still exist: "...the democratic process of government is safest in the hands of an educated,

enlightened people who participate actively in the democratic process through the well-written word."[29]

Gard's work in Wisconsin grew, and by the 1960's he was envisioning rural arts councils throughout Wisconsin. He secured the first National Endowment for the Arts "access" award for rural America in 1966, from which his seminal *The Arts in the Small Community: A National Plan* emerged.[30] These arts councils would encourage new work, would link the arts to other important local issues such as economic development, health, religion.

Gard drew on the thinking of Baker Brownell of Northwestern University in shaping the Wisconsin Idea Theater and in articulating its importance in community development. Brownell may have been the first person to use the term "community development;" and he believed that the arts–especially theater–have an important role to play in the community planning and community organizing process. He was brought to Montana after World War II by the Chancellor of the University of Montana to help small towns rethink their future. Just as Gard had called on Brownell as he articulated the role of the arts in Wisconsin communities, so did Brownell draw on Gard as he planned the Montana project.[31] Brownell worked with a Montana playwright to help synthesize the thinking of local community "self-study" committees, just as Percy MacKaye had done in Boston 40 years before. Perhaps the best-known of the dramas that resulted was "Darby Looks At Itself," presented in 1945, when Darby was in economic crisis resulting from the clear-cutting practices that had taken most of the timber. As part of the drama the town aldermen conducted a hearing on stage, voicing support for the self-study group. Among the play's protagonists was the Devil, representing "outmoded thinking." At the end of the play, an old lumberjack shouted:

> "'Our logging jobs are shot...because fifty years ago, twenty-five years ago, ten years ago, we listened to men like this devil here instead of men of vision who saw then a simple truth that is so pathetically clear now–that you can't cut all the timber from our Bitter Root forests and still have forests.' A wave of restlessness went through the mob of woodsmen. They moved forward against the devil and hurled him from the stage."[32]

THE WPA

No doubt people like Gard and Brownell were influenced by the Works Progress Administration's arts programs during the Great Depression of the 1930's. These were bold experiments in writing, art, theater, music, and dance that both put professional artists back to work and provided thousands of opportunities for the public to see

professional caliber shows, often for the first time–over 1,200 plays were produced; there were over 1,000 performances per month.[33] There were plays and puppet shows that toured to rural areas and to Civilian Conservation Corps camps; shows in English, French, German, Italian, Spanish and Yiddish; culturally-specific shows; new versions of classics (Orson Welles' "MacBeth" set in the Caribbean with an all-African-American cast was popularly known as the "Voodoo Macbeth"); traditional versions of classics as well as new scripts; the issue-based skits of the "Living Newspaper;" a radio theater; and a theater for the blind in Oklahoma to mention but a few. "Special emphasis was placed on preserving and promoting minority cultural forms. So, for example, black theater companies were established in Birmingham, Boston, Chicago, Hartford, Los Angeles, New York, Newark, Philadelphia, Raleigh, San Francisco, and Seattle–all places where economic and social conditions had made it impossible for black theater to exist outside of the fast-disappearing vaudeville stage."[34]

Most of the WPA art projects fall into the "arts *for* people" category, but people were expressing a need to make art for themselves. Painter Elba Lightfoot reflected:

> "We just felt that the Black minority so endowed with talent and creative energy needed an arena for itself. It was imperative that we had an outlet of our own. If we hadn't the means to make ourselves heard, we would never have been able to assume any responsibility of our own toward weaving the fabric of Black history."[35]

Particularly important to mention in the context of arts *of* the people, then, may be the network of community arts centers created by the Federal Art Project–100 of them in 22 states, serving an estimated eight million people.[36] Holger Cahill, the director of the Federal Art Project, is quoted as saying, "The core of the community art center idea is active participation, doing and sharing, and not merely seeing. . . ."[37] Perhaps the best-known of these centers was the Harlem Community Arts Center, operating 1937-42, associated with the Harlem Renaissance.

While the arts programs of the New Deal were often at the center of bureaucratic, political and artistic controversy, they were important in many, many ways. For instance, they helped preserve non-Anglo cultural forms, offering cultural experiences in many languages, recognizing regional differences in the arts, enabling culturally-specific theater:

> "[The Negro Unit of the Federal Theater Project] employed some 500 blacks in New York in mid-1936 and brought dramas that dealt with Nat Turner, Harriet Tubman, Pierre Toussaint, and African folktales into many Negro communities for the first time. The Federal Music Project gave performances

in all sections of the country of works by contemporary black composers; featured all-Negro casts in several of its operas; made a special effort to preserve, record and publish Negro folk music; conducted music instruction classes for blacks in at least a dozen states; and sponsored Negro concert bands in a score of cities.... And many thousands of Afro-Americans attended art classes funded by the Project in the South Side Community Art Center in Chicago and the Harlem Art Center."[38]

Adams and Goldbard note that the New Deal arts projects took "responsibility for our cultural commonwealth. They took on the task of recording history–including many parts otherwise deemed too painful or embarrassing to mention."[39] In large part, however, "minority" cultures meant African-American culture. Anthony Garcia, playwright and adjunct professor of Chicano Studies at Metropolitan State College in Denver, notes: "You are right in your recollection that there is very little that remains for us [in the Mexican-American community] in written form.... 'Las Pastorelas' that El Teatro Campesino produces is definitely in that category. I have an old pasturela script as well. Not much else, but some oral histories, and a few recorded and musical scores. Apparently the WPA and Alan Lomax missed the Mexicans."[40] Elsewhere he suggests that this absence of cultural documentation may be a result of a strong attempt by Mexican-Americans to assimilate into American society.

"This generation...lived through lynchings, the KKK, the Great Depression, World War II and the Korean War. The 1950's were marred by McCarthyism, and the concept of stepping out and articulating a separate identity through the arts was pretty much repressed. For Chicanos this was a period of pre-civil rights, where the Mexican-Americans wanted to prove that they were white and as such should benefit from segregation rather than suffer from it. ... This is why what Luis [Valdez, founder of El Teatro Campesino in 1965] did was so incredible. The conditions [in the 1960's] called for theater as a force for an independent identity. This did not exist in the twenty years from 1945-65. The Chicano Movement caused all of this to explode in a very different way, much as it did for the U.S. theater in the 1950's and early '60's when post World War writers like Arthur Miller and Tennessee Williams sought to create a new American identity. The theater became their forum. For us though the theater was in the streets because that generation before us still struggled with the idea of an independent identity from the American mainstream...because of the fear or marginalizing themselves."[41]

CULTURAL DEMOCRACY

A teacher in New York City was thinking of such ideas in the early 1940's as she observed the students in her classroom struggling with their cultural identities–and those of their classmates. Rachel Davis-DuBois (no relation to W.E.B. DuBois, though they were friends), wrote these words:

> "...the melting pot idea, or "come-let-us-do-something-for-you" attitude on the part of the old-stock American, was wrong. For half the melting pot to rejoice in being *made* better while the other half rejoiced in *being* better allowed for neither element to be its true self. . . . The welfare of the group... means finding ways to share unique qualities and differences. Democracy is the only atmosphere in which this can happen, whether between individuals, within families, among groups in a country, or among countries. This kind of sharing we have culled cultural democracy. Political democracy– the right of all to vote–we have inherited though we do not as yet practice it perfectly. Economic democracy–the right of all to be free from want–we are beginning to envisage and to plan for more courageously. But cultural democracy–*a sharing of values among numbers of our various cultural groups*– we have scarcely dreamed of. Much less have we devised social techniques for creating it."[42]

By the 1960's, the term "cultural democracy" was on the lips of many. The Civil Rights movement came into its own, and with it, a surge of public expression by many cultural groups, and the creation of such diverse groups as El Teatro Campesino (Luis Valdez' company that grew from the experience of migrant farmworkers), the Free Southern Theater (John O'Neal's company that grew from the Student Nonviolent Coordinating Committee), Roadside Theater (part of Appalshop, a cultural and job-training organization that grew from the War on Poverty in Appalachia). Scores of new organizations, new forms of expression, new audience awareness, new national support organizations, such as The Association of American Cultures, came on the cultural scene in literature, music, drama, dance, and performance art. Starting in the 1960's, work *of* people has been visible and well-documented. Indeed, it is sometimes assumed that community arts was a product of the '60's.[43]

FULL CIRCLE

The 1960's was also the time when community arts councils became a movement, one which started in Winston-Salem, North Carolina, and Quincy, Illinois, in 1948-9. Today the community, or local, arts agency movement includes literally thousands of

groups in rural towns, suburbs, cities, and urban neighborhoods. These institutions, different in so many ways, all provide access to the arts *for* people, and many facilitate arts *of, with* and *by* people. While this is not the place to describe the growth of these institutions, their beginnings embody the very tension described at the beginning of this chapter–the tension of meaning inherent when we say that "the arts are for everyone."

The local arts agency movement is linked to the Settlement House movement with its many "*of* the people" elements. The Junior League started in New York City in 1901 in support of the new Settlement House on the Lower East Side. As the League grew, becoming nationwide in scope, it retained an interest in the arts. Often that interest was reflected in its support of children's theater; but perhaps emulating the example of Jane Addams, local Leagues sponsored more challenging work, as well–for instance, in 1934 the Junior Service League in High Point, North Carolina, presented "Itchin' Heel," "said to be the first full-length play of Negro people played by an all-Negro cast."[44] Indeed, in 1939, the national League created the post of Senior Consultant for Community Arts–so Virginia Lee Comer was brought to Winston-Salem by the local League to help assess the breadth of arts in the community (a breadth which included a labor union hall as well as the more traditional arts groups and venues), and to help start the nation's first community arts council.

And, the local arts agency movement is also connected to the Rockefeller Panel Report, with its *for* the people orientation, that we encountered at the start of this chapter. Nancy Hanks was Executive Secretary of the Special Studies Project of the Rockefeller Brothers Fund, coordinating the study, which recommended the development of state and community art councils throughout the country, and Nancy Hanks' time as Chair of the National Endowment for the Arts is characterized by her passion for access.

Which brings us full circle back to the fundamental tension–arts *of* the people? Arts *for* the people?

CONCLUSION

This tension is vital to acknowledge. Both are important; indeed, both are vital. But they are not the same, and too often they are confused.

Arts *for* people is a concept that is more tangible, more manageable, more measurable, perhaps more easily describable. Many are the lives that have been changed by moments of "access." Many are the arts organizations which, rightly, extend their offerings *for* people.

Arts *of* people is harder to describe. The artist may be a facilitator or co-creator as much as a gifted maker or interpreter. The resulting work is often difficult to discuss and evaluate in traditional arts/aesthetic terms. Lines between process/product or artist/audience are often blurred. There is a dual mission: the complicated, exhilarating, often frustrating, often liberating process of creating community-based art is both pushing aesthetic boundaries and building democracy, in new and powerful ways.

The story of community-based arts development is a thrilling one, and at every phase it demands that we ask questions like:

- What does it mean to be a human being?
- What does it mean to be of my culture?
- What does it mean to live in the place that I do?
- What does it mean to have a voice?
- What does it mean to be an American?
- What does it mean to fuse all of this into an aesthetic that is thrilling, fresh, relevant, and deeply rooted here, in my place?

The arts and cultural expression can help us explore these questions as nothing else can. May we call on those who have come before us, who may help guide us as we create an America of, by, and for her people, with liberty and justice for all. There is no more important work.

Let us close with the words of Robert E. Gard of Wisconsin; these are the final words in *The Arts in the Small Community:*

. . . . a sense

That here,

In our place

We are contributing to the maturity

Of a great nation.

If you try, you can indeed

Alter the face and the heart

Of America.[15]

FOOTNOTES

1) Baldwin, James, "White Man's Guilt," Ebony, volume 20, August 1965, page 47. Note: This quote is often-mistakenly-said to be from The Fire Next Time. Thanks to librarian Patrick Muckleroy, Western State College, for tracking down the correct source.

2) Ewell, Maryo G., "Community Arts and the Human Community: Why We Do What We Do," in Overton, Patrick, Grassroots and Mountain Wings, Columbia College, 1992.

3) Rockefeller Panel Report,The Performing Arts: Problems and Prospects, McGraw-Hill, 1965.

4) Straight, Michael, Nancy Hanks: An Intimate Portrait, Duke University Press, 1988, p. 80-81.

5) Gard, Robert E., The Arts in the Small Community, University of Wisconsin Extension, 1969, p. 4.

6) Burnham, Linda Frye and Steven Durland, "Help Wanted! Communities Reach Out," Community Arts Network/API Online, February, 2007. http://wayback.archive-it.org/2077/20100906203654/http://www.communityarts.net/readingroom/archivefiles/2007/02/help_wanted_com.php downloaded January 17, 2012.

7) Durland, Steven, "Notes from the Editor" in High Performance #65, Vol. 17, No. 1, Spring 1994, p. 10.

8) Archived articles can be found at http://wayback.archive-it.org/2077/20100906194820/http://www.communityarts.net/apinews/index.php

9) DuBois, W.E.B., "Criteria of Negro Art," in Lewis, David levering, W.E.B. DuBois: A Reader, Henry Holt, 1995, p. 512 and 514.

10) West is quoted in Applebome, Peter, "Can Harvard's Powerhouse Alter the Course of Black Studies?" New York Times, November 3, 1996.

11) Lasch, Christopher, The Social Thought of Jane Addams, Bobbs-Merrill, 1965. See, for example, p. 51, 193, and 207-8.

12) Glassberg, David, American Historical Pageantry: The Uses of Tradition in the Early Twentieth Century, University of North Carolina Press, 1990, p. 283.

13) Prevots, Naima, American Pageantry: A Movement for Art and Democracy," UMI Research Press, 1990, p. 9.

14) Prevots, Naima, p. 17

15) DuBois, W.E.B., "A Negro Art Renaissance," from the Los Angeles Times; reprinted in Lewis, David Levering, W.E.B. DuBois: A Reader, Henry Holt, 1995, p. 508.

16) Prevots, Naima, p. 30-31.

17) Prevots, Naima, p. 20-21.

18) Prevots, Naima, p. 87.

19) Drury, Gwen, "The Wisconsin Idea: The Vision That Made Wisconsin Famous," online at http://www.ls.wisc.edu/documents/wi-idea-history-intro-summary-essay.pdf, downloaded 1/3/12, p. 57.

20) Konnack, Sally, on a 2005 note accompanying the script of "The Social Center Pageant," Freethinkers Hall library, Sauk City, WI.

21) http://www.csrees.usda.gov/Extension/ downloaded January 16, 2012.

22) Patten, Marjorie, The Arts Workshop of Rural America, Columbia University Press, 1937, p. 3-4.

23) Frederick Koch, quoted in Patten, Marjorie, The Arts Workshop of Rural America, Columbia University Press, 1937, p. 6.

24) Frank, Glenn, in Mrs. Carl Felton, "Goose Money," University of Wisconsin College of Agriculture, 1928, Foreword.

25) Frank, Glenn, quoted in Gard, Robert E., Grassroots Theater: A Search for Regional Arts in America, University of Wisconsin Press, 1955, p. 95.

26) In fact, there were two "Extensions" in Wisconsin–the federal Cooperative Extension network as well as the University's own Extension Division.

27) Gard, Robert E., Grassroots Theater, p. 217.

28) Wisconsin Rural Writers Association, "Creed," Wisconsin Rural Writers Association Newsletter, summer 1951, p. 7.

29) Wisconsin Writers Association, "Purpose," http://www.wiwrite.org/aboutus/index.htm downloaded January 3, 2012.

30) Gard, Robert E., Michael Warlum, Ralph Kohlhoff, Ken Friou and Pauline Temkin, The Arts in the Small Community: A National Plan. University of Wisconsin Extension, 1969; also at http://www.gardfoundation.org/windmill/ArtsintheSmallCommunity.pdf

31) Poston, Richard, personal correspondence to Maryo Gard Ewell, September 9, 1986.

32) Poston, Richard, Small Town Renaissance, Greenwood Press, 1971 (reprinted from Harper Brothers, 1950), p. 56.

33) Adams, Don, and Arlene Goldbard, "New Deal Cultural Programs: Experiments in Cultural Democracy," 1986, 1995, http://www.wwcd.org/policy/US/newdeal.html p. 9.

34) Adams, Don and Arlene Goldbard.,p. 11.

35) Finkelstein, Hope, "Augusta Savage: Sculpting the African-American Identity," M.A. Thesis, The City University of New York, 1990, p. 33.

36) Adams, Don and Arlene Goldbard, p. 8.
37) Finkelstein, Hope, p. 33.
38) Bowles, Elinor, Cultural Centers of Color, National Endowment for the Arts, 1992, p. 18.
39) Adams, Don and Arlene Goldbard, p. 11
40) Garcia, Anthony, e mail to Maryo Ewell, January 3, 2012.
41) Garcia, Anthony, e mail to Maryo Ewell, August 15, 2009.
42) Davis-Dubois, Rachel, Get Together Americans: Friendly Approaches to Racial and Cultural Conflicts Through the Neighborhood-Home Festival, Harper & Bros., 1943, p. 5-6. The term "Cultural Democracy" is said by James Bau Graves, http://www.loc.gov/today/cyberlc/feature_wdesc.php?rec=5051, to have first been used in Julius Draschler's Democracy and Assimilation, 1920
43) Indeed, that popular resource Wikipedia says of community arts, "The term was defined in the late-1960s and spawned a movement". . . " http://en.wikipedia.org/wiki/Community_arts downloaded January 4, 2012.
44) Spearman, Walter, The Carolina Playmakers: The First Fifty Years, University of North Carolina Press, 1970, p. 55.
45) Gard, Robert E. et al, p. 98.

ARTS-BASED COMMUNITY DEVELOPMENT: MAPPING THE TERRAIN
by William Cleveland
Center for the Study of Art Community

Thirty-five years ago, members of the nascent community arts movement used expressions like *beautification, quality of life*, and *community animation* to describe their efforts. Today, we hear terms like *social justice, sustainable economic development*, and *neighborhood revitalization* to describe the outcomes of these arts-based initiatives. Such goals dramatically raise the stakes and broaden the playing field for the creators, investors, and communities involved. And, as more and more public and private resources are invested in this work, many feel a need for increased clarity of definition and intention from all involved.

Another obvious sign of the changing nature of this field is the diverse vocabulary employed to name it. These include: *community art, community cultural development, art and social justice*, and *art and community building*. Some years back, when I first shared this article, I described the community arts movement as an expanding work in progress. Needless to say, it still is–and, given the dynamic nature of both art and community building, I believe it will continue to be. Nevertheless, this essay provides one way of looking at and defining the diverse constituency that we at the Center for the Study of Art and Community refer to as *arts-based community development*.[1]

MY BIASES AND ASSUMPTIONS

I left the University of Maryland in the early 70's as a developing writer and musician and knowing enough about psychology to be dangerous. In 1977, I fell into the arts and community nexus through an improbable gig supported by the US Department of Labor's Comprehensive Employment and Training Act (CETA).[2] Put simply, CETA placed unemployed people in full time public service positions with government and community based agencies. Keep in mind, this was a Federal

This paper was written for the book and online source, Building Communities, Not Audiences: The Future of the Arts in the United States, *edited by Doug Borwick and published by ArtsEngaged, 2012.*

"jobs" program, not an arts program. But, many, many artists and arts organizations qualified for participation and found themselves with full time jobs making art in hospitals, prisons, public housing, senior centers and the like. So many, in fact, that by the end of 1979 CETA had become the largest Federal arts program in history.[3] In the process it introduced a generation of artists to the notion that good art, public service, and community development were not mutually exclusive. For me and thousands of other artists and arts administrators, CETA also expanded the dictionary of American culture beyond the realms of decoration, entertainment, and investment. It taught us that artists and communities could partner to serve the public good and, most importantly, that the arts could be a powerful agent of personal, institutional, and community change.

A few years after the demise of CETA, I was invited to join in another unlikely cultural partnership at the California Department of Corrections. During the next decade, we built the largest arts residency program in the country with a faculty approaching 1000 artists and over 20,000 participants. Conceived during one of the most conservative eras in California political history, the notion of establishing a cultural community supported by the correctional system in every state prison was considered impossible. Nonetheless, California's Arts-In-Corrections Program did just that and ultimately lasted for more than three decades.

These boundary-crossing partnerships made a big impression on thousands of creative activists in and out of the arts. We learned, surprisingly, that some people were as afraid of art as they were of poor people and criminals. But, like our predecessors in the WPA and the civil rights movement[4] we came to know that the arts could translate to the needs of communities and public institutions without losing power or integrity. We learned not only that the creative process has an extraordinary capacity to heal, but that it was necessary for human and community development. Most importantly, we learned that the creative impulse cannot be destroyed and will, in the most desperate circumstances, emerge as a resource for survival. Needless to say, these experiences have had a lasting influence.

DEFINING THE FIELD

When the Center for the Study of Art and Community was established in 1992, these experiences informed both the philosophy and focus of our work.[5] Our intention was to help the emerging field learn from itself. As our work has evolved, we have developed a dictionary of sorts to help communicate with colleagues in and out of the arts. Building a common vocabulary has also been a critical aspect of our training

efforts. The increasingly cross-sector nature of arts-based community development has demanded greater clarity of focus and intent. In the mix, principles and definitions from other fields have been adopted and much common ground has been discovered—particularly with the areas of asset-based and sustainable community development. Here are some of the basic definitions and core concepts that have found a place in our dictionary.

The arts: Pertaining to the performing, visual, literary, or media arts.

Artist: A person who by virtue of imagination and skill is able create a body of work over time of aesthetic and/or cultural value in one or more arts discipline.

Arts-Based Community Development (ABCD): Community-based arts activities that equitably and sustainably advance human dignity, health, and productivity. These include arts-based activities that:
- EDUCATE and INFORM us about ourselves and the world
- INSPIRE and MOBILIZE individuals or groups.
- NURTURE and HEAL people and/or communities
- BUILD and IMPROVE community capacity and/or infrastructure.[6]

Asset-Based Community Development: A strategy for neighborhood improvement that both identifies and mobilizes local resources, capacities, institutions, and relationships to build thriving communities

Community: Our definition of community is derived from the one used by Alternate Roots:[7] Groups of people with common interests defined by place, tradition, intention, or spirit.

Community-based: Activities created and produced by and with community members that combine significant elements of community access, ownership, authorship, participation, and accountability.[8]

Community Development: A set of values and practices which plays a special role in overcoming poverty and disadvantage, knitting society together at the grass roots and deepening democracy.

Cross-Sector: Many people feel sustained community development requires collaborative effort that emphasizes a holistic, systems approach. This is because many community issues are diffuse, multidisciplinary, multi-agency, multi-stakeholder and multi-sector in nature. In this context, cross sector refers to community development activities among and between often separately defined areas of influence and expertise such as education, public safety, human services and the arts.

Cultural Ecosystem: The inter-dependent web of artists, arts organizations, funders, and community members that both fosters and sustains the making and presentation of art.

Sustainable development: We define sustainable development as locally generated economic, social, and cultural development that meets the needs of the present without compromising the ability of future generations to meet their own needs.[10]

MAPPING THE FIELD

Over the last four decades much has changed in the field. What started out as a very small, contained universe of intent and definition has become much larger and amorphous. Many artists who came to community work in the 1970's and 80's modeled their efforts on their previous experiences with school residencies. As such, the emphasis was primarily on teaching the arts and the development of culminating performances and exhibitions. As the field has evolved, artists have become full partners with colleagues in such areas as community development, public safety, planning, and public health.

In these arenas complicated questions about accountability and long-term impact loom large for all concerned. Under these circumstances the need for clarity of purpose has become more critical. In response we thought it would be useful to try to graphically map the diverse and interrelated world of arts-based community development. Our aim was to not to impose a proscriptive definition of the field but rather create something that would provoke a conversation about the importance of clear intentions in community-based work. See the next page for what we came up with.

As you can see, the four "neighborhoods" represented on the map reiterate the components of art-based community development described in the definitions section. The sub-categories, such as prison art, arts-based organizing, and arts education scattered about are provided to illustrate the general orientation of each of the neighborhoods. The nice thing about using a graphic is that it allows one to show the interdependent and integrated nature of the field since so many of the examples share aspects of two or three of the neighborhoods. Another way to experience this is to try to position community arts projects with which you are familiar on the map. See if you think they are in the right place. Another advantage of using the map is that it allows us to portray the diversity of our field. Participants in our community arts training programs have been quick to recognize the importance of discerning

A MAP OF ARTS BASED COMMUNITY DEVELOPMENT

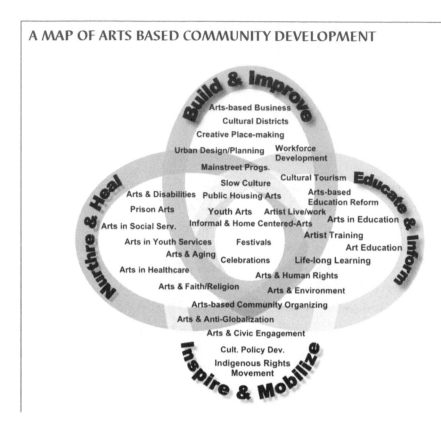

the different skill sets needed to work effectively in each of the neighborhoods. They have also suggested changes, many of which have been incorporated. Just like the natural environment, the map's ecology is not a static thing. It has grown with the field, changing and diversifying, in ways that were unpredictable when we started.

The State of the Field

Much of our work at the Center for the Study of Art and Community is about documenting, describing, and learning from the field.[11] We have also challenged the field to consider some hard questions about the efficacy of their work in and with communities. The information, ideas and opinions we have gathered show a field that is relatively new and growing rapidly. It reflects a field that is hungry to learn from itself and eager to make collegial connections. It also portrays a field largely unaware of its history, driven by a diverse pastiche of philosophies, practices, motivations and intents. The mix is complex and intriguing and through it all some patterns have emerged. Here are a few.

This is actually an old field: Community arts documenter emeritus Linda Burnham makes the point that "artists have been working with and for communities for thousands of years." We would argue further that community arts is a modern iteration of perhaps the oldest "field" with a lineage that stretches back to humankind's most essential pre-historic community making/defining practices.

This is a new field: Contemporary community arts practitioners are dealing with issues like prison reform, refugee and immigrant rights, community reconciliation, and environmental justice. Descriptors like these do more than expand the community arts dictionary. The intentions they represent greatly alter the nature of the work. Arts-centered efforts to improve economic or social health indicate the emergence of a new field (or fields) entirely. This is a realm of cultural practice that regards public participation and artistic creation as mutually interdependent. It also asserts that there are significant and tangible community benefits, beyond the aesthetic realm, that naturally accrue from certain kinds of community art endeavors.

The field is an ecosystem: Research has also revealed the highly interdependent nature of the community cultural development landscape. As such, the field operates within "a community cultural ecosystem," where artists, arts organizations, community development agencies, community members, funders, etc. function as parts of a mutually supportive system that is best understood and developed when considered as a whole. While there is a consensus in the field that individual artists are essential to the vitality and sustainability of the community arts ecosystem, they are its least supported and most vulnerable component. Many feel this is due to the lingering negative impact of the "culture wars" of the 1990's, which caused the elimination of most public sector support for individual artists.

Definitions of success have broadened: Much of our work at the Center has been focused on how these expanded aims affect our definitions of success and failure. In doing this we have had to acknowledge that the "we" has expanded. In addition to citizen participants, every new sector that becomes involved-be it public safety, human services, or community development-now has a stake in the work. In fact, artists doing community work often find themselves contending with a greatly expanded range of scrutiny and judgment. The melding of aesthetic goals and criteria with those associated with community building and social change has been both exciting and confounding.[12]

The field has expanded: Given the variety of definitions applied to the field, it is difficult to say how much larger it has grown. Based on our research and interaction with the field and data from national arts service organizations and

researchers, we feel confident in saying that there has been a significant increase in funding and programming in the community arts arena. The greatest expansion we have seen is in the broad category of youth arts. We would also observe that this growth has not necessarily had a stabilizing effect on artists and organizations with historic commitments to community-based work. As new opportunities have emerged, some have "chased the money," resulting in programs with little depth or commitment. On the other hand, we have also seen the emergence of a new generation of community artists and arts organizations like FutureFarmers (http://www.futurefarmers.com/) and Littleglobe (http://www.littleglobe.org/). Many of these newcomers are challenging traditional notions of community arts practice. Some are bringing significant experience from the community development, social service, and business sectors along with arts backgrounds. Others are environmental and community activists and community development professionals who recognize the arts as a primary resource for their work.

Some large investments have hurt: While the field is generally resource poor, a number of initiatives have involved significant investment by public and/or philanthropic organizations. Unfortunately, despite good intentions, some of these initiatives have come and gone without having a sustained impact. We have learned that, despite good intentions, the presence of powerful outside financial contributors can have a negative impact on local efforts to create healthy and sustainable communities. One reason for this is that many funders are still more interested in supporting specific programs (of which there are many) than they are in helping to build the local and national infrastructure and networks needed to sustain the field. This does not mean that we believe such investments should not be made. But, we do feel these efforts are potentially de-stabilizing and should be entered into with utmost caution.

Some efforts are falling short: Unfortunately, quite a few of the programs we have studied are described by participants and community leaders as unsuccessful. The shortcomings most often cited have been poor communication, differing commitment levels and a lack of a sustained impact. Almost none of these "failures" had anything to do with the lack of quality artists or enthusiasm by the project partners. More often than not, the difficulties encountered were due to poor partnership development and artists and arts administrators who lacked basic community engagement skills. All too often, the artists and their partner organizations described themselves as "damaged" in some way by the experience. In some cases, the constituencies being "served" were left with less than they started with because of the disruptions caused by the project.

Off-center is central: We have found that some of the most interesting and creative ideas in the field are being developed away from the centers of economic and political power. Innovations are coming from small towns like Whitesburg Kentucky and Colquit, Georgia where programs like AppalShop (http://appalshop.org/) and Swamp Gravy (http://www.swampgravy.com/) have thrived in environments where the gridlock of politics and self-interest does not dominate all policy. We see new approaches coming from urban neighborhoods in Philadelphia and Pittsburgh, where efforts such as the Manchester Craftsman's Guild (http://mcgyouthandarts.org/) and The Point Community Development Corporation (http://www.thepoint.org/) have harnessed local capacities to rebuild and re-vitalize their neglected infrastructures and local culture. Many of the field's best "thinktanks" are small, community-based, and locally accountable. These efforts often emerge when artists and arts organizations forge partnerships with local non-arts organizations and constituencies based on compelling mutual self-interest.

Sustainable community development is "slow culture": Community engaged artists understand that healthy neighborhood cultures are truly "hand built" by the citizens who live and work in them. This "with and by" strategy is a guiding principle of effective community building practice. We refer to it as "slow culture." This means that the art making process engages community members in all aspects of creation and presentation. A good example is Pomegranate Center. (http://www.pomegranatecenter.org) They combine design and art with community planning, public participation, environmental methods, hands-on learning, and mentoring in an integrated process to help communities become more livable, sustainable, and socially engaged. One prominent expression of their work is the creation of community gathering places–shared public spaces including parks, neighborhood focal points, community trails, and public artworks–that contribute to community distinction, vitality, and social interaction. Pomegranate believes that no one understands a community like its own residents. It makes sense then, that they engage community members at every stage of development: from planning and design through construction. We point out that "Slow Culture" movement existed long before Carlo Petrini (God bless him) sounded the trumpets for the Slow Food movement. Supporting indigenous creators whether they are making food or art is a cornerstone strategy for building caring, capable, and sustainable communities.

Arts-centered programs work: Our study of arts programs in community and institutional settings has led us to conclude that the two most critical contributors to success have been a clear artistic focus and the high quality of the artists involved.

<u>The most successful programs have been developed by artists making art, not by artists doing something else.</u> [Emphasis added by Editor.] These artists have created art programs, not therapeutic or remedial programs, that use art as a vehicle. This does not mean that they were not concerned with solving problems or unaware of the therapeutic or self-esteem building effects of their efforts–quite the opposite, in fact. They often contend that these benefits are the unavoidable consequence of making art. It is their belief that they do the most good by concentrating on the synergy produced when the creative process interacts with local assets (individual and community)–not on the diagnosis or treatment of what is "wrong." These artists also recognize the importance of learning the new skills necessary to thrive in different institutional or community environments. As such they often describe their evolving expertise as "hybrid" or "cross-sector."

Community cultural development shows significant promise as a stimulus for building sustainable neighborhoods. Over the past two decades, Susan Seifert and Mark Stern of the University of Pennsylvania have been researching the impact of art and culture on neighborhood development.[13] They have concluded that neighborhoods with very dense, highly interactive networks of artists and arts organizations produce specific benefits for those communities. These benefits include poverty reduction, population retention and growth, and increased civic participation. They postulate that the power of culture derives, in part, from the dynamic social networks it creates, particularly among active arts participants. They also say that the presence of cultural organizations produces high levels of "cross-participation" in a neighborhood that stimulates residents' involvement in other civic activities. They further suggest that these "cultural clusters" or "geographic concentrations of inter-connected companies and their associated suppliers in a given field," facilitate social engagement and cross-pollination of ideas that lead to innovation.

More research is needed: A growing body of research supports the efficacy of community arts programs and investment. Improved economies, academics, and self-esteem; the reduction of violence and recidivism; and an increase in employment and community cohesiveness are among the outcomes that have been documented. It should be noted, though, that in-depth research in the field is not well supported. The small body of good research that is only just emerging is not yet considered conclusive. If and when that point is reached, the field will more than likely have to contend with being defined, through the lens of the research, as a therapeutic or remedial methodology.[14]

Institutionally based programs have posed barriers to constituent ownership. Many institutional environments do not provide easy pathways for community or constituent involvement in the development of arts programming. As a rule, prisons, mental hospitals, senior citizens homes, and even schools are resistant to artist/client collaboration. Artists working in these settings must have the patience to develop collaborations in stages. The challenge is to gain the confidence of both staff and participants. Unfortunately, trust is often in short supply in institutional communities. Successful programs have gained cooperation and access by acknowledging their intruder status and by learning the ropes before insinuating themselves into an institution's established routine.

Training opportunities are increasing and improving: There has been a significant increase in the number and depth of community arts training and education opportunities available at both the community and university level. Many of these programs also explore the common ground shared by creative processes and community development/organizing processes. Most also provide enough hands-on arts-based experiential learning for students to begin to better understand the enormous demands inherent in the work and their own capacity to meet those demands.

LEARNING FROM THE FIELD

Power imbalances have been destabilizing: Our studies have shown that when large organizations from outside the community attempt collaborative projects with smaller local entities problems can occur. We have found that it is often very difficult for large successful organizations to truly share power. Their instinct is to take control when the going gets tough. Success depends on having the patience to share the struggle and share control.

Local ownership has been key: Our research also shows that the success of community-based work is often tied to the role the community has in identifying its own needs, formulating possible solutions, doing the work, and owning the result. If there is broad community participation in, and ownership of, the processes and products developed through an initiative, then the work has a better chance of contributing something lasting and worthwhile.

Outreach is out: We have also concluded that it is harder for arts organizations and funders to forge equitable and successful partnerships with constituencies with whom they are unfamiliar. Numerous well-meaning "outreach" efforts have failed because the initiating partner has underestimated the complexities of the environment

in which they were attempting to work. The term "outreach" itself assumes a center, a source and a destination or target. Many "under-served" communities have been subjected to a cycle of outreach and abandonment that has undermined local efforts and produced a legacy of bitterness. Some communities are now demanding that community arts investments and partnerships focus on developing a capacity for self-determination and self-service.

Unfamiliarity can also lead outside partners to mistake their conversation with individual community-based partners as representative of *the voice of the community.* Very few of us would make this mistake in our own communities. Outside partners have a responsibility to learn as much as they can about the social ecology of the environment they are working in. This is a demanding task. It can take an enormous amount of time, energy, and commitment.

Partnerships have been central: Successful practitioners say over and over that their most important resources are relationships. Effective community-based work is built upon long-term, trust-based partnerships. For this reason, we have found that many of the most productive collaborations are initiated by and for the communities for which they are intended. In these efforts, the most effective organizational partners are those who are familiar with both community assets and needs. Many times the most appropriate lead partner is the organization that has shown the greatest historical commitment to the issue and constituency being addressed. Community-based human service, educational, recreational, and religious organizations are often very good partners because of the central role they play in the community.

Clear intentions have produced better outcomes: Another indicator of success is degree of clarity with which the partners have articulated their respective roles and the anticipated outcomes. Social, economic, political and artistic goals are not necessarily incompatible. While combining them increases the complexity of the work, the potential for extraordinary outcomes on all fronts may be raised exponentially. All this makes the work far more demanding. Professional artists are particularly vulnerable in these kinds of partnerships. The artist's processes and the sources of their effectiveness are not universally understood–not even by the artists themselves. Nevertheless, everybody has a stake in the product of the collaboration. The most successful artists in community settings are those who see the process of collaboration as part of their palette.

Effective training promotes cross-sector learning and leadership: The best training programs we have found have been long term and rigorous. Community arts partnership institutes in St. Louis and Minneapolis are good examples. These

programs include 50-70 hours of class work spread out over a 3 to 6 month period. The time between classes includes both individual and group research and field study. Another aspect of good training has been field placements in an array of community-based programs that offer opportunities for the development of master/apprentice, mentor/mentee relationship.

These programs also:

- Provide participants and faculty sufficient time to develop a learning community using its own internal dynamics as a forum to confront some of the basic questions that emerge in the development of community arts programs.

- Provide students a range of strategies for discovering what they need to know in order to engage communities respectfully and effectively.

- Provide exposure to the history and ecology of arts-based community development, partnership development strategies, community research and reconnaissance methods, learning and teaching strategies, evaluation, funding, legal issues.

- Use an arts infused curriculum that emphasizes multiple learning styles.

- Challenge students to confront their motivations and assumptions about the work and the communities they engage.

- Develop a resource center and lasting support network to advance the work of graduates.

- Integrate the issues of race, rank, and privilege into the totality of the curriculum.

Community art making is necessarily cumbersome, messy and slow. Successful arts based community development practitioners understand there are no quick-fix shortcuts in community-engaged, participatory art making. Each community's cultural, social, and political ecosystem is unique. As such, successful approaches emerging from within one organization or community do not readily transfer to other cultural environments or contexts. Our research tells us that assumptions and expectations accrued from other sites can inform our programs but should not drive them. This is not because those experiences are not potentially valuable and informative but because the time spent learning about a community's culture is an indispensable part of building community trust.

We have also found that participants in successful creative collaborations know that a good partnership is like a good marriage. That means that even though it takes 10 times more energy to find consensus and get things done, the results make the

journey worthwhile. Successful partners also know that at various times on that journey the partnership will be tested and that those tests will not only be a measure of the strength and resiliency of the partnership, they will also be the crucible upon which the strength and resiliency of the collaboration will be forged.

FOOTNOTES

1) An insightful article that explores the evolving terminology used to describe the community arts landscape further is Trend or Tipping Point: Arts & Social Change Grantmaking, Animating Democracy, Americans for the Arts, 2010. http://impact.animatingdemocracy.org/arts-social-change-grantmaking-report-2010?

2) Enacted in 1973 and repealed in 1982

3) For more on CETA see Postscript to the Past: notes toward a history of community arts, Arlene Goldbard, High Performance #64, Winter 1993.) or go to http://wayback.archive-it.org/2077/20100906204001/http://www.communityarts.net/readingroom/archivefiles/1999/12/postscript_to_t.php Also: Artist!, Mike Mosher, Bad Subjects, Issue #33, Jan. 2001. or go to: http://eserver.org/bs/53/mosher.html

4) Artists have always been an integral part of social and economic development in America. Both the Works Progress Administration arts programs and the civil rights movement are prime examples.

5) See Bridges Translations and Change: The Arts an Infrastructure in 20th Century America, W. Cleveland, High Performance Magazine, 1992 http://wayback.archive-it.org/2077/20100906203935/http://www.communityarts.net/readingroom/archivefiles/1999/12/bridges_transla.php

6) This is inspired by a similar list developed by Maryo Ewell, a long time community arts activist and researcher and writer.

7) Regional Organization of Theaters South, http://www.alternateroots.org

8) From the Community Arts Forum, Belfast Northern Ireland, http://www.community-arts-forum.org

9) Adapted from the Community Development Challenge report, created by a group comprising leading UK organizations in the community development field (including (Foundation Builders) Community Development Foundation, Community Development Exchange and the Federation of Community Development Learning)

10) Derived from a definition used by the United Nations World Commission on Environment and Development.

11) Some recent CSA&C research projects providing "state of the field" relevant data include: Making Exact Change: How U.S. arts-based programs have made a significant and sustained impact on their communities. William Cleveland, Art in the Public Interest, 2005. A Study of Model Community Arts Programs, W Cleveland, P. Shifferd, 2002, for the Howard County Arts Council with the Center for Cultural Assessment (CCA). Continental Harmony: A study in Community-based Arts, P Shifferd, W. Cleveland, 2001,also with CCA and An Evaluation of the Mississippi Arts Commission's Core Arts Program 1998-2000, W. Cleveland, 2001

12) Korza, Pam and Barbara Schaffer Bacon. Trend or Tipping Point: Arts & Social Change Grantmaking. Animating Democracy/Americans for the Arts, Washington, D.C. 2010. http://impact.animatingdemocracy.org/arts-social-change-grantmaking-report-2010

13) Seifert and Stern, "From Creative Economy to Creative Society," Social Impact of the Arts Project, January 2008: 4

14) Three useful sources for ABCD research are the Social Impact of the Arts Project, www.ssw.upenn.edu/SIAP/, the Urban Institute's Arts & Culture Indicators Community Building Project, www.urbaninstitute.org/nnip/acip.html and the Arts Education Partnership's, Champions of Change http://aep-arts.org/Champions.html Also see, the Community Arts Network's archived compendium of ABCD research at http://wayback.archive-it.org/2077/20100906194905/http://www.communityarts.net/links/studies.php

Community Engagement Training

THE COMMUNITY ARTS TRAINING INSTITUTE (CAT) OF THE REGIONAL ARTS COMMISSION OF ST. LOUIS

by Roseann Weiss, Director

The Community Arts Training (CAT) Institute-most often called "CAT"-is an innovative cross-sector program centered on the belief that art has the power to be an agent for positive social change.

Founded in 1997 by the St. Louis Regional Arts Commission (RAC), the CAT Institute advances successful partnerships among artists of all disciplines, social workers, educators, community activists and policy makers. The CAT Institute is a catalyst for socially relevant arts-based programs, particularly in community settings such as neighborhood organizations, social service agencies, development initiatives and after-school programs that are transformative and sustainable.

A national model, the CAT Institute is the oldest sustained training program of its kind in the country. The CAT Institute is successful and sustainable because RAC commits significant financial resources (approximately $52,000 annually) and human resources (dedicated staff time) to the program. CAT enjoys prestige in the community and a deep sense of camaraderie among alumni, who are changing the St. Louis landscape.

The CAT Institute also succeeds because it creates a lively learning community of cohorts and a sense of partnership. This sense of community can take a little bit of ritual to achieve. Take, for instance, the small white cards given to each new CAT fellow that contains a brief phrase such as:

- *Be flexible; leave your expectations at the door*
- *Open wide, you are among friends*
- *Practice Listening*
- *It's all about relationships!*
- *Be a warrior, do the Haka!*

- *Take reflection seriously*
- *Lean into discomfort*

This card ritual occurs the evening before the first CAT Institute session when the new class gathers with CAT alumni and faculty for introductions and orientation. Bar and buffet included. Sometime in the middle of the evening, the new fellows are asked to line up on one side of the room and pick a card. Each takes a turn to read their card aloud:

- *Stay in the dream state as long as you can!*
- *Just breathe*
- *Enjoy the rain*
- *Caffeine is good. Evening. Morning. Whenever*
- *Make sure you take a break-especially if its scheduled*
- *Let it go. Let it flow (especially when writing)*
 Laugh (especially for no reason...)
- *Be "in the moment"*

These brief phrases are the advice handed down from the previous year's CAT Institute class. Some advice is very serious and some of it is purposefully silly. But above all, the ritual of the advice cards marks the beginning of a community building journey that never really ends:

- *Ask lots of questions, you may not like the answers*
- *It's more work than you think, lazy head*
- *Don't be afraid to use previous relationships to inform new assignments and projects*
- *Write spontaneously in a stream of consciousness mode regularly, you won't know whether you'll reach a great sea, a monumental waterfall, or a massive sinkhole*
- *Network with other CAT's constantly, they are your true source of wisdom*
- *CAT stands for: Creative Alien Transformer. This is a poem we wrote in CAT.*
- *Everyone is busy, that's not an explanation*
- *Continue to assume the best about everyone*
- *Building community takes time, takes trust, takes respect, and you will make mistakes so learn to repair—it's okay!*

ABOUT RAC

The Regional Arts Commission (RAC) is the St. Louis area's largest annual funder of the arts, granting about $3 million annually. Under the leadership of Executive

311

Director Jill McGuire, RAC also provides support and technical assistance to arts organizations and artists.

RAC's four-story building, which opened in 2003, was designed to meet the everyday needs of arts organizations and community groups with a studio, gallery, board room and meeting rooms, available for use at an extremely modest rate. RAC has been a leader in creating unique collaborations to integrate arts and culture into retail developments, stimulating both the arts and business. It also is the region's voice and face for public art.

Founded in 1985, RAC receives funding from a portion of the hotel/motel room sales tax revenue from St. Louis City and County. It also receives special project grants from national and local funders such as the Nathan Cummings Foundation and the Kresge Foundation, corporations, the Missouri Arts Council and the National Endowment for the Arts.

CONCEPT

RAC has, since its inception, provided grant support for arts programs that are housed within human services agencies and other community-based nonprofit organizations. RAC launched the Community Arts Training (CAT) Institute in 1997 to cultivate successful partnerships between grantees and area artists and also to take art outside of traditional settings into community settings.

"We didn't want to simply throw dollars at community arts projects," said Ann Haubrich, CAT's first director. "We were interested in much more than popsicle art and oatmeal box bongos. Not only did training need to take place on both sides of the fence, the fence needed to be dismantled so that the yard could be bigger. Artists wondered how communities operate, how social service agencies tick. Social workers/ community organizers/leaders wanted to gain a better understanding of where an artist works from, how creativity manifests itself, how art breaks down barriers."

RAC staff, community advisors from many sectors and Bill Cleveland, director of the Center for the Study of Art and Community, designed the core curriculum. The training prepares artists and community partners–those most often working within social service, community development and educational institutions–to create and sustain programs that are built on the notion that human creativity is a natural resource and is essential to the development of caring and capable communities.

GOALS

RAC's executive director Jill McGuire states, "Among the goals RAC has

accomplished through the CAT Institute is to make visible and make stronger the immense impact of art in our everyday lives. Communities working with artists have the opportunities to create new ways of relating; new ways of viewing the world; new avenues for problem solving and new ways to be civically engaged. Artists working in a community context often create unanticipated relationships and expand the scope of their art in very exciting ways."

The overall goal of the curriculum is to promote the development of strong, arts-based community programs that amplify the voices of underserved communities, regenerate neighborhoods and promote positive change. The CAT Institute seeks to:

- Bring artists and community activists/social service providers together to understand the others' language and points of view so that successful, collaborative programming occurs;
- Create the space for participants to confront and grapple with unique issues in program planning and adaptability, partnership development, hands-on projects, teaching and situational strategies and assessment tools;
- Provide an active, progressive experience through a rigorous, mentor-based curriculum; and
- Facilitate an ongoing support system for artists and community organizers/social service providers engaged in community-based work.

VALUES

The most intrinsic value to the CAT Institute is that it is cross-sector. Just training artists to work in community settings would be missing the true notions of partnerships and collaborations. By creating a community of cohorts people from different sectors of the community, from different backgrounds, ethnicities, ages, sexes and orientations-the CAT Institute models both the challenges and the joys of working together towards common goals.

METHODOLOGY

The training is intimate and focused and includes presentations, discussions, critical response to reading assignments, site visits, case studies, creative writing assignments, participation in interactive projects with demonstrations and viewing performances.

Readings include books and articles about negotiation, power and privilege, creativity, theories of learning, critical response, evaluation and assessment, and

funding as well as fiction and poetry. Fellows are also encouraged to research and share relevant books and articles.

The CAT faculty is composed of experienced practitioners. For example, current faculty includes Jane Ellen Ibur, writer and arts educator; Renee Franklin, director of community and school programs at the Saint Louis Art Museum; Sue Greenberg, executive director of St. Louis Volunteer Lawyers and Accountants for the Arts; Bill Cleveland, writer and director of the Center for the Study of Art and Community; and Emily Kohring, theater instructor at Grand Center Arts Academy; CAT Institute alumni and a variety of guest lecturers.

FELLOWS

Each fall, 16 CAT fellows (eight artists and eight social service professionals, community organizers, policy makers or educators) are selected through a nomination, application, and interview process conducted by CAT Institute faculty and a small committee of alumni. Thanks to RAC's continued financial commitment, there is no tuition to participate in the CAT Institute. This has made it possible for people from many sectors to take part in the training.

For the 2011/2012 CAT Institute class, RAC received nearly 100 nominations. Clearly, the training and the opportunity to network and collaborate has gained high value among artists and their community partners.

CURRICULUM

CAT Institute fellows participate in more than 55 hours of training, which occur during intensive, two-day sessions held once a month during a five-month period and in lab project assignments. The challenging curriculum includes training on partnership and survival strategies, conflict resolution, learning styles, teaching strategies, public relations, identifying funding sources, legal and liability issues, assessment techniques and advocacy. CAT fellows are drawn from all sectors and some may have completed high school while others may have an MFA or an MSW. The curriculum is designed to engage, provoke and challenge while creating opportunities for each fellow to approach the issues individually and collectively.

Fellows are required to make a significant commitment of time for CAT work during these five months. Their homework assignments include extensive reading. In addition, they design in lab teams a detailed plan for an arts-based community project or program. Each team must meet to go through the outlined steps of creating this

program or project and are assigned the task of writing a mock RAC grant for it. This process of working together is where the actual understanding of collaboration begins.

BRIEF SAMPLE CURRICULUM OUTLINE

WEEKEND 1

A) Introductions and Overview: What is community? Brief introduction to community-based arts/arts-based community programs.

B) Programs and Process: Who we are; the journey is as important as the destination; Communication and negotiation skills in program design; Lab teams, Site visits and assignments. Sample reading: "Getting to Yes, Negotiating Agreement without Giving In" by Fisher, Ury, and Paton and "The Beginner's Guide to Community-Based Arts" by Mathew Schwarman and Keith Knight.

WEEKEND 2

A) Research-Evaluation-Process: What are we trying to accomplish and how do we know we've succeeded? Assessment tools; Criteria; Social services and arts evaluations. Sample reading: "Towards a Critical Response," article by Liz Lerman from The Dance Exchange Toolbox

B) Program design and legal issues; grants writing introduction: Some practical considerations in community arts program design, contracts, budgeting, non-profits; Sample reading: "Making Exact Change: How U.S. arts-based programs have made a significant and sustained impact on their communities," by William Cleveland

WEEKEND 3

A) Community Arts and Change: Partnerships and power; Group assets inventory. Sample reading: "Art and Upheaval: Artists on the World's Frontlines," by William Cleveland and "Creative Community: The Art of Cultural Development," by Don Adams and Arlene Goldbard

B) Cultural competency, diversity, and identity issues in program design; Understanding power and privilege: Characteristics of oppression; how does this impact our work and our leadership? Sample reading: "The Bluest Eye," a novel by Toni Morrison

WEEKEND 4

A) Art based education programs; Learning styles and teaching strategies for youth and adults: Working with Standards/Grade Level Equivalencies;

Incorporating ways of learning in program design. Sample reading: "Fist Stick Knife Gun: A Personal History of Violence in America," by Geoffrey Canada

B) Considerations in sustaining programs; Risk management, freedom of expression and other considerations; Creative process in program design: Tapping into the creative process. Sample reading: "A Whole New Mind: Why Right-Brainers will Rule the Future," by Daniel Pink

WEEKEND 5

A) Partnerships - true collaborations; Funding: Unanswered questions; Where can we find support for programs? What's next?

B) Support and Resources - Marketing and PR: Getting the word out; Advocacy and cultivating support; Lab Team project presentations; Graduation celebration.

ALUMNI

There is now a network of about 200 CAT Institute graduates. Most are working in the St. Louis area. They are visual artists, actors, musicians, dancers, writers, media artists, social workers, educators, administrators, community activists, and a city alderman. There also are a number of "cross-overs"–alumni with MSWs and degrees in psychology who are continuing their art-making practice. They have formed a network of practitioners with a shared experience.

There are many factors and many measures of success for community arts programs. With CAT Institute influenced programs, there appear to be recurring factors of transformation and change on three levels. The first level of transformation usually occurs with the participants. There can be a personal change when tapping into the creative parts of the self and in the expression of that self. There can be a sense of power. The second level usually happens within the organization where a program takes place. For instance, a case manager who creates work with an artist along side his clients–who is willing to succeed and fail along side them–will have a deeper understanding of those clients. His organization and how it works will often be influenced by that process. Thirdly, there can be a community transformation when the work created is made public through a performance or exhibition or publication.

CAT Institute alumni are like the pebble in the pond–radiating influences. They are embedded into community organizations, social service agencies, schools, governments and arts institutions.

Several examples:

- Under the direction of a CAT Institute alum, the St. Louis City Juvenile

Detention Center offers hands-on art workshops such as drumming, metal crafting, hip hop poetry, murals, and circus performance taught by artist/mentors, who also participated in CAT. The program helps the troubled residents get through a challenging time and has inspired some teens to pursue art after they left the detention center.

- For more than ten years, the men in transitional housing at Peter & Paul Community Services have been documenting their personal journeys from homelessness to independent living with visual art, video, poetry, and drama. Not only does art create personal change in the participants but it also creates change in the organization and in our community by sponsoring exhibitions, video installations, and public readings. The shelter director, a CAT graduate, works with CAT alumni artists to facilitate this program. A participant in this program, formerly homeless, is currently a CAT Institute fellow.

- VSA Missouri has now published two literary journals of art and writing by artists with disabilities, "Blindness Isn't Black" and "Where We Can Read the Wind." This program was revitalized by a writer who is CAT Institute alum; it is now directed by another CAT Institute grad who is both a visual artist and a social worker.

- Yeyo Arts Collective is a group of women-many are CAT Institute alums-based in a downtown St. Louis storefront. Among their programs are Girls Create for girls 7 to 14 years old and the Window Mural Project. The Murals Project emphasizes community painting workshops and the history of mural making as well as creating art on boarded up windows of abandoned buildings. The Collective also runs the GYA Community Gallery and Fine Craft Shop.

CAT Institute alumni have access to professional development opportunities such as summer workshops or the more informal CAT Cafes. The CAT Cafes can be as simple as getting together with refreshments or can include a specific topic of discussion such as marketing programs to get some attention to issues. Most recently, alums organized an evening of "CATtalks" based on the TED.com model. Alums communicate via a list serve and a social media site. An alumni roster is posted on RAC's website (www.art-stl.com). Many agencies say the roster is among their most important "go to" resources.

CONVENINGS

The scope of the Community Arts Training (CAT) Institute is continuing to evolve. In 2010, RAC hosted the St. Louis region's first arts-based community development

conference. "At the Crossroads: *A Community Arts and Development Convening*" connected and engaged people working in diverse practices, inspiring new ideas and creative collaborations in communities. Sponsored by the Nathan Cummings Foundation with special support provided by the Whitaker Foundation and PNC, the conference attracted 175 cross-sector practitioners and thinkers.

Working with partners in Cleveland and Detroit, planning is underway for another conference in 2012 underwritten, in part, by the Kresge Foundation.

EXPANSION

Thanks to a major grant from the Kresge Foundation, the CAT Institute is creating two new models for arts-based community development training. As an addition to the annual CAT Institute, a place-based CAT Institute with a reshaped and formatted curriculum is being designed. CAT faculty are working with north St. Louis neighborhood partners to pilot a program that would be equally vigorous and comprehensive as the annual training while taking place in an alternative time frame. The goal is to be able to make the CAT Institute even more accessible to specific community partners.

A core group of CAT faculty and advisors is also designing a pilot master/graduate CAT Institute for alumni and experienced community art practitioners that is short-handedly called TIGER. This one year extensive training is being designed as an opportunity to go deeper into the practice of arts-based community development. With a curriculum that is heavily research and inquiry based, this program will also contribute to the field through documentation and assessment.

We are often asked how the Community Arts Training (CAT) Institute could be replicated in other places. The CAT Institute in St. Louis–with fifteen years of accumulated knowledge–is a model for cross-sector training. Essential to successful training is the architecture of each class. If artists of a variety of disciplines and community activists, educators, and social service professionals can come together in a committed, intentional way to understand each others' language and values, then a community arts training could be established.

In addition, the identity and roles of those partners in the planning and implementation of the training would need to be tailored to each community. The CAT Institute is not a "workshop." Learning to collaborate across borders and boundaries takes discipline and time. It is a key element of success to spend time in the up-front design about what would be specific and unique to that community and its needs. The "bones" of a curriculum may be similar but what is needed to generate successful

arts-based community development may be different in each place a community arts training is created.

Other essential components for establishing a community arts training are adequate, sustained funding, and experienced practitioners from a variety of sectors as faculty.

The future of the CAT Institute depends on the strength of its network–both in St. Louis and across the country. Alumni of the CAT Institute often take the role of faculty and mentors. With the establishment of an inquiry-based "master" CAT Institute class, our hope is that an even stronger cohort of CAT alums will be able to fulfill those roles and add to the community arts and development field.

During a recent CAT Café in which alums mingled, networked, noshed, and talked, the connections seemed to be strong. In a recent survey, an over-whelming majority of CAT Institute alums said they worked with other CAT alums as partners. With each new class the community is growing. The new fellows will remember and pass on the advice to an expanding ring of arts-based community practitioners:

- At CAT you are who you are, not what you do
- Don't fear your own voice
- CAT is a contact sport. Bring your cup
- Process! Process! Process!
- Start thinking about where you want your CAT tattoo
- Share what you are learning, share what you already know
- If you feel like something was not discussed enough, organize another discussion
- Be prepared to read. Don't read and drive
- Don't break the rain-stick...again
- Learn how to open the door
- This is a musical instrument
- Respect the unexpected
- Change your seat
- Social Dreaming is freaky stuff
- Whoever brings the most snacks will be the most enlightened
- Always consider the real world
- May the circle be unbroken
- It's really about the journey

CURRICULUM/CONTENT FOR COMMUNITY ENGAGEMENT TRAINING

It should be clear by now that a need exists for training for arts organizations in how to encourage and implement community arts work. Individual programs exist in colleges and universities as well as in particularly lucky communities. Most established training and educational programs for artists and arts managers do not include community engagement in the curriculum, although change is coming. The Eastman School of Music has an Institute for Music Leadership that attempts to address some of these issues, and the Association of Arts Administration Educators has recently adopted a set of curriculum standards for education in community engagement.

There is not, however, a universal curriculum for community arts preparation. Bill Cleveland has been a leader in developing educational programming in this field, having been the driving force behind the CAT Institute in St. Louis. And even this work is more directed toward individual artists and projects than toward mainstreaming community engagement in arts institutions. What follows is a "blue-sky" (and preliminary) outline of content for such a curriculum, focusing on those coming to the training from the arts world, derived from the insights gathered in putting together this book.

STRATEGIC ISSUES FOR ARTS INSTITUTIONS
The Case for Engaging

As redundant as mentioning it is in the context of this book, preparation for community arts work on the part of arts organizations must begin with a thorough examination of the reasons–practical, moral, and arts-centric–that the work is important.

Understanding the Roadblocks

Early in this book, the range of obstacles to change was discussed. A thorough understanding of those obstacles as well as strategies for addressing them is an essential part of preparation for community engagement if it is to be done through or with established arts organizations.

Mainstreaming Community Engagement

Mainstreaming was considered earlier in this book under Principles for Effective Engagement. The point was made that without a systemic shift in approach, many of the potential benefits of engagement are lost. A thorough curriculum would include discussion of how organizational systems (governance, programming, marketing, fundraising, and advocacy) can be re-tooled through substantive interaction with the entire community. It would also present methods for evaluating the opportunity cost of existing work as one step in the potential reallocation of resources.

INTRODUCTION TO COMMUNITY ARTS
History, Theory, and Examples:
Community Engagement through the Arts

To be a successful practitioner in the community arts world, individuals and organizations must have an understanding of how proposed approaches relate to the history of community arts work; of theoretical models exist on which to base project design; and, especially, of earlier projects, programming, and values-based systemic transformation there are either to emulate or avoid. There is no need to re-invent either the wheel or the hula hoop.

ESSENTIAL SKILLS AND KNOWLEDGE FOR COMMUNITY ARTS PRACTITIONERS: COMMUNITY-FOCUSED
Cultural Humility (sometimes aka, Cultural Competency or Diversity Training)

Whatever term is used, it is essential for the community arts practitioner to "know what they don't know" in dealing with people who are different from them. Cultural assumptions are pervasive and largely invisible. Until individuals have the experience of and opportunity to examine those assumptions, they will be unprepared to participate effectively in partnerships that cross lines of human difference. As has been discussed earlier, cultural humility must influence arts programming. Decisions as to what expressions of a culture are to be employed in community arts projects first requires active consultation with the partnering community. Beyond that, however, understanding the options, the relevance and importance of those options to the community being engaged, and an awareness of issues of quality in the presentation of those options are critical to being an effective partner in program development.

In addition, cultural humility demands an appreciation of cultural differences in the processes by which other cultures accomplish tasks. Aspects of process that can be

important are traditions with respect to assumed levels of input from participants; habits of decision-making: consensus, majority rule, or leadership command, for example; and expectations regarding time frames for project implementation.

The Understanding of Privilege

While some may not separate it from cultural humility, an awareness of the role that privilege has in easing the lives of members of majority populations and power groups (*e.g.*, wealthy, educated, male, non-elderly) and creating internalized oppression in others is critical. This concept was first raised in the section on The Process of Engagement. Awareness of this issue is particularly important for members of majority populations or power groups if they are to participate with people from outside their group in the development of successful partnerships.

Communities and Community Organizing

An understanding of a community's constituencies and of methods of engaging with each is important to successful engagement work. Principles and practices of advocacy and lobbying (and an understanding of the legal and regulatory limits on the latter) at all levels of government are important for community arts workers. Awareness of the concerns, needs, and interests of all stakeholders in the public schools (school boards and administrators, teachers, staff, children, and parents) is essential for anyone undertaking community arts work associated with K-12 education. Familiarity with community business interests–chambers of commerce, as well as economic development and tourism authorities–is a valuable basis for much community arts work, especially, of course, projects that support economic development. And skills in working with neighborhoods, faith communities, and cultural communities (*i.e.*, populations bound by ethnic heritage) are vital to almost any community arts project.

A number of models and approaches to community organizing–involving a broad spectrum of people in decision-making and program planning–exist. Whatever model is used, the principles of "winning friends and influencing people" in the community must be understood by people leading community engagement work. Saul Alinsky's approach in establishing chapters of the Industrial Areas Foundation is one option. The IAF model focuses on power analysis, determining what individuals and groups in a community hold power (formal–*e.g.*, economic and political–and informal) in differing situations. This knowledge is then used to effect change. Such knowledge can also be useful in the creation of community arts projects.

Discussion of Difficult Issues

If for no other reason than the experience-based mistrust of arts organizations, it is valuable for community engagement workers in the arts to have skills in leading and participating in discussions of difficult issues. Beyond that, the issues being addressed by community arts projects often are or have the potential for being contentious ones. Competence in participating in constructive dialogue is critical to successful project development and implementation.

Conflict Resolution

Principles of conflict resolution become valuable when disparate individuals and organizations are brought together to design and implement programming that addresses significant issues in a community

Self Knowledge

Community arts workers need to understand their own motivations for participation in the work. This knowledge can reveal blind spots that could get in the way of successful collaborations and direct the student toward particularly fulfilling areas of practice.

Strategies for Engagement

Generic techniques for encouraging collaboration and participation should be taught along with methods particularly appropriate for target populations. Story collection, action research, cultural asset mapping, and relational meetings (as conducted by community organizers for the Industrial Areas Foundation) are just a few of the possible approaches.

Learning Styles/Teaching Techniques

An understanding of Multiple Intelligences as described by Howard Gardner is valuable for artists generally, since the arts contribute to learning in most of them. In addition, awareness of the Intelligences aids in devising learning opportunities for disparate individuals. Further, a survey of teaching techniques that have been successfully employed in community arts programs can provide a basis upon which to build in devising new projects.

Interdisciplinary Knowledge

Community arts practitioners are inevitably interdisciplinary workers. As such,

they need knowledge (vocabulary and practices) of the community systems and populations with which they will be working. In addition, when dealing with cultural groups other than one's own, awareness of cultural norms and traditions is essential. Among the areas in which community arts workers collaborate are, for example:

SOCIAL SYSTEMS

 Community Development

 Criminal Justice/Correctional Systems

 Economic Development

 Educational System (Public K-12 particularly)

 Health Care (including mental health)

SPECIAL POPULATIONS

 Developmentally Disabled

 Disenfranchised Groups

 Elderly

 Immigrants

 Incarcerated

 Infants and Children

 Middle Class (See "Reflections on the Practice of Community Engagement")

 Physically Disabled

 Suburban (See "Reflections on the Practice of Community Engagement")

 Youth

These lists are far from exhaustive, and even with these it is obvious that no individual could be competently knowledgeable in all categories. Nevertheless, community engagement training needs to provide background on selected areas in which the student will be working.

ESSENTIAL SKILLS AND KNOWLEDGE FOR COMMUNITY ARTS PRACTITIONERS: SELECTED ARTS-SPECIFIC CONTENT
Creative Entrepreneurship

An awareness of the options for entrepreneurship in community arts work–structural, financial, social, to name a few–is helpful as community arts projects are designed. Thoughts "outside the box" can lead to more powerful, more sustainable projects.

Cultural Mapping

Cultural mapping can be one of the most valuable skills for the community arts

worker. The discipline is rooted in respect for the cultural heritage of the population being addressed. Skills in this area are important for those seeking to enter into partnership with populations new to and under-served by the arts.

Design and Implementation of Arts-based Education Programs

A working knowledge of the vocabulary, practices, and structures of educational institutions in the community is essential for anyone hoping to develop curricular or co-curricular arts-based programs.

Economic Impact of the Arts

In order to be taken seriously when communicating with community development officials, community arts workers should have a firm understanding of the potential that the arts have for economic development and the research that confirms its impact.

Principles and Practice of Public Arts

Public art is a common element of community arts work. Understanding the particular design/development, funding, implementation, legal, and maintenance challenges represented by public art projects is important for people in the field.

ESSENTIAL SKILLS AND KNOWLEDGE FOR COMMUNITY ARTS PRACTITIONERS: THE DESIGN AND IMPLEMENTATION OF COMMUNITY ARTS PROGRAMMING
Making Community Arts Partnerships Work

The arts organization that has re-oriented itself in a community service framework and has developed awareness and skills in the areas outlined above is prepared to begin productive partnerships. As was discussed in the chapter The Process of Engagement, relationship building, particularly between organizations, is time-consuming; and, as William Cleveland pointed out, for established institutions there is a reluctance or inability to partner based on inertia and/or the need for sole ownership. While he was referring primarily to artist/organization partnerships, the same holds true for inter-organizational collaboration. The individual readiness of potential partners must be determined. The Meet-Talk-Work construct is helpful; the Eightfold Path of Community Engagement, also presented above, can provide a further means of guiding the process of establishing effective partnerships.

Project-Specific Skills: Project Parameters, Program Design, Resource Development, Marketing, Evaluation

Each of the listed skills have (with the exception of marketing) been discussed in the Principles for Effective Engagement chapter of the book. Instruction in marketing is simply necessary because if the community does not know about the program, they will not be able to participate in it.

As was made clear at the beginning of this section, the topics outlined here represent a first, early effort to present important categories of content that should be included in community engagement training for arts organizations. It is neither thorough nor final. Experience will provide the opportunity to add and delete topics as well as to expand, refine, and clarify those that are included.

REFLECTIONS ON THE PRACTICE OF COMMUNITY ENGAGEMENT

In arts organizations large and small of all genres in metropolises and hamlets across the country, the arts are engaging with communities. There seems to be an upsurge in interest and activity in engagement. Awareness of the need for reconnection is growing. The signs of real change, of real progress are more hopeful than they have been in years past. And there are positive results to report, not just in better communities but also in stronger arts organizations.

Ballet Memphis, Community MusicWorks, Houston Grand Opera, Pillsbury House Theatre, The Queens Museum of Art, and the St. Paul Chamber Orchestra represent a broad cross-section of types of arts organizations that have made substantive commitments to community engagement. The shorter examples that precede and accompany those case studies include others of many sizes and locales that do so as well. Together they demonstrate that "life after engagement" is not only possible but often affords a true path to viability.

Maryo Gard Ewell's history of community arts activity in the U.S. shows that making connections between the arts and the "person on the street" is not new. While her history does not carry us back to Neolithic campfires, it reminds us that community-arts engagement should be a norm, not an exception. William Cleveland's overview of the on-the-ground community arts movement that blossomed in the aftermath of the 1960's and continues unabated presents developments in the field arising primarily from social service and community activism roots. Some of the work coming out of this movement has developed into significant arts institutions.

However, on the whole, the work to which Ewell and Cleveland refer has had little impact on or relationship to the arts establishment in this country. Indeed, the work is nearly invisible to many within that establishment. As arts organizations increasingly adopt community engagement as a core value, it is important that the history of and lessons learned in grassroots community arts work be understood and utilized. At the same time, the field should take to heart Mr. Cleveland's well-founded concern that, due to inertial forces and the need to control, institutions make problematic

collaborators. Cultural humility is not just an important skill for individual community arts workers; it is critical for arts institutions.

Without training in the knowledge and skills necessary for community arts work, many members of the arts establishment will not be prepared for successful engagement. Good preparation is essential, and, while the number of exceptions is growing, it is not yet widely available in traditional arts or arts management educational programs. Opportunities for continuing education in this field will be needed for the foreseeable future.

The outsider looking at descriptions of community arts work tends to focus on examples addressing poverty and social justice issues. This is true for at least two reasons. First, many of such programs are by nature riveting and "high concept." The description of the Los Angeles Poverty Department's work as theatre of, by, and for the homeless is evocative, compelling, and highly memorable. Second, there are foundation funding streams to support at least initial phases (though usually not on-going operation) of such efforts. It should be re-emphasized however that funding even for this category of community arts work faces a Catch-22: Deemed social service by arts funders and arts by social service funders, it is fundable by neither.

The most important point here is that community engagement is not limited to the urban environment or to poverty or social justice work. Community engagement is truly about what artists have always posited if not acted on–"Art is for everyone." It is by harnessing the power of community engagement to become meaningful to *all* that arts institutions and the arts industry will gain traction and flourish. This work cannot come to be seen as simply social programs to aid the down and out. And the examples here show that engagement *can be* for all. Ballet Memphis has teemed with the Chamber of Commerce; HGOco is involving Houston's immigrant populations with opera; the Queens Museum of Art began its engagement work with the middle class of "old Queens;" the St. Paul Chamber Orchestra takes its suburbs seriously, choosing venues and pricing its tickets to draw residents from outside the urban core; and everyone is involved in public school education. The examples are there; the lessons from them must be remembered, analyzed, and built upon.

History and burgeoning current practice in engagement show that transitions to a focus on community are possible and can be beneficial to arts organizations. To date, most of the transitioning work that has taken place has been ad hoc, one organization at a time, led by visionary thinkers. The final section of this book brings other voices to bear on the need for and value of change and outlines a strategy for intentional, systemic transformation of the arts industry.

The Future of the Arts in the U.S.

THE FUTURE OF THE ARTS IN THE U.S.

The hyperbole of this section's title is intentional. It is designed to gain attention for the topic by demanding rebuttal. Of *course* the arts will always exist in the U.S., regardless of the not-for-profit arts industry's response to this book and, more to the point, to the admonitions of the many in the field who are attempting to get the industry's attention on this topic. As raised in the introduction, the question is whether the institutions that are currently the center of the nation's arts infrastructure will be viable in the second half of the Twenty-first Century.

There are signs that the arts world is beginning to re-imagine itself in ways that resonate with the premises of this book. In recent months, a number of leaders of major arts institutions have committed to community engagement as central to their mission or reaffirmed it as a core value.

Clive Gillinson, Executive and Executive Director of Carnegie Hall:
> *How can Carnegie Hall contribute to the lives of people?*
> *I'm never thinking about audiences. I'm thinking about serving people.*
> *We will matter if we matter to society.*

Arnold Lehman, Director, Brooklyn Museum of Art reminded that the Brooklyn Museum of Art, in transforming itself, added a core value focused on enhancing the visitor experience and a commitment to the Museum's neighborhood. Granted, he and the BMA have been under fire over the results, but this was a significant step taken by a major arts entity.

Howard Sherman, COO, Los Angeles Music Center:
> *How do we stay relevant in the Twenty-first Century? In adhering to our mission statement that commits us to "building civic vitality by strengthening community through the arts."*

Leonard Slatkin, Music Director of the Detroit Symphony at the conclusion of the strike in 2011:
> *If there's one thing we've learned, it's that we have to be more involved in the communities outside of Orchestra Hall. We won't abandon it, but direct connections with other populations are absolutely critical.*

These are all, in the context of this book, gratifying statements. That does not mean that each is the last word from these institutions nor that any tide has finally turned in the direction of community engagement. They do, however, signal the application of serious attention to the issue.

The essays that follow represent the thinking of three thought-leaders in the arts community, each of whom has strong views about the necessity of community engagement for the viability of arts organizations and for securing a healthy society.

ESSAYS ON ENGAGEMENT

CLAIMING VALUE, ILLUMINATING COMMON PURPOSE
by Ben Cameron

In the U.S. of the late 1950's and through the 1960's, as a result of the work of generous foundations and the then newly established National Endowment for the Arts, the arts exploded beyond the major metropolitan areas of New York, San Francisco, and Chicago to cities and communities as far flung as Blue Lake, CA, Whitesburg, KY and Douglas AK–all homes to major arts entities today. The future seemed rosy for those of us who made a life in the arts.

We were accustomed to seeing ourselves as descendants of the artists who defined community around a common campfire and so the 1989 NEA controversies involving the works of Andres Serrano and Robert Mapplethorpe came as a shock. We had assumed that the role of the arts as central to healthy communities was broadly understood. While we were quite capable of discussing critical and aesthetic theory, we were often unprepared to address challenges based not in issues of quality but of value. "What is the value of these images for my community?" critics asked in essence. "What is the value of supporting the arts? Indeed, what is the value of the arts at all?"

These controversies marked a turning point for many of us. Ever since, the arts world has worked diligently to quantify its value–value commonly now framed as economic, educational, and social.

The arts are indeed critical to local and national economic vitality. Arts advocates often cite local economic impact studies which prove that arts organizations typically leverage an additional $3-5 or $5-7 for the local economy for every dollar spent on a performing arts ticket–dollars for local restaurants, parking, and gift shops, for local printers who print programs, for fabric stores where the cloth is bought for costumes, for the piano tuners who tune the instruments, for the caterers who run the concessions. And more. Today, in fact, the more than 104,000 nonprofit arts and culture organizations generate $166.2 billion in economic activity. Where the arts are

Edited, with permission, from a speech to the Family Philanthropy Conference of the Council on Foundations. 2 February 2010, San Diego, CA ©2010 by Ben Cameron and Council on Foundations. All rights reserved.

imperiled, entire local small business communities and governments feel the effects as well.

But the arts' community value is far more than economic. With the advent of new research, we have become increasingly sophisticated about quantifying our value in other dimensions as well. Social behavioralist Shirley Brice Heath of Stanford University–not an arts researcher–was among the first to study the arts in the broader context of after school programs–girl scouts, sport teams, and more. In working with high-risk students in inner city East Palo Alto, Heath was admittedly surprised to find that it was the arts students who dramatically outperformed their peers in significant ways. It was the arts students who were four times more likely to win academic awards and four times as likely to participate in math and science fairs, who showed significant reduction in disciplinary infractions, who performed better on verbal and math SAT scores–a differential of 80-120 points in some studies–and who were more than eight times more likely to graduate than students without arts experiences. These studies have been reinforced by a Harvard study focusing on students working with Shakespeare, work that promotes greater complexity in thinking, greater verbal acuity, tolerance of ambiguity, interpretive skills, and increased sense of self-discipline and self-esteem.

The arts nurture healthy communities in other ways as well–and not just through links between creation of cultural districts and crime reduction. A UCLA study proves that high school seniors who participated in the creation of theatre are 40% less likely to tolerate racist behavior than kids who were not theatre participants, and was I the only one who noticed the New York Times features on Columbine in the aftermath of school shootings–features where the students repeatedly said the ONLY place they felt a sense of community, where the cliques lost their power, and the disenfranchised felt welcome was in the performing arts center?

For these reasons, those of us who work in the arts can now stand proudly and confidently in front of civic leaders and government officials and say, "If you care about economic prosperity, you must care about the arts. If you care about educational achievement for your children, you must care about the arts. And if you care, perhaps most significantly, for harmonious race relations and a more inclusive, cooperative society, you must care about the arts. In other words, if you care about your community, you must care about the arts."

In spite of these arguments, the last 10 years have witnessed a gradual erosion of arts funding–regular declines in the percentage of the philanthropic dollar attached to the arts, the inability of arts giving to keep pace with inflation, the disappearance of

major national arts funders like the AT&T and Philip Morris (aka Altria) Foundations, and the elimination of discrete arts programs altogether at both the local and national level. With the national economic collapse, local and state arts giving is under assault– resulting in devastating cuts or even the total elimination of government support in many cases; corporate philanthropy has largely abandoned the field; and individual donors, who have far less disposable income, are pulling back in ways that affect both contributed and earned revenues.

But I would suggest that the real crisis the arts face is not economic.

Our world today is most dramatically marked by a host of shifting demographics, among them age and geographic distribution; by our increasing diversity (I joyfully embrace the new nation we will soon become, defined by plurality rather than majority); and by advancing technology. For the arts in particular, these shifts have already brought enormous challenges–challenges to the historically Eurocentric orientation of the institutional arts, with special challenges to forms like opera, ballet, and symphonic music. Technology for its own part is radically changing how we think, how we behave, how we congregate, even how our economy works. Together, these forces are provoking a fundamental realignment of cultural expression and communication–a realignment that is shaking the newspaper and television industries as well as the publishing and book industries, and (in an indication of what may be yet to come) that has left the recorded music and music distribution industries in disarray.

Far from making the arts irrelevant, diversity and technology promise to make the arts more important than ever. As we stand on the brink of an age in which the ability to think and to behave creatively will be paramount, the arts cannot be viewed as part of the need: they must be viewed as part of the solution to any community issue.

Widely available, affordable technology has democratized arts production. Who among us does not know a 14-year-old hard at work on her second, third, or fourth film? Digital media and the Internet have democratized distribution. Any one of us may now upload our film onto YouTube or Facebook and have an instant world-wide audience with the click of a button.

This double impact is occasioning a massive redefinition of authorship and the cultural market. Today everyone is a potential author and, while the market for traditional arts audiences may be eroding, the market for arts participants–those citizens who dance or write poetry, who paint or sing, who make their own films–is exploding. The market paradigm is shifting from consumption to broader participation.

334

As a result, attendance at institutional arts events is today only one option among many.

Let me be clear: I believe our historic arts institutions will continue to be worthy of our investment. They represent the best opportunities for lives of economic dignity for many artists and the logical place where artists who need and deserve to work at a certain scale can find an appropriate home. We must continue to nurture and promote these groups, and especially support their efforts to change, to adapt to the larger world.

But to see these institutions as synonymous with the totality of the arts and of the arts' potential for community improvement is far too limiting. The most dramatic recent development in the arts is the rise of the hybrid artist, the artist who works in multiple arenas-who works in science or technology, prison reform or education, AIDS awareness or environmental reform, not for economic survival (although that may be a benefit) but because of a deep belief that the work she or he is called to do cannot be accomplished in the traditional hermetic environment of an arts institution but can only be accomplished through deep engagement with other fields.

Today's dance world is not defined solely by the great companies of New York City Ballet and Alvin Ailey, but by companies like Liz Lerman's Dance Exchange, a multi-generational company with dancers in age from 18 to 79, who collaborates with genomic scientists to embody and explore the DNA strand or with nuclear physicists at CERN in Geneva to explore the fundamental questions of physical existence.

Today's theatre world is defined, not only by great institutions like the Steppenwolf of Chicago, Arena Stage of Washington, DC or New York's Public Theatre but by a dense network of small ensembles and groups dedicated to community building and social action-groups like Cornerstone Theatre of Los Angeles. In the aftermath of 9/11, Cornerstone called together 10 religious communities-Bahai, Jewish, Muslim, Catholic, Native American and even gay and lesbian believers-to work, both within faiths and collaboratively across faiths-to create plays that allowed these diverse religious congregations to explore common belief and engage in social healing.

Today's museums embrace not only great visual artists working in traditional media, but groups like Stan's Cafe, who use grains of rice (creating one pile with a grain of rice for every African with HIV next to a pile with one grain for every African) to graphically embody and contrast the distribution of population and wealth-powerful embodiments and depictions that serve as preludes to substantive action and policy reform.

Today's leading poets work not merely in the isolation of the study or the retreat but also with Iraqi war veterans to help them translate and articulate their experiences as a part of healing, while today's playwrights work not only with directors and actors but also with youth gangs, helping them articulate, channel, and represent their experiences as alternatives to violence.

Indeed, however important the arts have been to date, they will be even more important as artists and arts organizations increasingly engage with and support their communities.

The arts will be ever more important to economic vitality and business success, especially as creative industries explode. Leaders of new and emerging industries will benefit from arts exposure. As author Daniel Goldman, in his book *Working with Emotional Intelligence*, notes, the primary indicators of success in leading include empathy, commitment, and integrity; the ability to listen to others and motivate them; the ability to communicate and influence; to initiate and accept change-the very principles that lie at the heart of creating art, the very abilities instilled by arts instruction. Not surprisingly, both the Harvard and Yale Business schools have recently restructured their curricula to promote critical and creative thinking.

The arts will play an increasingly pivotal role-if we let them-in educational and cognitive reform. Traditional emphasis on science and math, while critical, falls short of the advanced integrated thinking of left- and right-brain demanded by the future-a shift articulated by, of all people, Mike Huckabee, who has compared science and math-only education to creation of a data base without a server. Already, we see a dramatic move within colleges and universities to embrace and seize the power of the arts to promote deeper reflection and awareness. As but one example, Dartmouth University's two-year campus-wide examination of class and privilege teamed the political science, psychology, economics, humanities, sciences and business departments with artists like director Peter Sellars and Anne Galjour, who interviewed local citizens and recreated their experiences in a play. This project has placed the arts at the table in the University's strategic long-term planning.

Perhaps most significantly, the arts will become central as we strive to form community, to better understand and work with each other in a democratic pluralistic society. As Francois Materasso observes, the arts enable people with non-majority values, ideas, or lifestyles to represent themselves to the majority, to become subjects of their own characterization rather than the object of characterizations by others. How has our understanding of the injustices of the criminal system been expanded by *The Exonerated*, the play about prisoners on death row performed across the country

and at state capitols; of Iraqi war refugees reshaped by *Aftermath*, currently touring the nation, or of the experience of women through *The Vagina Monologues*? How did the film *Philadelphia* and productions of *The Normal Heart* and *The Laramie Project* humanize the HIV positive and gay community for an indifferent nation?

Ever since Charles Dickens' novels produced changes to child labor law, and Uncle Tom's Cabin galvanized the abolition movement, the arts have been critical to social innovation. Those of us who remember the Vietnam war protests–protests that always began with singing "Blowin' in the Wind"–or the civil rights movement–where we always sang "We Shall Overcome"–cannot be surprised by the power of the music to form instant community poised to move together. Arts can be a massive force for social change.

In a moment when we all must confront the fallacy of a market orientation uninformed by social conscience that threatens to permanently rip the fabric of community, we as a society must turn to the arts. We must embrace the role of the arts in the formation of our collective and individual characters, particularly the character of the young, who are increasingly subjected to "bombardment" of sensation through violent film and video. And in an age of demonization and fear of difference, of intolerant social policies and politicians who encourage us to view our fellow human beings with fear and hostility and suspicion, we must nurture the arts–the arts which gather audiences to look at our fellow human beings with curiosity and generosity. If we have *ever* needed that capacity, we need it now.

We are all united by common purpose. We work together to promote a healthier, more vibrant world, to ameliorate human suffering and nurture a more thoughtful, empathic, substantive and, yes, economically prosperous society.

The future of the arts, indeed the future of a healthy world, lies in artists and communities embracing each other. The way forward is defined by discovering, claiming, and utilizing the nearly limitless values of the arts for improving the human condition. New habits of mind and practice may be necessary for artists; new habits of thought and work may be needed in communities. But when they succeed in finding and fulfilling their common purpose, we will have reclaimed the legacy of community that sprang forth around pre-historic campfires, the flames next to which the arts were born.

CHANGING OUR FUTURE
by Russell Willis Taylor

OZYMANDIAS

I met a traveler from an antique land
Who said: Two vast and trunkless legs of stone
Stand in the desert. Near them, on the sand,
Half sunk, a shattered visage lies, whose frown,
And wrinkled lip, and sneer of cold command,
Tell that its sculptor well those passions read
Which yet survive, stamped on these lifeless things,
The hand that mocked them, and the heart that fed;
And on the pedestal these words appear:
"My name is Ozymandias, king of kings:
Look on my works, ye Mighty, and despair!"
Nothing beside remains. Round the decay
Of that colossal wreck, boundless and bare
The lone and level sands stretch far away.
Percy Bysshe Shelley

As we consider the future of the nonprofit arts in America, this well-known verse strikes a chilling note for arts leaders. But it need not describe our future – the world around us is giving us all the information that we need to change and to become, in the words of choreographer Bill T. Jones, indispensable to the society in which we do our work.

Established nonprofit arts organizations in the United States, and indeed throughout the Western world, are facing an existential challenge that has been increasing for many years. The simultaneous pressures of shrinking resources, new consumer behaviors, increasingly diverse populations and commercial entrants into a space made profitable by new technologies, have all combined to highlight the creative challenges of running a mission-driven organization in a market-driven world. This book, which examines how organizations go about becoming indispensable to their communities, reminds us that the mission of a sustainable arts organization cannot be the perpetuity of that organization alone. We exist in no small measure to prove that not all value is created in markets, and we do it by engaging, supporting, and creating communities.

Where we are in the business of preserving irreplaceable works for future generations, then yes–our existence can and should be secured in one form or another. But the current scope, scale, and sequestered nature of many of our cultural institutions clearly need reconsideration. The late Stephen Weil, a great thinker about the role of museums in American life, once remarked that museums must be <u>for</u> someone, not just <u>about</u> something. This is true for all nonprofit organizations: it is the lives we change and the relationships we create that make us both necessary and sustainable.

We are also in the business of risk. By accepting the ideal and rigor of mission, we inherently acknowledge that we will be creating experiences and artistic work that will not bear immediate fruit in the mass marketplace. This does not mean that we should take pride in empty houses; instead, we operate in advance of profits rather than in ignorance of them. Much of our work is marginal in the best prophetic sense of that word: Guttenberg in time becomes Penguin Books, Cubism in time becomes an accepted aesthetic, and The Sopranos owes as much to Jane Austen–given its closely observed social description and withheld information about characters–as it might to <u>The Godfather</u>. By connecting with people about the things that matter to them but for which they are not yet ready or able to pay the full costs of creation, we foster communities of learning, of experimentation and of exploration.

Differentiation is a powerful market strategy, but even more importantly for cultural organizations it is our reason for being. If we do not provide something for someone that no one else can, then we have no reason to exist. This is not to say that there will be no duplication in our markets, but rather to assert that we are already linked to our communities in our founding and that strengthening that link is the key to our future. We are in the business of relationships, not transactions.

The model we have developed over the past 50 years is often described as supply-led rather than demand-driven. The economic language is distasteful to some who fear that becoming demand-driven means pandering and lowering the quality of our programming. Many leaders in our field define our role as shaping the taste of the nation and moving our audiences to a higher aesthetic plane. Participation has occupied a limited place in organizations that create professionally developed artistic experiences of the highest quality–we create and expect an air of reverence in our audiences. For reasons that we find mystifying, those audiences are shrinking. It's almost as if they don't understand how good for them all of this will be.

And yet–those same audiences are participating in the arts on their own terms, in their own time, at a growing rate every day. They may be enjoying portable culture on an IPod, they may be in book clubs, pottery classes, redesigning their living spaces or

learning a new language- but somehow they are managing to engage in the cultural activities that mean something to them without our help. How can this be?

We are a tribal species. Where and when we can, we prefer to gather. And we like to gather most when we can celebrate, express ourselves, and form communities that make us feel better about the human condition. The arts have long occupied that meeting ground space; have provided throughout history what the writer Jeremy Rifkin calls "the cultural commons" where we can come together as equals in a transitory experience. Mission-driven organizations that move away from creating that space and from using as much resource as they can possibly garner to invite, welcome, and nurture as many people as there are in our communities endanger the value that the nonprofit arts create: creating value that does not in any way commodify the consumer. We are there to serve, not to exploit, and it is this notion of service that has somehow been overshadowed by the drive for artistic excellence at all costs. Even when that cost may be organizations that become financially unsustainable and increasingly irrelevant.

Many cultural institutions in the United States have embraced the idea that participation of all types is not a limited *program*, but is instead a *philosophy* for the entire organization. Engaging with our audiences–and our non-attenders–to find out what they are interested in is second nature to some nonprofit cultural organizations. They are becoming indispensable, and understand that this is a daily and iterative process with their communities. The exciting and endless range of possibilities that open up for us as we realize that what we need to know we have only to ask should be a source of real inspiration to cultural leaders now. There has never been a time when we needed to be in communities with one another more, and the arts can lead the way. There is no need to despair.

NB: Many of my thoughts and views have been informed by my colleagues at NAS, by leaders in our field including funders, and by international colleagues who took part in a 2010 Salzburg Global Seminar Seminar on the future of the performing arts. To all of them, thank you.

PRODUCER-CONSUMER ENGAGEMENT: THE LESSONS OF SLOW FOOD FOR THE REFLECTIVE ARTS
by Diane Ragsdale

At first glance there would appear to be little in common between the food industry and the not-for-profit arts world discussed in this book. Upon reflection, however, interesting parallels and, therefore, lessons, come into focus. By the second half of the twentieth century, food delivery had largely bifurcated into "low brow" Fast Food (mass-produced in both chain restaurants and grocery store-based prepared foods) and "high (or higher) brow" restaurants charging extreme prices for elite, hand-crafted dining experiences. Cost and convenience pushed the public toward the former in increasing numbers. Thus stated, the relationship between food and the arts is somewhat clearer. However, the Slow Food movement, begun 25 years ago, altered the dynamics of the binary food industry. Today, significant change has occurred. A middle ground of producer-consumer engagement has emerged and, as a result, both Fast Food and *haute cuisine* have been transformed.

In 1986, McDonald's opened a restaurant near the historic Spanish Steps in Rome. It was the inciting event that compelled Carlo Petrini to write a manifesto and launch the Slow Food movement, a counterpoint to the Fast Food industry, which had revolutionized dining beginning in the mid-twentieth century. Over a matter of a few decades, Fast Food gained dominance not because farmers had stopped growing fresh, delicious produce, but because the distribution chains that deliver food to restaurants and kitchen tables were increasingly oriented to a new high-profit marketing strategy. They focused on providing quick, affordable solutions to time-crunched and budget-crunched women and men who were working full-time and trying to put meals into their stomachs and those of their kids three times a day. Once people began eating processed foods they became habituated to them. Over time, as Carl Honoré writes in his book, *In Praise of Slowness*, there was declining appreciation for such things as fresh, local, seasonal produce; recipes handed down through the generations; sustainable farming; artisanal production; and leisurely dining with family and friends.[1] This was the difficult reality that Carlo Petrini faced when he started the Slow Food movement.

Over the past 25 years Slow Food has deployed several strategies aimed at changing people's values and their relationship to food, among them:
Through festivals, markets, and events, Slow Food connects the general public directly with the farmers and artisans from their community because it believes that if you

341

have a relationship with your local poultry farmer, taste his goods, and understand how he raises his birds, you may be more likely to buy your chickens from him than Tyson.

- Slow Food knows that the taste buds of many have become accustomed to fast food so it helps adults and kids reawaken their senses and study all aspects of food by offering Taste Education events that are hands-on, social, and enjoyable. Education is core to the Slow Food strategy.

- Slow Food values what you do in your own garden and kitchen as much as what Alice Waters does at Chez Panisse. It actively develops and nurtures your inner Alice Waters.

- Slow Food encourages consumers to see themselves in a powerful, active role rather than in a passive one and considers engaged consumers to be "co-producers." Being a co-producer (a responsible consumer) entails choosing to purchase and enjoy locally grown meats, vegetables, fruits, breads, and cheeses, caring about where food comes from, how it tastes, and how one's food choices affect the larger environment and the local culture.[2]

- Slow Food does not necessarily have a price advantage over fast food. If anything, Slow Food can be more expensive than Fast. Food produced locally has an advantage in shipping costs, but the economies of scale savings possible with industrial agriculture are largely unmatchable. The price difference is compounded if the Slow Food is also organic. The best results in competitive pricing come with the elimination of some or all intermediaries made possible through Community Supported Agriculture.

However, one of the most important lessons of the Slow Food movement is that consumers (who can afford it) have been convinced not only of the advantages of quality over cost savings, but also have begun to think about the "cost" of a meal in terms of its impact on society. Food that is better tasting, more nutritional, better for the environment, and supports local farmers and artisans is evidently worth the expense for a wide range of people. And one effective method of making that case has been to reintroduce food consumers to food producers. Where relationships between farmers and the public are strong, the Slow Food movement is especially successful.

It is also not coincidental that at the same time the Slow Food movement has gained traction there has been an increased interest in community gardening. Slow Food encourages those who do not have financial or geographical access to locally grown produce (and even those that do) to become producers themselves. Participation in food production then becomes a reinforcing loop as individuals proselytize (by

example and enthusiasm) to friends and acquaintances, yielding an ever-growing number of Slow Food converts as well as ever more producer-disciples.

Slow Food appears to be making headway with its cultural revolution through food. Can we say the same about the not-for-profit arts and culture sector, particularly the "high" end of it? Are we making headway with our "audience development" strategies, which seem to be primarily aimed at identifying, targeting, hooking, and snagging patrons? We've created more organizations, and produced more products over the past three decades, but declining arts participation rates would seem to indicate that fine arts institutions are reaching a smaller percentage of the population as time goes on. Perhaps this is because, despite all the rhetoric around "community engagement," much of what we do, often in the name of "quality" or "excellence," inhibits rather than encourages participation.

- We privilege the professionally performed and passively received experience over other forms of participation.
- We cater to and value the opinions of our longtime patrons, the intelligentsia, and the critics over everyone else.
- Through advertising and pricing, we give people the perception that the arts are intended for an elite group of culturally sophisticated people.
- We fail to provide the information, guidance, and encouragement that could help "outsiders" confidently and enjoyably enter and navigate the arts scene and derive greater pleasure from the arts.
- We create large, intimidating uptown venues or dark, edgy downtown venues, and do very little, if anything, to make newcomers feel welcome, comfortable, and part of the "tribe."
- We promote artistic hierarchies and (often inexplicably) value certain kinds of art over other kinds of art.
- We resist allowing what we do to be digitally recorded, distributed, and repurposed, even though we know that this might help us reach more people.

In essence, we have too narrow a viewpoint on what a legitimate artistic experience is and whom we exist to serve. Intentionally or not, we do very little to enable the vast majority of people to having a meaningful relationship with art. It's no wonder we're facing our own difficult reality in the not-for-profit arts and culture sector. However, I would suggest that our fate is in our own hands and we could start today and create more meaningful relationships with our communities.

I hold up as both inspiration and evidence choreographer Elizabeth Streb, whose company, in a matter of a few years, became a vibrant and vital aspect of her

neighborhood in Brooklyn, New York. In 2003, Streb (who has described her work as wrestling-meets-ballet) opened a performance space in Williamsburg called S.L.A.M. (Streb Lab for Action Mechanics). When she arrived, Streb opened the garage doors and let her neighbors wander in off the streets to watch rehearsal or just to use the restroom. S.L.A.M. is "all public, all the time." She added popcorn machines and let people know it was OK to eat and drink during the performances. When Streb discovered that her patrons were keen to join in on the action she opened a school. Today, in the course of a week, more than 400 students attend one of the 40 classes on offer. Streb even gives students from the school a chance to demonstrate what they have learned in showcases embedded into the performances by the professional company. She also uses her resources to foster the development of other professional artists; moreover, she has created innovative programs to enable community members (even those of modest means) to commission the creation of new works.[3]

Streb does not behave as if achieving artistic virtuosity and being relevant and accessible to the community are competing or mutually exclusive goals. She is pursuing excellence *and* equity. And it's paying off. Streb is cultivating what Kevin Kelly calls "true fans"–a diverse group of people who are deeply engaged, enthusiastic, and loyal. She has developed a robust social network that drives all manner of participation in her organization. Streb's success both as an art maker and a community maker is realized not when another ticket gets sold at the box office, but thirty minutes after the show when the majority of participants are still lingering to talk with one another and the artists. Streb's existence matters to the community of Williamsburg because the community of Williamsburg mattered to Streb from the day she arrived there and has ever since.

There's a lot of hand wringing about the future of the fine arts these days. But, observing the successful (and quite similar) strategies of Slow Food and Elizabeth Streb, it seems that the issue is not so much what to do as whether arts organizations are willing to let go of some of their longstanding (and arguably no longer useful) beliefs and practices and do it.

So what *are* the lessons? At the risk of over-simplifying and trivializing either Slow Food or the reflective arts, here are some of the possibilities.

- In spite of the (often) greater expense, Slow Food has created many converts by not only demonstrating the superior quality of Slow Food (in terms of taste and nutritional value) but by raising awareness for the food traditions, varieties of produce, animal breeds, and artisanal goods distinctive to a particular region or community (particularly those at risk of being lost). If the

arts want to matter to society-at-large, reflective arts experiences must not only be of high quality, they must also be relevant–topically and culturally–to the lives of community members.

- Educational experiences for consumers have been central to the Slow Food revolution. Furthermore, these experiences have been designed with respect for the "students." There is no sense that the learner is somehow lacking if they are not aware, a priori, of the difference between arugula and Swiss chard. If we want more people to be meaningfully engaged with the arts, education needs to be a core, rather than peripheral, strategy for the nonprofit arts sector.

- A significant part of the case for the values of Slow Food (e.g. quality, health, biodiversity, community, sustainability) has been made by connecting producers and consumers through markets, festivals, and events. More direct connections among community members and artists (and arts organizations) could have a similar effect.

- The facilitation of individual household, school, and community gardens has expanded the tent for the Slow Food movement. The promotion of gardening has not only increased access to better food, it has been an important tool in raising awareness of the means of production and appreciation of the end product. Likewise, the professionalized arts sector might cultivate more appreciative fans if it were to celebrate and enable hands-on participation.

- Over time, Slow Food has begun to have an impact on the entire food industry. Market forces have pressured supermarket chains, fast food restaurants, and schools to add local, natural, and organic options and have made haute cuisine more sensitive to local and environmentally sustainable materials and means. Extrapolating the lesson, an Engaged Arts movement could forge a middle way and perhaps lead the commercial entertainment industry toward a more supportive (and ultimately symbiotic) relationship with independent artists and producers and the not-for-profit arts industry toward more substantive engagement with the communities it serves. Both industries would likely end up more sustainable as a result.

Where might the arts and culture sector have been today if, starting in the mid-80s, we had encouraged and supported the development of arts amateurs and hobbyists; made a point of connecting people with the artists living in their communities; offered taste education programs and made learning about the arts enjoyable, social, and integral to what we do; and empowered our patrons as co-producers?

In his book *Man's Search for Meaning*, Viktor E. Frankl asserts that the path to self actualization is self transcendence. He says one cannot aim for self actualization any more than one can aim for happiness or success; they are side effects, not goals to be pursued directly. Likewise, I would suggest that relevance (or meaningful existence) is not a goal that arts institutions can pursue directly; rather, it is a side effect of transcending the need to be appreciated, preserved, and supported in perpetuity and, instead, eagerly serving the needs of their communities. Doing so requires preparation for and commitment to engagement as described in this book.

Without a transformation toward greater engagement with the public, the constituent units of the arts and entertainment industries–especially not-for-profit arts organizations–appear to face uncertain futures. The lessons of the Slow Food movement and its impact on the food industry provide a glimpse of the benefits of engagement and the potential that change represents. Our communities will be better off, and our arts organizations more vibrant, if we press for such change, and do so sooner rather than later.

[This essay was developed from ideas first presented in a talk given at the Arts Marketing Association of the UK 2009 conference, www.a-m-a.co.uk.]

FOOTNOTES

1) Carl Honoré, *In Praise of Slowness: How a Worldwide Movement is Challenging the Cult of Speed*, (New York: HarperCollins Publishers, Inc., 2004): 59
2) http://www.slowfood.com/
3) http://www.streb.org/V2/space/index.html

WINDS OF CHANGE

THE RESPONSIBILITY FOR CHANGE

If change is necessary, or even desirable, that change must be internally driven. No matter how real the lack of time, resources, energy, or constituent support for such change, change, if it is to happen, can only be generated from within. The fact that elements of the art world do not like this reality and would prefer not to deal with it does not obviate the necessity, for them and for the arts community as a whole, of doing so.

A graduating theatre student, child of Mexican immigrants, was speaking (in Spanish) with a stranger in a Latino grocery store. He was asked what he was studying.

"Theatre," he replied.

"Like movies?"

"No, live theatre, on the stage."

After a pause, the stranger asked, "Do they still do that?"

The stranger's lack of awareness of contemporary theatre in the U.S. was, no doubt, exacerbated by a language barrier. But his disconnection from live theatre is far more typical of the general populace than not. It reflects a small difference in degree, not a substantial one in kind.

The arts are simply not a vital fact of life in the U.S. for any but the truest of true believers. If it were otherwise, funding, attendance, perceived relevance, and visibility (to name a few issues) would not be the challenges they are.

The arts community can choose to decry what it identifies as the sources of this disconnection–poor public schools and arts education, societal focus on trivia, lack of reflective capacity, a grossly materialistic culture, etc., but gnashing of teeth serves no constructive purpose. It can also advocate vociferously for change *in those other sectors* as solutions to the arts world's problems. But, there is no force or constituency external to the arts community that can or will apply its influence or resources to make the arts more relevant to life as lived in this country. Nor, upon honest reflection, can any be expected to do so. The responsibility for that rests solely with the arts community.

THE MODES OF CHANGE

If change must come from within, it is important to understand the nature of

and players in the arts industry. The arts infrastructure as it exists in the U.S. today has essentially two halves. One is the "front lines:" producing and presenting organizations and artists. The other is the support structure that serves direct arts providers. The thoughts that follow are designed to stimulate thinking about steps to be taken in organizing and implementing an enhanced focus on community engagement.

SUPPORT STRUCTURES

Of the two halves, the support structures–arts service organizations, arts training and education programs, and funders (private foundations and government agencies primarily)–have the advantage of not being "in the trenches." They have the luxury of a longer and broader view of their respective areas of interest and time, in comparison to those on the front line of the arts, to digest trends and insights in the field. By virtue of their connections with multiple arts providers, they have the capacity to reach numerous organizations at once, and, to one extent or another, they have standing with their constituents to advocate for change. At the same time, since they are all constituent driven, there is sometimes a countervailing tendency for them to be beholden to the habits and opinions of their members–a relationship that has occasionally had the result of stifling or delaying change.

Arts Service Organizations

On the national, regional, and state levels, arts service organizations can best support change in arts organizations. They can do so through the information disseminating vehicles at their disposal-print publications, electronic media, workshops, and conferences. Those that have funding mechanisms can redirect current or channel new financial support to training opportunities for members (*e.g.*, externally run workshops) and projects for direct transformation of individual organizations.

Local arts agencies, with their immediate connections with artists and arts organizations may well be the most productive vehicle through which to effect change. The best mechanisms for reaching LAA's would be through their specific state and national service organizations.

Arts Training/Education

Artists need training in how to *be* in community at the same time they develop their requisite arts-specific skills. Not all artists pursue a degree in higher education, but those that do would benefit from the type of instruction suggested here. While a few undergraduate and graduate artist programs in higher education have made great

348

strides in preparing their students for engaging with communities (the Eastman School of Music, New England Conservatory, and the Rhode Island School of Design are but three examples) and others are beginning to add engagement and entrepreneurship to their curricula, broader efforts would be helpful. In particular, working with the principal arts program accrediting bodies (*e.g.*, National Association of Schools of Dance) and the discipline-specific support organizations (*e.g.*, College Music Society) would assist in raising awareness about this category of training and in providing recommendations on how to include it in curricula.

Similarly, arts administration students need exposure to the principles and practices of community engagement. As with artist education programs, some arts administration programs place heavy emphasis on community engagement. As mentioned earlier, the Association of Arts Administration Educators has developed a curriculum standard for community engagement education, though addressing the standard is not a requirement for membership.

Foundations

While very few foundations exist exclusively as arts infrastructure, the Catch-22 issue referred to earlier, where neither arts nor social service funders view community-focused arts projects as falling within their mandate, needs to be addressed. In addition, foundations and government funding agencies need to be made more generally aware of the potential for community improvement that the arts represent. As but one idea in practice, the NEA under Rocco Landesman has partnered with numerous other federal agencies (*e.g.*, Education, HUD, Veterans Affairs) on arts-related projects, gaining access to funds otherwise unavailable. The foundation service world can provide an access point for educating foundation leadership just as arts service organizations can serve that role for their constituents.

THE FRONT LINES

It is on the front lines of the arts world where the community is actually engaged. As has been described earlier, the path to engagement begins with the artist or arts organization committing to engagement as an essential role. Artists and arts organizations have two basic modes through which they can do this work. The most obvious is participation in community-focused arts projects; programming is central to engagement. The other is simple community citizenship-providing neighborly service as resources allow and participating in community-betterment projects even when they are not arts related.

Producers

Arts producers are those who directly create art or curate and organize arts events: art museums, performing arts organizations, and artists. Each category presents its own opportunities for connecting with the community. Reaching them through arts service organizations has been discussed immediately above. Another vehicle for change, not unrelated, is through the experience of peers. Awareness of successful examples that enhance viability provides inspiration and legitimizes engagement as a viable option.

Museums: As discussed earlier, art museums engage communities through education, historically one of their three core functions. Exhibits designed around community issues and interests are a beginning. Related educational programming draws visitors, encourages discussion, and enhances a sense that the museum is interested in the community. Such work positions a museum to be seen as a valued member of the community. In addition, the 4C self-image articulated by the Walker Art Center (Container, Convener, Connector, Catalyst) or the Queens Museum's view of itself as a Community Hub add depth to engagement.

Performing Arts Organizations: It is in the immediacy of performance, direct contact with performers, and shared experience (with other attendees) that performing arts organizations have their power. Performances gather groups of people together, groups that can be encouraged to participate in discussions, presentations, and follow-up events related to the performance. As performing arts organizations become more adept at collaboration and at programming that is responsive to community interests, they will reap the benefits associated with being valued by an ever-increasing percentage of the population.

Artists: Ultimately it is the artist that is central to community engagement. Performing arts organizations and museums establish and support frameworks through which the work takes place, but it is an artist's output upon which any community arts project is based. (Yes, program design/selection and the curatorial process that creates an exhibition yield artistic products, but each is created from individual artists' creations.)

Artists are crucial to community arts activities. They are often the face of community engagement, so it is essential that they be trained in and adept at this work. The current lack of training for artists in this skill has been

discussed before. Yet even simple non-arts human interactions (*e.g.*, mundane tasks as simple as picking up the dry cleaning) can be powerful in establishing connections that support more substantive work. Being seen as a member of the community goes a long way toward breaking down the "heroic artist" barrier that prevents some from seeking out the benefits of the arts. The experience of the NEA's rural residency program attests to the power of this element of engagement. In 1992, the Ying Quartet lived and worked in Jesup, Iowa, a farm town with a population of about 2000. Their presence and work in the community electrified Jesup and transformed notions about what being a musician meant. Artists who add in-depth training in engagement to the rich dynamic of personal presence can be powerful change agents.

Presenters

Presenters take artistic product created by others and make it available to the public. Performing arts series, museums and galleries that mount traveling exhibitions, and concert/theatrical venues that do not produce their own programming fall into this category. Presenters are uniquely positioned for community engagement work. Functioning as curators (choosing the art work to present) they select from a vast array of options available regionally or nationally. Choices can be made that are particularly suited to their locale's interests or issues without the burden of mounting the production or exhibition. Since their missions are often even more directly tied to community support than that of others cited here, a community engagement agenda can be particularly valuable to their sustainability.

CONCLUSION

The most exasperating part of this work is the assumption made by many in the arts that they "are doing it." In spite of the examples cited at the beginning of The Future of the Arts, on the whole, in any substantial way, they are not; or at least many of the mid-size organizations that make up the bulk of the arts infrastructure in the U.S are not. Arts organizations should honestly ask themselves the following questions:

- In what direct, tangible ways are the lives of specific people in your community outside of the arts world made better by your programming and other activities?
- Are you actively involved in on-going, mutually beneficial partnerships with individuals and organizations that had to be convinced you were trustworthy and/or did not initially believe the arts to be truly important? (In other

words, individuals or organizations who/that were not "true believers" going in to the project(s).)

- Does your work look *substantially* different from your peers' and is it perceived as such by your community?

These questions highlight the intense involvement in community engagement that is required to be effective in it. Meaningful answers take an organization far beyond and much deeper than traditional outreach programming that has as its principal intent increasing audience size.

Colleagues whom I deeply respect challenge me as to whether I believe all arts organizations should adopt community engagement as central to their mission, whether excellence is not enough of itself. I am a product of the established arts infrastructure, so it has taken me a long time to sort through what I think about this question. I now believe that, in the abstract, excellence alone *may* be sufficient justification for the existence of an arts organization. But there are important questions that organizations citing excellence as their *raison d'etre* should answer, and, to my mind, there are few that, as a result of those answers, can reasonably eschew a heavy emphasis on community engagement.

Before addressing those questions, however, some observations need to be made about the limitations that can be imposed by "excellence only" or "excellence primarily" missions. Excellence in this context often implies (but need not be limited to) a single genre of a single culture. At the 2011 Conference of Americans for the Arts, Felicia Filer–Director, Public Art Division, City of Los Angeles–observed that, "Any arts organization that is culturally specific in art or audience is not sustainable." While that is a broad generalization subject to many caveats and exceptions, the essential point is a valuable one. Inclusiveness in programming as well as in relationship building is vital to the health of arts organizations in the U.S. of the future. (And, arguably, the present.) It is especially important to acknowledge that many mainline arts organizations *are* culturally specific in their offerings without realizing it. Eurocentric programming can no longer be monolithically normative.

A majority culture has the luxury of not thinking of itself as a culture, just as whites in the U.S. have not in the past been required to think of themselves as "white," a luxury not generally enjoyed by other populations–blacks and Hispanics for example. European culture has been the unexamined template for the arts. In its light all alternatives have been "other." Filer's observation highlights the fact that Eurocentric programming is and will be increasingly subject to the same pressures and limitations as the artistic expression of any other culture. The first step in addressing the issue

is acknowledging the cultural specificity of much programming by established arts organizations.

Of course, Ms. Filer's comment applies equally to culturally specific arts organizations focused on non-European cultures. And the practical issue remains the same. As a means of refining the point and opening more breathing room for each culture's art, perhaps it would be valid to say that "Any arts organization that is culturally specific in art or audience *and that does not actively connect with individuals and communities not directly part of its culture–making that art meaningful to them,* is not sustainable." This, then, is a direct path back to the questions presented above highlighting the seriousness of an arts organization's commitment to being a member of its community.

So here are further questions, both practical and values-based, to be considered by arts organizations with a mission focused exclusively or primarily on excellence, organizations that do not choose community engagement as a significant part of their mission.

- Is the cultural expression at which you excel one that is sustainable for the foreseeable future? Excellence in the performance of Gesualdo's music or John Heywood's plays does not undergird entire industries today. How long will it be before your work is considered historic reenactment rather than living art?
- Can the expense of your excellence be covered through fundraising if you are not widely seen as a community resource interested in and touching the lives of all?
- Given demographic trends in this country, for how long will the resources (human and financial) required to support this culturally-specific work be socially and politically acceptable?
- And even if the art is sustainable, is your level of excellence so unique that it is justifies focus on that excellence without significant attention being paid to community involvement?
- Why are you resisting community engagement? Is it really a concern about losing focus on excellence or is it about attachments to a familiar medium, genre, or cultural heritage? Varieties of perspective and cultural influence have always been beneficial to the development of the arts. Community engagement is a direct path to that variety. It is arguably the road to on-going excellence.

353

In general, then, it would appear that community engagement *is* an essential core value that should be central to the mission of almost all arts organizations. At the same time, some few orchids of culturally-specific excellence not substantively engaged with their communities may continue; they should be cherished as long as they can be viable. However, they should choose their course with eyes wide open.

Change on the scale envisioned here can only be accomplished if every element of the arts organization is committed to the change and to maintaining the process of implementing it over a very long period. Board, administrative and artistic staff, and volunteers must understand the importance of pursuing a new direction and be ready to articulate the reasons to a curious or skeptical public.

To develop the social, economic, and political support that will be required for survival, artists and arts organizations must learn how to work with the members of their communities in exploring the meaning of the arts and the role they should play in all of our lives. The goal is to become vital members of our communities, partners in all that is important to those communities. In explaining the significance of community roots in securing audiences and support for arts activities, I tell my students, "All the arts are local" (with apologies to the late Tip O'Neill). This is not just a statement about making our product viable; it is also a statement about where we are most able to be an agent of change in people's lives. It is in understanding ourselves as community builders that we can find the key to our future and fulfill the call that led us into this profession in the first place.

What we are facing in the next generation or two is only a crisis if we believe that the continued existence of established arts organizations is important. As stated in the beginning, the arts will always exist. It's only the organizations about which there is any doubt. If their survival is important, those organizations, for structural and, in some cases, philosophical reasons, are in serious jeopardy. It *is* a crisis. If their survival is not important, why worry?

My primary reason for urging change in the established arts community is that the arts have so much to offer to every member of our communities and the benefits the arts can represent are not now reaching very far into those communities. Also, we as a society have invested much in an arts infrastructure that could and should be turned to a far broader public good. Finally, the arts that the established institutions present *are* powerful and meaningful. They have much to offer everyone. If established arts institutions gradually fade from the scene as a result of social irrelevancy, then the arts they present will also be lost. That would be tragic.

Perhaps the most critical transformation necessary is a re-imagining of the arts world's understanding of and relationship with the community in which it exists. Our communities should not be seen as a collection of market segments to be tapped in an effort to sell tickets or extend "reach." Communities are not resources to be exploited in the interest of furthering the health of the organization or even the arts as a sector. It is from community that the arts developed and it is in serving communities that the arts will thrive. It is not the arts that are central here. It is the community. Even the self-focused artist in the "heroic" mold is subject to this truth. Their work will only endure if it enriches the community over time. It will otherwise fade to oblivion with Ozymandias. The same is true of arts organizations.

It is the creation and support of healthy, vital communities that provides the justification for the expenditures of human and financial resources that the arts require. Communities do not exist to serve the arts; the arts exist to serve communities.

ABOUT THE AUTHOR

Doug Borwick is an artist. He holds the Ph.D. in Music Composition from the Eastman School of Music and is an award-winning member of ASCAP. He gained experience as an arts administrator and producer working with the Arts Council of Rochester (NY) and through founding and leading the NC Composers Alliance in the mid-1980's.

Dr. Borwick is an educator, having served for nearly thirty years as Director of the Arts Management and Not-for-Profit Management Programs at Salem College in Winston-Salem, NC. (He was named Salem Distinguished Professor in 1997.) He recently served as President of the Board of the Association of Arts Administration Educators, an international organization of higher education programs in the field.

And Dr. Borwick is a leading advocate for community engagement in the arts. He is author of Engaging Matters, a blog for ArtsJournal. In addition, he is CEO of ArtsEngaged, offering training and consultation services to artists and arts organizations seeking to engage with their communities more effectively as well as CEO of Outfitters4, Inc., providing management services for nonprofit organizations

Contributor Biographies

Barbara Schaffer Bacon co-directs Animating Democracy, a program of Americans for the Arts that inspires, informs, promotes, and connects arts and culture as potent contributors to community, civic, and social change. Additionally, she provides leadership in program development for Local Arts Advancement at Americans for the Arts. Barbara has written, edited, and contributed to many publications including *Trend or Tipping Point: Arts & Social Change Grantmaking; Civic Dialogue, Arts & Culture: Findings from Animating Democracy; Case Studies from Animating Democracy; Animating Democracy: The Artistic Imagination as a Force for Civic Dialogue; Fundamentals of Local Arts Management;* and *The Cultural Planning Work Kit.* She has worked as a consultant in program design and evaluation for state and local arts agencies and private foundations nationally. Barbara previously served as executive director of the Arts Extension Service at the University of Massachusetts. She is president of the Arts Extension Institute, Inc. and serves on the board of WomanArts. Barbara served for 14 years on the Belchertown, MA school committee. In 2011 Barbara was appointed by Governor Deval Patrick to serve as a member of the Massachusetts Cultural Council.

Susan Badger Booth is an Assistant Professor in the Communications, Media, and Theatre Arts Department at Eastern Michigan University where she came after serving on the faculty at Bowling Green State University. Prior to entering academia, Professor Booth spent a decade working as a property artisan for regional theatres and opera companies such as the New York Shakespeare Festival, the Old Globe Theatre, and the Santa Fe Opera Company; she later served as the first Development Director for the Arden Theatre Company in Philadelphia. As the first Manager of the Toledo Cultural Arts Center, Professor Booth developed a campaign to raise $19.7 million to renovate the historic Valentine Theatre. She is currently Associate Consultant on the Washtenaw County Master Cultural Plan (2008). Additional research projects include: Developing Entrepreneurial Skills based on Geographic Opportunities in the Detroit area (2010), Supply Chain Theory and the Creative Economy (2009), Scholarship of Teaching and Learning in an Arts Management Academic Service-Learning Project (2010) and a Feasibility Study to Expand Arts Education in Washtenaw County (2011). Susan is the faculty advisor for the AMP! student organization at EMU. Professor Booth is on the

Boards of the Association of Arts Administration Educators (AAAE) and Arts Enterprise (AE).

Sandra Bernhard is currently Director of HGOco, Houston Grand Opera's unique initiative that explores ways of making opera relevant to its changing audiences. She has directed main stage productions at major companies throughout the U.S. including San Francisco Opera, Washington National Opera and Lyric Opera of Chicago. Bernhard held the J. Ralph Corbett Distinguished Chair of Opera at the College-Conservatory of Music (CCM) from 2003 to 2007. She has written librettos and opera education materials for productions at San Francisco Opera, Chautauqua Opera, Virginia Opera, Utah Opera and Florida Grand Opera, and has taught for the Merola Opera Program, the Adler Fellowship Program, the Domingo-Cafritz Young Artist Program, San Francisco Conservatory of Music, Louisiana State University, Utah Opera Young Artist Program, Florida Grand Opera Young Artist Program, Rising Star Audition Program, and Chautauqua Opera among others. At CCM, Ms. Bernhard received the 2007 Harmony Fund for projects exploring diversity in a theatrical event and four National Opera Association Awards for her directing. She is a board member of the Defiant Requiem Foundation, headquartered in Washington D.C.

Tom Borrup is a leader and innovator in creative community building and creative placemaking–leveraging cultural and other community assets to advance economic, social, civic, and physical development of place-based communities. Consulting with cities, foundations, and nonprofits across the U.S, his approach integrates the arts, economic development, urban planning and design, civic engagement, and animation of public space. His book *The Creative Community Builders' Handbook*, released in July 2006, profiles communities that have transformed their economic, social, and physical infrastructures through the arts and provides a step-by-step planning guide. As Executive Director of Intermedia Arts in Minneapolis from 1980 until 2002, Borrup developed a nationally-recognized multidisciplinary, cross-cultural organization in a diverse urban community. He has been a member of many nonprofit boards and funding panels for public and private agencies, and was a trustee of the Jerome Foundation from 1994 to 2003 where he also served as Chair from 2001 to 2003. Borrup served on a variety of funding and policy panels over the 20 years for the National Endowment for the Arts in the media arts, visual arts, presenting, design, and advancement program categories. He teaches for the Graduate Program in Arts and Culture Management at Saint Mary's University of Minnesota, and online for the Arts Extension Service at the

University of Massachusetts and Drexel University's Arts Administration Graduate Program. He is currently enrolled in the Ph.D. Program in Leadership and Change at Antioch University.

Ben Cameron has, since 2006, been Program Director, Arts at the Doris Duke Charitable Foundation in New York, NY, supervising a $13 million grants program focusing on organizations and artists in the theatre, contemporary dance, jazz and presenting fields. In addition to its annual grantmaking budget, the Foundation announced an additional $50 million initiative designed primarily to serve individual artists.Previously, he served as the Executive Director of Theatre Communications Group. Other roles include Senior Program Officer at the Dayton Hudson Foundation, Manager of Community Relations for Target Stores (supervising its grantmaking program) and Director of the Theater Program at the National Endowment for the Arts. He has addressed arts gatherings in seven foreign countries as well as throughout the US; has served on the national boards of the Arts and Business Council and Grantmakers in the Arts; and received honorary degrees from Goucher College in Baltimore, DePaul University in Chicago, and American Conservatory Theatre in San Francisco, in addition to an MFA from the Yale School of Drama. In 2007, he was one of five recipients of the Distinguished Alumus Award from the University of North Carolina at Chapel Hill and received the Sidney Yates award from the Association of Performing Arts Presenters in 2012.

William Cleveland is a pioneer in the community arts movement and one of its most poetic documenters. His books *Art In Other Places*, *Making Exact Change*, and *Art and Upheaval: Artists at work on the World's Frontlines* are considered seminal works in the field of arts based community development. Activist, teacher, lecturer, and musician, he also directs the Center for the Study of Art and Community. Established in 1991, CSA&C works to build new working relationships between the arts and the broader community, specializing in the development and assessment of arts-based community partnerships and training for artists and their community and institutional partners. The Center works with artists and arts organizations, schools, human service and criminal justice agencies, local and state government and the business and philanthropic organizations. Mr. Cleveland's 30-year history producing arts programs in cultural, educational and community also includes his leadership of the Walker Art Center's Education and Community Programs Department, California's Arts-In-Corrections Program, and the California State Summer School for the Arts. He has also been an Assistant Director of the California Department of Corrections and worked as a youth

services counselor and resident artist under the auspices of the Department of Labor's Comprehensive Employment and Development Program. His most recent book *Between Grace and Fear: The Role of the Arts in a Time of Change* written with Patricia Shifferd was published in 2010.

Lyz Crane is currently serving as Communications Associate for ArtHome while pursuing a Master of Public Administration at New York University's Robert F. Wagner School of Public Service (EGD: May 2012, focus: policy analysis). At NYU, Crane is the Co-Chair of the Student Network Exploring Arts and Culture (SNEAC) and also working to coordinate a series of events through the Office of the President and the Right Honourable Gordon Brown on the subject of the Global Civil Society and the universal moral sense. Previously, Crane served as the Director of Program Development at Partners for Livable Communities, where she provided technical assistance to cities, developed publications, and spoke at conferences nationally and internationally. While there, she also served as the Program Manager of the Shifting Sands Initiative and Douglas Redd Fellowship. Crane graduated from Barnard College, Columbia University with a BA in Urban Studies and Sociology and in 2009 was named a 'Next American Vanguard' by urban affairs magazine Next American City.

David Dombrosky brings over fifteen years of experience in arts management and technology to his role as Chief Marketing Officer for InstantEncore. He frequently writes and presents on the uses of technology within arts organizations. Prior to joining the InstantEncore team, David established an arts and technology consultancy, taught graduate courses in arts management at Carnegie Mellon University, directed Carnegie Mellon's Center for Arts Management and Technology, and spent eight years at South Arts designing and managing regional and national programs in the visual, performing, media, and literary arts. In 2007, Americans for the Arts honored his service to the field with its Emerging Leader Award. David holds a M.A. in Communication Studies as well as B.A. degrees in Psychology and Speech Communications from the University of North Carolina at Chapel Hill. He resides in Pittsburgh, Pennsylvania with his partner and serves on the board of the National Alliance for Media Arts and Culture

Maryo Gard Ewell of Gunnison, Colorado, provides an array of services to community arts world through keynote speaking, writing, consulting, training, and teaching. Her specialty is community development and the arts-the linking of the arts to the furthering of broader community ends-and she is especially interested in the evolution and patterns of community arts development in

the United States. She currently manages the Creative Districts program for the Colorado Council on the Arts where she had been a program manager/associate director from 1982-2003; she co-teaches Cultural Ecosystems for the MA in Arts Administration program at Goucher College, and teaches Grantwriting at Western State College in Colorado. She has worked with the Ohio Arts Foundation and with Americans for the Arts to help preserve the history of the state arts agency and local arts agency movements. Ewell has worked for community arts councils in Connecticut, and for state arts agencies in Illinois and Colorado. She is past president of the Gunnison Arts Center, a board member of the Community Foundation of the Gunnison Valley, and president of the Robert E. Gard-Wisconsin Idea Foundation. Honors include the 2012 Arts Education Advocacy Award from Think 360 Arts; the 2004 Arts Advocacy Award from the Gunnison Arts Center; the 2003 "Arts Are The Heart" award for service to the arts in Colorado; and in 2001 an Honorary Doctor of Humane Letters degree from Goucher College. She received the Selina Roberts Ottum Award from Americans for the Arts in 1995. With an undergraduate degree in social psychology from Bryn Mawr College, she holds an MA in Organizational Behavior from Yale, and an MA in Urban & Regional Planning from the University of Colorado-Denver.

Pam Korza co-directs Animating Democracy, a program of Americans for the Arts that inspires, informs, promotes, and connects arts and culture as potent contributors to community, civic, and social change. She co-wrote *Civic Dialogue, Arts & Culture: Findings from Animating Democracy*, and the *Arts & Civic Engagement Tool Kit*. She co-edited *Critical Perspectives: Writings on Art & Civic Dialogue*, as well as the five-book *Case Studies from Animating Democracy*. She has consulted and offered workshops and presentations on the principles and practices of arts and civic engagement for artists, cultural organizations, funders, and at cross-sector gatherings across the country as well as at colleges and universities. Pam serves as a National Advisory Board member for Imagining America, a consortium of colleges and universities that supports public scholarship and practice to strengthen the public role and democratic purposes of the humanities, arts, and design through mutually beneficial campus-community partnerships. Pam previously worked with the Arts Extension Service (AES) at the University of Massachusetts, a national service organization that promotes community development through the arts.

Denise Kulawik, Principal of Oneiros, LLC, serves as Development Consultant to Pillsbury House Theatre, bringing 20 years of fundraising, communications, non-profit management, and governmental experience to her role. Her industry

experience ranges from the arts, economic, and sustainable development sectors to healthcare, health policy, and education policy. Most recently, Kulawik served as the Associate Director of Institutional Giving at the Guthrie Theater in Minneapolis, Minnesota. She began her career as a staff writer, then Director, Research & Communications and finally as Vice President for Marketing for J. Donovan Associates, Consultants in Philanthropy, an AAFRC consulting firm with clients throughout North America. She has served as a Program Coordinator and Consultant to the Massachusetts Commonwealth Department of Medical Security, and as Associate Director of Development and later, Acting Director, Planning & Operations, for Health Care For All, one of the nation's leading policy and advocacy organizations working on behalf of underserved health care consumers. Kulawik has served numerous start-up entrepreneurial social ventures including the Center for Women & Enterprise, the ALS Therapy Development Foundation, the Rainbow Health Initiative of Minnesota as well as artists and arts and cultural organizations including Pillsbury House Theatre, Carlyle Brown and Co., Mad King Thomas and Anne Krocak. Kulawik has presented on fundraising topics for The Boston Foundation, the Center for Women & Enterprise Community Entrepreneurs Program, and the Women Waging Peace Colloquium presented by the Hunt Alternatives at Harvard's Kennedy School of Government. Ms. Kulawik received her undergraduate degree in dramaturgy from the University Professors Program at Boston University. Kulawik is also a working artist. Her original screenplay, *What to Listen for In Music*, is now in development by New Globe Films.

Helen Lessick is an artist and creative catalyst working in public and private, in policy and sculpture, installation, performance, and site-related conceptual overlays of signage, brochures, pamphlets and maps. Ms. Lessick has been honored with solo museum exhibits across the West, a Pollock Krasner fellowship, and multiple project grants from private and municipal foundations. In 2010 she completed permanent public artworks in Los Angeles and Hollywood, CA. Her community art project in Nairobi, Kenya debuts in 2012. A civic arts advocate uniting creativity and municipal planning, Ms. Lessick has served cultural programs as a public arts administrator and collection manager in Los Angeles, Seattle, and Houston and worked as a consultant with the cities of Norfolk, Austin, and San Diego and the State of Washington. She was a founding member of Socrates Sculpture Park, an artist-initiated effort to turn a dilapidated waterfront pier on New York's East River into a living sculpture and community arts space. She is currently

spearheading WRAP, a national effort to link web-based art in public resources with academic arts and critical assessment web sites. A Philadelphia native, Ms. Lessick went west to earn her BA in art from Reed College in Oregon and MFA in studio art from the University of California/Irvine. A peripatetic creative, she has contributed to art and artists communities in the United States and Europe. Her practice is currently based in Los Angeles.

Stephanie Moore is a freelance arts and culture researcher based in Los Angeles, CA. Her continued research on cultural mapping and community development stems from her longstanding interest in folk and traditional arts. Her research *Cultural Mapping: Building and Fostering Strong Communities* earned her a Master's degree in Arts Management and a Graduate Certificate in Nonprofit Management from the University of Oregon in 2011. Stephanie has worked as a research assistant on multiple cultural planning and collaboration initiatives with Creative Planning, the Sustainable Cities Initiative, and the California Association of Museums.

Dorothy Gunther Pugh is Founding Artistic Director and CEO of Ballet Memphis. In 1986, Dorothy founded the company with two professional dancers and a budget of $75,000. Today, Ballet Memphis employs 18 professional dancers, operates with a $3.4 million budget, and is regularly lauded for its artistic innovation and excellence. Dorothy is one of only five female artistic directors of American dance companies of similar size and budget, and she frequently speaks on gender issues in the ballet world at universities, in the media, and on national symposia and panels including recent appearances with *PBS Newshour*, the Glass Slipper Ceiling Symposium sponsored by Richmond Ballet, Dance USA, and at the University of Wisconsin at Madison. Dorothy is a Fellow and the only Memphian in the Royal Society for the encouragement of Arts, Manufactures and Commerce (RSA). She has received the Gordon Holl Outstanding Arts Administrator's Award and the Women of Achievement Award for Initiative. In 2007, she received a fellowship to Stanford University's Graduate School of Business to study at the Center for Non-Profit Innovation. In 2009, she helped spearhead an arts initiative by the Greater Memphis Chamber called "Investing in Inspiration." She also serves on the board of the Greater Memphis Chamber and she is a current fellow with the National Arts Strategies Chief Executive Program.

Diane Ragsdale is currently working at Erasmus University in Rotterdam, where she is lecturing and researching the impact of social and economic forces on US nonprofit resident theaters since the early 1980's in pursuit of a PhD. For the six years prior to moving to Europe, Diane worked in the Performing Arts program

at The Andrew W. Mellon Foundation in New York City, where she had primary responsibility for theater and dance grants. Before joining the Foundation, Diane served as managing director of On the Boards, a contemporary performing arts center in Seattle and as executive director of a destination music festival in a resort town in Idaho. Prior work also includes stints at several film and arts festivals and as a theater practitioner. She is a frequent panelist, provocateur, or keynote speaker at arts conferences within and outside of the US. You can read her blog, Jumper, on Arts Journal.com and follow her on Twitter @DERagsdale.

Noel Raymond is the Co-Director of Pillsbury House + Theatre where she has helped lead, develop, and implement arts programming to promote community vitality since 1995. Raymond has served on the Boards of Directors for the Multicultural Development Center; the Burning House Group Theatre Company, which she co-founded in 1995; and the South Minneapolis Arts Business Association (SMARTS). As an actor, Raymond has performed locally and nationally with many theatres including: Pillsbury House Theatre, the Guthrie Theater, and Penumbra Theatre in Minneapolis, and the Hangar Theatre in New York. Raymond's directing credits include *No Child...*, *An Almost Holy Picture*, *Far Away*, *Angels in America: Parts I and II*, and *[sic]* at Pillsbury House Theatre; *From Shadows to Light* at Theatre Mu; and *The BI Show* with MaMa mOsAiC. Noel is a core company member of Carlyle Brown and Company and has directed the premiere productions of Carlyle Brown's *Are You Now...* and *Therapy and Resistance*. She has served on numerous panels including: National Theatre Criticism/Affiliated Writers Program, Minnesota State Arts Board's Artist's Initiative Program, the Playwright's Center Many Voices and Affiliate Membership Programs, United Arts General Fund, and "The Art of Social Justice" breakout at the Neighborhood Funder's Group/MN Neighborhood Institute conference.

Prerana Reddy has been the Director of Public Events & Community Engagement at the Queens Museum of Art since 2005. In addition to organizing screenings, talks, performance, and openings, she also oversees the museum's full-time community organizer, with whom she works on QMA's community development initiative for Corona, Queens residents, many of whom are new immigrants with mixed status families and limited English language proficiency. She has also co-curated *Fatal Love*, an exhibition of South Asian American Contemporary Art as well commissioned two editions of *Corona Plaza: Center of Everywhere*, Queens Museum's socially-interactive public art projects. She is now coordinating *Corona Studio*, a series of long-term participatory artist residencies as well a related effort

to develop an MFA concentration in Social Practice at nearby Queens College. She designed and initiated QMA's community engagement blog: http://community. queensmuseum.org. Reddy has a Masters degree in Cinema Studies from NYU, with a Certificate in the Culture and Media Program in conjunction with the Anthropology department. She has extensive film programming experience, having worked for several years with the South Asian film & video collective 3rd i NY, the NY Arab & South Asian Film Festival, and the New York African Film Festival. She is currently on the film programming committee and the board of directors of Alwan for the Arts, an Arab & Middle Eastern cultural organization based in lower Manhattan. She is part of the South Asian Solidarity Initiative, which fights against neoliberal economic policies and state-sponsored violence in the region. She has been the recipient of the Ford Foundation's Douglas Redd Fellowship for emerging leaders in the arts and community development field and was a 2010 fellow at the Asia Pacific Leadership Program at the East-West Center in Honolulu.

Sebastian Ruth is the Founder and Artistic Director of Community MusicWorks, a nationally-recognized organization that connects professional musicians with urban youth and families in Providence, RI. As a member of the Providence String Quartet, the organization's resident ensemble, Sebastian has performed in recent seasons in Providence, Boston, Los Angeles, Banff, and New York, and with members of the Borromeo, Muir, Miro, Orion, and Turtle Island String Quartets, with pianist Jonathan Biss, and violist Kim Kashkashian. Sebastian graduated from Brown University in 1997, where he worked closely with education scholars Theodore Sizer, Mary Ann Clark, and Reginald Archambault on a thesis project exploring the relationship between the moral education and music. Sebastian serves on the board of the International Musical Arts Institute, the Board of Visitors of the Longy School of Music, and the Advisory Boards of RISD's Office of Public Engagement and Music Haven, a non-profit organization in New Haven, Connecticut modeled after Community MusicWorks. In 2010, Sebastian visited the White House to receive the National Arts and Humanities Youth Program Award from First Lady Michele Obama on behalf of Community MusicWorks. Also in 2010, Sebastian learned that he had been selected for the prestigious MacArthur Foundation Fellowship for "creating rewarding musical experiences for often-forgotten populations and forging a new, multifaceted role beyond the concert hall for the twenty-first-century musician."

Russell Willis Taylor, President and CEO of National Arts Strategies since January 2001, has extensive senior experience in strategic business planning, financial analysis and planning, and all areas of operational management. Educated in England and America, she served as director of development for the Chicago Museum of Contemporary Art before returning to England in 1984 at the invitation of the English National Opera (ENO) to establish the Company's first fund-raising department. During this time, she also lectured extensively at graduate programs of arts and business management throughout Britain. From 1997 to 2001, she rejoined the ENO as executive director. Mrs. Taylor has held a wide range of managerial and Board posts in the commercial and nonprofit sectors including the advertising agency DMBB; head of corporate relations at Stoll Moss; director of The Arts Foundation; special advisor to the Heritage Board, Singapore; chief executive of Year of Opera and Music Theatre; judge for Creative Britons; and lecturer on business issues and arts administration. She received the Garrett Award for an outstanding contribution to the arts in Britain, the only American to be recognized in this way, and served on the boards of A&B (Arts and Business), Cambridge Arts Theatre, Arts Research Digest, and the Society of London Theatre. Currently serving on the advisory boards of The University Musical Society of the University of Michigan, Salzburg Global Seminar and the Center for Nonprofit Excellence in Charlottesville, Mrs. Taylor is a Fellow of the Royal Society of Arts.

James Undercofler currently holds the position of tenured Professor of Arts Administration at Drexel University. He will soon leave Drexel to take a post at Ithaca College, where he has been working on the launch of an innovative master's degree focused on Entrepreneurship in the Arts, as well as undergraduate programs focused on leadership and advocacy. Prior to Drexel he held positions as President and CEO of The Philadelphia Orchestra, Dean of the Eastman School of Music of the University of Rochester, Founding and Executive Director of the Minnesota (now Perpich) Center for Arts Education and Director of the Educational Center for the Arts in New Haven, Connecticut. Mr. Undercofler's background includes activity as a French horn player, youth orchestra conductor, as well as that of an active teacher. His education includes degrees from the Eastman School of Music and Yale University and extensive post-masters study at the University of Connecticut. He serves on numerous not-for-profit boards, including the Greater Philadelphia Cultural Alliance where he chairs the strategic planning committee, Alarm Will Sound (a contemporary music ensemble in New York), and the Black Pearl Chamber Orchestra. Over his long career he has been the recipient of

numerous awards and citations, and has been a featured speaker at national and international conferences. Undercofler blogs on ArtsJournal in State of the Arts (www.artsjournal.com/state).

Roseann Weiss is Director of Community Art & Public Art Initiatives at the St. Louis Regional Arts Commission (RAC). In this position, she serves as director of the Community Arts Training (CAT) Institute - an innovative program centered on the belief that art can amplify the voices of communities, regenerate neighborhoods and be an agent for positive social change. Roseann also leads RAC's public art initiatives, which include identifying resources for new projects. Roseann has 25 years of experience in arts administration in both nonprofit institutions and gallery settings.

ACKNOWLEDGEMENTS

After over a decade living with the beginnings of the notion that has resulted in this book, there are far too many people to recognize and thank than I can possibly do justice (or at this point even remember). I have just discovered that my "Thank you's" list, dutifully begun partway through, has languished with little or no attention for a long time.

Nevertheless, I must make the attempt to recognize at least some of the many, many people who have made this possible. First, to the twenty-plus contributors who, after being cajoled and (in some cases) brow-beaten by me to write a section or a chapter, I am deeply and eternally grateful. I have not done a word count, but clearly the portions I wrote and co-wrote are a small percentage of the total. To a person, these leaders in the field were anxious to stimulate conversations about the arts' role in the future of communities, to highlight the great work that is being done, and to encourage others to become active "engagers." It would be a mortal danger to single out individuals in this group, but I want to particularly thank Barbara Schaffer Bacon and Pam Korza of Animating Democracy whose advice and counsel over many years (going back to long before this book decided it was a book); Maryo Gard Ewell whose knowledge, wisdom, and calming presence has gotten me through many conferences, meetings, and assorted crises; Diane Ragsdale, a kindred spirit who has encouraged me to think that perhaps I'm not crazy; and Russell Willis Taylor who has been incredibly generous and supportive whether we are talking over a "meal" at an off-ramp Cracker Barrel in North Carolina or serious food at Molyvos in Manhattan. In addition, Susan Badger Booth asked that the work of Justin Fenwik be recognized in assisting her with completing the chapter on social entrepreneurship.

To my many friends and colleagues at the Association of Arts Administration Educators, I want to express thanks for tolerating my harangues about the arts and community engagement for all these years as well as for believing that I might be able to contribute in some way to the organization's future. The Presidency of AAAE's Board, which ends at close to the same time as the release of this book, was an unexpected privilege and a (mostly) joyous responsibility. Its relationship to this book was to provide me with a platform from which I could to talk to arts industry leaders around the country not only about the role of higher education in preparing the arts

administrators of the future but also about the critical importance of community engagement.

To the administration at Salem College, where I have taught for a bit less than thirty years, I must say thanks for support, encouragement, . . . and the money to go to conferences to learn and to test my ideas. They have been consistently helpful. Similarly, to my faculty colleagues, thanks for creating an environment where interdisciplinary thinking rules and the slightly odd idea can grow and be developed. But especially to my many, many students over the years, I am grateful for the opportunity to try out the concepts contained in this book. You have challenged and encouraged me in identifying community focus as a central element of sustainability for arts organizations. Many of the central points in this book were the result of "on the fly" inspirations that came up in class discussions. (That's why I kept turning around and writing things in my notes.) Also, over the last several years, my Arts in the Community students have been guinea pigs for the theoretical portions of the book. Sorry to subject you to a work in progress, but thanks for the opportunity.

To Doug McClennan, the guru responsible for ArtsJournal, I am grateful for the seriously bully pulpit that is AJ's Blog Central. I'm not quite sure why, when I asked if he would be interested in a blog about the arts and community engagement, he said yes. I'm just glad he did. Engaging Matters has provided me the opportunity to write on the topic on a regular basis. While it can be nerve-wracking, it has been extremely helpful in providing a vehicle for organizing ideas and for getting feedback from readers.

Finally, as is usually the case, I need to thank my family. Adult children are wonderful. It has been great fun to kick these ideas around with my son, daughter-in-law, and stepchildren. And they don't seem to care that the occasional professional colleague thinks I'm nuts. They've known that all along and choose to accept it as an endearing eccentricity. (At least when my back's not turned.) I'm anxiously awaiting the day when I can have these conversations with my grandson. So far, he just smiles when I pontificate.

But most of all, I am indebted, in too many ways for which there are no adequate words, to my wife. Julie, thanks for your patience, support, and belief in this work and in me. (And, of course, for your proofreading skills!) I can't say whether this book would exist if you were not in my life, but if it did, the process of getting here would have been far less fun and the aftermath *far* less attractive.